AMERICAN ART NOUVEAU GLASS

AMERICAN

ALBERT CHRISTIAN REVI

ART NOUVEAU GLASS

NELSON

TO
LEO,
JOAN
AND
JOHN

ACKNOWLEDGMENTS

The author wishes to express his sincere thanks to several persons who gave him much valuable information and assistance in the compilation of facts contained in this book: Mr. Frederick Carder, Mrs. Victor Durand and her daughter, Mr. Sam Farber, Mr. & Mrs. Howard Gianotti, Mr. Carl Gustkey, Mrs. A. Douglas Nash and her family, Mr. Leslie Nash and his family, Mr. J. E. Pfeiffer, Mrs. Marcia Ray, Mr. Bob Rockwell, and Mr. James Stewart and his daughter. There were a great many other individuals, libraries, and museums who helped along the way, and to all of them we express our heartfelt thanks. The publishers of *Spinning Wheel* magazine very generously allowed us to use material we had written for them, too.

A. Christian Revi
Hanover, Pa.

CONTENTS

AMERICAN ART NOUVEAU GLASS

INTRODUCTION

THE closing years of the nineteenth century witnessed more radical changes in the decorative arts than they had known for more than a century. These changes affected not only the graphic arts, but such things as home furnishings, architecture, clothing, jewelry, and—to a degree—human behavior. Identified as Art Nouveau, this period began about 1890 and phased out completely in the early 1930s. Now, after more than thirty years of neglect, there is a renewed interest in all facets and manifestations of the Art Nouveau era. Collectors and interior designers are avidly seeking out the decorative objects of this rebellious age.

During the height of the Art Nouveau period (1890–1910), the applied arts took an about-face tantamount to a complete rejection of the lingering romantic traditions of the Victorian era. The new school of thought manifested itself as a composite of several design concepts, containing elements of Japanese art, pre-Raphaelite affectation, and the architectural forms and motifs of ancient cultures—Egyptian, Byzantine, Moorish, and Roman. Sometimes these fusions of various design elements were happy affairs—often they were not at all compatible.

While a handful of artists were courageously creating superb expressions of Art Nouveau, many clung to the past, revamping obsolete Victorian designs and presenting them as "new art." A few of the exponents of Art Nouveau never seemed to quite rid themselves of the

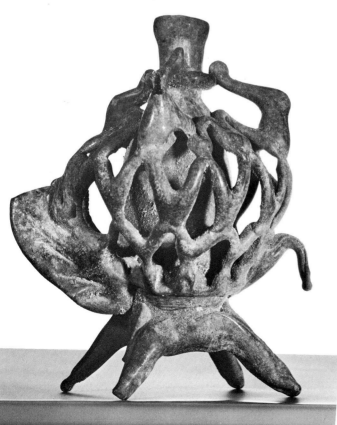

Fig. 1—Cypriote glass vase in ancient form; signed "L.C.T."; height 4½ inches. *Author's collection; ex-coll. Leslie H. Nash*

Fig. 2—Bottle of thick yellowish glass with "basket" decoration; Persia, 5th to 7th century A.D., or later. *Collection Corning Museum of Glass*

clutter and over-embellishment which typified the Victorian era, even though the Art Nouveau movement was premised on a breaking away from this one glaring fault. After 1910, strenuous efforts to produce even more startling and impressionistic forms in all of the art mediums led, inevitably, to a deterioration of this gallant effort at reform.

Collectors and art-conscious people in all walks of life are more and more realizing the significance of the contributions made by dedicated artists and designers of the Art Nouveau period. Alphonse Mucha and Emile Galle of France, Louis Comfort Tiffany in America, Victor Horta of Belgium, Jan Toorop in Holland, and Charles Rennie Mackintosh, the famous English artist and designer, are representative.

In America, Louis Tiffany was acknowledged as the foremost exponent of the new art. His contributions encompassed a wide area—furniture, fabrics, rugs, interior designing, metalwares and jewelry, lighting techniques, and, most important of all, his beautiful art glass. Initially, Tiffany's designs were modelled after ancient artifacts, but very soon he developed a style of his own in which traces of the Japanese influence are evidenced; these he adapted to conform to the accepted precepts of the Art Nouveau movement. The Japanese influence is patent in Tiffany's long-stemmed flower-form vases, subtly colored and decorated to suggest a single perfect bloom. His vases and bowls with floral

decorations trapped within the body of the glass also reflects an Oriental inspiration.

Of more importance was Tiffany's use of organic forms that seem to be constantly in motion, like some restless manifestation of nature. The shapes of such objects usually assume the primitive plastic form of hand-blown glass, an inverted baluster form, or a gourd shape; the decoration only suggests a realistic image.

Tiffany's replicas of ancient glass filled a need for persons seeking a link with ancient cultures. Because of this, they rarely deviated from their antique counterparts in form, decoration, or color. Although these copies of ancient glass objects were made in the Art Nouveau period, they do not mirror the revolutionary changes in art that took place at that time. Therefore their value to present-day collectors lies elsewhere —perhaps in still satisfying the need for which they were originally designed.

The most obvious ancient influence to be found in Art Nouveau glass was an imitation of the nacreous surface deterioration found on many pieces of ancient glass. This was manifested in lustred effects, which sometimes covered the entire object, or was utilized as a part of the over-all design in the form of threads and patches pulled into fantastic forms with the glassmaker's tools. In at least one instance this reproduction of the iridescent effects found on ancient specimens of glass was carried to the ultimate when Tiffany produced his

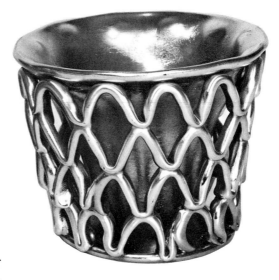

Fig. 3—Blue Lustre cup with "basket" (cage) decoration; signed "L. C. Tiffany / Favrile / 6938 D"; height 3¼ inches. *Author's collection; ex-coll. Arthur E. Saunders*

Fig. 4—Vase, XVIII Dynasty (ca. 1450-1350 B.C.), Egyptian; height 3 7/16 inches. *Collection Corning Museum of Glass*

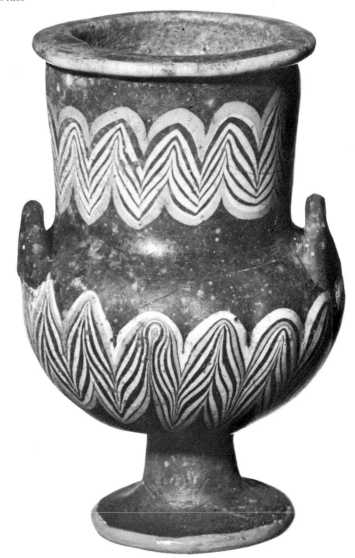

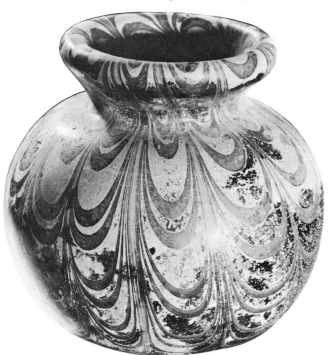

Cypriote glass (Fig. 1)—an exact duplicate of the iridescent and pitted surface of badly decomposed glass.

The free standing "cage" or "basket" decoration composed of heavy zigzag threads of glass attached to a glass object, such as the ancient Persian bottle (Fig. 2), which made its appearance in pre-Islamic and Islamic glass of about the fifth to seventh centuries A.D., was reintroduced at the Tiffany glassworks. Small vases and cups of this description were made in their blue and gold lustred glass (Fig. 3).

Inlaid threaded designs appeared in ancient Egyptian glass of the XVIII Dynasty (1450–1350 B.C.). Usually the threads of glass were "combed" into wavy or feathery designs while the object was still in a plastic condition, and then rolled on a marver to firmly embed the applied decoration into the surface of the glass. We find a decided relationship between the footed vase attributed to ancient Egypt during the XVIII Dynasty (Fig. 4) and a footed sherbet glass produced by the Quezal Art Glass & Decorating Company about 1910 (Fig. 5). In the latter instance the leaf-shaped decoration on the cup and foot of the article was produced by pulling applied threads of green glass into these patterns.

We call your attention to a jar (Fig. 6) attributed to Syria during the post-Roman period, about fifth century A.D., with embedded dragged threads of glass decorating its surface, and its very near counterpart (Fig. 7), a small Kew Blas vase with lustrous

Fig. 5—Quezal footed sherbet; opal glass with pulled threaded decoration in green, white and gold lustre; height 4 inches. *Author's collection*

Fig. 6—Jar, possibly 4th or 5th century A.D. (Near East); height 3 inches. *Collection Corning Museum of Glass*

14

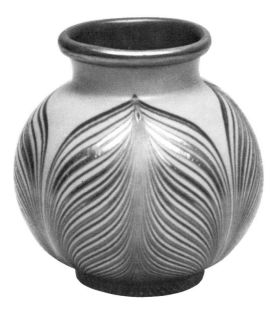

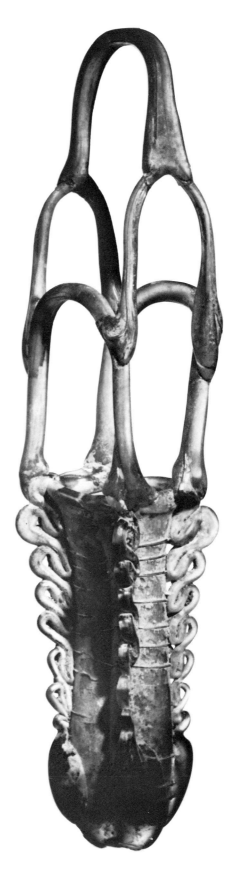

Fig. 7—Kew Blas vase with pulled threaded decoration of green and gold lustre on opal body; Union Glass Works, Somerville, Mass., ca. 1910; height 4 inches. *Collection L. A. Randolph*

Fig. 8—Balsamarium or saddle flask; Roman Empire, possibly Syria; ca. 3rd to 4th century A.D.; height 12⅝ inches. *Collection Corning Museum of Glass*

Fig. 9—Gold Lustre vase with pinched decoration; Tiffany Furnaces, ca. 1910; height 3½ inches. *Collection Mrs. Claranell M. Lewis*

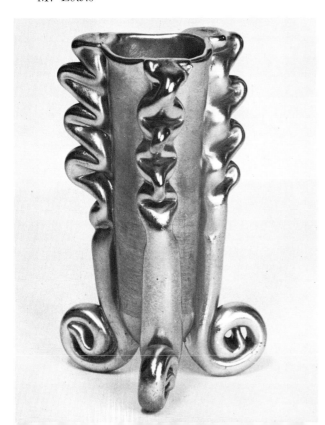

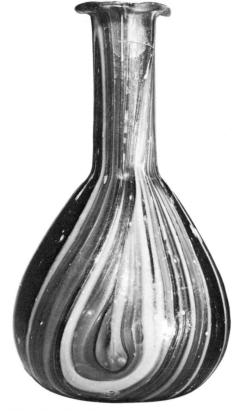

Fig. 10—Bottle; 1st century B.C.; height 4⅛ inches. *Collection Corning Museum of Glass*

Fig. 11—Laminated glass vase identified by Leslie Nash as the second piece of glass made at the Tiffany glassworks in Corona, Long Island, N.Y., ca. 1893; height 5½ inches. *Author's collection; ex-coll. Leslie H. Nash*

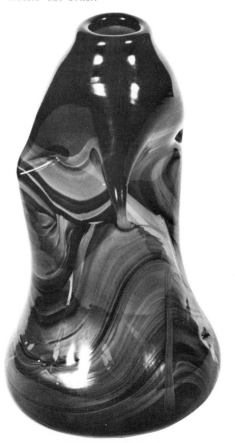

dragged decoration, produced about 1910 at the Union Glass Company.

Also note the ancient balsamarium (Fig. 8) made in Syria during the third or fourth century A.D. and the Gold Lustre vase with pinched decoration (Fig. 9) made by the Tiffany Glass Company about 1910. These objects, though made more than a thousand years apart, are most definitely related in form and decoration.

Imitating striated stones, such as chalcedony, agate, and jasper, was a technique practiced by ancient Roman glassmakers about the first century B.C. (Fig. 10). This kind of glass was revived by the Venetians in the late fifteenth century, and references are made to the manufacture of "jasper," "chalcedony," and "Schmelzglas" in many sixteenth- and seventeenth-century glass recipes. In the early nineteenth century, Friedrich Egermann of Bohemia produced a similar ware which he called "Lithyalinglas." The same kind of glass was made by the Tiffany Furnaces and the Quezal Art Glass & Decorating Company prior to, and shortly after, the year 1900. In the former factory such wares were designated "Laminated" and "Agate" glass (Fig. 11), and it was very likely known by similar names at the Quezal factory (Fig. 12).

Many people still believe that Millefiori glass was a Venetian invention; actually such wares date back to ancient Alexandria during the Roman occupation—first century B.C.

16

to first century A.D. (Fig. 13). This beautiful and interesting example of the glass arts is found in many specimens of nineteenth-century glass, but rarely do we find an object of the Art Nouveau period (Fig. 14) composed entirely of cross-section disks of millefiori. In most instances, cross-section disks from millefiori rods were used to represent flowers (Fig. 15). Paperweights and vases with heavy paperweight bases were produced at the Tiffany glassworks in which sections of millefiori rods were incorporated, emulating coral formations, sea urchins, polyps, and sea anemone (Fig. 16). The under-the-sea illusion was heightened by adding trailing threads of green glass, in imitation of seaweed, and incorporating the whole set-up in a matrix of light green glass the color of sea water.

The Vitro di Trina footed sherbet glass (Fig. 17), made at the Tiffany glassworks, was identified in Arthur E. Saunders' notes and papers as "a copy of the Diaper Pattern plates made by the Murano Glass Company, Venice, Italy." Mr. Saunders was a former gaffer at the Corona glassworks and, if we are to accept his notes as factual, only two such specimens of this ware made by Tiffany are now in existence in this country. The Vitro di Trina technique dates back to sixteenth-century Venice; but even this comparatively recent innovation in glass decorating has its genesis in ancient Egypt.

The ultimate in ancient glass was undoubtedly the cameo productions

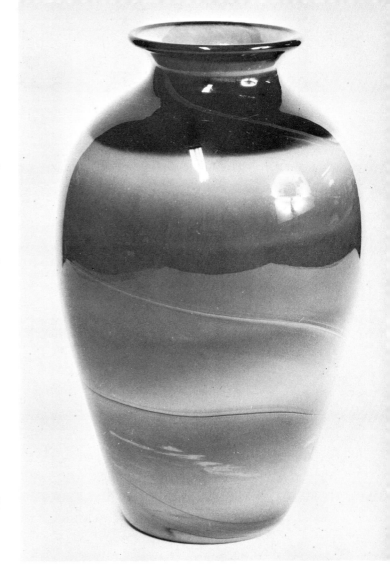

Fig. 12—Laminated glass vase of variegated black, brown, yellow, green and gray glass; signed "Quezal"; height 5 inches. *Author's collection*

Fig. 13—Millefiori bowl; Roman Empire, possibly Alexandrian, 100 B.C.-100 A.D.; height 1 7/16 inches. *Collection Corning Museum of Glass*

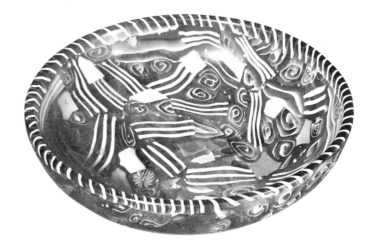

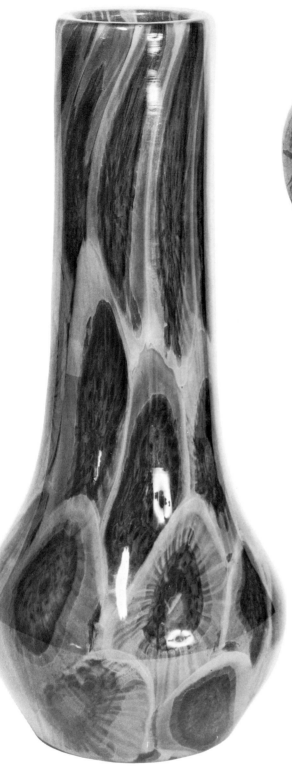

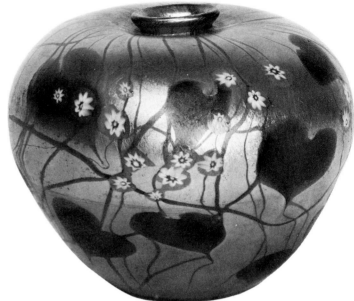

Fig. 15—Gold Lustre vase decorated with green leaves and tendrils, and white and green millefiori florettes; signed "L.C.T./ Favrile/W6694"; ca. 1900; height 3¾ inches. *Author's collection; ex-coll. Arthur E. Saunders*

Fig. 16—Large doorstop of Aquamarine glass with green seaweed and millefiori elements representing polyps or sea anemones; Tiffany Furnaces, ca. 1905; diameter 5½ inches. *Author's collection; ex-coll. Arthur E. Saunders*

Fig. 14—Millefiori vase made entirely of cross-section disks of brown, tan, and black glass; Tiffany Furnaces, ca. 1900; height 8⅝ inches. *Author's collection; ex-coll. Arthur E. Saunders*

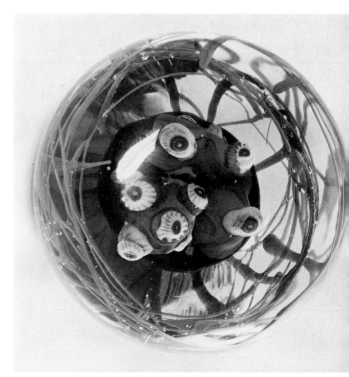

of the first century B.C. to the first century A.D., which most authorities agree were made by Roman and Alexandrian craftsmen (Fig. 18). While the art of carving glass cameos was initially revived in England in the last quarter of the nineteenth century, it was again put into practice during the Art Nouveau era—especially in France. Tiffany Furnaces' Cameo glass productions far surpass the Acid Cut-Back productions of the Steuben glassworks and the very colorful acid-etched productions of the French Cameo glass artists. The Tiffany Cameo pieces were hand-worked; it took as long as five or six weeks to produce a single object of modest size and decoration (Fig. 19).

Frederick Carder's early training in the classical styles of ancient Greek and Roman art forms no doubt determined the more or less sterile designs of his productions for Steuben. Almost everything made at the Steuben Glass Works has a perfectly symmetrical form and is well balanced. The few times one begins to see the free-flowing lines indicative of the true Art Nouveau influence in Steuben's wares, it will be apparent, too, that even then it has been tempered with the deep-grained sense for classical designs with which Mr. Carder was so thoroughly imbued.

As for the art-glass wares produced by other American manufacturers —Quezal, Durand, Lustre Art Glass, and so on—it is obvious that they aped the productions of Tiffany and Steuben; none of them ever introduced a truly different idea in

19

Fig. 17—Vitro di Trina sherbet glass with lustred surface; Tiffany Furnaces, ca. 1910; height 3⅝ inches. *Author's collection; ex-coll. Arthur E. Saunders*

Fig. 18—The Aldjo (Auldjo) Jug; Roman Cameo glass; 100 B.C.-100 A.D.; height 8 inches. *Collection British Museum*

Fig. 19—Carved Agate glass, variegated green, brown, and yellow; design of leaves in heavy cameo relief; signed "Louis C. Tiffany / Favrile / 276D"; ca. 1910; height 8½ inches. *Author's collection; ex-coll. Arthur E. Saunders*

design or technique. For this reason much of their glass is in good taste—as far as Art Nouveau designs are concerned.

In the last analysis, it was the glassworker carrying out the artists' designs that determined whether or not an object was a thing of beauty. Most of these men could hardly be considered dilettantes. They were laborers in the true sense of the word, but with an artist's soul for creating beauty. Very few of them were aware of their artistic sense, but it made itself seen and felt in their productions.

The high production cost precluded much possibility of anyone making a great deal of money in the manufacture of quality Art Nouveau glass. Some companies, like Durand, subsidized their art-glass department with the monies made on their commercial wares. In Tiffany's case the glassworks was run on a philanthropic basis and never made enough to cover its overhead. Those firms that were successful, in a financial sense, did not establish any great fortunes for the men connected with the business.

l'Art Nouveau was an ephemeral renaissance. Its followers were considered avant-garde in their day, even eccentric, but no one doubted their devotion to this new idea. Art Nouveau burned passionately in the hearts of its devotees and, as is always the case, this intense feeling was short lived.

TIFFANY GLASS COMPANY

CONCERNING Louis Comfort Tiffany's early activities in the glass trade, several reports have been published, some of which should be critically evaluated. Mrs. Lura Woodside Watkins (*Antiques,* August 1943) stated that the Farrall Venetian Art Glass Manufacturing Company of Brooklyn, New York, was "Tiffany's glassworks in South Brooklyn." Miss Dorothea M. Fox maintained (*Antiques,* November 1943) that Tiffany "established his own glass furnace and studios at Corona, Long Island, in 1878," and that it was first under the direction of "Andrea Beldini of Venice, Italy, and later Arthur J. Nash, glass manufacturer of Stourbridge, England."

Regarding Mrs. Watkins' contention, no connection between Farrall and Tiffany was noted in the corporation papers of the Farrall firm, dated May 27, 1882; and Mr. Tiffany himself, in an extravagantly bound monograph, published in 1914, stated that between 1880 and 1893, he had purchased his colored glass from many glasshouses in Brooklyn.

Concerning Miss Fox's statements, Nelson Otis Tiffany, in *The Tiffanys of America,* noted that Louis C. Tiffany organized and became president of the Tiffany Glass & Decorating Company, in 1892.

For all practical purposes, the first documentary evidence of Mr. Tiffany's association with any glass company is found in the corporation papers issued to the TIFFANY GLASS COMPANY, December 1, 1885. The

purpose of this corporation, as stated therein, was "to manufacture glass and other materials, and to use and adapt glass to decorative and artistic work of all kinds." The corporation consisted of Louis C. Tiffany, Pringle Mitchell, Benjamin F. McKinley, John L. DuFais, John Cheney Platt, and Henry W. deForest.

At a meeting of the stockholders of the Tiffany Glass Company, held at their offices at 333 Fourth Avenue, New York City, on February 11, 1887, it was decided to reduce the firm's capital stock from $105,000 to $90,000. This could be interpreted to mean that the Tiffany Glass Company was not the financial success the organizers had hoped for.

On February 18, 1892, the TIFFANY GLASS & DECORATING COMPANY was incorporated for the "manufacture and sale of glass, decorative objects and materials of all descriptions, and the applying of these materials to buildings and other structures; also the manufacture and sale of furniture, house and church fittings of all kinds, and the conducting of a general decorating business and all things incident thereto."

The stockholders in this corporation included Louis C. Tiffany, Pringle Mitchell, John Cheney Platt, John DuFais, and George Holmes. Evidently the Tiffany Glass & Decorating Company, too, was not very successful, for on March 12, 1902, its capital stock was decreased from a par value of $100,000 to $5,000. In this instrument, the signatures of the following also appeared as

stockholders: Henry deForest (representing Allied Artists), George Schmitt (representing Schmitt Brothers Furniture Company), Frederick Wilson (a designer of stained glass windows), and George Kunz (a jewelry expert acting for Tiffany & Company).

The STOURBRIDGE GLASS COMPANY was incorporated April 7, 1893, with Arthur J. Nash, A. Stuart Patterson, and George Holmes as stockholders. Patterson owned 38 shares of stock, while Nash and Holmes each held one share. (In this first incorporation, Louis C. Tiffany's name did not appear.) The factory was located in Corona, Long Island, New York, at the corner of Main and Irving Streets.

On June 2, 1893, a certificate for a capital stock increase, from $15,000 to $20,000, was signed by Pringle Mitchell, vice-president of the Stourbridge Glass Company, and A. Stuart Patterson, secretary. Another capital increase was signed on June 26, 1893, by stockholders Charles L. Tiffany (Louis C. Tiffany's father), Charles T. Cook (president of Tiffany & Company from 1902 to 1907), A. Stuart Patterson, and George Holmes. On September 13, 1893, still another certificate of stock increase was issued. For the first time on any of the Stourbridge Glass Company's documents, Louis C. Tiffany's name appeared. He was designated as president.

On September 29, 1902, the stockholders voted to change the name of the Stourbridge Glass Company to TIFFANY FURNACES. On

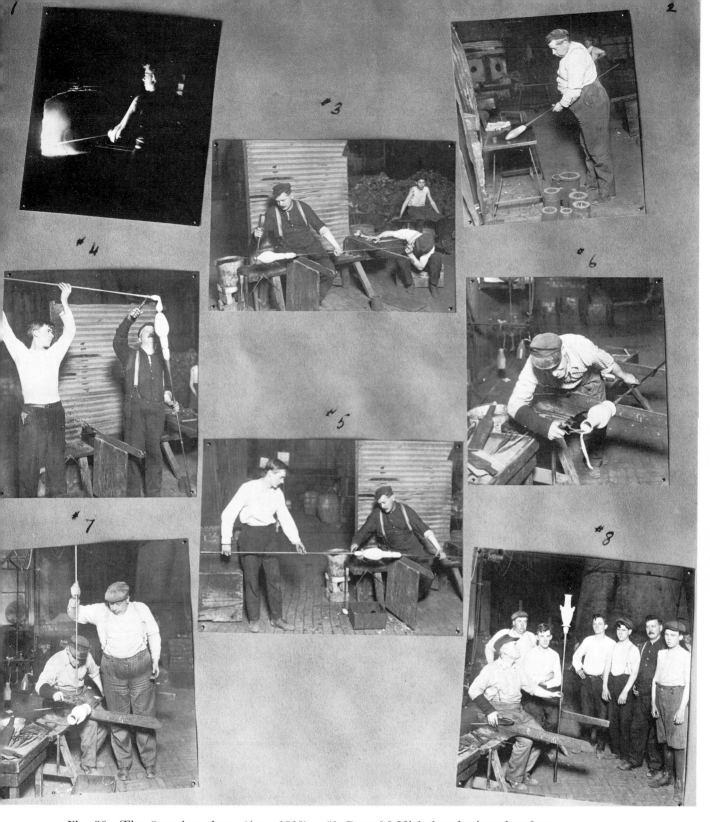

Fig. 20—The Saunders shop (Apr. 1910) : #1, Dave McNichol gathering glass from the pot; #2, Harry Britton marvering a gather of glass; #3, John Page blowing glass into first form; #4, John Page casting a foot for the vase; #5, John Page and Dave McNichol transferring vase for finishing; #6, Arthur Saunders shearing ragged neck of vase; #7, Harry Britton bringing handles to be applied by Saunders; #8, the finished vase atop the pontil rod held by the gaffer, Arthur Saunders, while standing by are Dave McNichol, Harry Britton, William Saas, John Page, and two unidentified "boys" (helpers) .

the official instrument, Louis Tiffany was listed as president, holding 153 shares of stock; William H. Thomas, secretary, with one share; and Arthur J. Nash, vice-president, with 35 shares. Dr. Parker McIlhiney, a friend of Mr. Tiffany, and A. Douglas. Nash were also named as stockholders in this newly formed corporation; both held five shares.

The firm continued under this style until January 6, 1920, when the name was changed to Louis C. Tiffany Furnaces, Inc. The official document regarding this change of name was signed by Louis C. Tiffany, president, and A. Douglas Nash, secretary.

By this time, Mr. Tiffany had formed the Louis C. Tiffany Foundation, an organization that sponsored the work of young artists, and he gave the Foundation 110 shares of his stock in the glassworks, keeping only one share for himself. Arthur J. Nash still owned 15 shares; Leslie H. Nash, 18 shares; A. Douglas Nash, 22

shares; Joseph Briggs, manager of the Mosaic Department of the Tiffany Studios, eight shares; Charles L. Tiffany, five shares; and George F. Heydt, associated with Tiffany & Company, one share.

The Louis C. Tiffany Furnaces, Inc. was officially dissolved April 2, 1924, and the A. Douglas Nash Co. became effective on that date. Jimmy Stewart, who worked at the Corona factory all during its existence, from the time he was a "boy" to gaffer, told us that Tiffany's entire stock of glass and other art wares, some $600,000 worth, were given as a gift to Joseph Briggs, formerly manager of the Mosaic Department at the Tiffany Studios. Part of the stock was sold right at the studio on 23rd Street, New York City, by auctioneer Percy Josephs. The remainder was removed to the empty Bank of America Building at 46th Street and Seventh Avenue, and sold at auction by Mr. Josephs.

Fig. 21—The Stewart shop: *left to right,* Jimmy Stewart, his helper Joseph Orella, Thomas Heather, blower, assisted by John Nelson (kneeling), and at the furnace, Dave McNichol.

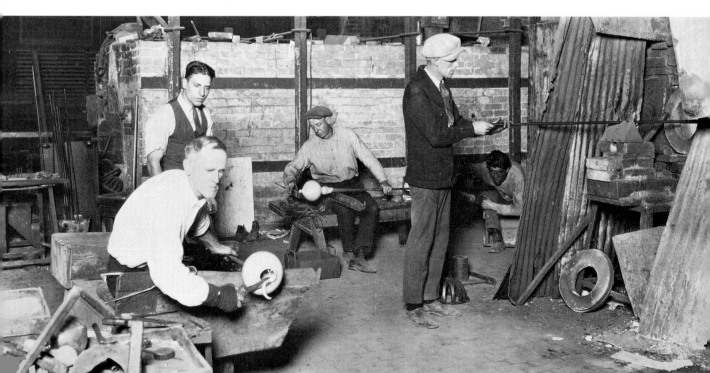

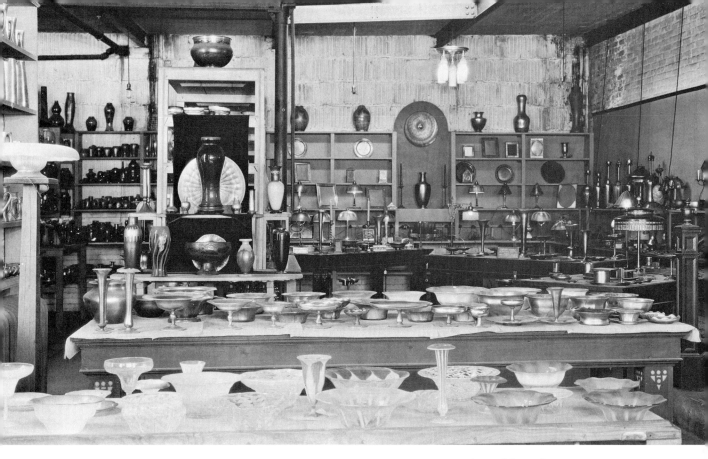

Fig. 22—A section of the factory showroom; tables and shelves are laden with various kinds of Favrile glassware.

As to the actual beginnings of the Stourbridge Glass Company's factory in Corona, there is disagreement in the Nash family. One branch has always maintained that the glass factory at Corona had been solely the property of Arthur J. Nash and his sons until Mr. Tiffany came along, just after their first factory had burned, when they were in need of financing. The other branch of the Nash family affirms that Mr. Tiffany was associated with the glassworks from the start, and that without his financing there would never have been a glassworks at Corona.

All documentary information clearly points to this latter version. In fact, Mr. Tiffany brought Arthur J. Nash to America more than a year

before the glassworks was built and established him in a small laboratory in Boston, Massachusetts, where Nash carried on experiments with glass and glass decoration.

Mrs. A. Douglas Nash insists that the lion's share of credit for Tiffany glass should be given to Louis C. Tiffany. She said, in interview, that his designs made the glass what it was, and that his name as an artist, in addition to the wealth and social prominence of his family and, of course, his persistence, put it over. However, it was the Nashes' practical knowledge of glassmaking and design which made the Tiffany dream come true. It was a fortunate combination of abilities.

Several difficulties attended the

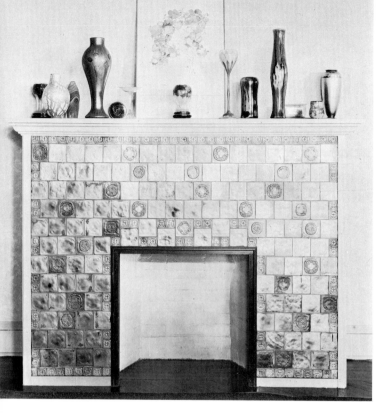

Fig. 23—A Tiffany tiled fireplace in the factory's office. On the mantel are various pieces of Tiffany Favrile glass and a watercolor of morning-glories painted by Mr. Tiffany.

establishment of the factory. In the first place, the people of Corona, then a quiet country community, did not want a glass factory in their town. They feared sparks from the furnace stack might ignite their frame houses; they also resented the intrusion of "foreigners." Arthur J. Nash and a local minister finally convinced them that a glassworks would be a benefit, not a detriment, to the town.

Then, almost as soon as the factory was erected, it burned to the ground. Arson was suspected. The man who was believed to have set the fire, desirous of leaving town, barged into Mr. Nash's home, confronted Nash with a pistol, and demanded money to get away. Mr. Nash and his older sons disarmed the intruder, but he

managed to escape them and run away. He was never again seen in the area. The factory was rebuilt and the production of glass continued.

Arthur J. Nash, assisted by his sons and Dr. Parker McIlhiney, Mr. Tiffany's chemist friend, developed many formulas for glass and glass-decorating processes in fulfilling Mr. Tiffany's desires for certain colors and effects. Often Mr. Tiffany's ideas seemed impractical, sometimes impossible. But when a question was raised concerning the feasibility of carrying out some of his ideas, he would say, "What is thinkable, is do-able." Though this pronouncement often exasperated practical glass technologists like the Nashes, Tiffany was many times proven right. On the other hand, years of experimentation and thousands of dollars for materials and labor might be expended before it was determined an idea was definitely not "do-able."

Mr. Tiffany always seemed to have money for these experiments and never complained when they were unsuccessful. The glassworks never showed a profit, but this did not disturb him. He seemed to look at the enterprise as his own private "toy," existing solely to fill his need for artistic expression.

Tiffany revelled in the public's admiration and praise of his glass, and boasted of the collections of his art glass represented in museums at home and abroad. His advertisements, catalogs, and brochures never failed to play up this appreciation by museums, implying his glass was

purchased in recognition of its artistic merit. He carefully refrained from mentioning that, in many cases, he himself had made outright gifts of his glass to these institutions. Today his boasts would be quite truthful for, at long last, art museums the world over are eager to acquire examples of his Favrile glass. The few which do have comprehensive collections of his wares are proud to exhibit them.

The artistic success of Tiffany glass was the result of the happy combination of Louis C. Tiffany's interpretation of Art Nouveau in his designs and the technical skill provided by the Nashes. A great deal of the credit goes also to the glassworkers, who, in the last analysis, brought the glass to life. In selecting his workers, Nash aimed for the best. He always hired union men, believing them to be the most skilled and reliable workers. Some of his men—John Hollingsworth, Jimmy Grady, and Harry Britton, for example—he brought over from England. They worked at Corona as long as the factory existed, and even as old men were vigorous and competent.

It has been hinted that Thomas Manderson, one of Tiffany's gaffers, played an even larger part than the Nashes in the success of Tiffany productions. According to Noreen Stewart (Jimmy Stewart's daughter), who quoted her father's on-the-spot opinion, Manderson was one of the finest gaffers employed at Corona. He started in the early days before

iridescence had been fully developed, doing the rough shapes and dull colors that were sold under the Stourbridge label. His abilities increased with advances of glass techniques developed by the Nashes, and he became an extremely competent gaffer. He was not, however, a master chef. He merely followed, like any good cook, the orders and recipes handed him.

Great pains were taken to follow Mr. Tiffany's sketches and color plans exactly. Neither Mr. Nash nor Mr. Tiffany wished imperfect pieces to leave the factory. Nor did they want their experimental pieces analyzed by competitors. So secretive were the Nashes about their formulas that laboratory containers and drawers in which various ingredients were stored were not labelled as to contents by name, but by number or color. The formulas were never written out except in the Nashes' private code. (Mrs. A. Douglas Nash says she has never found one of these code books among her husband's possessions, nor has she ever seen one.)

Before he came to America to work for Mr. Tiffany, Arthur J. Nash had been manager of the White House Glass Works in Stourbridge, England, which was operated by Edward Webb. In the Nash family's collection were a few pieces of an opaque ivory-colored glass with enamel and gold decorations. These were all identified by the White House Glass Work's mark—a representation of a spider's web and the letter "E" (for Edward Webb).

Members of the family, and a few old friends and employees of the Tiffany Glass Company, remember Arthur Nash as a gentleman of very fine character, loving and generous. His wife was a beautiful woman, very mindful of the niceties, and somewhat demanding in her sense of family and social etiquette.

The closing of the Tiffany factory was a blow to Mr. Nash's pride from which he never completely recovered. He died in 1934 at the age of 85 years.

There were at least six or seven shops (groups of workers, headed by a gaffer), working at various periods of the company's long career. From time to time, as need arose, some of the men were transferred from one shop to another, either temporarily or permanently. It is difficult at this late date to assemble a comprehensive and correctly correlated list of their names and the positions they filled. Our list of workers was compiled from the recollections of Jimmy Stewart and members of the Nash family; it is neither complete nor in chronological order.

Manderson Shop: Thomas Manderson, gaffer. This shop did all of the experimental work, called "knick-knacks" by the factory hands; none of these experimental pieces were ever sold commercially. This was considered a most important shop, and Manderson the most inspired gaffer.

Fig. 24—A view of the metalwares shop in back of the glassworks. (Leslie Nash is the man in the coat and tie, second from the left.)

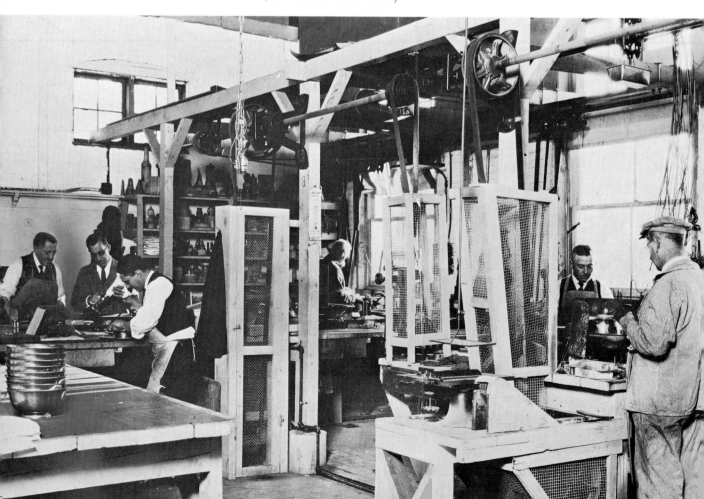

Grady Shop: James H. Grady, gaffer. Names of other men who worked for him could not be determined.

Hollingsworth Shop: John Hollingsworth, gaffer; James Stewart, decorator (later Stewart had his own shop) ; Anthony Sterling, gatherer (he was the stepson of Edward Drake, another worker in the factory) .

LeFevre Shop: August (Auggie) LeFevre, gaffer (he came from Toledo, Ohio, and later influenced A. Douglas Nash to work for the Libbey Glass Company) ; Victor Lilequist, blower (a first-class stemware maker) ; David McNichol, decorator (he also worked in the Saunders and Stewart shops) ; Victor LeFevre, gatherer (he was August LeFevre's brother) .

Matthews Shop: Joseph Matthews, gaffer; Morris Cully, blower; "Big Florrie" Sullivan, decorator; Robert Hicks, gatherer.

Saunders Shop (Fig. 20) : Arthur E. Saunders, gaffer; Harold (Harry) Britton, decorator; David (Dave) McNichol, gatherer; William Saas, assistant decorator; John Page, servitor.

Stewart Shop (Fig. 21) : James A. Stewart, gaffer; Thomas Heather, blower; David McNichol, decorator; John Nelson, gatherer; Joseph Orella (an Italian boy, who was Mr. Stewart's helper) .

Young assistants, known as "boys" in the glass factory, were also employed at the Tiffany Furnaces. Some of these "boys," like Jimmy Stewart, worked themselves up to become gaffers, the top position in the trade.

Louis Comfort Tiffany

Louis Comfort Tiffany (1848–1933) was the son of Charles L. Tiffany, founder of Tiffany & Company in New York. It was expected young Louis would follow his father in this eminent jewelry firm; instead he turned his creative nature to the arts. There was hardly an art form which did not, at one time or another, engage his restless talents. His was a competitive nature, with a passion for perfection, and whatever he undertook, he accomplished with great flair and elegance. A nonconformist, individualistic, exacting and autocratic, determined to be best, and greatly talented, he was a romantic always in his quest for beauty.

Painting was his first involvement, and he studied for a year in Paris. In 1871, he was made an associate of the National Academy of Design, a full Academician in 1880. Then seeking a wider field of expression, he turned to the applied arts.

As New York's most fashionable decorator, he produced dozens of luxurious interiors, designing for them all manner of decorative accessories from wallpapers to fireplace tiles (Figs. 22-24) . The Goelets and the Vanderbilts were among his clients. So was the White

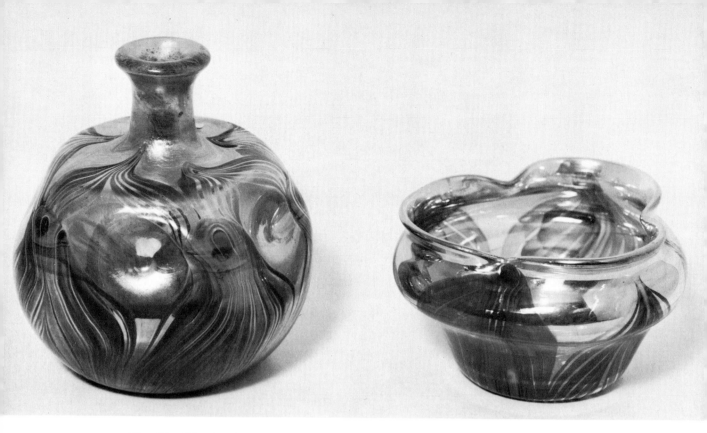

Fig. 25—The bottle and bowl represent Arthur J. Nash's first experiments with "Gold" and "Silver Mirror" lustres; they were made in England about 1890. When Mr. Nash came to America in 1892, he brought along these pieces as examples of his work. The bottle is marked "B 1," and the bowl is marked "B 2." *Collection Neil Reisner; ex-coll. Arthur J. & Leslie H. Nash*

House, which he was commissioned to redecorate during President Arthur's administration. His own summer home, "Laurelton Hall," at Oyster Bay, Long Island, was planned and built and furnished to his own designs. (Later he converted this opulent mansion to an Art Foundation for students.)

When interest in the glass accessories he was creating for his interiors superseded his interest in decoration, he began to design and manufacture his own stained-glass windows, mosaics, and tiles; this proved another successful venture.

At the Paris Exposition in 1889, he saw Gallé's work with art glass, and became even more enthralled

with glass production. By 1900, he had begun to experiment with his own Art Nouveau glass, working out new and unconventional forms and techniques. His early experimental pieces went mainly to museums, but by 1896, he begun to put his wares on the market.

For a short time in his later life, while vice-president and art director of his father's firm—positions he assumed in addition to his own business—he designed handsome art jewelry, bold and unusual. It was too expensive for general trade, and his work in this area was not long continued.

Mr. Tiffany was twice married, first to Mary Woodbridge Goddard,

who died in 1884, then to Louise Wakeman Knox, who died in 1904. His daughters recall him with deep affection as a loving and devoted, though sometimes an exacting, father.

He died at the age of 85, having lived to see the fashionable world he knew, and which he had so greatly influenced, change and pass him by. The very characteristics that had made him important in his influential years became, in his old age, eccentricities. Though he watched with care the transitional work being done by the art students at his Art Foundation at Laurelton Hall, he never fully understood their work, and rarely approved it. He seemed never to have been embittered by the change in public taste, but he was lonely.

Louis Comfort Tiffany had loved the limelight—he loved perfection and produced it. The present-day surge of renewed appreciation for his work would have pleased him and he, quite likely, would have accepted it as his due.

Lustred Glassware

Louis C. Tiffany, in U.S. Patent No. 837,418, issued to him on February 8, 1881, noted that lustering glass was a "process well known to glass manufacturers." This was quite true. Ludwig Lobmeyer of Vienna had introduced lustred glassware as early as 1873, and at the Paris Exposition of 1878, Messrs. Monot & Stumpf of Pantin, France, exhibited iridescent glass which they called "Chiné Metallique." These early

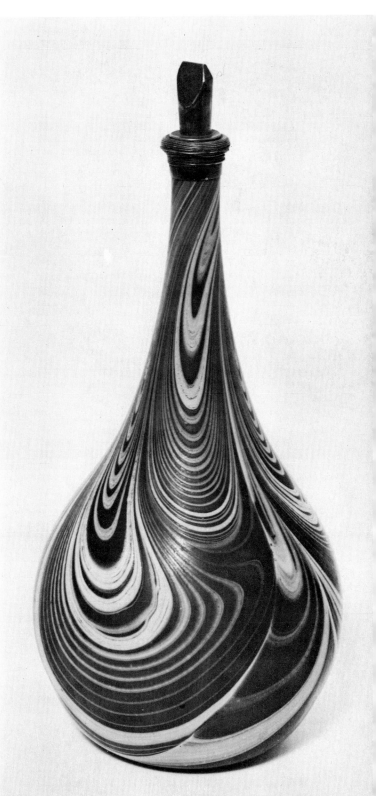

Fig. 26—Translucent blue glass bottle with white threads in a drag loop pattern; one of the early pieces of Favrile glass; signed "L.C.T. 268"; original Tiffany Glass & Decorating Company paper label; height 9½ inches. *Collection Neil Reisner; ex-coll. Arthur J. & Leslie H. Nash*

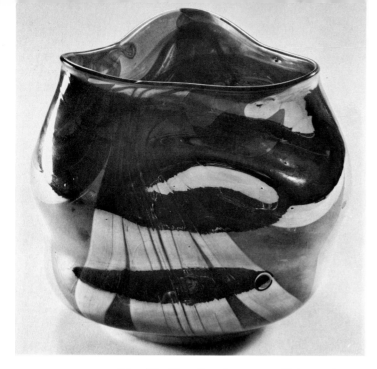

lustred wares were mirror-like in appearance, not at all like the soft luminous sheen we associate with iridescent glass produced in the Art Nouveau era.

After experimenting for several years, Arthur J. Nash finally developed a lustre for glassware that closely approximated the nacreous finish found on ancient glass that had been exposed to the corrosive elements of earth and atmosphere (Figs. 25-30).

At first, lustres were used sparingly on Tiffany glass, and early examples were seldom completely covered with iridescence. As an appreciative public demanded more and more iridescent glass, the Tiffany glassworks finally began to produce tablewares and decorative objects completely covered with lustre.

The lustrous effects artificially produced on glass depend entirely upon the color and density of the metal. Transparent glass emits a brilliant iridescence; opaque glass acquires only a pearl-like sheen. A transparent yellow glass, somewhat the color and density of olive oil, produces a beautiful gold lustreware; transparent cobalt blue glass, sandwiched between two layers of transparent yellow glass, emits a deep blue iridescence. So it is with other colors found in lustred glassware.

"Textured Lustre Ware" was Tiffany's name for multicolored iridescent wares with inlaid decorations. Occasionally glass "jewels" were applied to such objects

Fig. 27—Favrile glass vase, light amber with applied decorations; mirror-like lustre finish; paper label "TGD Co."; Tiffany Glass & Decorating Company, ca. 1896; height 6 inches. *Smithsonian Institution*

Fig. 28—Favrile glass vase, marbelized greens and browns with applied threaded and hooked decoration in yellowish-white; paper label "TGD Co."; Tiffany Glass & Decorating Company, ca. 1896; height, including bronze stand, 10½ inches. *Smithsonian Institution*

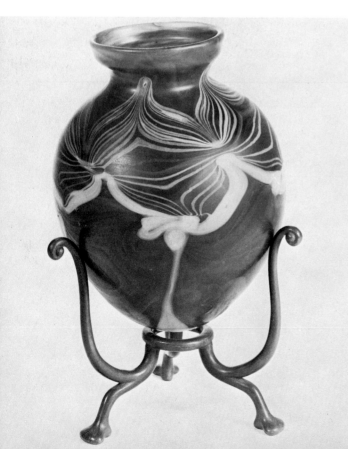

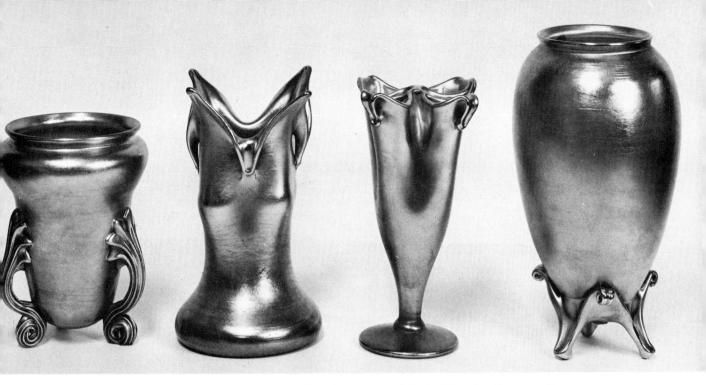

Fig. 29—Tiffany Gold Lustre vases in various forms; ca. 1910; height of tallest vase 7 inches. *Author's collection; ex-coll. Arthur E. Saunders*

Fig. 30—Tiffany bowl-vases and a mug. *Left to right*: Gold Lustre mug with green and white threads in zigzag pattern, engraved "First Prize / Marion (Saunders) / Children"; signed in base "L. C. Tiffany / Favrile." Gold Lustre glass vase with "cage work" top. Gold Lustre glass bowl-vase with pinched decorations around rim. Gold Lustre glass bowl-vase with "shell' handles. Each piece about 3 inches high. *Author's collection; ex-coll. Arthur E. Saunders*

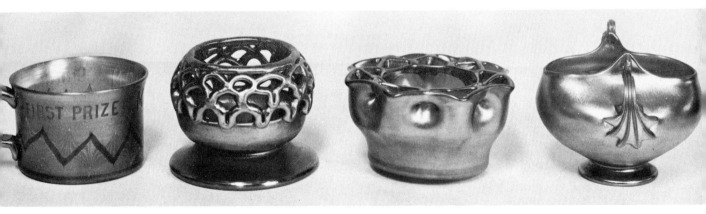

while they were being formed (Fig. 31). Textured Lustre Wares are fewer in number than Tiffany's plain gold or blue iridescent glass pieces and have always commanded a premium price (Figs. 32-49).

"Lustre Decorated Wares" were made by working threads and patches of transparent colored glass in various designs on a body of opaque glass. When the article was lustred, the applied decoration became brilliantly iridescent in contrast to the rest of the object (Figs. 50-55).

What glassworkers called "under-the-water effects" were

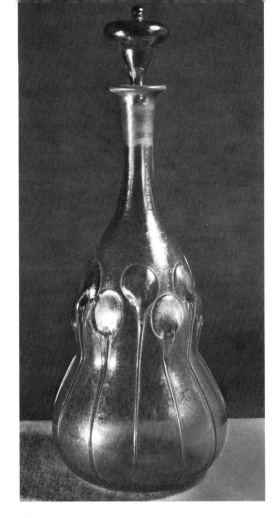

Fig. 32—Gold Lustre glass decanter in the Moravignian design; height 12 inches. *Victoria and Albert Museum*

Fig. 31—Gold Lustre vase in bronze stand decorated with Blue Lustre glass "jewels"; signed "L. C. Tiffany / Favrile / 5272G"; original paper label; painted on base, "Alaska-Yukon Exhibition, 1st Award"; height 20 inches. *Collection Neil Reisner; ex-coll. Arthur J. & Leslie H. Nash*

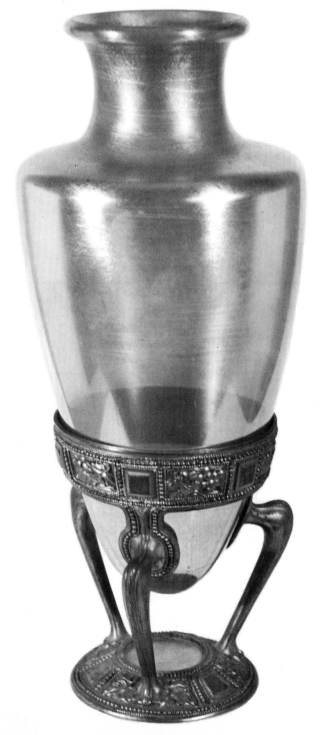

Fig. 33—Gold Lustre decanter in the Victoria pattern; signed on base "L. C. Tiffany / Favrile"; height 10 inches. *Victoria and Albert Museum*

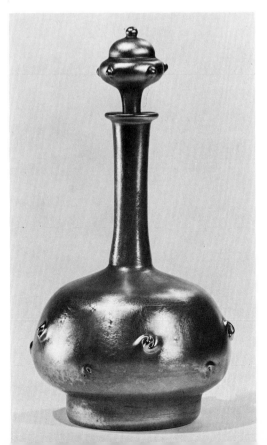

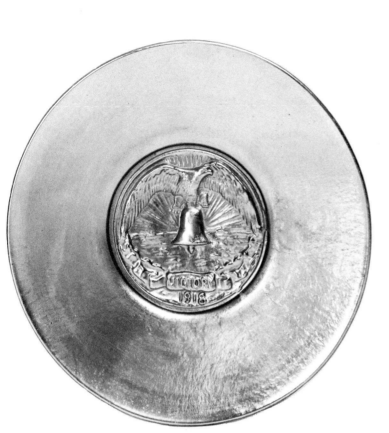

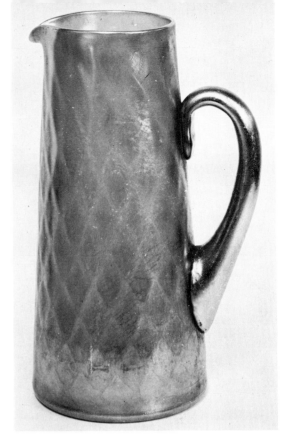

Fig. 35—Gold Lustre glass commemorative plate; press-molded design of American eagle and the legend "Victory — 1918" in center; signed "L.C.T. / 191 T"; diameter 5 inches. *Author's collection*

Fig. 34—Tiffany Gold Lustre glass tankard pitcher in Diamond Optic pattern; height 9½ inches. *Collection Mr. & Mrs. H. O. Simms*

Fig. 36—Tiffany stemware. *Left to right*: Gold Lustre cocktail glass with cut stem. Radiant Lustre sherbet glass (only the interior of the bowl has been lustred). Radiant Lustre wine glass. *Author's collection; ex-coll. A. Douglas Nash*

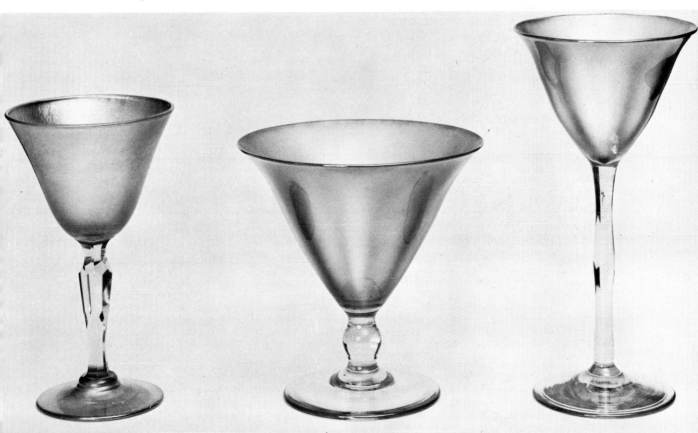

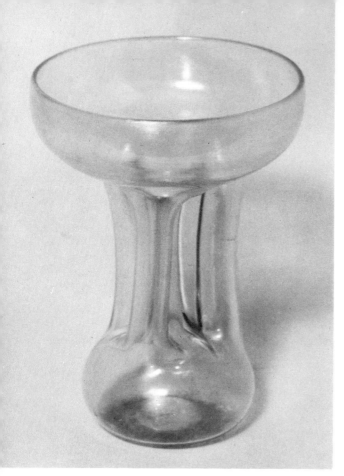

Fig. 38—Gold Lustre punch bowl with green leaf decorations all around; signed "L. C. Tiffany / Favrile / 9351 D"; diameter 16 inches. *Author's collection; ex-coll. A. Douglas Nash*

Fig. 37—Lustred champagne glass with quadruple hollow stem; signed "L.C.T. / Favrile" and "L.H.N." (Leslie H. Nash's initials). Glasses like this were especially designed for Mr. Tiffany's famous "Egyptian Party." The gay crowd, resplendent in their exotic costumes, threw their glasses to the floor after drinking a toast to their fabulous host, Louis C. Tiffany. Leslie Nash prudently tucked his glass into the folds of his flowing Arabian costume as a remembrance of that opulent fete. Height 5 inches. *Collection Neil Reisner; ex-coll. Leslie H. Nash*

Fig. 40—Gold Lustre vase with green leaf decoration and "shell" handles; Tiffany Furnaces, ca. 1910; height 6¼ inches. *Author's collection; ex-coll. Arthur E. Saunders*

Fig. 42—Blue Lustre glass bowl; signed "L. C. Tiffany / Favrile"; diameter 10 inches. *Author's collection; ex-coll. Arthur E. Saunders*

Fig. 41—Gold Lustre vase with green leaf decoration; gilded bronze base signed "Tiffany Studios / New York"; height 26 inches. *Collection Richard Cole*

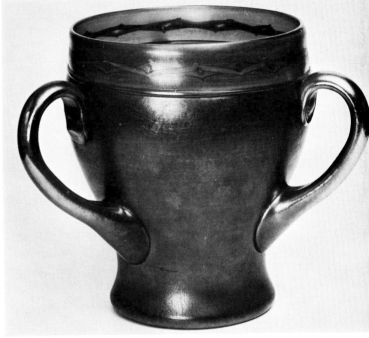

Fig. 43—Blue Lustre loving cup with Gold Lustre handles; rim decorated with lustred glass and trailed and tooled decoration; signed "L. C. Tiffany / Favrile / 1260 G"; height 7 inches. *Author's collection*

Fig. 39—Gold Lustre vase with engraved ivy leaves and tendrils; signed "L. C. Tiffany / Favrile / E 262"; height 4½ inches. *Author's collection; ex-coll. Arthur E. Saunders*

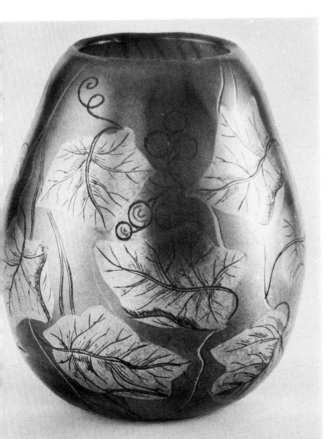

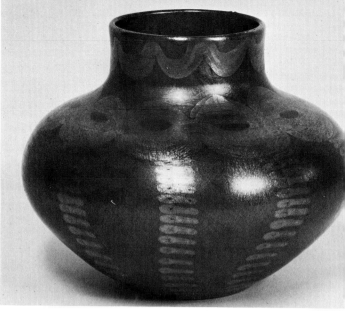

Fig. 44—Textured Lustre glass vase; dark blue with gold, green, and yellow applied threaded decoration; signed "L. C. Tiffany / Favrile"; height 4½ inches. *Author's collection*

Fig. 46—Gold Lustre vase, ribbed, with applied threads of crystal glass all over; berry pontil prunt. *Author's collection; ex-coll. A. Douglas Nash*

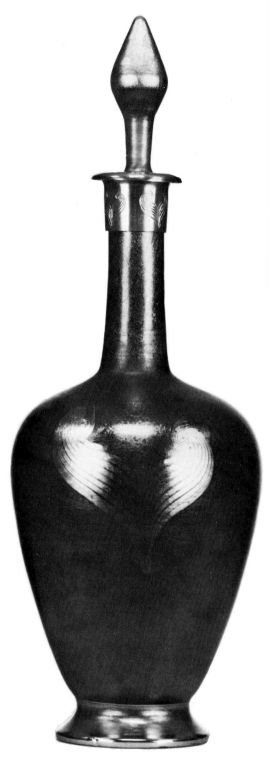

Fig. 45—Decanter of Textured Lustre glass in dark blue and gold; silver-gilt mounting with engraved decoration to match those on bottle; signed "Louis C. Tiffany / Favrile"; height 10¾ inches. *Author's collection; ex-coll. Arthur E. Saunders*

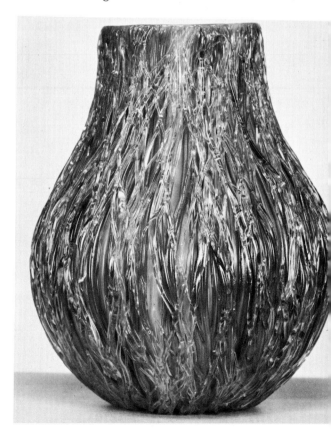

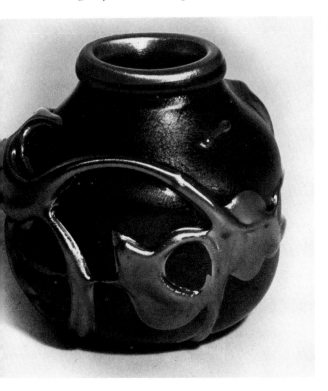

Fig. 47—Black lustred glass vase with silvery lustre decoration; signed "T.G.C." (Tiffany Glass Company); height 2½ inches. *Collection J. Jonathan Joseph*

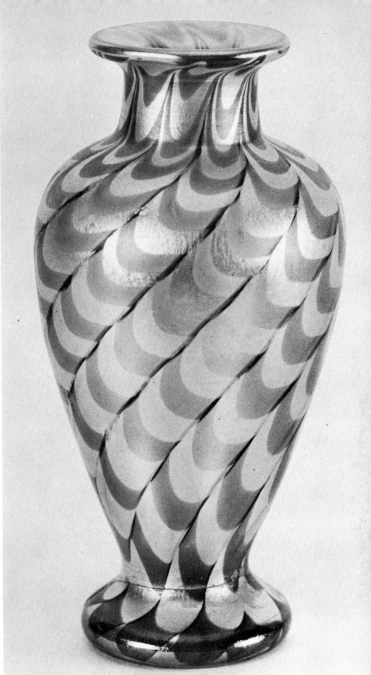

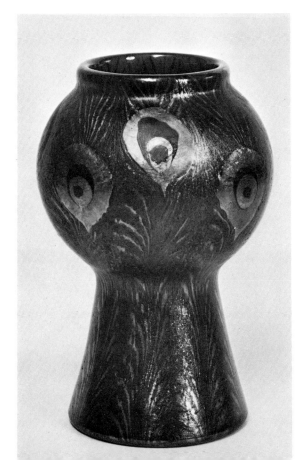

Fig. 48—Textured Lustre glass vase with pulled decorations in green and gold lustre; Tiffany Furnaces, ca. 1910; height 5 inches. *Author's collection; ex-coll. Arthur E. Saunders*

Fig. 49—Textured Blue Lustre glass vase with "Peacock Feather" decoration; signed "Louis C. Tiffany / Favrile"; height 5 inches. *Author's collection; ex-coll. Arthur E. Saunders*

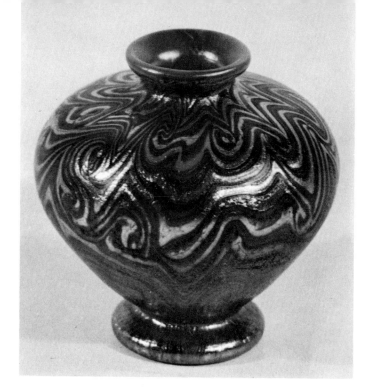

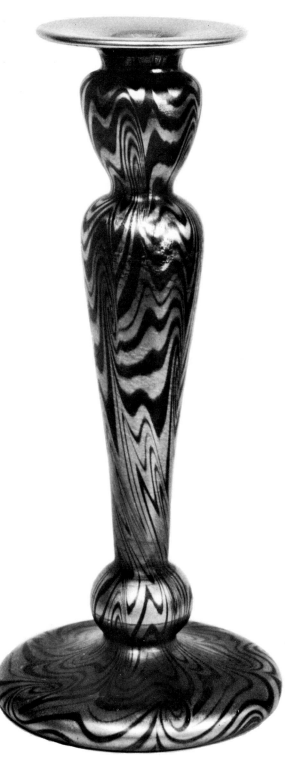

Fig. 50—Copper-red vase with silvery "Damascene" decoration; signed "L.C.T. / E 2056"; height 2½ inches. *Collection Neil Reisner; ex-coll. Arthur J. & Leslie H. Nash*

Fig. 52—Green and opal lustred vase with intaglio carved and gilded bees; signed "L. C. Tiffany"; height 6¼ inches. *Collection Mr. & Mrs. R. L. Suppes*

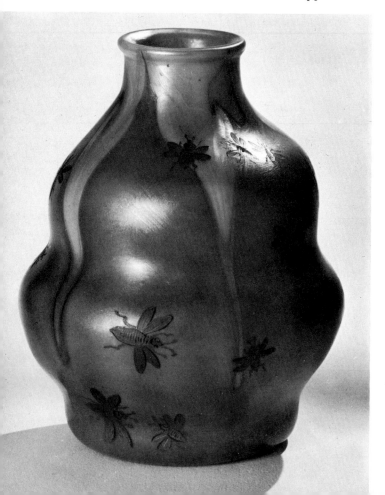

Fig. 51—Blue Lustre glass candlestick with "Damascene" decoration in gold lustre; Tiffany Furnaces, ca. 1910; height 10 inches. *Author's collection*

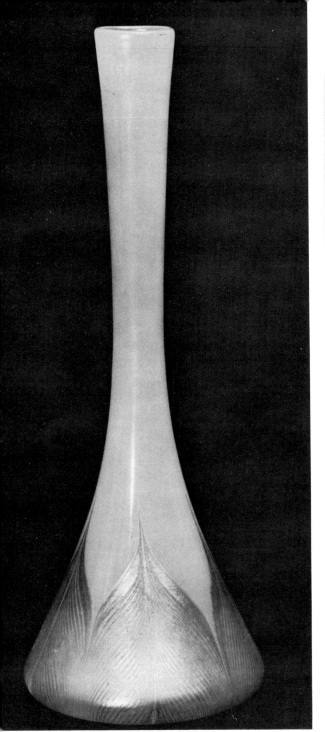

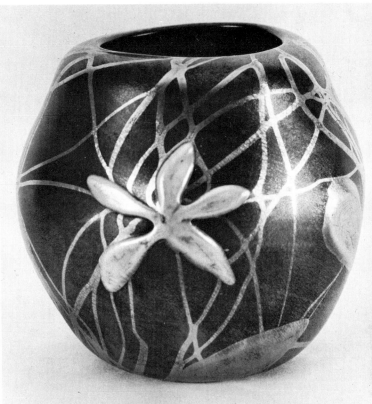

Fig. 53—Opaque brown vase with applied yellow flower in relief; leaves and tendrils in gold lustre; signed "L.C.T. / Q 9473"; height 4½ inches. *Author's collection; ex-coll. Arthur E. Saunders*

Fig. 54—Alabaster vase with gold lustre leaf decoration in base; signed "L. C. Tiffany / Favrile / 4953 J"; height 12 inches. *Author's collection; ex-coll. A. Douglas Nash*

Fig. 55—Translucent yellow glass vase with gold lustre rim and foot; signed "L.C.T. / Favrile / 1386 P"; height 3 inches. *Andrew Dickson White Museum of Art*

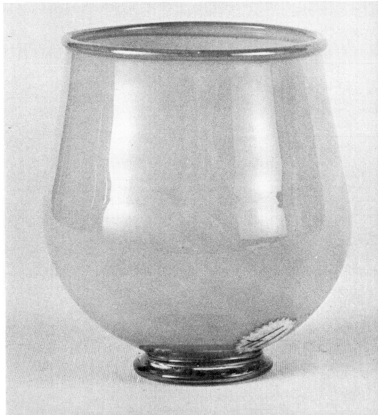

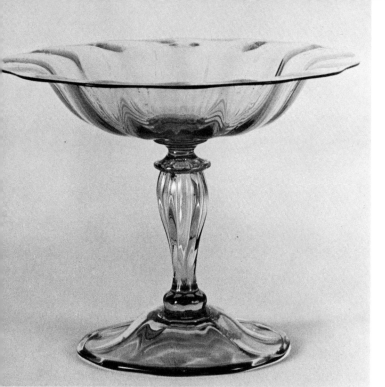

Agate Glass

Tiffany stated several times that his Agate glass was "glass of a chemically reactive character." To a degree, this is true.

"Agate" glass, sometimes called "Laminated" glass, was produced by

Fig. 56—Antique green flint-glass tazza in the Venetian style; "Phantom Lustred"; signed "L.C.T. / Favrile / 1397 P"; height 8 inches. *Andrew Dickson White Museum of Art*

Fig. 57—Gold Lustre glass sword made at the Tiffany Glass Company by Arthur Saunders ca. 1910; length 14 inches. *Author's collection; ex-coll. Arthur E. Saunders*

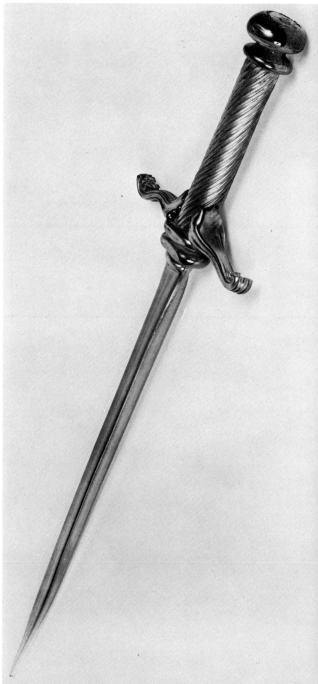

produced by internally lustering decorated wares of transparent or translucent glass. Internally lustred glass must have been introduced about 1913, at the same time Tiffany's "Morning-glory," "Gladiola," and "Aquamarine" glass appeared. Collectors and dealers refer to some internally lustred objects as "paperweight Tiffany." This is a manufactured nomenclature, and we sincerely hope this misnomer will be dropped from the vocabulary of Tiffany-glass terms.

In its latter years, the Tiffany Furnaces reverted to the use of mirror-like lustres on delicately tinted transparent colored glass. Most of their "Phantom Lustre" wares, as they were called, can be found in forms we usually associate with Venetian glassware (Figs. 56-59).

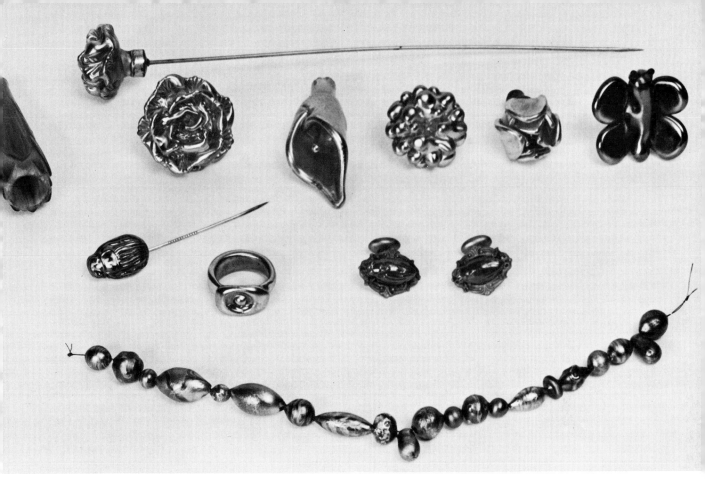

Fig. 58—*Left to right and top to bottom:* Green and white cameo-carved cigar holder. Assortment of hatpin decorations in various flower forms in Gold Lustre and a Blue Lustre butterfly. Blue Lustre "Beetle" tiepin set in silver and gold. Blue Lustre glass ring made by Arthur Saunders for his wife. Samian Red (lustred) "Beetle" cuff links. A small string of Textured Lustre beads. All made at the Tiffany Glass Company by Arthur Saunders. *Author's collection; ex-coll. Arthur E. Saunders*

putting several different-colored opaque glasses into one pot, then stirring them together until the melt had the appearance of striated chalcedony. Sometimes chemically reactive glass was combined with nonsensitive glass in these melts. In such cases, the heat generated by the furnace changed the color and character of the reactive glass at the same time the different glasses were being mixed together and the objects formed, producing a laminated effect throughout the metal (Figs. 60-61).

Objects made of Agate glass had to be worked quickly and at a relatively low temperature. Otherwise, the furnace heat would turn the mix into a mass of dark brown or black glass, totally unsuited for its intended purpose.

Polishing or carving the surface of Agate glass objects exposed more of the laminated structure of the metal. If an object turned black while being formed, the surface of the glass was either polished down or designs were carved through the black exterior to reveal the true color of the glass beneath it (Figs. 62-64).

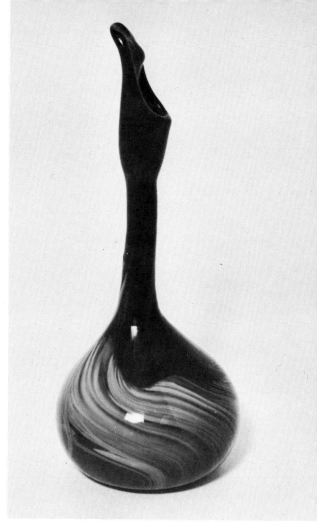

Fig. 59—Arthur J. Nash's Design Patent No. 50,664 of Apr. 24, 1917, for a flower holder.

Fig. 60—Laminated glass vase; black streaked with yellow, green, and orange; signed "L.C.T.—First Piece"; purported to be the first piece of glass made at the Corona, Long Island, N.Y., glassworks; height 6½ inches. *Collection Neil Reisner; ex-coll. Arthur J. & Leslie H. Nash*

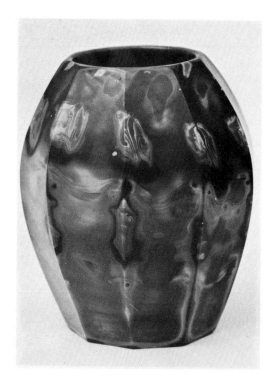

Fig. 62—Agate glass vase cut with flat panels to expose the laminated effect in the metal; height 3 13/16 inches. *The Metropolitan Museum of Art; gift of the Louis C. Tiffany Foundation*

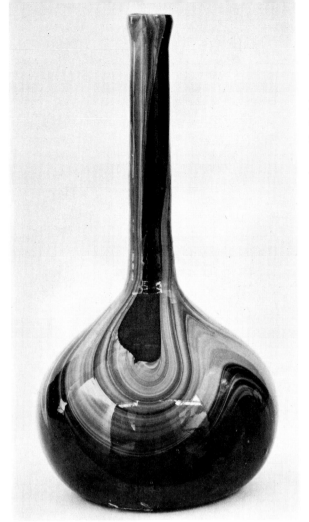

Fig. 61—Laminated glass vase and detail of paper label on the bottom of the vase, reading " ffany Fabrile Glas "; ca. 1896. *The Metropolitan Museum of Art; H. O. Havemeyer collection*

Fig. 63—Agate glass vase, blackened exterior cut and engraved with geometric decorations revealing the agate-colored glass beneath; original paper label "Tiffany Glass & Decorating Company"; height 5½ inches. *Smithsonian Institution*

Striking replicas of Etruscan and American Indian pottery were made in this way. Original paper labels and engraved marks found on such objects indicate they were among the early productions of the Tiffany Glass & Decorating Company.

Occasionally Agate glass was plated over crystal or colored glass and interesting effects were obtained by cutting designs through the outer layer of Agate glass to expose the transparent glass beneath it.

Another of Tiffany's Agate wares, reddish brown in color and heavily lustered inside and out, was given the name "Metallic Glass" (Fig. 65).

Antique and Cypriote Glass

For some years before he came to America, Arthur J. Nash had been experimenting with lustrous effects on glass and, when at the Tiffany works he finally developed a means for reproducing the iridescence found on ancient glass, long buried in the earth, Tiffany's dream of producing copies of ancient glass objects was realized.

To the wares made at the Tiffany factory which approximated the corroded and nacreous texture of ancient glass, the terms "Antique" and "Cypriote" were applied.

Study of several objects identified in Tiffany inventories and catalogs, dating from 1897 to 1927, revealed that the terms "reproduction of antique glass," "reproduction of ancient Cypriote," "gold lustre decorated, Egyptian motif," and other descriptive phrases suggesting

Fig. 64—Agate glass vase variegated green, yellow, and blue-gray, over crystal; panels cut back to crystal glass and engraved with leaf and vine decorations; an exhibition piece marked "Ex.L.C.T. / Favrile"; height 5½ inches. *Collection Neil Reisner*

Fig. 65—Metallic glass bowl-vase; reddish-brown glass with darker streaks throughout; signed "L. C. Tiffany / Favrile / 2-1389 P"; height 3 inches. *Andrew Dickson White Museum of Art*

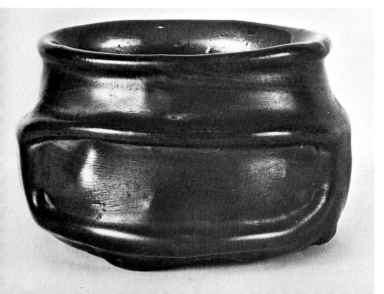

antique influences were rather loosely applied to objects emulating ancient forms and decorations. Sometimes objects bearing the same designation differed in appearance. Some, labelled "Antique," were decorated with iridescent threads and patches on a dark ground while others were a combination of smooth and textured iridescent glass, as if the objects had been only partially affected by the corrosive action of time and atmosphere. While other antique finishes were occasionally labelled "Cypriote," only one, a finely pitted nacreous surface, was consistently so-called.

According to Jimmy Stewart, Tiffany's Cypriote glass was made by rolling a gather of transparent yellow glass over a marver covered with pulverized crumbs of the same metal. The crusty surface of the object was then heavily lustred, resulting in a superb imitation of ancient glass (Figs. 66-68, 70-71).

In preparing captions for our illustrations of these Tiffany copies of ancient objects, we have endeavored to interpret the distinction between Antique and Cypriote glass as indicated in the Tiffany inventories and catalogs—no simple task in view of Tiffany's apparent indecision to settle upon specific and consistent names.

The Metalwares Division of the Tiffany glassworks made metal stands, the kind used by museums to support unstable pieces of ancient glass, for the copies of such artifacts made at the glassworks. This supports

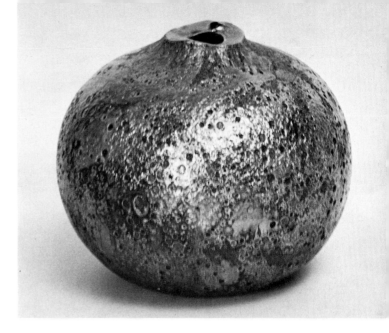

Fig. 66—Cypriote vase; signed "L.C.T. / 3319 P"; noted on A. Douglas Nash inventory as one of the first successful experimental pieces of this glass produced; height 2½ inches. *Author's collection; ex-coll. A. Douglas Nash*

Fig. 67—Cypriote vase; signed "1376 P / L. C. Tiffany / Favrile"; height 4¾ inches. *Andrew Dickson White Museum of Art*

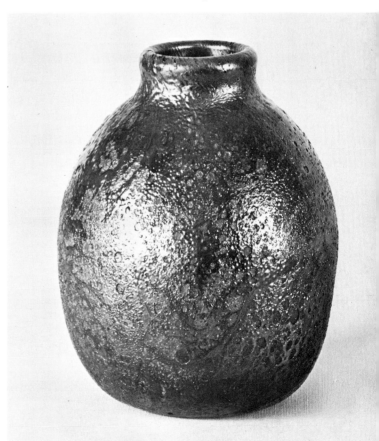

Jimmy Stewart's statement that Louis C. Tiffany often brought museum pieces of ancient glass to the factory for the glassworkers to copy exactly. One has only to examine several examples of Cypriote and Antique glass to realize how successful the workers were in their imitations.

Lava Glass

Tiffany's Lava glass was made by introducing pieces of basalt or talc in the melts, and decorating portions of objects made from this metal with gold lustre glass. The combination of lustred areas with the rustic texture of the Lava glass suggested to Tiffany and his staff of designers forms resembling volcanic eruptions. Originally it was to be called "Volcanic" glass, but Mr. Tiffany rejected this name in favor of "Lava" glass.

Fig. 69—Lava glass bowl; blackish-green body with gold lustre decorations; Tiffany Furnaces, ca. 1910; height 6½ inches. *Metropolitan Museum of Art; gift of the Louis C. Tiffany Foundation*

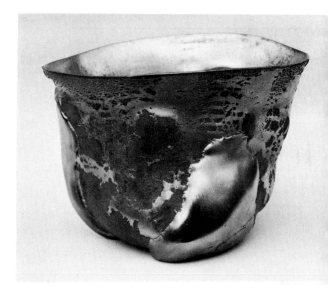

Fig. 68—Cypriote vase in bronze stand; signed "L.C.T. / Favrille / 1401 P"; height with stand 7½ inches. *Andrew Dickson White Museum of Art*

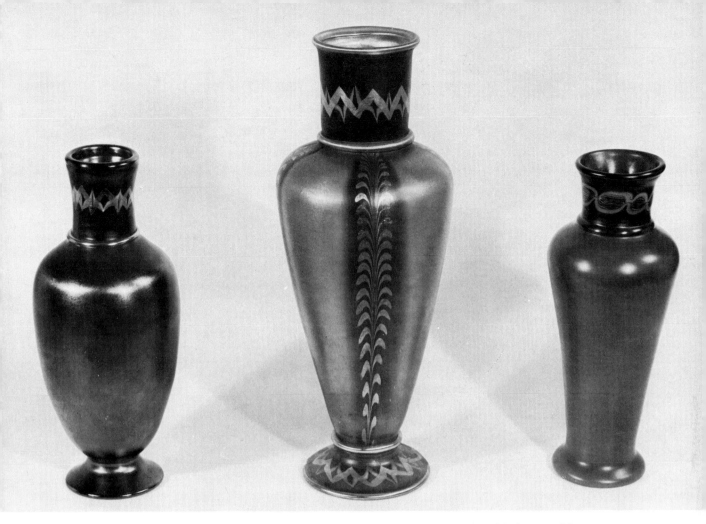

Fig. 70—Egyptian decorated vases. *Left to right:* Dark Blue Lustre body with blue, gold, and green lustre decoration; signed "Louis C. Tiffany / Favrile / Ex 260"; height 7¾ inches. Green body with blue, green, and gold lustre decorations; signed "Louis C. Tiffany / Favrile / 206 N"; height 10¼ inches. Turquoise blue body with blue and silver decorations; signed "L.C.T. Ex"; height 7¾ inches. *Collection Neil Reisner; ex-coll. Arthur J. & Leslie H. Nash*

The Tiffany conception of nature's violence is seen in our illustrations of a small pitcher with an undulating black and gold lustre surface (color plate) and of a vase, decorated around the top with a representation of molten lava spilling from the rim of a volcano (Fig. 69) .

If grotesque forms offend a collector, he should not add a piece of Tiffany's Lava glass to his collection. These pieces are seldom symmetrical in shape, and their beauty lies in the collector's appreciation of the vigorous forms in which this ware was made.

Reactive Glass

"Reactive Glass" refers to wares made at the Tiffany factory from sensitive glass that changed color when reheated at the furnace. A few of these wares were given specific names—"Morning-glory," "Rainbow," "Opalescent Optic," and "Flashed Glass" (also known as "Opalescent Colored Glass") — but in the main, the term "reactive"

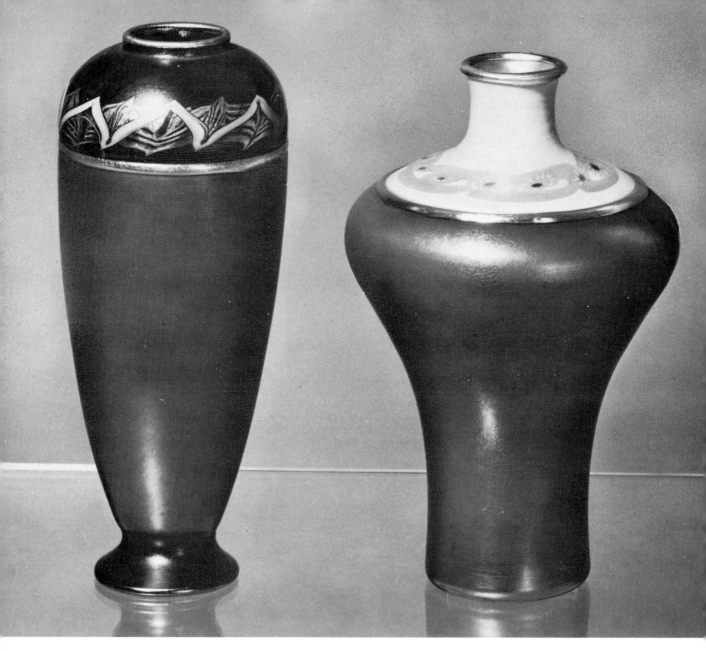

Fig. 71—Egyptian decorated vases. *Left to right:* Dark green body with black foot and collar; collar decorated with gold and green lustre. Opaque green body with beige collar; guilloche decoration about collar inlaid with millefiori florettes in cream and green. Both vases made at Tiffany Furnaces, ca. 1920; height each vase 8¾ inches. *Collection Maude Feld*

was applied to all Tiffany glasses that responded to changes in temperature in one way or another.

One of the most beautiful examples of Tiffany's Reactive glass we have ever found is shown in our color plate. To our sense, it is a classic Art Nouveau form—a simple gourd shape, so natural to the ductile quality of glass. Inlaid decorations of yellow-green, brown, and blue glass, in organic forms which seem alive and growing, were worked into a body of opalescent gold-ruby glass. Inscriptions engraved on the base of this vase identify it as an

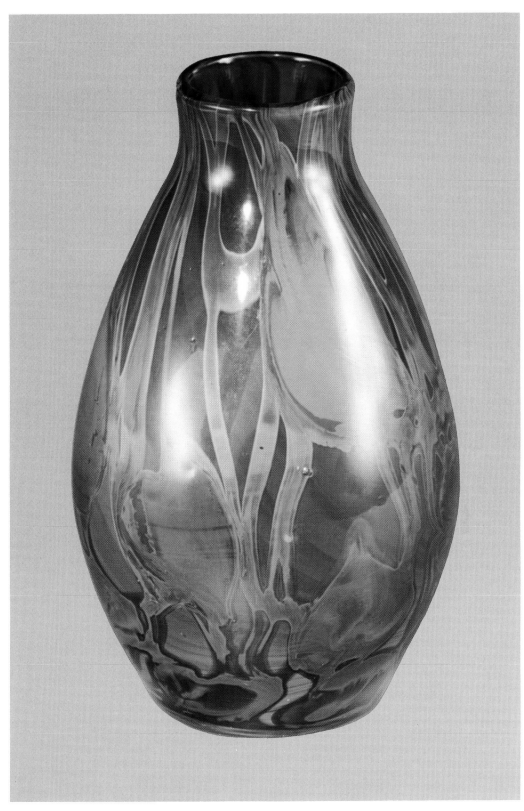

Reactive glass vase; reddish-purple (gold-ruby) body with yellow-green, brown, and blue decorations in organic forms; signed "Louis C. Tiffany / Favrile / 9661 A"; also marked "St. Louis" (St. Louis Exhibition, 1904), and "Salon 1906" (Paris Salon, 1906); original paper label; height 7 inches.— *Author's collection; ex-coll. A. Douglas Nash*

"exhibition piece" which Tiffany showed at the St. Louis Exposition (1904) and at the Paris Salon (1906). For several years it was on loan exhibition at the Museum of Art, Carnegie Institute in Pittsburgh, Pennsylvania, along with other fine pieces of Tiffany glass from the A. Douglas Nash collection.

Morning-glory glass was the culmination of several years of experimentation at the Tiffany glassworks, and according to Mrs. A. Douglas Nash, several people worked on this project before success crowned their combined efforts. To produce Morning-glory glass, a parison was formed from transparent celadon-colored glass and decorated with vines and leaves in various shades of green, brown, and yellow. Wherever flowers were to appear on the finished article, small round patches of opalescent gold-ruby glass were applied and touched with cold metal prunts simulating the form of the morning-glory blossom. When the object was reheated at the furnace, the flowers struck various shades of opalescent purple, red, and blue, in a beautiful and realistic representation of the convolvulus. The vase shown in our color plate was one of fifty Morning-glory pieces made in 1913, and exhibited at the Paris Salon (1914) where they won first

Fig. 72—Morning-glory vase with internal lustre; Tiffany Furnaces, ca. 1905; height 8 inches. *Collection Rollins College*

Fig. 73—Gladiola vase with internal lustre; Tiffany Furnaces, ca. 1910; height 16½ inches. *Metropolitan Museum of Art; gift of the Louis C. Tiffany Foundation*

Fig. 74—Reactive glass vase; gold-ruby body with blue decorations; signed "L. C. Tiffany / Favrile / 6-1393 P"; height 5½ inches. *Andrew Dickson White Museum of Art*

Fig. 75—Rainbow tumbler; uranium-yellow glass with opalescent Optic Rib pattern; Tiffany Furnaces, ca. 1920; height 4 inches. *Author's collection; ex-coll. A. Douglas Nash*

honorable mention for their creators. A. Douglas Nash considered this vase one of their finest examples of Morning-glory glass.

Some pieces of Morning-glory glass were internally lustred, adding the subtle "under-the-water" illusion so pleasing to collectors of Tiffany glass (Fig. 72).

Gladiola vases, for the most part, were made by applying shaded green leaves and sections of millefiori rod, especially formed to represent the gladiola blossom, on a body of opalescent gold-ruby glass (Fig. 73).

Reactive wares designated as Tiffany's "Opalescent Optic," "Rainbow," and "Flashed Glass" were relatively simple to manufacture. They far outnumber the Morning-glory and Gladiola just discussed. For these simpler wares, a gather of sensitive glass, crystal or colored, was blown into a figured mold and reheated until the raised pattern struck an opalescent (milky-white) color. Then it was blown and tooled into its final form. One of the best examples of this ware that we have found is an opalescent crystal tazza, decorated with a wreath of green leaves and vines ornamented with sections of millefiori rod representing morning-glory blossoms.

Rainbow glass was manufactured from a sensitive uranium-impregnated metal, transparent yellow-green in color. It was usually pattern-molded before being reheated to bring out an opalescent effect in the finished article. An optic

52

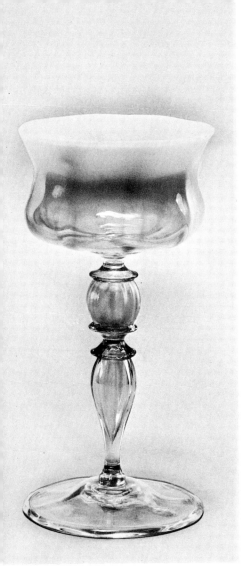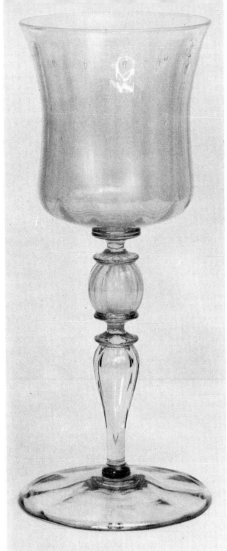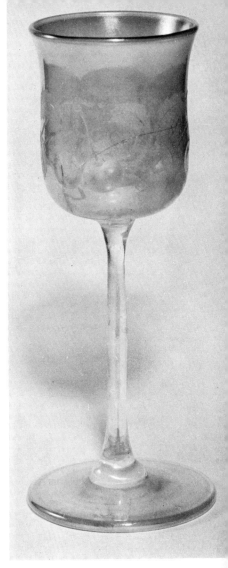

Figs. 76-77-78—*Left to right:* Champagne glass in the Venetian style; opalescent pink bowl, uranium-yellow foot and stem; Optic Rib molded, Phantom Lustre; original Tiffany paper label on foot; ca. 1925; height 7½ inches. *Collection Mr. & Mrs. John L. Riggs.* Opalescent yellow goblet in the Venetian style; Optic Rib pattern; Phantom Lustre; Tiffany Furnaces, ca. 1925; height 9 inches. Opalescent green cordial glass; lustred; carved intaglio design of cherries and leaves on bowl; Tiffany Furnaces, ca. 1920; height 4½ inches. *Author's collection; ex-coll. A. Douglas Nash*

tumbler in this ware, formerly owned by A. Douglas Nash, is shown (Fig. 75).

Flashed glass was made by partially plating a body of sensitive opalescent crystal with colored glass. Tablewares and decorative articles of every description were made in this ware. Because of its wide use, Mr. Tiffany considered it "too commercial." A reliable source informed us that the production of Flashed glass, which appeared rather late in the Tiffany era, caused the only real disagreement Arthur J. Nash and Louis C. Tiffany ever had (Figs. 74-84).

Collectors and dealers now refer to "Flashed Glass" as "Pastel Tiffany." It can be found in shaded

Fig. 79—Flashed green footed tumbler; opalescent optic pattern of laurel leaves; lustred; signed "L. C. Tiffany / Favrile"; height 5 inches. *Author's collection; ex-coll. A. Douglas Nash*

Fig. 81—Flashed brown and yellow basket with opalescent Diamond Optic pattern; lustred interior; enamelled bronze rim and handle marked "Louis C. Tiffany." *Collection Mrs. Cecelia Ayer*

Fig. 80—Flashed green and opal cigarette dish; Tiffany Furnaces, ca. 1925; diameter 5 inches. *Author's collection; ex-coll. A. Douglas Nash*

Fig. 82—Flashed blue to amber bowl with opalescent Diamond Optic pattern; exterior lustred; signed "L. C. Tiffany, Inc. / Favrile / 1561-2917 N"; diameter 14 inches. *Collection Mr. & Mrs. Ned Stinnett*

Fig. 83—Flashed yellow, opalescent optic plate; Tiffany Furnaces, ca. 1920; diameter 11 inches. *Author's collection; ex-coll. A. Douglas Nash*

Fig. 84—*Left:* "Moonstone" cocktail glass; height 4½ inches. *Right:* Champagne glass in opalescent Reactive Star pattern; height 8 inches. *Author's collection; ex-coll. A. Douglas Nash*

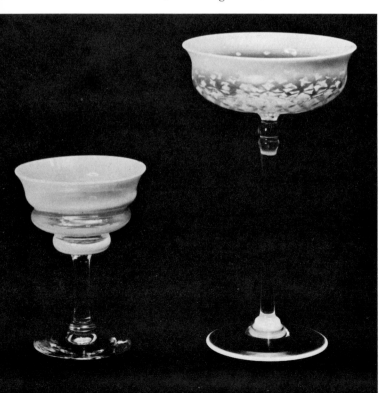

ruby (pink), blue, lavender, yellow, and brown, in a variety of opalescent optic patterns—"Venetian Diamond," "Laurel," "Dot," and "Rib." Most of these objects were either wholly or partially finished with a light lustre which added much to their appearance.

Carved Glass

Glass that had been cut or engraved, either in cameo relief or intaglio, was always referred to in Tiffany catalogs, brochures, and inventories, as "Carved." It mattered not whether it was plain crystal, tinted, lustred, or Agate.

Only the finest engravers were employed at the Tiffany works, and many man-hours were spent on some objects. For instance, the crystal bowl (Fig. 85), carved with a relief decoration of acorns and oak leaves, took a man over 200 hours to engrave. A. Douglas Nash purchased this piece for his own collection, perhaps because the price asked for this bowl was more than anyone else cared to pay for it at that time. Arthur Saunders' notes on his Tiffany glass collection stated that it took a man four weeks to produce the carved Agate glass vase which is shown in our color plate.

Sometimes patches of colored glass were applied to objects and carved in cameo relief to represent flowers, leaves, dragons, and insects (Figs. 86-89).

Of course, not every piece of Tiffany's carved glass required much time to make. This is true of the

56

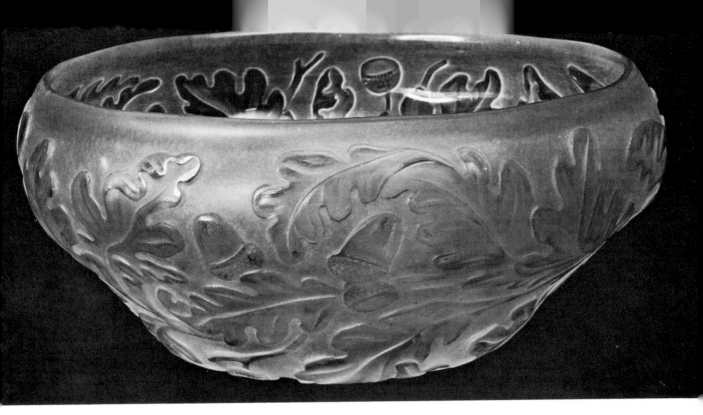

Fig. 85—Crystal bowl with carved relief decoration of acorns and oak leaves; signed "L. C. Tiffany / Favrile / 252 D"; original paper label in base; diameter 10 inches. *Author's collection; ex-coll. A. Douglas Nash*

copper-wheel-engraved designs we find on many of their vases, bowls, lamp shades, and tablewares. Jimmy Stewart told us that a number of these lightly engraved objects were decorated in such fashion to erase imperfections on the surface of the glass. Before this means of salvage was adopted, imperfect pieces usually ended up on the cullet heap. To obviate such losses, imperfect pieces were sent to the cutting shop where the blemishes were over-cut with designs of flowers, leaves, insects, etc.

Some of Tiffany's carved Rock Crystal wares were internally lustred, and glow like a moonstone. A carved Rock Crystal vase from the A. Douglas Nash collection was described in his inventory as being "lathe-cut" (Fig. 90). Lightly tinted transparent glass was also engraved at the Tiffany factory, giving us some particularly beautiful examples of their carved glass.

Jimmy Stewart, who worked at Corona for many years, advancing from "boy" to gaffer, was able to give us the names of a few of the engravers employed at the Tiffany factory. Arthur Richter, Sr., a Mr. Kretschmer, and Ernest Flogle were among the first workers in the cutting shop. Later, Arthur Richter, Jr., joined his father in this craft.

Mr. Stewart said that Ernest Flogle was noted for his fine-line engraving, and that most of the facsimilies of Mr. Tiffany's signature in small, Spencerian script were executed by Flogle. Objects bearing Tiffany's signature in a somewhat bolder and larger style were

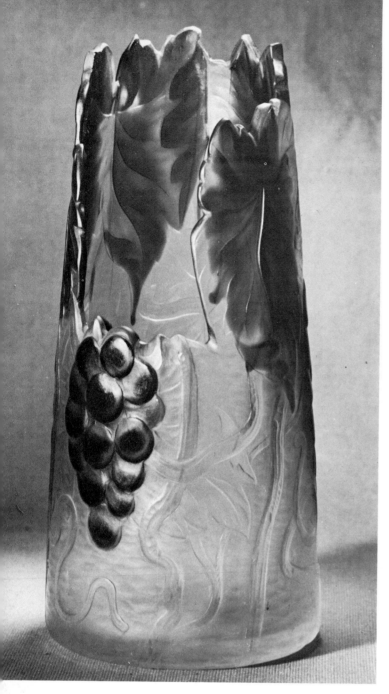

identified by Stewart as the work of Kretschmer. Undoubtedly there were other engravers employed in the Tiffany cutting shop during the years the factory operated, but Mr. Stewart could not remember them all. At the time we interviewed him, Jimmy Stewart was 87 years old, remarkably alert, both mentally and physically.

When we asked if Louis C. Tiffany ever made or signed a piece of his glass, Mr. Stewart was much amused to think anyone could imagine such a thing, for Mr. Tiffany was neither a glassblower nor an engraver, and never possessed the talent or skill required for such work.

Aquamarine Glass

Aquamarine glass was made at the Tiffany glassworks during the later part of 1913. At first, only two kinds of Aquamarine glass were produced—one in which aquatic

Fig. 86—Carved crystal vase with cameo-relief decoration of purple grapes and green leaves; signed "L. C. Tiffany / Favrile / 9506 A"; height 9½ inches. *Collection Minna Rosenblatt*

Fig. 87—Opaque orange-red glass with cameo-carved decoration of flowers and leaves; signed "L.C.T. Ex"; height 2¾ inches. *Collection Neil Reisner; ex-coll. Arthur J. & Leslie H. Nash*

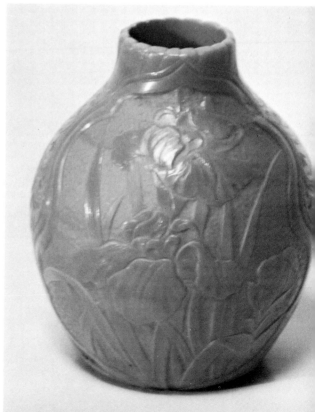

Tiffany Glass Company

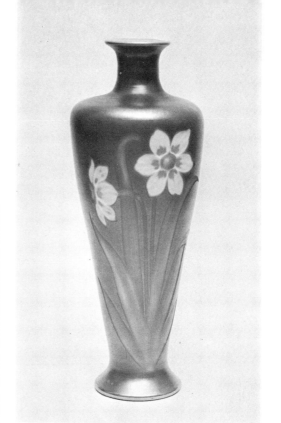

Fig. 89—Gold Lustre over opal glass vase with intaglio carved narcissus flowers and leaves; signed "L. C. Tiffany / Favrile / 1946 K"; height 8¼ inches. *Collection L. A. Randolph*

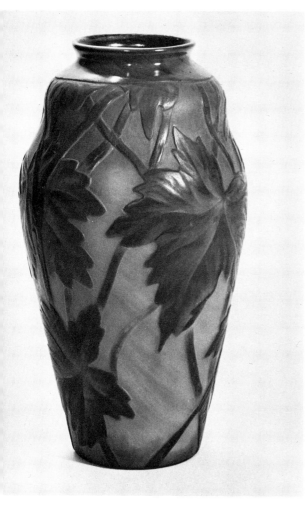

Fig. 88—Cameo-carved vase, green leaves on yellow body; signed "L. C. Tiffany / Favrile / 1395 P"; height 6¾ inches. *Andrew Dickson White Museum of Art*

Fig. 90—Lathe-cut Rock Crystal vase; signed "L. C. Tiffany / Favrile / 9698 A"; original paper label; height 11 inches. *Author's collection; ex-coll. A. Douglas Nash*

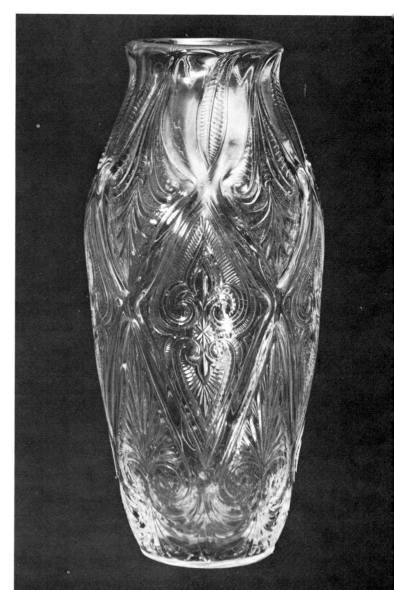

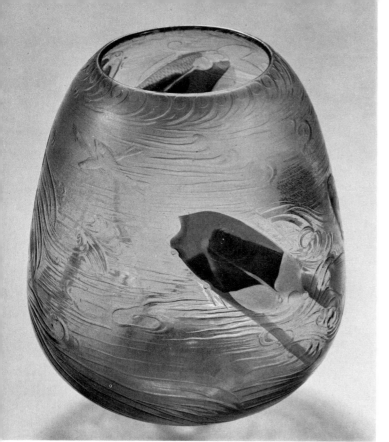

Fig. 91—Aquamarine glass vase with internal decoration of brown and yellow tropical fish; intaglio-cut decoration of fish and wave motifs; original paper label; Tiffany Glass & Decorating Company, ca. 1896; height 7⅛ inches. *Smithsonian Institution*

plants, such as pond lilies, appeared; the other with representations of fish, seaweed, and other marine life; both were encased in a heavy matrix of light green glass simulating the color of sea water. All of these pieces were heavy. Some had only a slight depression, not more than two or three inches deep, in the top of the object to give the effect of a vase or bowl filled with water.

Because they were difficult to make, only a comparatively few pieces of Aquamarine glass were produced (Figs. 91-96). These sold, at that time, from $200 to $250 each.

The little notebook Tiffany gaffer Arthur Saunders kept, concerning pieces of Tiffany glass in his collection, stated that he was sent to Hamilton, Bermuda, in July 1913, to study marine life in a glass-bottomed boat. His daughter Marion recalled that she and her mother accompanied him to Bermuda on the *R.M.S.P. Orsala*.

One of the first pieces Mr. Saunders made after this trip was a large ball of Aquamarine glass with representations of what would appear to be either sea urchins or polyps on a rock formation, with seaweed realistically portrayed with trailings of green glass.

Large doorstops, paperweights, mantel ornaments, fish bowls (some with goldfish and aquatic plants encased in the glass), vases, bowls, and a few other objects comprise

Fig. 92—Aquamarine glass vase with yellow and black millefiori flowers and green leaves; Tiffany Furnaces, ca. 1909; height 6 inches. *Author's collection; ex-coll. Arthur E. Saunders*

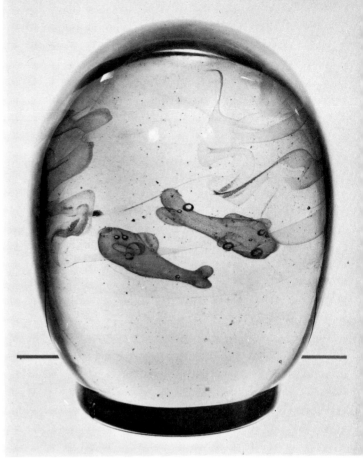

Figs. 93-94—*Left to right:* Aquamarine glass vase with internal decoration of white and yellow millefiori florettes and dark green leaves; signed "L.C.T."; height 2 inches. *Collection Neil Reisner; ex-coll. Arthur J. & Leslie H. Nash.* Aquamarine glass doorstop; internal decoration of fish and seaweed in Nile green; signed "L. C. Tiffany / Favrile / 1984 H"; height 6 inches. *The New York Historical Society*

Figs. 95-96—*Left to Right:* Aquamarine paperweight with internal decoration of sea urchin with long tentacles in Nile green; signed "L. C. Tiffany / Favrile"; height 3¼ inches. *John Nelson Bergstrom Art Center and Museum.* Aquamarine paperweight with internal decoration of pond lily and leaves; signed "L. C. Tiffany / Favrile / 1392 P"; diameter 4½ inches. *Andrew Dickson White Museum of Art*

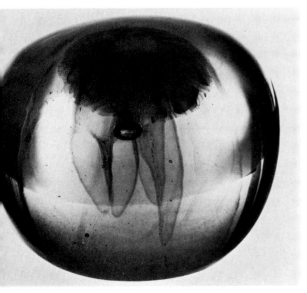

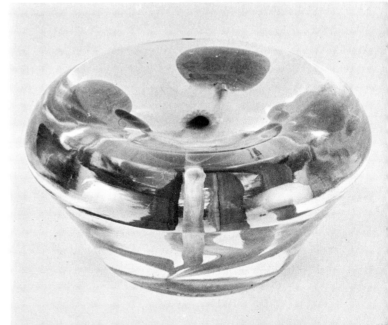

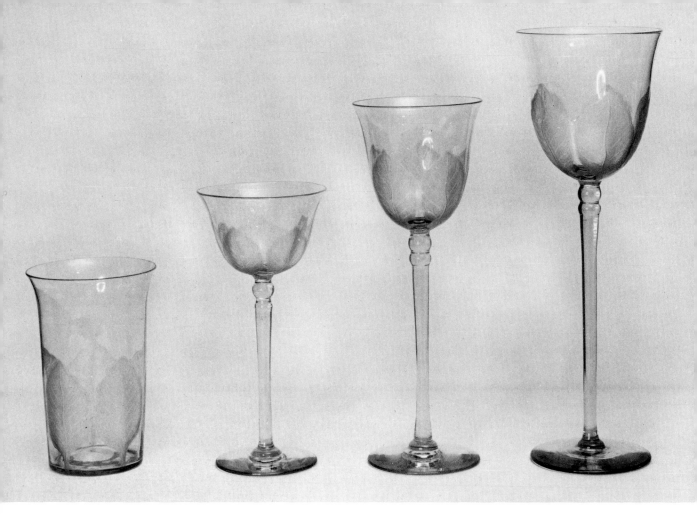

Fig. 97—Antique Green stemware with
carved leaf decoration; Tiffany Furnaces,
ca. 1920; height of tallest glass 8 inches.
*Author's collection; ex-coll. A. Douglas
Nash*

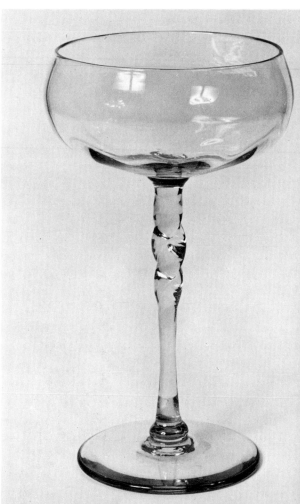

Fig. 98—Antique Green champagne glass
with twisted stem; Tiffany Furnaces, ca.
1920; height 7 inches. *Author's collection;
ex-coll. A. Douglas Nash*

the bulk of Aquamarine glass productions.

Later on, Tiffany used this delicately tinted glass for other wares, such as the vase with pendant sprays of white dogwood blossoms, deep green leaves, and brown branches shown in our color plate. By adding more green to the color of Aquamarine glass, Tiffany developed the colors they called "Antique Green" and "Pomona Green" (Figs. 97-98).

Venetian Techniques

Most art-glass manufacturers, at one time or another, use techniques developed centuries ago by the Venetians. This was true of the Tiffany works. No one should be surprised to know that millefiori rods, as intricately made and beautifully colored as any produced on the Continent, were fashioned at the Corona factory and put to use in many different ways by Tiffany craftsmen (Fig. 99).

The millefiori rods used at the Tiffany works ranged in size from a quarter of an inch to four or five inches in diameter. Tiny white millefiori florettes with green, red, yellow, or blue centers were imbedded in the surface of glass vases, bowls, and so forth, usually with green leaves and tendrils added to create the illusion of flowering vines. A vase shown in our illustrations has large cross-sections of millefiori rod encased in the glass body to stimulate huge flowers with mustard-colored leaves and stems (Fig. 100).

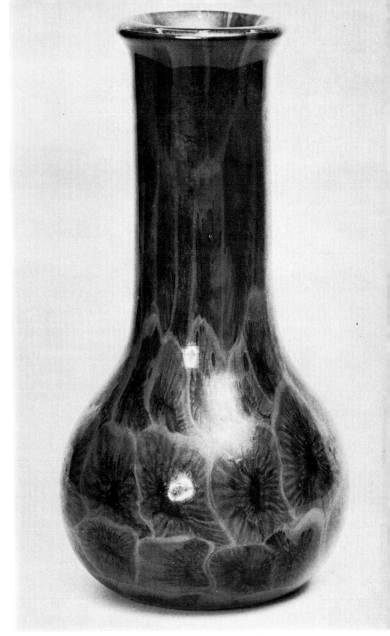

Fig. 99—Tessera vase composed of brown and tan millefiori sections; lustred inside and outside; signed "L.C.T. Experimental"; height 8 inches. *Author's collection; ex-coll. A. Douglas Nash*

A collection of Tiffany glass was presented to the Andrew Dickson White Museum of Art, Cornell University, in 1927. The inventory of this collection, typed on Louis C. Tiffany Furnaces, Inc., stationery, referred to one vase as "Green Millefiori effect" (Fig. 101). We

63

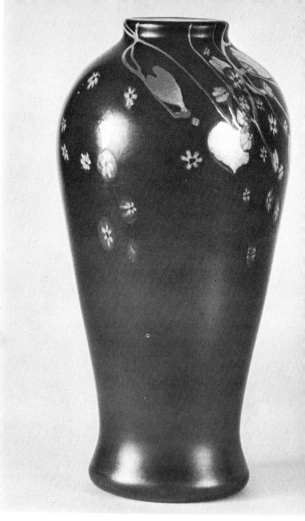

Fig. 101—Opaque green vase with mille-fiori florettes, and gold lustre leaves and vines decoration; signed "L. C. Tiffany / Favrile / 1392 P"; height 6½ inches. *Andrew Dickson White Museum of Art*

Fig. 100—Amber glass vase with large blue and gold millefiori flowers, and mustard-colored leaves and vines; internal lustre; signed "Louis C. Tiffany / Favrile"; height 8 inches. *Author's collection; ex-coll. Arthur E. Saunders*

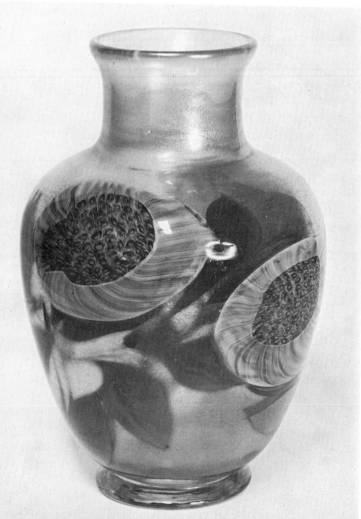

must conclude that this was the Tiffany designation for such wares, and that to refer to them as "paperweight Tiffany" is incorrect.

Lengths of millefiori rod were used by the Tiffany glassworkers to simulate coral growths and aquatic plants and animals. Usually these representations were embedded in a heavy matrix of Aquamarine glass. The realism obtained in such productions was remarkable.

Arthur Saunders wrote in his notebook that the "Diaper" pattern sherbet glass in his collection was one of a very few such pieces made at the Tiffany glassworks, and that the idea for this ware was borrowed from a plate produced by the Venice and

Tiffany Glass Company

Murano Glass and Mosaic Company about 1880. Advanced students of glass will recognize at once that the sherbet glass (see Fig. 17) represents a revival of the old Vitro di Trina technique introduced in Venice sometime in the seventeenth century (Fig. 102).

Reticulated Glassware

When we interviewed Leslie Nash several years ago, he readily admitted that Tiffany's "Reticulated" glass was not an original idea. Jimmy Stewart recalled that as early as 1895, when he was just starting out as a "bit boy," this kind of ware was already in production at the Corona factory. At the Paris Exposition of 1879, Salviati & Company of Venice, Italy, exhibited hanging baskets in Reticulated glass. Fritz Heckert of

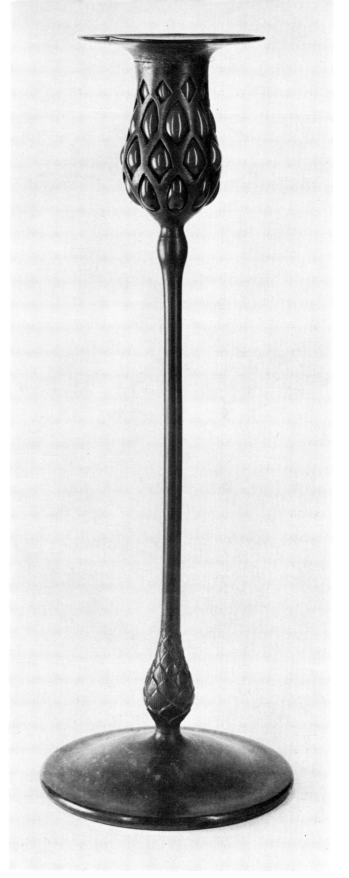

Fig. 103—Reticulated glass candlestick; opaque jade-green glass and "Tiffany Green" bronze; marked "Tiffany Studios—New York"; height 14¾ inches. *Author's collection*

Fig. 102—Venetian Lace (Vitro di Trina) vase; opal threads on crystal body; Tiffany Furnaces, ca. 1920; height 3 inches. *Author's collection; ex-coll. Arthur E. Saunders*

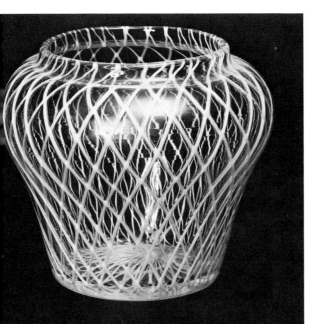

Petersdorf, Germany, registered a patent in England for Reticulated glassware on August 18, 1881. Both Salviati and Heckert claimed Reticulated wares had an ancient origin.

To produce Reticulated glassware, metal frames with apertures in various designs were formed by stamping, casting, or pressing. Forms were also constructed from heavy twisted wire; this was one of the methods used at the Tiffany works.

Fig. 104—Reticulated glass lamp base; opaque jade-green glass and "Tiffany Green" bronze; marked "Tiffany Studios / New York / 25922"; also marked with Tiffany Glass & Decorating Company monogram; height 19½ inches. *Collection Walter P. Chrysler, Jr.*

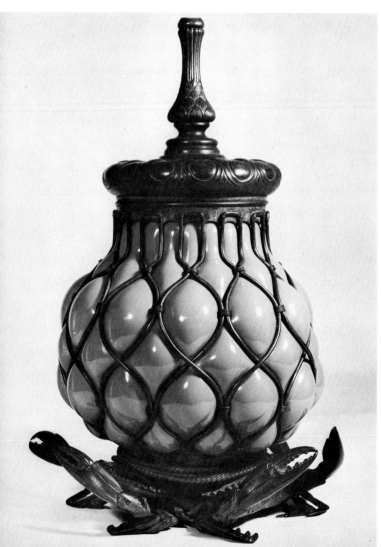

The metal form was heated and a gather of colored glass was blown into it with such force that the glass protruded from the apertures. The finished article had the appearance of being set with jewels. Gilding, silvering, or bronzing the metal framework heightened this illusion.

Leslie Nash and Jimmy Stewart both said that several kinds of colored glass were used in Tiffany's Reticulated wares. However most of these productions are found in opaque jade-green glass, encased in antiqued bronze frames (Figs. 103-104).

Thomas Campbell, a "wire worker" at the Metalwares Division, worked more than a year to develop the antique bronze finish called "Tiffany Green." Campbell also made many of the handsomely decorated bases for Tiffany lamps, where real flowers and foilage, electroplated with copper, were soldered to the metal body or standard.

Favrile Color Nomenclatures

Unfortunately no comprehensive color chart was ever published by Mr. Tiffany, but from various sources, we have compiled a list of colors made at the Tiffany glassworks. Some of them are well known to collectors; a few are shown in our color illustrations; most, though, must be imagined from the descriptive names given them at the factory.

Red: Ascot Red, Opal Red, Pink, Ruby, Samian Red, Shell Pink, Venetian Red.

Green: Antique Green, Apple

66

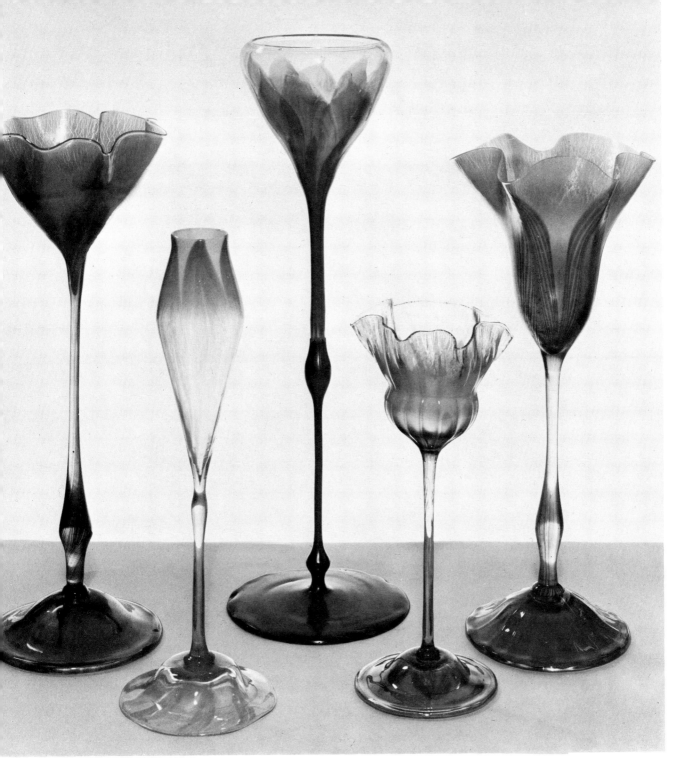

Fig. 105—Collection of flower form vases. *Left to right:* Opalescent white with green leaf design on base; signed "L.C.T. W 4431"; height 14 inches. Amber glass with opaque yellow top and red leaves; signed "L.C.T."; height 12 inches. Pink petals and green leaves in bowl; crystal stem set into bronze holder marked "Tiffany Studios"; height 18 inches. Amber glass with opalescent white petals; inner surface of bowl lustred; signed "L.C.T."; height 10 inches. Opal glass with green leaf decoration and lustred "stretched" edge; signed "L.C.T. W 4490"; height 14 inches. *Photo courtesy of J. Jonathan Joseph*

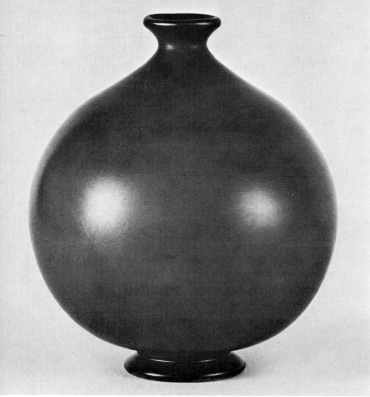

Fig. 106—Tel El Amarna vase with mat lustre; signed "L. C. Tiffany / Favrile / 1383 P"; height 4¾ inches. *Andrew Dickson White Museum of Art*

Fig. 107—Cocktail and goblet of topaz-colored glass with ruby dots; Tiffany Furnaces, ca. 1920; height of goblet 6½ inches. *Author's collection; ex-coll. A. Douglas Nash*

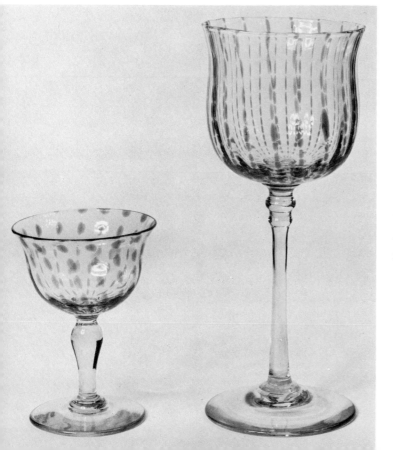

Green, Aventurine Green, Celadon Green, Light Green, Opal Green, Pomona Green.

Blue: Cinnabar Blue, Grotto Blue, Heavenly Blue, Mazarin Blue, Opalescent Blue, Tel El Amarna, Violet Blue and Opal.

Purple: Violet, Purple Violet.

Yellow: Golden Yellow, Opaque Yellow, Yellow, Yellow and Opal.

Moonstone, Fluorescent, Flint Crystal, Onyx, Lava, Opal, Black, and Gray were still other color terms we found in their enumerations, but most certainly the few we have named do not cover Tiffany's full range of colored glasses.

Whenever leaded-glass windows and lamp shades were described in their literature, the terms "Foliage," "Emerald," "Chipped Ruby," and "Wisteria" were used. Jimmy Stewart said that literally hundreds of sheets of colored glass—transparent, opaque, and variegated—were kept on hand in their storeroom for the making of stained-glass articles.

The names, "Tiffany Favrile Fabric Glass," "Tiffany Favrile Sunset Glass," "Tiffany Favrile Horizon Glass," "Tiffany Favrile Twig Glass," and "Tiffany Favrile Lace Glass" were given to certain kinds of colored and textured glass used in their stained-glass productions. Obviously these glasses were made in various colors and combinations of colors and textures as their names imply.

Pressed "Jewels," "Turtle Backs," "Scarabs," and "Tiles" were manufactured in a wide range of

68

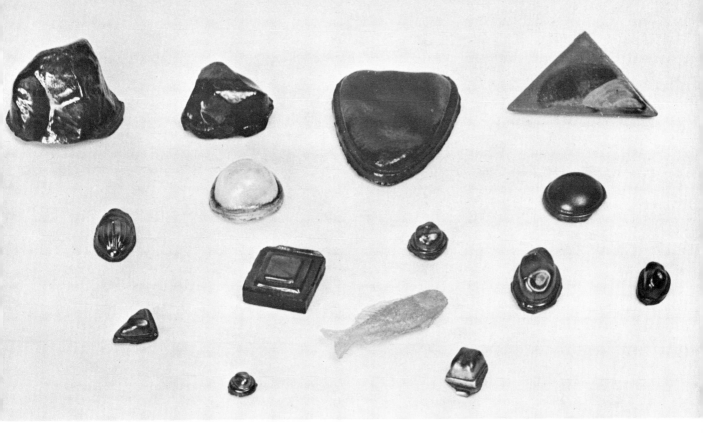

Fig. 108—An assortment of lustred "jewels" in various colors; center foreground is an orange-colored fish used for internal decorations in Aquamarine glass objects. *Author's collection; ex-coll. Arthur E. Saunders*

colors, plain and lustred, to decorate lamp shades, windows, metalwares, and other articles made by Tiffany.

The *Tiffany Blue Book for 1911* listed under "Tiffany Favrile Beetles" (scarabs) mounted in 18-karat gold, belt pins, belts, charms, hatpins, lorgnon chains, necklaces, pendants, scarf pins, sleeve links (cuff links), studs and collar buttons, and watch guards.

Tiffany's production of Art Nouveau glass was so varied, and so prolific, that many of the articles made at the Corona glassworks were not given proper names. In such instances the firm identified these wares by describing the decorating or manufacturing technique. Inventories of Tiffany and Nash collections listed such wares as "Vari-colored, internal lustre, polished outside," "Red and ivory and green reactive crystal," and "Opalescent, green colloidal." In view of this we have included some illustrations of Tiffany glass for which only a description of the object is provided (Figs. 105-124).

Tiffany Windows and Lamps

Several years before he began to make stained-glass windows, Louis C. Tiffany studied these works of art in ancient cathedrals all over Europe. During one of his visits abroad, he acquired a small stained-glass window. He and his artists examined it minutely, studying every facet of its manufacture, from

Fig. 109—Tiffany glass lustred tiles; all marked "L.C.T. Favrile" and "Patent Applied For"; Tiffany Furnaces, ca. 1910. *Andrew Dickson White Museum of Art*

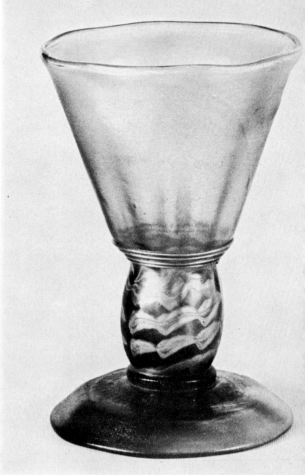

Fig. 110—Horn-glass goblet; smokey amber glass with gold lustre decoration on stem; signed "L.C.T. / Favrile / 1402 P"; height 3 1/3 inches. *Andrew Dickson White Museum of Art*

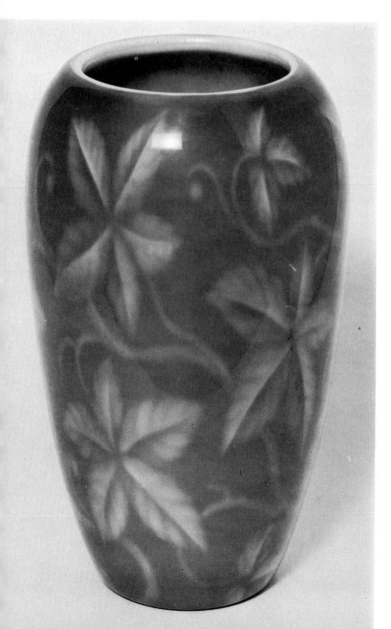

Fig. 111—Cased green over opal glass vase with shaded green and white leaves between opal and flint glass. (This was reported to have been a carved design cased over with crystal, but an experimental piece in the author's collection indicates the designs were pattern molded in the green and opal glass prior to blowing the parison into a cup of crystal glass.) Signed "Louis C. Tiffany / Favrile / Ex. 1927" and "A. J. Nash X-428"; height 8½ inches. *Collection Neil Reisner; ex-coll. Arthur J. & Leslie H. Nash*

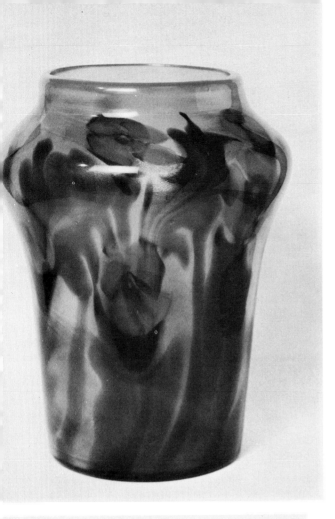

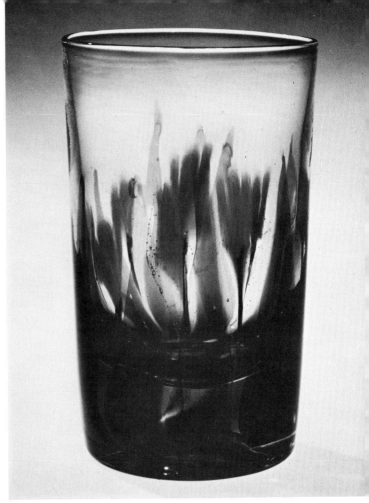

Figs. 112-113—*Left to right:* Flint-glass vase with internal decoration of orange-red poppies and blue-green leaves; internal lustre; signed "L. C. Tiffany Inc. / Favrile / 7793 M"; height 7 inches. *Collection Neil Reisner.* Flint-glass tumbler with internal decoration of yellow flowers and green leaves; signed "16 A Coll. L. C. Tiffany / Favrile"; height 4⅝ inches. *Collection Jerome Strauss*

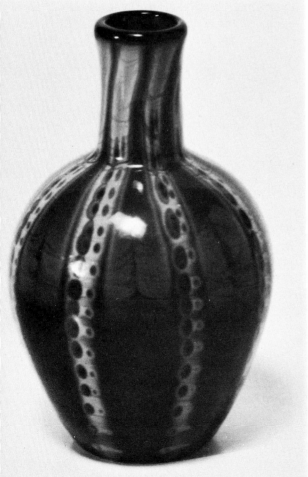

Fig. 114—Opaque olive-green and black vase; signed "L.C.T."; height 3 inches. *Collection Neil Reisner; ex-coll. Arthur J. & Leslie H. Nash*

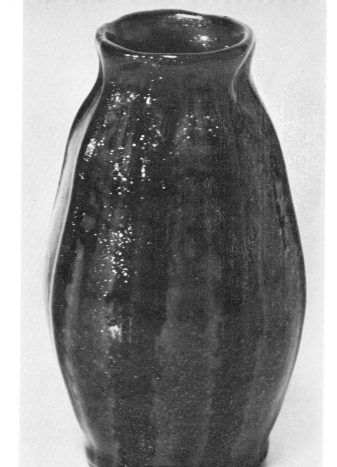

Fig. 115—Light and dark green textured vase with chrome oxide flakes forming in the green glass (somewhat like Aventurine); signed "L. C. Tiffany / Favrile / 9779 J"; height 3½ inches. *Collection Neil Reisner; ex-coll. Arthur J. & Leslie H. Nash*

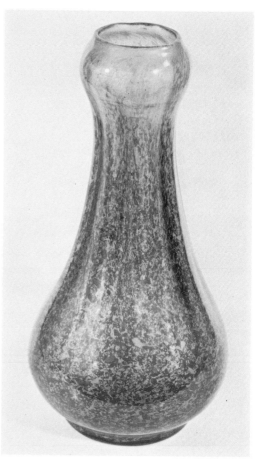

Fig. 117—Optic rib vase textured with internal multi-colored flakes in transparent amber glass body; signed "L.C.T. / Favrile"; an exhibition piece; height 11½ inches. *Collection Neil Reisner; ex-coll. Arthur J. & Leslie H. Nash*

Fig. 116—Black and gold textured vase with gold lustre guilloche decoration; signed "L. C. Tiffany / Favrile / 8411 J"; height 4½ inches. *Collection Neil Reisner; ex-coll. Arthur J. & Leslie H. Nash*

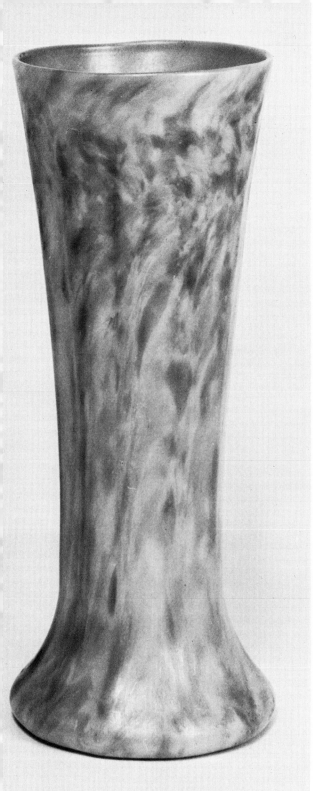

Fig. 119—Opalescent glass bowl with green colloidal decoration; signed "L.C.T. / Favrile / 1388 P"; diameter 6 inches. *Andrew Dickson White Museum of Art*

Fig. 120—Opalescent glass vase with air-bleb pattern throughout the body (called "Pearls" by Leslie H. Nash); an experimental piece; height 3½ inches. *Collection Neil Reisner; ex-coll. Arthur J. & Leslie H. Nash*

Fig. 118—Opal glass vase with mottled green and opal exterior, lustred; signed "L. C. Tiffany / Favrile"; height 9½ inches. *Author's collection; ex-coll. Arthur E. Saunders*

73

Fig. 122—Experimental opal glass vase with molded water and wave decoration lightly decorated with pink; Tiffany Furnaces, ca. 1925; height 6 inches. *Author's collection; ex-coll. A. Douglas Nash*

Fig. 121—Reactive glass vase of a changeable golden-yellow color; an experimental piece marked "L.C.T. Exp."; height 8 inches. *Author's collection; ex-coll. A. Douglas Nash*

Fig. 123—Gold Lustre glass goblet engraved "Sample approved by A. J. Nash," and "Sample for Stem"; height 5 inches. *Author's collection; ex-coll. A. Douglas Nash*

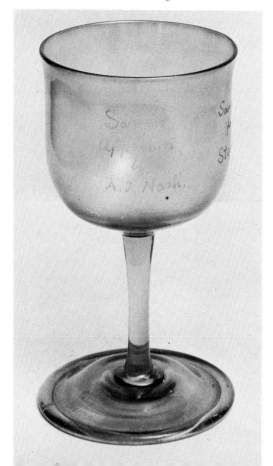

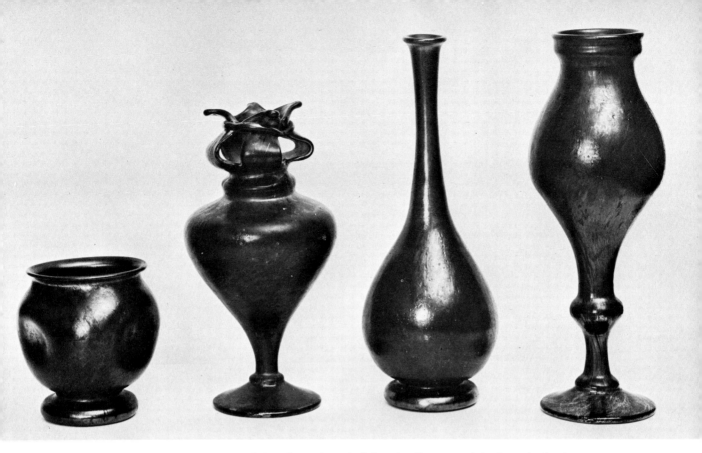

Fig. 124—Experimental pieces of Cypriote glass; height of tallest vase 8 inches. *Author's collection; ex-coll. Arthur E. Saunders*

the color of the glass to the method of joining the bits and pieces together into pictorial essays.

Tiffany was impressed with the gradations of color found in his ancient specimen and drew several conclusions about its coloring and construction. Most of his ideas about the means for coloring the glass panes literally went down the drain when a worker in the studio happened to wash the small window —much of the shading Tiffany had so admired was actually dirt that obscured the true color of the glass.

Still a great deal was learned from the ancient window concerning the joining of the pieces of glass, and Tiffany improved these techniques and patented them. On February

8, 1881, he filed a patent for "Glass Tile, Mosaic, &c.," in which he outlined his method of combining opalescent glass with a reflective background to produce greater brilliancy and iridescence. On the same date, Tiffany also patented a novel means for producing "Colored-Glass Windows." This consisted of combining two windows with an air space between them which allowed light to pass through one glass mosaic before it penetrated the other. Tiffany claimed this increased the "brilliancy and iridescence" of stained-glass windows.

Metallic lustres on segments of a stained-glass window was the gist of a third patent for "Colored-Glass Windows," issued to Tiffany on the

same date. The metallic lustre was produced by forming a film or oxide of certain metals on the surface of the glass to increase its reflective powers.

Before he had his own glass factory, Louis C. Tiffany purchased sheets of colored and opalescent glass from various sources in and around New York City. One of these suppliers was Louis Heidt of Brooklyn, New York. Heidt supplied Tiffany with "cathedral" and "drapery" glass. Cathedral glass was usually colored or opalescent, plain or textured. Drapery glass was something special; as the name implies, it was used to represent the folds in garments or draperies. Jimmy Stewart was a young boy working in the Heidt factory at the time Tiffany was purchasing his stained glass from that source; he was one of the workers who wiggled a forty-pound roller back and forth across a marver covered with molten glass to produce the drapery effect. The folds in the glass were governed by the way the men manipulated the roller. Folds could be as fine or as broad as the customer desired. A man named Schwartz usually came to the Heidt factory to select glass for the Tiffany workshop, where the windows were made, and often left orders for special colors and textures in both cathedral and drapery glass.

At the Tiffany Glass Company's workshop, the workers selected certain areas from colored sheets of glass and cut them out to conform

to the designs made up by Tiffany and his staff of artists. The "cartoons," as sketches for stained glass windows are called, were followed as closely as possible, but Mr. Tiffany's desire for realistic interpretations of his designs was not always possible of fulfillment. Too often he was unable to obtain the exact colors he envisioned. This frustration was one of the many reasons why he wished to operate his own glass factory.

In examining several Tiffany windows, we discovered that thin flakes of colored glass were placed on top of portions of the design to produce shading impossible to obtain in any other way. Just how these flakes of glass were applied to the glass panels was difficult to ascertain; we suspect they were simply glued to the surface of the design.

Tiffany's workers excelled in their method of joining the pieces of glass together. Whereas other stained-glass manufacturers cut sections of glass to conform to the leading, Tiffany workers did the exact opposite and made the leading conform to the pieces of glass. Thus they were able to blend and control the colors used in their designs (Figs. 125-126).

At first, Tiffany leaded-glass shades were made the same way their windows were; later, preformed skeletons of lead were used. The most exacting care was taken by the workers to choose colors that would blend harmoniously. The flowing unbroken line of Tiffany leading is

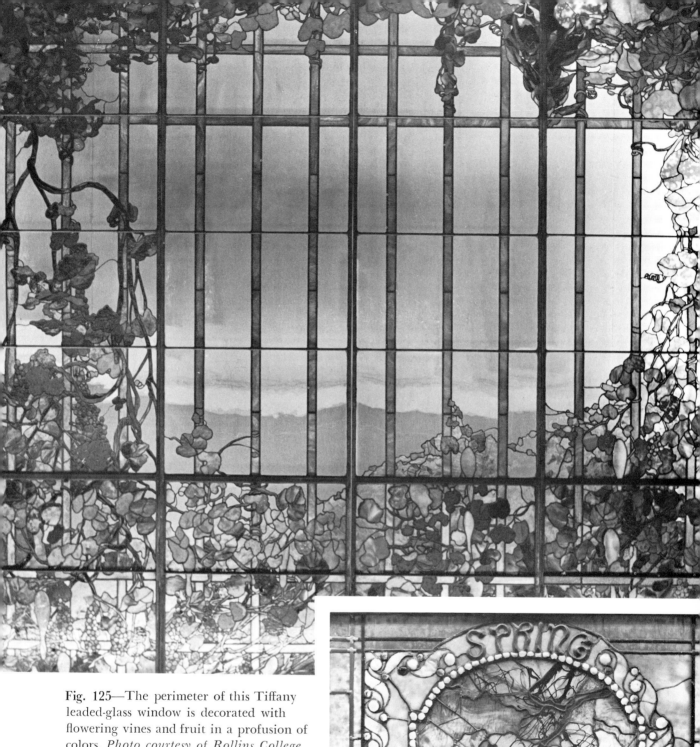

Fig. 125—The perimeter of this Tiffany leaded-glass window is decorated with flowering vines and fruit in a profusion of colors. *Photo courtesy of Rollins College*

Fig. 126—"Spring" is the title of this small window (one of four representing the four seasons); tulips and leaves are the central motif; the rest of the window is decorated with variously colored glasses, textured and marbleized. *Photo courtesy of Rollins College*

77

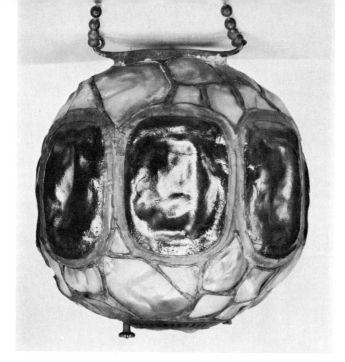

Fig. 127—Hanging ball-shaped lamp with antiqued bronze fittings and chain; composed of rough opal "gems" and dark red "turtle backs," all heavily lustred; diameter 13 inches. *Author's collection; formerly hung in the A. Douglas Nash home ca. 1896*

Favrile glass lamps and shades were made at the glass factory in various styles, known as "Arabian," "Florentine," "Iris," "Nuremburg," "Ribbon," "Wave," "Damascene," "Murano," "Etruscan," and so forth. The names were designations for either the form of the lamp or the kind of decoration on the glass itself. An enumeration of the entire line of Tiffany lamps would require a monograph in itself, and we regret that illustrations of more Tiffany lamps cannot be shown in this book. Suffice it to say, lamps of every description and for every use were made by Tiffany, and this field of

a feat never before or since duplicated by anyone in the trade. Consequently they are far superior in design and coloring to any made by their contemporaries.

Some years after the glass factory was opened at Corona, a Metalwares Division was established there and production of stained-glass windows was transferred to Long Island. However, the leaded-glass shades were still made at the studio in New York City. Lamp bases and other metal fixtures were manufactured in the rough at Corona and sent to the Tiffany Studios to be finished.

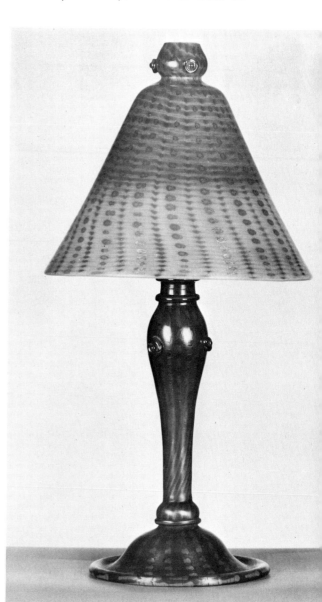

Fig. 128—"Arabian" lamp of lustred glass in green and gold; signed "L. C. Tiffany / Favrile"; 13¾ inches. *Author's collection*

78

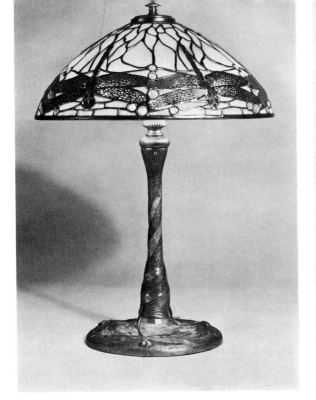 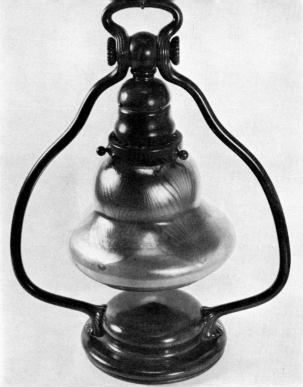

Figs. 129-130—*Left to right:* "Dragonfly" lamp; gilded bronze base, and a shade of colored glass and gilded leading; gold lustre glass mosaic work on foot and stem; marked "Tiffany Studios"; height 18 inches. *Collection J. Jonathan Joseph.* Desk lamp; bronze fixture marked "Tiffany Studios / New York"; shade of opal glass with gold lustre leaf decorations; height 11½ inches. *Collection Dr. & Mrs. Seymore B. Gray*

Figs. 131-132—*Left to right:* Gilded bronze lamp, antiqued finish and with ruby-colored enamel decorations around the base; base marked "Louis C. Tiffany Furnaces, Inc. / Favrile / 369"; also with the initials "W.W." (perhaps standing for William Winter); Favrile glass shade in the "Murano" design on brown and tan lustred glass; shade signed "L.C.T. / Favrile"; height 15 inches. Tiffany desk lamp; bronze base marked "Tiffany Studios / New York / 419"; shade of green and gold lustre in the "Murano" design; height 13½ inches. *Author's collection*

Figs. 133-134—*Left to right:* Tiffany lamp with leaded shade representing large magnolia blossoms and green leaves; height 20 inches. Tiffany table lamp with leaded laburnum shade. *Collection Bruce Randall*

Fig. 135—Tiffany table lamp with leaded red poppy shade. *Collection Bruce Randall*

80

collecting has great potential (Figs. 127-136).

Several designs for lamp shades were issued to Mr. Tiffany and others associated with his firm. On May 2, 1899, Tiffany registered his design for the Nautilus lamp, which was produced in Favrile glass, leaded glass, and with the Nautilus shell itself as a shade (Figs. 137-138).

Pressed-glass panels for lamp shades, representing folded silk, were designed and patented by Henry O. Schmidt of New Britain, Connecticut, on February 18, 1913, and assigned to Tiffany Studios of New York City (Fig. 139). The molded glass panels were made in green, white, and amber, acidized to a mat finish, and inserted in metal frames designed especially to hold them. On October 14, 1913, a quite similar design for pressed-glass lamp shades was patented by Leslie H. Nash, and on February 23, 1914, the trade name for these pressed-glass shades, "Favrile Fabrique," was registered by Arthur J. Nash for Tiffany Furnaces (Fig. 140; see also Fig. 157).

Over the years we have found a few small lamps made up of Tiffany Favrile glass lamp vases and shades, but with metal fixtures marked "Bryant." The lamps appeared to be of the 1910–1920 period and later, and some had a light placed within the lamp vase which produced a soft luminescence when it was lighted. This practice was rather late—in the 1920s to be more precise—and at this period Tiffany's metalwares

Fig. 136—"Pond Lily" lamp with seven Gold Lustre glass shades; bronze base signed "Tiffany Studios"; height 21 inches. *Collection Mr. & Mrs. Howard Decker*

Fig. 137—"Nautilus Shell" lamp shade; Design Patent No. 30,665, patented May 2, 1899, by L. C. Tiffany.

Fig. 138—"Nautilus" lamp with mottled green and opal leaded-glass shade; mermaid base of bronze marked "Tiffany Studios / New York / 28631"; height 16 inches. *Author's collection*

Fig. 139—Henry C. Schmidt's Design Patent No. 43,582 of Feb. 18, 1913, for Favrile Fabrique glass panels for lamp shades.

division at Corona was in full operation. It is quite possible that the Bryant company supplied some of Tiffany's metal lamp fixtures—at least the light sockets and switches. The Favrile glass parts on the lamps we examined were all signed "L. C. Tiffany/Favrile"—there were no numbers added after the signature.

Henry O. Schmidt also registered a design for a Pond Lily lamp, almost identical to one patented by Philip J. Handel of Meriden, Connecticut, in 1902. There was nothing in the patent papers about it being assigned to Tiffany, but this is quite possible. Schmidt was listed in the New Britain directories from 1912 to 1915 as a "designer." After 1915, his name no longer appeared in their records. We were unable to trace a connection between Schmidt and any other lamp manufacturer, and we cannot be certain that his lamp design was ever put into production by Tiffany or any other firm.

A design for a glass shade decorated with Queen Anne's Lace was patented by Louis C. Tiffany, February 3, 1914 (Fig. 141). From the patent illustration we surmise it was made of mold-blown glass, probably in frosted crystal or pastel colors. Another design for a lamp was patented by Mr. Tiffany on February 19, 1918 (Fig. 142). It is difficult to determine from the design drawing what flower was represented; it may have been a pond lily.

Shortly before the Tiffany Furnaces closed their doors in 1928, they

Figs. 140-141—*Left to right:* Leslie H. Nash's Design Patent No. 44,731 of Oct. 14, 1913, for a Favrile Fabrique candle-lamp shade. Louis C. Tiffany's Design Patent No. 45,205 of Feb. 3, 1914, for a Queen Anne's Lace lamp shade.

Fig. 142—*Left:* Louis C. Tiffany's Design Patent No. 51,800 of Feb. 19, 1918, for a flower form lamp.

Fig. 143—Vase of vitreous enamel on repoussé copper body; marked "L. C. Tiffany Favrile EL 68"; height 2½ inches. *Andrew Dickson White Museum of Art*

made lamp shades of copper wire screening, painted with designs in translucent and transparent enamels. The most beautiful, according to Jimmy Stewart, were those decorated with red roses, with green leaves and brown stems. We examined a shade of this description when we were in Leslie Nash's home several years ago. Until the lamp was lighted the shade seemed quite drab and uninteresting.

Vitreous Enamelwares

As the name implies, Tiffany's vitreous enamelwares were simply ground glass applied like paint to a metal body, and fired until the enamel vitrified (melted) and fused to the surface of the metal (Figs. 143-153). In this ware, everything from small cigarette boxes to elevator doors was made at the Tiffany Furnaces. Some of the objects were handsomely etched and engraved to highlight their designs.

Miss Julia Munson (now Mrs. Julia Sherman) was in charge of the Enamelling Department for several years. Working under her was Patty Gay, an exceptionally fine artist. Jimmy Stewart's sister, Florence (Florie) Stewart, and his sister-in-law, Margaret Smith, also worked under Miss Munson's direction after serving their apprenticeship. When the Enamelling Department was first established, Mr. Tiffany

Fig. 144—Decorative objects for home use from Tiffany's catalog of glass and enamel wares, ca. 1920.

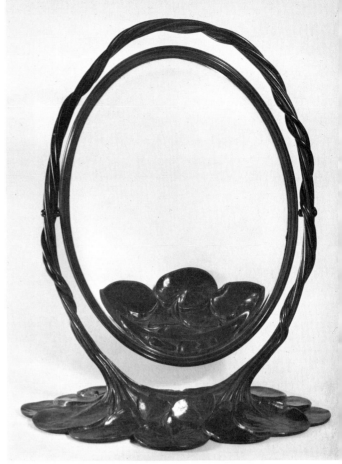

Figs. 145-146—*Left to right:* Bronze mirror with bevelled glass; frame surrounded by small leaves set with blue lustred glass; back and foot decorated with peacock feathers and lustred glass inserts; marked "Tiffany Studios / New York" and "T.G. & D. Co."; height 16 inches. *Author's collection.* Gentleman's bronze mirror with bevelled glass; lily-pad design in base; marked "Tiffany Studios / New York"; height 20 inches. *Collection J. Jonathan Joseph*

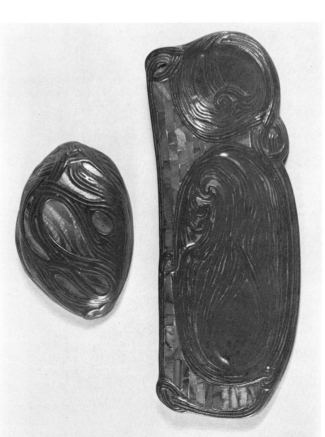

Fig. 147—Paperweight of bronze and lustred glass; marked "Tiffany Studios / New York." Pen tray of bronze inlaid with lustred glass mosaic; marked "Tiffany Studios / New York"; length 7¾ inches. *Collection J. Jonathan Joseph*

Figs. 148-149—*Left to right:* Gilded metal footed compote (foot not shown), rim decorated with blue enamel roundels; marked "Louis C. Tiffany Furnaces, Inc. / Favrile / 506"; diameter 10½ inches; height 3½ inches. Gilded metal plate with rim decorated with brown enamel; marked "Tiffany Studios / New York / 1612 A"; diameter 10 inches. *Author's collection*

Figs. 150-151—*Left to right:* Gilded metal plate with geometric design around rim; marked "Tiffany Studios / New York / 1744"; diameter 9¾ inches. Gilded metal compote with roundels of Mother-of-Pearl shell set into the rim; marked "Tiffany Studios / New York / 1706"; height 3½ inches; diameter 6½ inches. *Author's collection*

Fig. 152—Gilded bronze vase with amethyst-colored enamel decoration on foot; marked "Louis C. Tiffany Furnaces, Inc. / Favrile / 166 A"; height 11 inches. *Author's collection*

Fig. 153—Gilded bronze vase with green and black enamel decoration on foot; marked "Louis C. Tiffany Furnaces, Inc. / Favrile / 171"; height 10 inches. *Author's collection*

purchased a large house adjoining the Tiffany Furnaces for a workshop, and it was used as such until the department moved to the studio in New York City.

The metal blanks for these enamelwares, made of hammered or spun copper, brass, and bronze, were produced at the Metalwares Division of the Tiffany Furnaces. Electro-depositing baths for gold, silver, nickel, brass, copper, and other metallic finishes were also located in Corona until they, too, were moved to the Tiffany Studios in New York City.

Favrile Pottery

Art pottery was made at the Tiffany factory for only a short while, presumably because efforts to produce distinctive designs entailed too much time and labor.

Plaster-of-Paris molds for natural subjects, such as flowers and foliage, were produced from living models that were sprayed with shellac until they were rigid, then electroplated with copper before being made into the plaster molds. Some pieces of Tiffany pottery were copied from ancient specimens of tooled leather, American Indian pottery, ancient bronzes, and forms of marine life, such as octopi, seaweed, and coral growths. Each piece is incised with the initials, "L.C.T.," in a cipher in the base of the object (Figs. 154-156).

Most of Tiffany's pottery is found in muted green and buff-colored glaze or unglazed in a putty color.

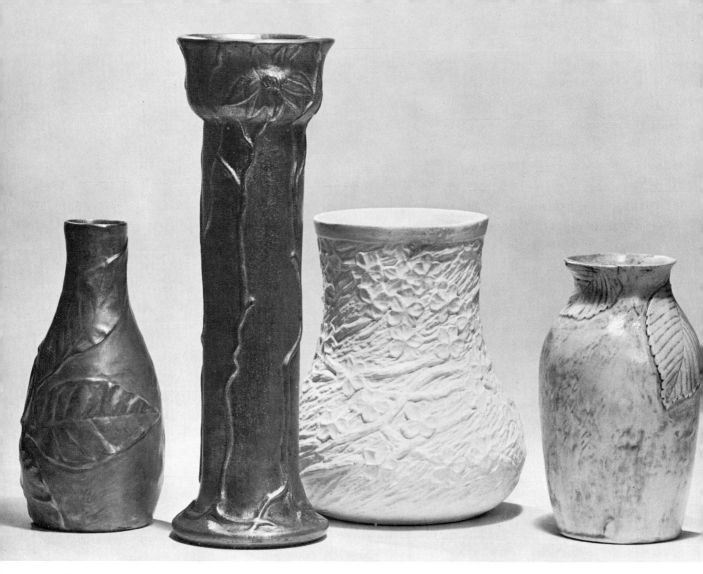

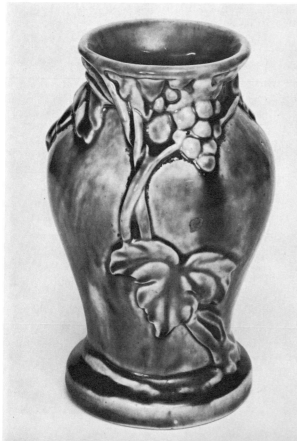

Fig. 154—A group of Favrile Pottery vases. *Left to right:* Gold lustre glaze with relief design of large leaves; "L.C.T." cipher mark in base. "Bronze Pottery" with silver-plated copper exterior and mottled green glazed interior; relief decoration of flowers, leaves, and vines; "L.C.T." cipher mark and "L.C.Tiffany / Favrile / Bronze Pottery / B.P. 313" impressed in copper base; height 8¼ inches. Unglazed buff-colored pottery with molded-relief decoration of flowers, leaves, and vines; "L.C.T." cipher mark in base; height 5⅛ inches. Buff and tan glaze with molded-relief decoration of leaves; "L.C.T." cipher in base; height 4¾ inches. *Collection Mr. & Mrs. R. L. Suppes*

Fig. 155—Mottled green and yellow glazed pottery vase; incised "LCT" in base; height 5 inches. *Author's collection; ex-coll. Arthur E. Saunders*

We have also seen these wares in dark blue, green, and reddish-brown. Even though Tiffany's production of art pottery was limited, there is no reason to believe it was not made in other colors, too.

Evidently Tiffany pottery was not very popular—at least not in the beginning. Jimmy Stewart told us that a good deal of the pottery was put out of sight whenever Mr. Tiffany was expected to visit the factory—they did not want him to know how little demand there was for these wares.

Marks and Outlets for Tiffany Glass

The only satisfactory explanation of the numbers and letters found on many pieces of Tiffany glass was given to us by Jimmy Stewart.

According to Mr. Stewart, the glass made at the factory was stored in their stockroom, unmarked, until it was sent out to various outlets at home and abroad. Before a piece of glass left the factory, it was sent from the stockroom to the Cutting Department where the identifying signature, letters, and numerals were engraved on the object.

Most articles were signed either with Mr. Tiffany's initials, "L.C.T.," "L. C. Tiffany/Favrile," "Louis C. Tiffany/Favrile," or a combination of the above signatures, with letters and numbers. The fine art wares were almost always given the distinction of a full signature. The numbers represented the stock inventory numbers; the letters identified the outlets to which they were sent on consignment.

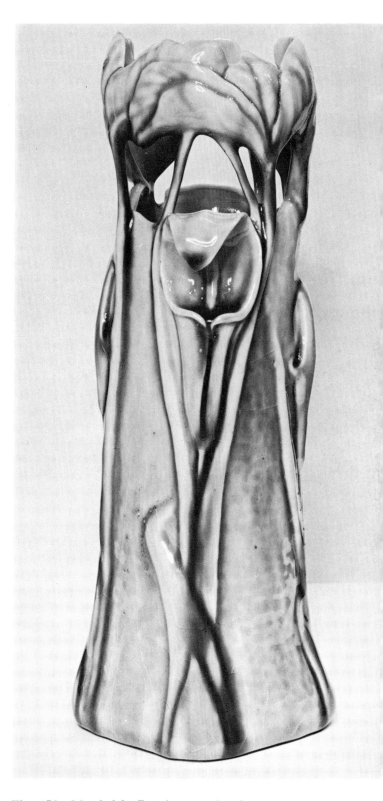

Fig. 156—Mottled buff and green glazed pottery vase; incised "LCT" in base; calla lilies and leaves in relief; height 13 inches. *Author's collection; ex-coll. A. Douglas Nash*

Occasionally two different sets of letter and number marks are found on a Tiffany piece, indicating that it had been sent out to more than one retailer before it was finally sold.

According to Jimmy Stewart, the inventory numbers ran consecutively. Because of this, articles that had remained in stock for a period of months, or even years, before being shipped out on order would bear numbers dating far beyond the actual time of their manufacture. The position of the retailer's code letter was left to the discretion of the engraver and could either precede or follow the inventory number. Consequently, this feature, too, has little or no meaning when we try to apply it as a means for dating Tiffany glass objects.

Mr. Stewart's explanation of the Tiffany marks seems almost conclusively verified by the fact that an identical pair of Gold Lustre vases, once owned by the author, were marked "8331 H" and "8332 H," while another vase we examined of exactly the same form, size, and color was marked "8677 L."

There were some exceptions to the code marks used by the Tiffany glassworks. Objects which Mr. Tiffany took for his private collection are sometimes marked "A Col" (collection). Exhibition pieces were marked as such, and a few of these have the name of the exhibition added to the other marks engraved on the base.

Each piece of Tiffany glass was sent out on consignment only; it remained the property of the Tiffany Furnaces until it was sold to a retail customer. This enabled Mr. Tiffany to recall any item he wished returned, and prevented the retailer from selling a piece under the stipulated price set on it by Tiffany. If a piece of glass failed to sell after being shown at a retail outlet for a period of three months, it was automatically returned to the factory and put back into stock. Should an article not sell after having been shown at three retail outlets, it was either sold to an employee at a discount, given to a friend, or destroyed—all in accordance with Mr. Tiffany's explicit instructions for the disposition of unsold wares. In many instances the price asked for a piece of Tiffany glass was more than a retail customer cared to pay. We can only guess how many thousands of dollars worth of Tiffany glass was destroyed simply because it had not sold readily.

In the case of pottery and metalware (including leaded shades and windows), various trade names, trademarks, and design numbers were incised in the paste or punched into the metal. Designers and decorators often scratched or stamped their initials into metalwares with a sharp tool. A lamp in the author's collection has the initials "W.W." scratched in the base, probably done by William Winters, a designer-decorator at the Tiffany Studios in New York City (see Fig. 131). A bronze mirror decorated with

embossed peacock feathers and inlaid with lustred glass (see Fig. 145) has the cipher of an unidentified designer punched into the back of the metal frame.

Original paper labels, bearing one of Tiffany's registered trademarks, found occasionally on some objects give us some indication of the period in which the pieces were manufactured. But here, too, it should be remembered that these paper labels, like the stock numbers, were not affixed to an article until it left the factory. This could have been a long time after it was actually made.

A trademark for decorative glass consisting of the firm's initials, "T.G.D.Co." within a circlet (see Fig. 157) was issued to the Tiffany Glass & Decorating Company on November 13, 1894. This mark can sometimes be found handsomely engraved in the base of Tiffany glass pieces, but usually white paper labels with the mark printed in black ink were affixed to these early Tiffany productions. According to the trademark papers, the Tiffany Glass & Decorating Company had been using this mark on their wares since February 1892. Prior to that date, simple labels, reading "Tiffany Fabrile Glass" were employed. The term "Fabrile" was later changed to "Favrile"; both mean "handmade."

On February 9, 1904, after the name of the company had been changed to Tiffany Furnaces, another trademark was registered, a monogram of the letters "L.C.T."

Favrilefabrique

Fig. 157—Three Tiffany trademarks. *Top to bottom:* Tiffany Glass & Decorating Company; trademark registered Nov. 13, 1894. Tiffany Furnaces (for decorative glassware); trademark registered Feb. 9, 1904. Tiffany Furnaces (for glass panels for lamp shades); trademark registered June 23, 1914.

and the word "Favrile." This mark is found on paper labels printed in black ink on white or in gold on a green ground. Later, when it was decided to use this monogram on other wares produced by the firm, the trademark was registered again to

cover enamelwares, metalwares, and pottery. The date of this re-registry was September 12, 1905. This trademark was again reissued on December 23, 1919, and on May 25, 1920; it was continued in use until the firm closed.

The trade names "Tiffany" and "Tiffany & Co." were registered by Tiffany & Company, the jewelry firm, on August 31, 1920. Though the papers stated it was to be used on "table-glassware," we believe it was meant for glassware purchased from other sources and sold at the Tiffany store in New York City.

There were not many retail outlets in America for Tiffany's glass, and only quality shops were chosen for their distribution, such as Caldwell & Sons, Philadelphia, Pennsylvania; Marshall Field & Company, Chicago, Illinois; and Shreve, Crump & Lowe, Boston,

Massachusetts. In New York City, it was sold exclusively at Tiffany & Company. For a while a salesman distributed Tiffany wares in the Far West, calling on fine specialty shops and jewelry stores. Because of the distance involved, it was difficult for Mr. Tiffany to control his prices and the special requirements he stipulated for the display and sale of his products, so the distribution and sale of Tiffany wares on the West Coast was curtailed, only a few tested and reliable outlets being retained.

Tiffany's overseas sales were not great because of the import duty imposed on foreign glass by European countries. Exhibitions of his wares were held in several large cities on the Continent, and some of the objects exhibited were either sold there at cost or given to museums rather than risk transporting them back to America.

A. DOUGLAS NASH CORPORATION

SHORTLY after the Tiffany Furnaces closed, A. Douglas Nash purchased the Corona glassworks from Louis C. Tiffany and established himself in the business under the style of A. DOUGLAS NASH ASSOCIATES. Although the sale of the glassworks to A. Douglas Nash was a friendly transaction, Mr. Tiffany stipulated that his name was not to be associated with the company or its productions.

Corporation papers were filed in December, 1928; the name of the firm appeared in that instrument as the A. DOUGLAS NASH CORPORATION. Besides A. Douglas Nash and his father Arthur J. Nash, the following stockholders were listed, most of them Douglas Nash's close friends: William J. Neal, Elmer W. Sellstrom, Samuel D. Jones, Paul S. Van Bloem, and Morris L. Willets.

Douglas's brother, Leslie Nash, had opened his own factory in Woodside, Long Island, producing metalwares and decorated glassware, using undecorated blanks supplied by another glass factory, and was not connected in any way with the A. Douglas Nash Corporation.

Douglas Nash was president, general manager, and designer for the new corporation. Arthur Higgins, formerly a bookkeeper for the Tiffany Furnaces, was employed as a salesman. Douglas's son, Donald Nash, was in charge of their showroom at 101 Fifth Avenue, New York City.

We learned from Donald Nash

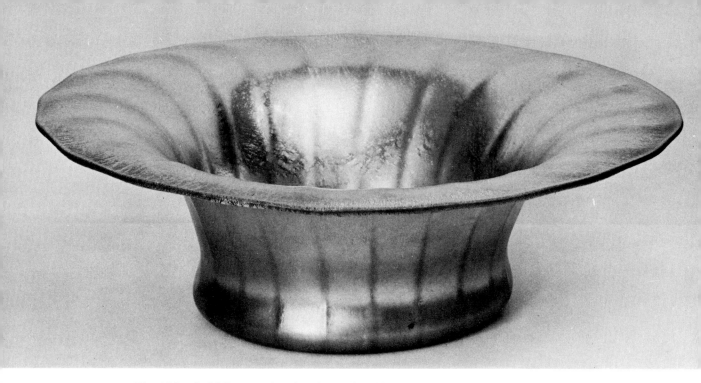

Fig. 158—Gold Lustre glass bowl, Optic Rib pattern; signed "174 Nash"; diameter 16 inches. *Author's collection; ex-coll. A. Douglas Nash*

that Tiffany & Company sold a great deal of his father's art glass from their Fifth Avenue store. Ovington's in New York City, Caldwell & Sons in Philadelphia, and Marshall Field & Company in Chicago were other substantial outlets for Nash glass. West Coast sales were handled for the firm by a salesman who went about with two trunks full of samples, selling exclusively to specialty shops and jewelry stores.

Initially only one shop was making art glass at the Nash factory; Jimmy Stewart, from the old Tiffany Furnaces, was the gaffer. After eight or nine months, August LeFevre came to work as a second gaffer. Even then, there were never two complete shops operating simultaneously; the men who helped the two gaffers—gatherers, decorators, and so on—would go from one to the other as they were needed.

Identification marks, letters, and numbers were engraved on Nash glass at the time the pontil marks were ground smooth in the cutting shop (Figs. 158-162). At first, the initials "A.D.N.A." were used; after the firm was incorporated, the mark was changed to "Nash." Letters usually referred to the color of the object, and numerals to its size.

The A. Douglas Nash Corporation failed in 1931. In March, 1932, Douglas Nash moved to Toledo, Ohio, where he worked for the Libbey Glass Manufacturing Company (now Owens-Illinois Glass Company) as advisor, designer, and technician.

Nash designed some beautiful colored and engraved glassware for Libbey that was shown at a special exhibition at the Waldorf Astoria Hotel in New York City. The guest list was restricted to people in the art

94

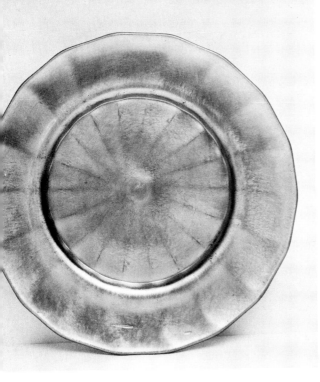
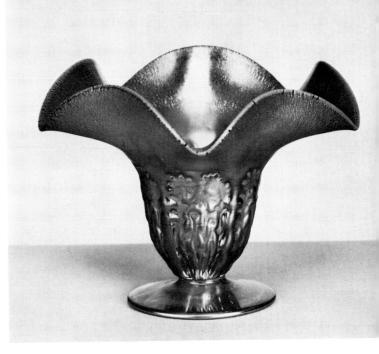

Figs. 159-160—*Left to right:* Gold Lustre glass plate, "Optic Rib" pattern; signed "112 Nash"; diameter 8 inches. Blue Lustre glass vase, optic leaf-shaped design on lower part of body; signed "Nash"; height 5 inches. *Author's collection; ex-coll. A. Douglas Nash*

Figs. 161-162—*Left to right:* Gold Lustre glass vase, optic leaf-shaped design on lower part of body; signed "549 Nash"; height 6 inches. Blue Lustre glass vase with purple and gold lustre "Damascene" decoration; signed "Corona" (an early mark of the A. Douglas Nash Corporation); height 3½ inches. *Author's collection*

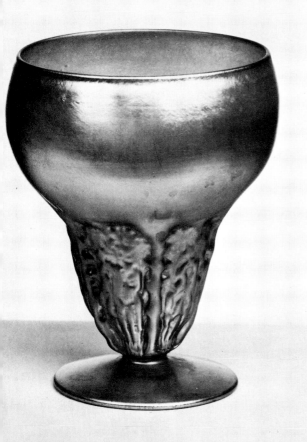
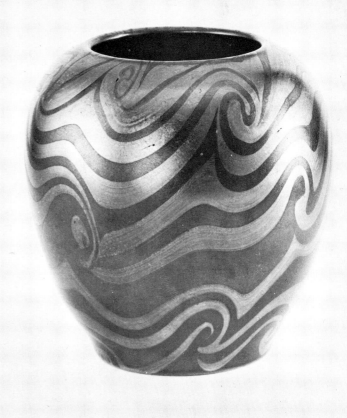

Fig. 163—Design Patent illustration of a pitcher assigned to the Libbey Glass Co. by A. Douglas Nash, November 8, 1932.

Fig. 164—Design Patent illustration for footed "Glass Container" ("Syncopation") assigned by A. Douglas Nash to the Libbey Glass Co., April 25, 1933.

world; no one from the wholesale or retail trade was invited. The exhibition was a huge success, but Nash's designs were too lavish and too expensive to produce at that time. The Depression had already taken its toll of the nation's economy, and few people could then afford fine glass.

Also for the Libbey Glass Manufacturing Company, Douglas Nash registered two designs: the first was for a pitcher with a combination optic and molded pattern (Fig. 163); the second, obviously influenced by the phase of post-impressionism known as "Cubism," was for a "glass container." The date on this second design patent was April 25, 1933 (Fig. 164).

After leaving Libbey in 1935, he was listed as being an employee of Lamson Brothers Department Store in Toledo, Ohio. In the latter part of 1935, Nash went to Pittsburgh, Pennsylvania. There he did experimental work and designing, though not in art glass, for the Macbeth Glass Company of Charleroi, Pa., and also worked for the Pittsburgh Plate Glass Company, where he developed a machine for rolling color on clear plate glass. In 1939, Nash returned to New York City, and died there a year later.

Chintz Glass

Chintz glass was one of the most popular wares made by the A. Douglas Nash Corporation. Nash had initially developed it at the Tiffany Furnaces, but Louis Tiffany

96

did not seem to like it, and it was never put into production. When the first piece was made at the Nash factory, Douglas Nash brought it home for a "family inspection." Mrs. Nash told us that one of the younger members of her brood remarked that it "looked like chintz." Then and there, Nash decided on "Chintz" as the appropriate name for his creation.

The manufacturing process for Chintz glass was not patented until March 27, 1934, at which time Nash was employed by the Libbey Glass Manufacturing Company (Fig. 165). Though the patent was assigned to Libbey, we have been assured by the Patent Department of Owens-Illinois Glass Company that the ware was never put into production because Libbey found it too expensive to produce. The few pieces Libbey made for experimental purposes are now

Fig. 165—Patent drawings for A. Douglas Nash's Chintz glass process. The illustrations show the various stages of production from the initial blow (Fig. 1) to the completed article, a plate (Fig. 9). Fig. 2 is the mold in an open position; Fig. 3 is the pattern-molded parison; Fig. 4 the process of rolling the ribbed parison over a marver covered with colored powdered glass; Fig. 5 the decorated parison; Fig. 6 a portion of another mold for producing the fine line decoration; Fig. 7 the parison with its completed decoration; and Fig. 8 the plate (the dotted lines show the form of the plate before it was twirled into its flattened shape. Figs. 10, 11, and 12 show two pattern molds for leaves and flowers and the parison decorated with these designs in colored powdered glass.

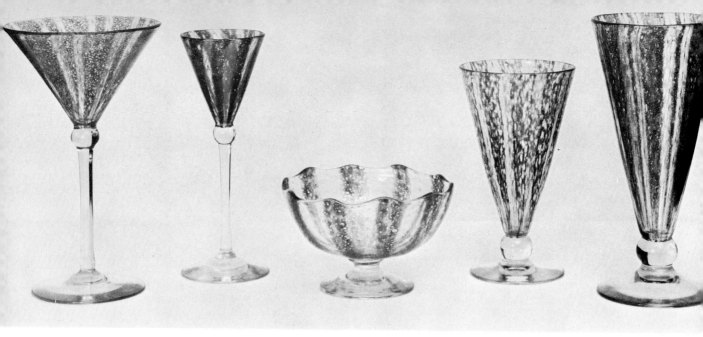

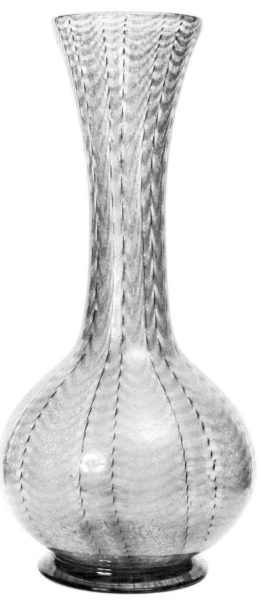

Fig. 166—Stemware of blue and brown striped Chintz glass; tall footed tumbler 7 inches high. *Author's collection; ex-coll. A. Douglas Nash*

Fig. 168—Chintz glass vase, green and blue stripes; "Nash"; height 20 inches. *Author's collection; ex-coll. A. Douglas Nash*

Fig. 167—Chintz glass covered box, blue and brown stripes; diameter 4½ inches. *Author's collection; ex-coll. A. Douglas Nash*

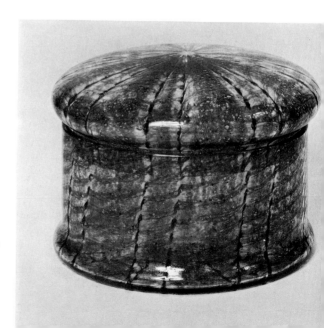

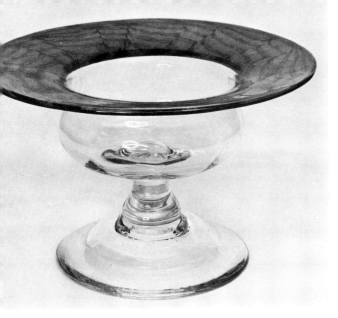

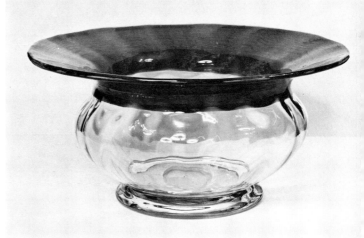

Figs. 169-170—*Left to right:* Compote of light green flint glass, with wide rim of red and gray striped Chintz decoration; diameter 8 inches. Bowl of light green flint glass, with rim of red and gray striped Chintz decoration; diameter 11 inches. *Author's collection; ex-coll. A. Douglas Nash*

Fig. 172—Lustred Chintz glass vase; signed "GD 57-Nash"; height 13 inches. *Author's collection; ex-coll. A. Douglas Nash*

Fig. 171—Candlestick of light green flint glass, bobeche decorated with red and gray Chintz glass; height 5 inches. *Author's collection; ex-coll. A. Douglas Nash*

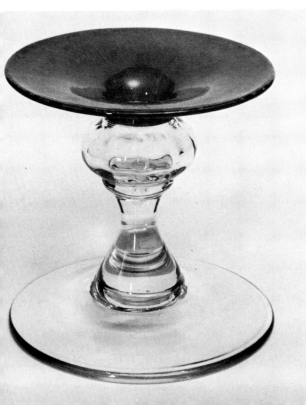

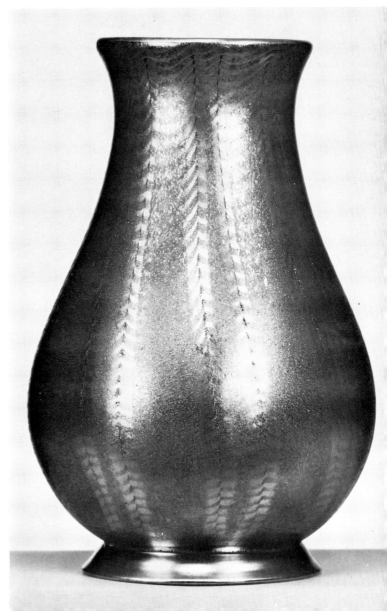

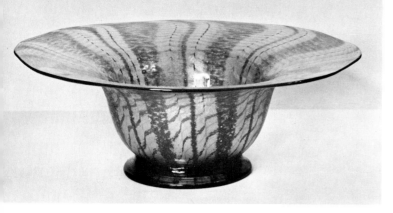

Fig. 173—Footed bowl of gold lustred Chintz glass; diameter 12 inches. *Author's collection, ex-coll. A. Douglas Nash*

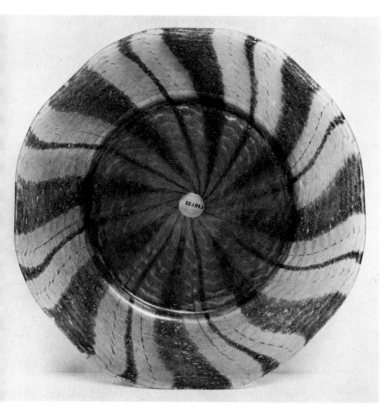

Fig. 174—Lustred Chintz glass plate; diameter 11 inches. *Author's collection; ex-coll. A. Douglas Nash*

in the Toledo Museum of Art, along with several other pieces of Libbey glass designed by Nash.

Chintz glass was made by blowing a gather of glass into a mold with

intaglio configurations in the form of stripes, or ribs. The pattern-molded gather was rolled over a marver covered with powdered glass after each molding, resulting in a multi-colored pattern of alternating broad and fine stripes (Figs. 166-178). Nash indicated in his patent that floral designs could also be made in this manner, but we have been told by his family that no such wares were produced.

Jimmy Stewart, the gaffer at the Nash factory, said that they experienced a great deal of difficulty in making Chintz glass; it was hard to keep the shape of the object because the glass was too soft, and the applied colors often ran together while the object was being reheated and shaped at the glory hole.

Chintz glass was made in a variety of colors—green, blue, lavender, and a dusty rose color which Nash called "Rose Petal." For backgrounds, transparent Aquamarine glass, opalescent glass, opaque, or transparent colored glass was used. A few pieces were lustred gold or blue. Some variations were called "Sprayed Glass" because they appeared to have been sprayed with color, though they were not actually made in that way (Fig. 179).

Unfortunately for Nash, Chintz glass was overshadowed by Steuben's "Cintra" glass, and both suffered from a cheap imitation made in Czechoslovakia. Eventually Cintra and Chintz were taken off the market, neither one able to meet Czechoslovakian competition.

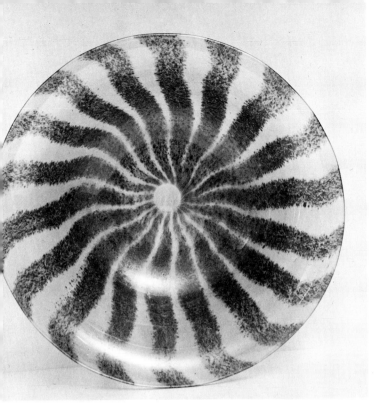

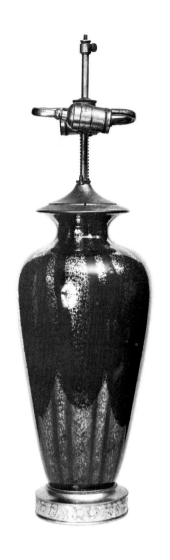

Figs. 175-176—*Left to right:* Chintz glass bowl, silver lustre stripes; signed "Nash"; diameter 8 inches. *Author's collection; ex-coll. A. Douglas Nash.* Chintz glass lamp; vase of opaque dark red glass with silver lustre stripes; height to top of lamp vase 24 inches. *Author's collection*

Fig. 177—Chintz glass bowl-vase, opal and brown stripes; signed "Nash"; height 5 inches. *Author's collection; ex-coll. A. Douglas Nash*

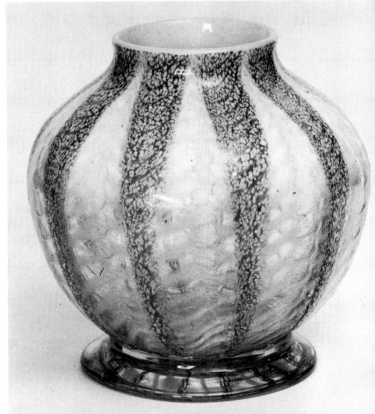

101

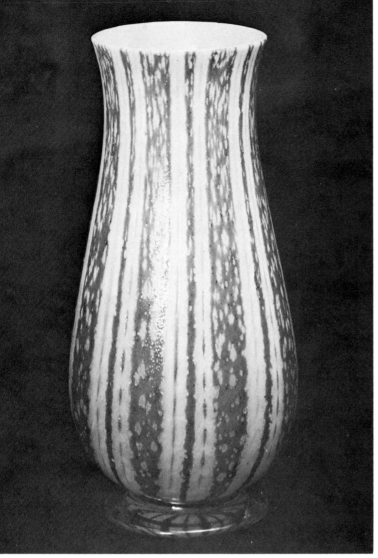

Grotto," "Smoke," and "Trylon."

The "Amethyst" wares shaded from pale citron to rose to blue, and had handsome reeded stems (Fig. 180).

"Banded" wares were decorated about the rim of each piece with a broad band of green, blue, amber, or rose. The stem in this line was slightly twisted where it joined the bowl of the drinking glass (Figs. 181-182).

"Beryl" was a pinkish-amber color, produced with a dilute nitrate of

Fig. 179—Sprayed Chintz glass vase, light and dark green stripes on opal body, Optic Rib pattern; height 7 inches. *Author's collection; ex-coll. A. Douglas Nash*

Fig. 178—Chintz glass vase, opal and orange stripes; signed "Nash"; height 8 inches. *Author's collection; ex-coll. A. Douglas Nash*

Tinted Glassware

Delicately tinted tablewares were produced by the A. Douglas Nash Corporation using transparent mineral stains applied to pattern-molded crystal blanks. The articles were run through a lehr for almost a week to set the stain permanently to the surface of the glass. Each color was given a specific name —"Amethyst" (also called "Alexandrite"), "Banded," "Beryl," "Blue

A. Douglas Nash Corporation

Fig. 180—Amethyst ring jug, handle and foot of amber-tinted crystal glass; signed "29 Nash"; height 12 inches. *Author's collection; ex-coll. A. Douglas Nash*

Fig. 181—Banded stemware; water goblet 7 inches tall. *Author's collection; ex-coll. A. Douglas Nash*

Fig. 182—Banded finger bowl and tumbler; signed "204 Nash"; tumbler 6 inches tall. *Author's collection; ex-coll. A. Douglas Nash*

Fig. 183—*Far left:* Trylon cocktail glass. *Other pieces:* Beryl stemware; height of Pilsner glass 9 inches. *Author's collection; ex-coll. A. Douglas Nash*

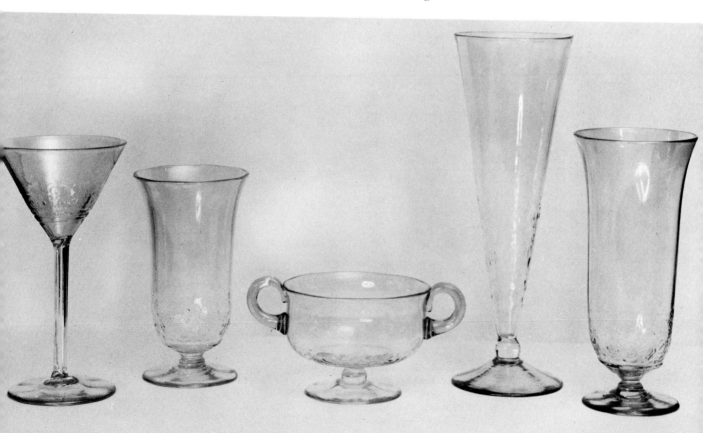

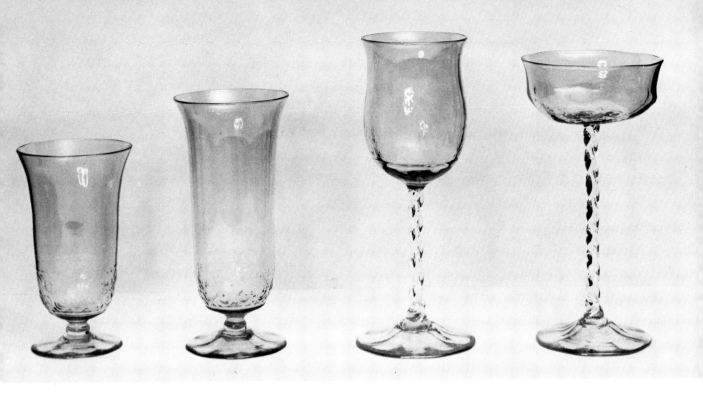

Fig. 184—Blue Grotto stemware; champagne glass 8 inches high. *Author's collection; ex-coll. A. Douglas Nash*

silver. Light blue handles are to be found on some of the pieces in this line (Fig. 183).

"Blue Grotto" was a bicolored ware, shading from greenish blue to light amber. Stems for goblets, wines, and cordials were twisted from top to bottom (Fig. 184).

"Smoke" shaded from light citron to a grayish-yellow. Goblets, wines, and cordials had reeded stems (Figs. 185-187).

The name "Trylon" was derived from the three-sided stem used for this line of tableware (Fig. 183). The bowl and foot of a cocktail glass from the A. Douglas Nash collection was tinted a topaz color; but Trylon may have been produced in other colors, too.

Bubbly Glass

Experiments with Bubbly glass had been carried on at the Tiffany Furnaces some time before that factory closed. A few experimental pieces were made, but they did not please Mr. Tiffany and the idea was put aside. When Douglas Nash was manufacturing glass himself, he revived the technique and put Bubbly glass on the market.

To produce the bubbled effect a potato, or sometimes a small willow-tree branch, was thrown into a pot of glass after the impurities had been skimmed off the top. This simple procedure effected a bubbly condition throughout the metal (Figs. 188-190).

In many instances Nash's Bubbly glass looks like Steuben's Cluthra—splashed with colors and full of bubbles of various sizes. Innovations were produced with colored patterns within the glass, and some pieces were pattern-molded with optic designs.

105

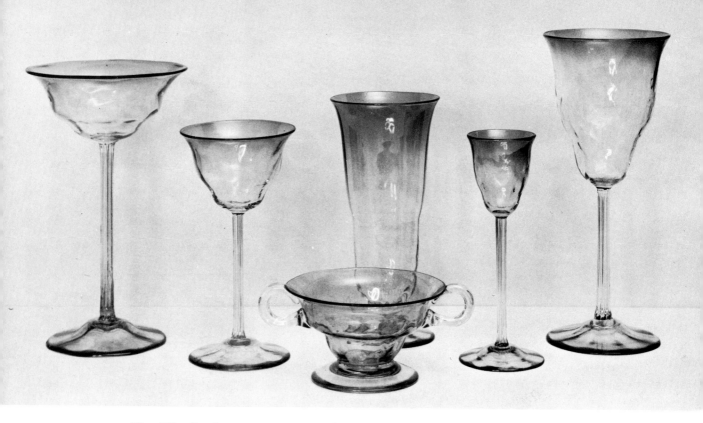

Fig. 185—Smoke stemware, some pieces signed "Nash"; water goblet 8 inches tall. *Author's collection; ex-coll. A. Douglas Nash*

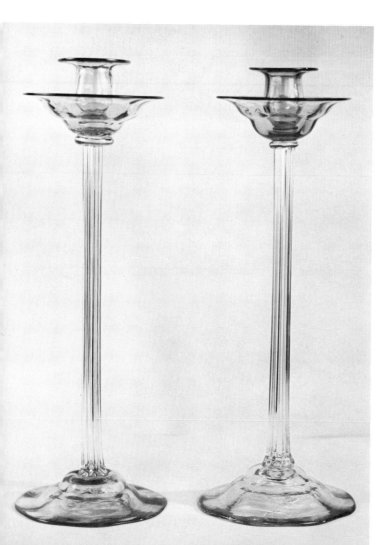

Fig. 186—Pair of Smoke candlesticks; signed "141 Nash"; height 13 inches. *Collection Ralph Anderson*

Fig. 187—Shaded green to crystal footed nut dish; height 2½ inches. *Author's collection; ex-coll. A. Douglas Nash*

Fig. 188—Bubbly glass vase, mottled plum, yellow, and brown on opalescent body; height 7 inches. *Collection Richard Cole*

Fig. 189—Bubbly glass vase, mottled purple, blue, and ruby on alabaster-colored opaline body; height 10 inches. *Author's collection*

Steuben's Cluthra, and a cheap Czechoslovakian copy undersold Nash's Bubbly glass and it was taken out of production soon after it was introduced.

Single- and Double-Ring Glassware

Some of the most unusual pieces of glass produced at the A. Douglas Nash factory were single- and double-ring ewers (Fig. 191) and decanters. The idea for such pieces has an ancient origin in pottery, but to produce the same effect in glass was difficult. After a ball of glass had been formed, it was flattened on two sides; the center was then depressed and cut through. The technique is simple to explain; to accomplish the desired results was not easy. It was a process that required great skill. Single- and double-ring articles were made in a variety of glasses, including Chintz.

Fig. 190—Bubbly glass bowl-vase with "buried blue lattice" pattern in glass; signed "Nash"; height 6 inches. *Author's collection; ex-coll. A. Douglas Nash*

Fig. 191—Double-ring ewer, light amethyst body with crystal handle and foot; signed "30 Nash"; height 12 inches. *Author's collection; ex-coll. A. Douglas Nash*

"Silhouette" Pattern

Just before he closed his glass factory in Corona, Long Island, Douglas Nash designed a new tableware set that he called "Silhouette." In this suite, crystal bowls and feet were joined by a pressed animal-form stem in jet black glass. Mrs. Nash told us that the molds were made in a mold shop in Brooklyn, New York.

When we interviewed Donald Nash, Douglas's son, he said that the Silhouette pattern was never produced for the A. Douglas Nash Corporation, but that his father did make this new line at the Libbey

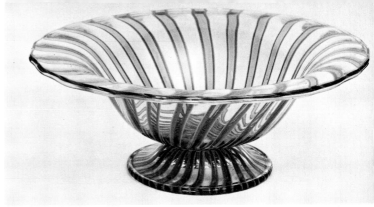

Fig. 193—Flint-glass footed bowl with lavender and green stripes; Mirror Lustre finish; signed "Nash"; A. Douglas Nash Corp., ca. 1930; diameter 11 inches. *Author's collection; ex-coll. A. Douglas Nash*

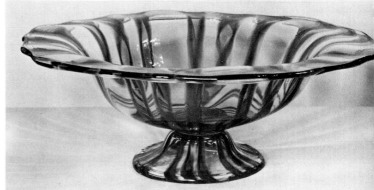

Fig. 192—"Silhouette" cordial, black bear stem with crystal bowl and foot; A. Douglas Nash Corp., ca. 1930; height 3 inches. *Author's collection; ex-coll. A. Douglas Nash*

Fig. 194—Flint-glass footed bowl with twisted green and lavender stripes; Mirror Lustre finish; signed "Nash"; diameter 12 inches. *Author's collection; ex-coll. A. Douglas Nash*

Fig. 195—Flint-glass bowl with selenium-red stripes; A. Douglas Nash Corp., ca. 1930; diameter 11 inches. *Author's collection; ex-coll. A. Douglas Nash*

Fig. 196—Footed opalescent-green bowl, Optic Leaf pattern, Fairy Lustre; signed "Nash"; diameter 8 inches. *Author's collection; ex-coll. A. Douglas Nash*

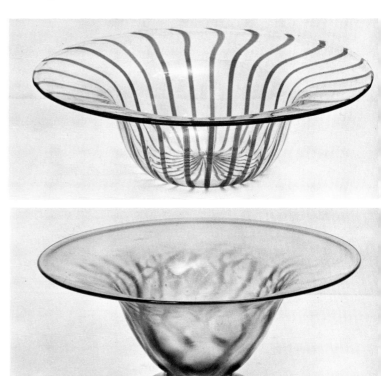

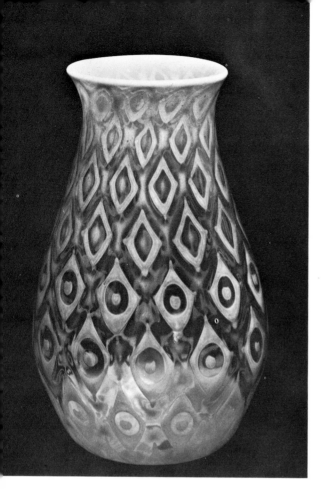

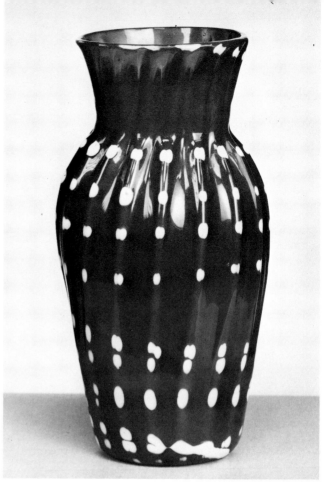

Figs. 197-198—*Left to right:* Opalescent Diamond Optic vase; signed "Nash"; height 6½ inches. *Author's collection; ex-coll. A. Douglas Nash.* Opaque red vase with opal dots, Optic Rib pattern; signed "G D 154 Nash" height 9 inches. *Author's collection*

Fig. 200—Moravignian vase, crystal with ruby decorations; Libbey Glass Co., ca. 1932; height 10 inches. *Author's collection*

Fig. 199—Chrome-green Aventurine footed bowl; A. Douglas Nash Corp., ca. 1930; diameter 6 inches. *Author's collection; ex-coll. A. Douglas Nash*

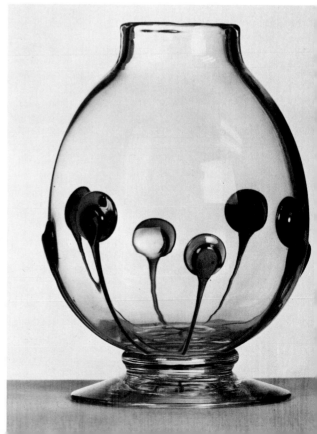

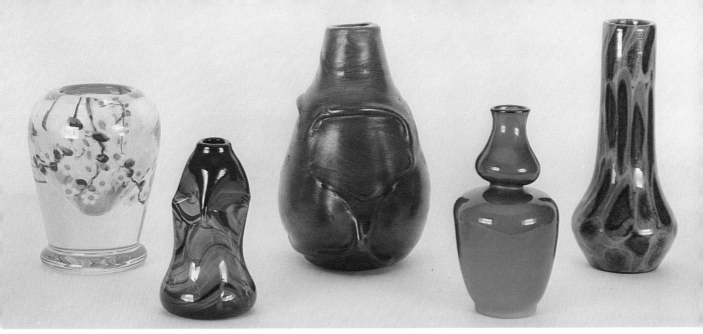

Left to right: Aquamarine vase decorated with dogwood blossoms; signed "Louis C. Tiffany / Favrile"; height 6½ inches *(ex-coll. Arthur Saunders).* Laminated (Agate) glass vase; signed "L.C.T."; purported to be the second piece of glass made at the Tiffany factory; height 5 inches *(ex-coll. Arthur J. & Leslie H. Nash).* Metallic glass vase; signed "L.C.Tiffany / Favrile / V 532"; height 9 inches. Tel El Amarna vase; signed "L.C.Tiffany / Favrile / 4015 N"; height 5 inches. Millefiori (Tessera) vase; signed "Louis C. Tiffany / Favrile"; height 9 inches *(ex-coll. Arthur Saunders).—Author's collection*

Left to right: Textured Lustre vase set with "Jewels"; signed "L.C.Tiffany / Favrile / 3532 P"; height 6 inches *(ex-coll. A. Douglas Nash).* Cypriote vase; signed "L.C.T."; height 3 inches *(ex-coll. Arthur J. & Leslie H. Nash).* Blue Lustre tree; one of a pair made for Tiffany's display window, Christmas, 1905; signed "Louis C. Tiffany / Favrile"; height 14 inches *(ex-coll. Arthur Saunders).* Miniature Cypriote bowl-vase; signed "Louis C. Tiffany"; height 1½ inches *(ex-coll. Arthur Saunders).* Lava glass pitcher; signed "Louis C. Tiffany / Favrile"; height 5 inches *(ex-coll. Arthur Saunders).* Gold Lustre vase with millefiori decoration; signed "L.C.T. / W 6694"; height 4½ inches *(ex-coll. Arthur Saunders).—Author's collection*

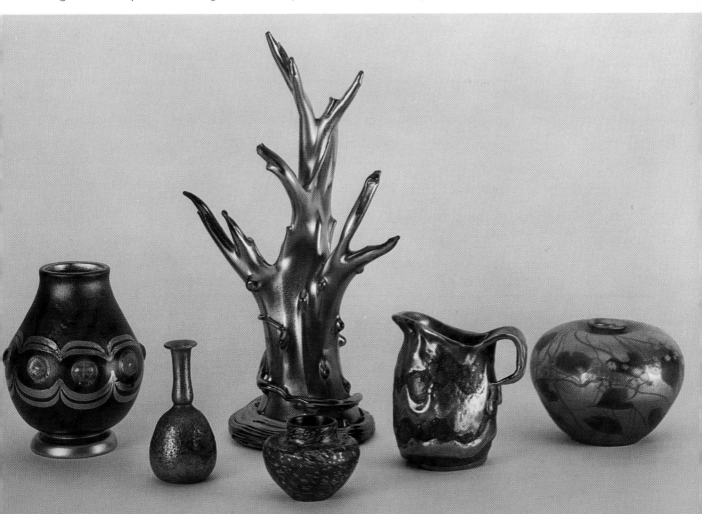

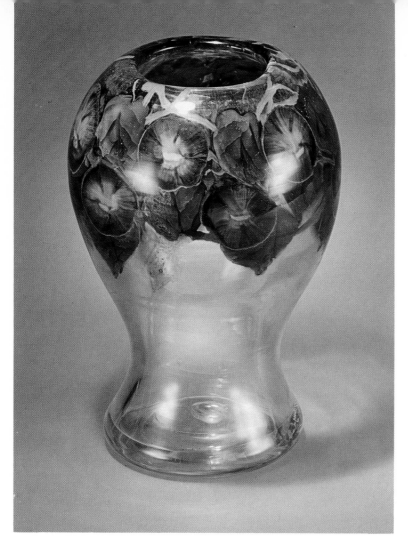

Morning-glory vase; signed "L.C.Tiffany / Favrile / 3309 J"; height 6½ inches.—*Author's collection; ex-coll. A. Douglas Nash*

Left to right: Cameo carved and lustre-decorated Chinese vase; signed "Louis C. Tiffany / Favrile / 353 J"; height 9 inches *(ex-coll. A. Douglas Nash)*. Blackened Agate glass vase with carved intaglio decoration; signed "L.C.T. / 3804"; original "T.G. & D.Co." label; height 3 inches *(ex-coll. A. Douglas Nash)*. Cameo-carved Agate glass vase; signed "L.C.Tiffany / Favrile / 276 D"; height 9 inches *(ex-coll. Arthur Saunders)*. Cameo-carved Opal glass pitcher with green lustre top; signed "L.C.Tiffany / Favrile / 3313 P"; height 6¼ inches *(ex-coll. A. Douglas Nash)*. Cameo-carved crystal vase with purple blossoms and green leaves; signed "L.C.Tiffany / Favrile / 2612 C"; height 9½ inches *(ex-coll. A. Douglas Nash)*.—*Author's collection*

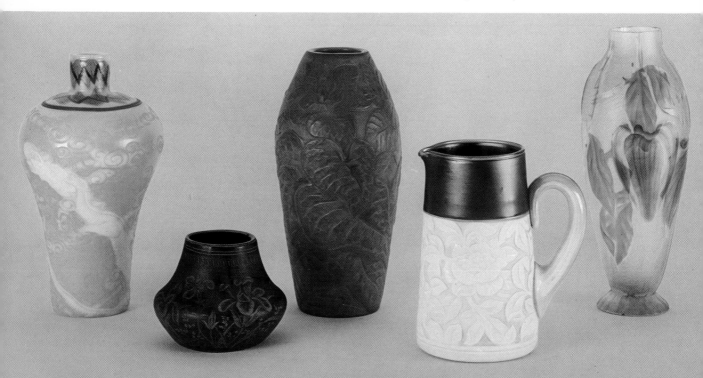

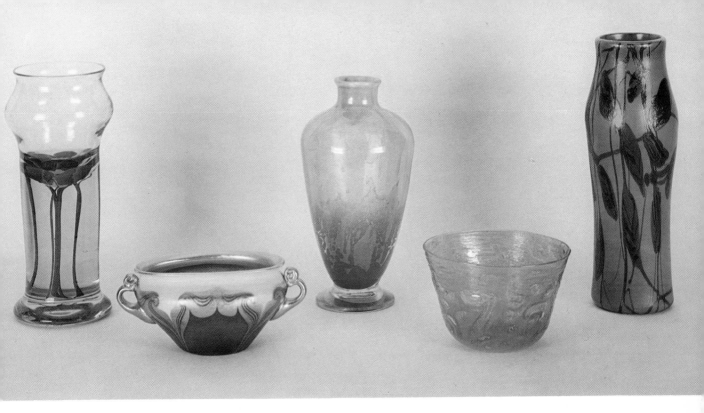

Left to right: Aquamarine vase with internal decoration of pond lilies; signed "Louis C. Tiffany / Favrile"; height 9 inches *(ex-coll. Arthur Saunders)*. Opal and blue glass bowl-vase with lustred decoration and lustred interior and handles; signed "L.C.Tiffany / Favrile / 3896 D"; height 3 inches *(ex-coll. Arthur Saunders)*. Shaded red to yellow vase with internal textured effect, flaked and chipped; signed "L.C.T. Exp." (Experimental); height 9 inches *(ex-coll. A. Douglas Nash)*. Green Bubbly glass bowl with wave and water optic pattern; signed "L.C.T. Exp" (Experimental); height 4 inches *(ex-coll. A. Douglas Nash)*. Yellow vase with red and black leaves and vines; signed "L.C.T. / T 8497"; height 10 inches.—*Author's collection*

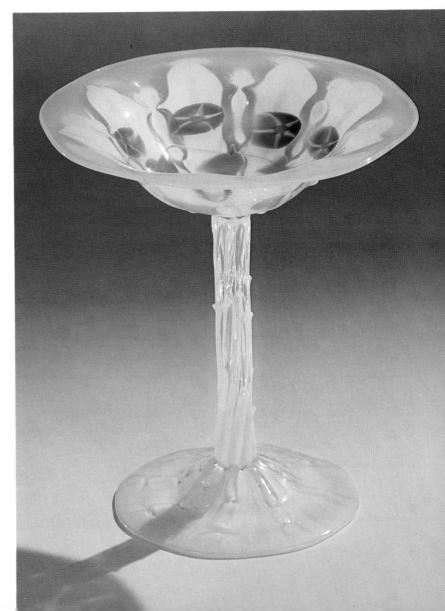

Opalescent Reactive glass compote, top decorated with blue morning-glories and green leaves and vine; signed "L.C.Tiffany / Favrile / 3007 P"; height 7⅜ inches.—*Author's collection*

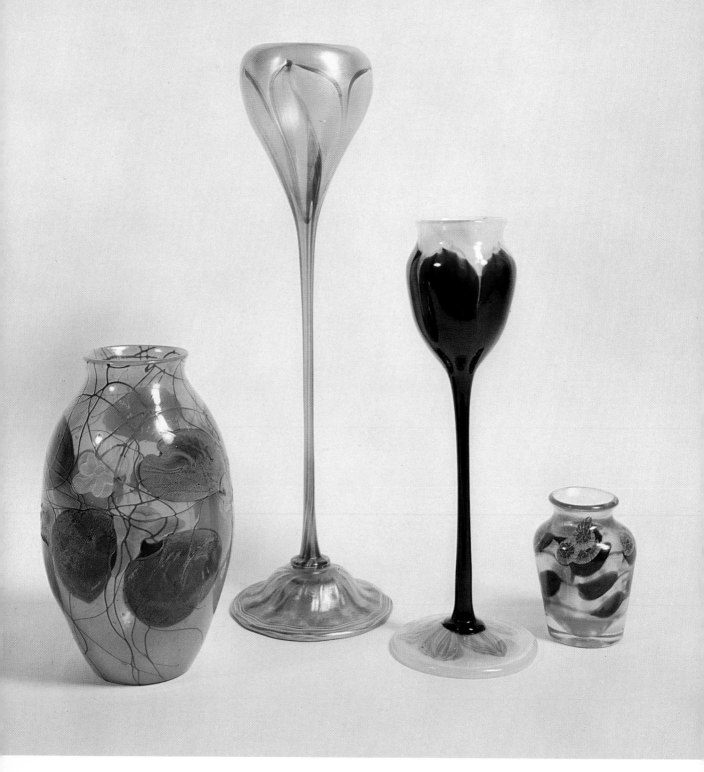

Left to right: Yellow Reactive glass vase with internal decoration of brown and green leaves; cameo-carved white and orange nasturtium blossoms; signed "L.C.Tiffany / Favrile / 845 A"; height 8½ inches. Amber flower form vase with red and white petals; signed "L.C.T. 8054"; height 16½ inches. Red and white flower form vase; signed "L.C.Tiffany / Favrile"; height 11½ inches. Aquamarine vase with pink and white millefiori blossoms and green leaves; internal lustre; signed "L.C.Tiffany / Favrile / 8145 D"; height 3¾ inches.—*Collection J. Jonathan Joseph*

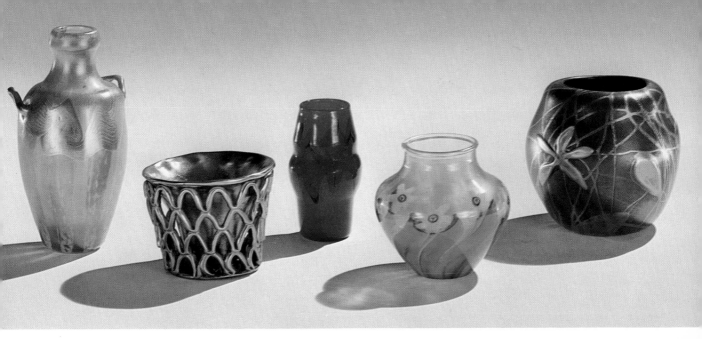

Left to right: Antique vase; olive-green colloidal stripes, lustre decoration; signed "o664" and with original Tiffany Glass & Decorating Company paper label on base; height 6½ inches. Cage cup of Blue Lustre glass; height 3⅛ inches *(ex-coll. Arthur Saunders)*. Samian Red vase with black and gray decoration; signed "L.C.T. / E 2228"; with original Tiffany Glass & Decorating Company label on base; height 4 inches. Opaque dark brown vase with flower and leaf decoration in gold lustre; signed "L.C.T. / Q 9473"; height 4⅛ inches.— *Author's collection*

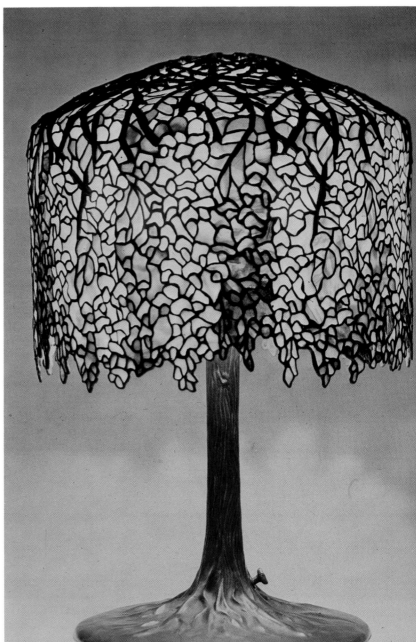

Wisteria lamp; marked "Tiffany Studios / New York"; height 27 inches.—*Collection J. Jonathan Joseph*

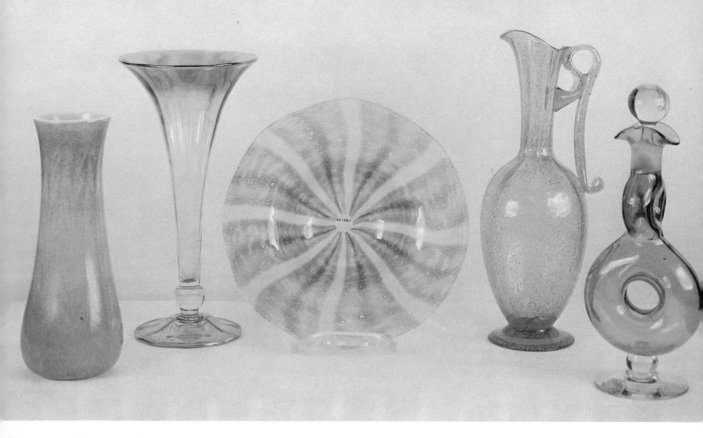

Left to right: Sprayed rose and green Chintz vase; signed "Nash"; height 8 inches. Mirror Lustre vase; signed "Nash"; height 10 inches. Rose petal Chintz bowl; signed "Nash"; diameter 7 inches. Blue Bubbly glass ewer; signed "Nash"; height 11 inches. Green and crystal double-ring decanter; signed "Nash"; height 9 inches.—*Author's collection; ex-coll. A. Douglas Nash*

Left to right: Alexandrite goblet. Smoke cordial. Banded tumbler. Beryl footed bowl with blue handles. Trylon cocktail. Blue Grotto footed tumbler.—*Author's collection; ex-coll. A. Douglas Nash*

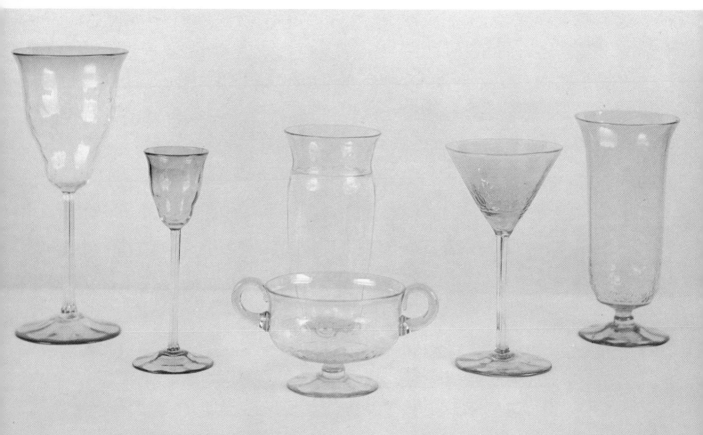

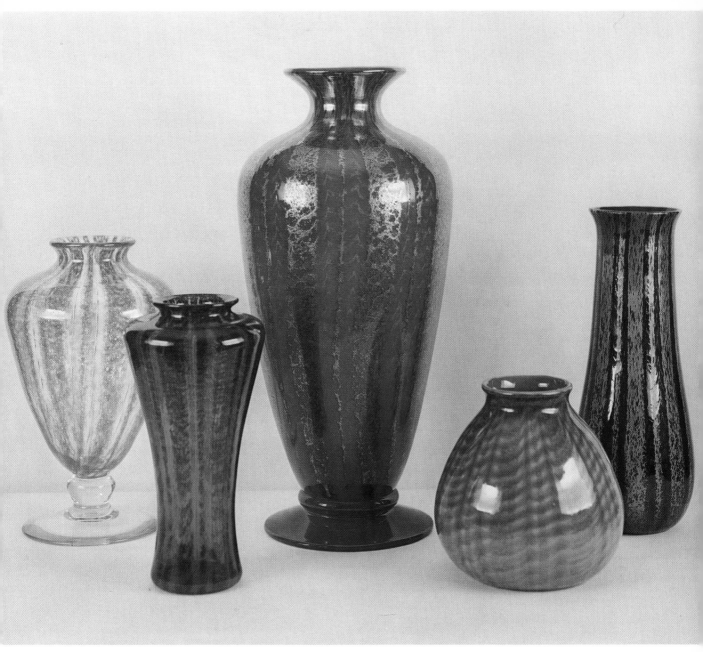

Left to right: Orange Chintz vase; height 12 inches. Green and brown Chintz vase; signed "Nash 96"; height 10 inches *(ex-coll. A. Douglas Nash).* Red and silver Chintz vase; signed "RD 75"; height 19 inches *(ex-coll. A. Douglas Nash).* Brown and tan Chintz vase; signed "Nash"; height 6 inches. Black and orange Chintz vase; signed "Nash 69"; height 12 inches *(ex-coll. A. Douglas Nash).—Author's collection*

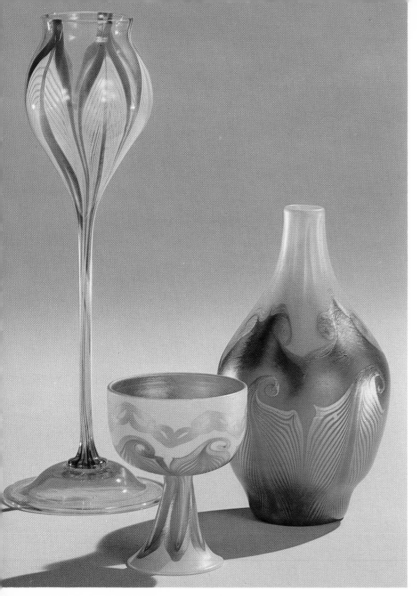

Left to right: Flower form vase, amber with leaf decoration in opal and brown; signed "Quezal o7651"; height 11½ inches. Sherbet of opal glass with green and gold leaf decoration, lustred interior; signed "Quezal"; height 4 inches. Lustred vase, green over opal, with leaf decoration; height 7 inches. Identified by Jimmy Stewart as the work of Thomas Johnson, Quezal Art Glass & Decorating Company, ca. 1901.—*Author's collection*

Left to right: Melon vase decorated with gold lustre flowers and tendrils; signed "Quezal"; height 6 inches. Gold lustre vase with applied coiled snake decoration; signed "Quezal"; height 6 inches. Opal vase with green and gold lustre Heart and Clinging Vine decoration; gold lustre foot and lining; signed "Quezal"; height 11 inches. Agate (laminated) glass vase signed "Quezal / J 91"; height 6 inches. Opal glass vase with leaf decoration of pulled green and gold lustre glass threads, gold lining; signed "Quezal"; height 9 inches.—*Author's collection*

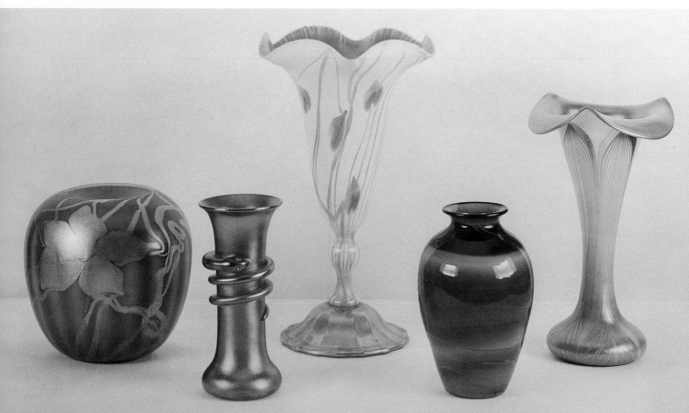

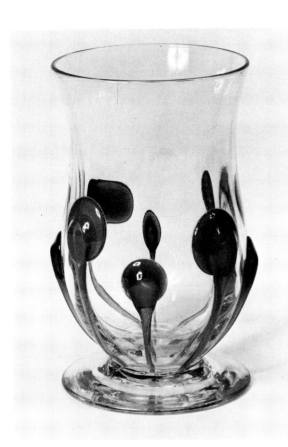

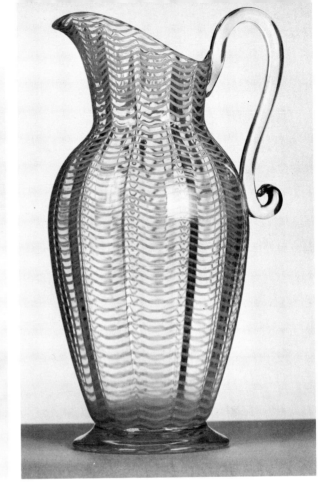

Figs. 201-202—*Left to right:* Moravignian footed tumbler, crystal with ruby decorations; Libbey Glass Co., ca. 1932; height 5 inches. *Author's collection; ex-coll. A. Douglas Nash.* Threaded pitcher with crystal foot and handle; threads of chartreuse-colored glass on optic ribbed body; designed by A. Douglas Nash for the Libbey Glass Co., ca. 1932; signed "Libbey"; height 10 inches. *Author's collection*

Fig. 203—"Talisman" footed crystal tumbler, Optic Rib pattern, with ruby threaded decoration; Libbey Glass co., ca. 1932; height 5 inches. *Author's collection; ex-coll. A. Douglas Nash*

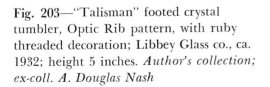

Figs. 204-205—*Left to right:* Crystal plate with dark blue threaded decoration; signed "Libbey"; diameter 8½ inches. Ashtray, decorated with pulled design of red, blue, and purple glass threads on a crystal ground; Libbey Glass Co., ca. 1932; diameter 5 inches. *Author's collection; ex-coll. A. Douglas Nash*

Fig. 206—Tall goblet, with bowl and domed foot of crystal glass striped with blue, green, and ruby in a plaid design; stem of encased colored marbles in green, red, and blue; Libbey Glass Co., ca. 1933; height 9 inches. *Author's collection; ex-coll. A. Douglas Nash*

Fig. 207—Footed opalescent white bowl with green and rose plaid design; original paper label on foot "Libbey Glass Co., Toledo, Ohio"; diameter 13 inches. *Author's collection; ex-coll. A. Douglas Nash*

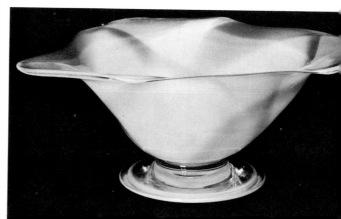

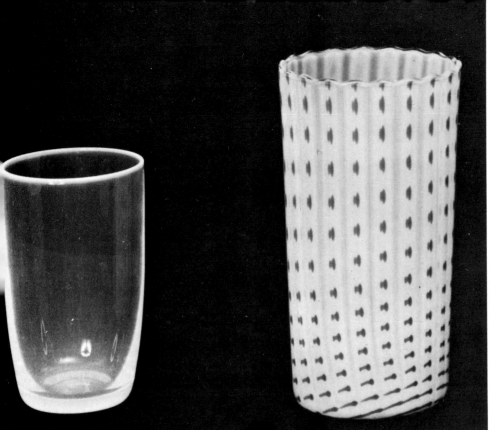

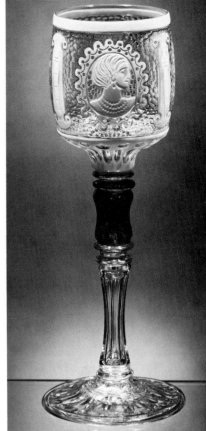

Figs. 208-209—*Left to right:* "Moonstone"
5-ounce tumbler; height 3 inches. Opales-
cent glass tumbler with blue dots; height
4 inches. *Both:* Libbey Glass Co., ca. 1932.
*Author's collection; ex-coll. A. Douglas
Nash.* Libbey "Victoria" goblet, designed
by A. Douglas Nash, ca. 1933. The copper-
wheel engraved bowl is a double overlay
of crystal overlaid with pink and milk
glass. Illustrated in Libbey's 1933 catalog
of their famous Nash line, and described as
a custom-made chalice or long-stemmed
goblet. Retail price was $2,500 a dozen.
(Research confirms that only one dozen of
these goblets was made.) "This museum
piece," the catalog states, "contains four
exquisite reproductions of a cameo, in the
same opalescent pink tones typical of the
finest cameos carved from shells." Stem is
hollow with hollow ruby button; signed
"Libbey"; height 9¼ inches. *Collection
Carl U. Fauster*

Fig. 210—Cut crystal footed vase, Royal
Fern pattern (designed by A. Douglas
Nash for the Libbey Glass Co., ca. 1932);
signed "Libbey"; height 9 inches. *Author's
collection; ex-coll. A. Douglas Nash*

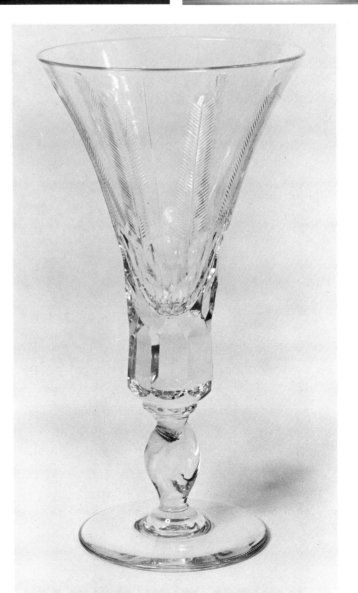

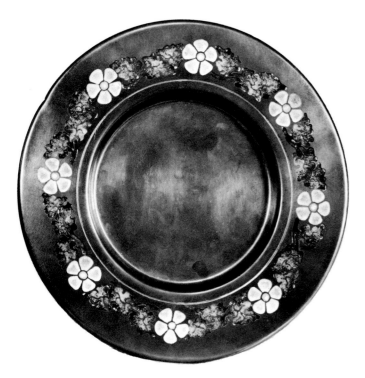

Fig. 211—Gilded metal plate with enameled rim of pink flowers and green leaves; marked "A. Douglas Nash Corp. / 809"; diameter 8 inches. *Author's collection*

factory, using black and opalescent crystal stems in a variety of animal forms—rabbits, bears, monkeys, and antelopes.

The stem of the cordial glass shown in our illustration represents a bear standing on a ball (Fig. 192). Donald Nash owns a tall vase with a jet black rabbit in crouching position forming the joint between the base of the vase and its crystal foot. We have seen the monkey stem and the graceful antelope stem in opalescent crystal; both pieces bore Libbey's trademark lightly etched in the base.

Other Nash Productions

At his Corona factory, Douglas Nash continued the production of Gold Lustre glass similar to Tiffany's

ware. To give his glass a new look, it was sometimes blown in basic wooden molds forming optic patterns on the glass. Heavy ribs, "Venetian Diamond," and leaf-shaped designs were his most popular patterns.

Lightly lustred opalescent and transparent colored glasses were also made; some were given specific names —"Mirror Lustre," "Fairy Lustre," and "Silver Lustre" (Figs. 193-195).

The opalescent optic wares made by Tiffany were continued by Nash with some changes in the optic patterns (Figs. 196-198). Green Aventurine glass was produced for a while, but not much of it was marketed (Fig. 199). An adaptation of Tiffany's "Moravignian" pattern (Figs. 200-201) was made while Nash was with the Libbey Glass Manufacturing Company (Figs. 202-210).

The A. Douglas Nash Corporation also produced some enameled metalwares in bronze and copper (Fig. 211). On special order, they made gilded bronze plaques bearing various State Seals in colored enamels; not all States were represented in these orders. Nash tried to produce pottery, but this effort never reached the commercial stage. Only a very few pieces of Nash pottery were made.

QUEZAL ART GLASS & DECORATING COMPANY

N February, 1901, Martin Bach and Thomas Johnson, former employees of the Tiffany glassworks, established the Quezal Art Glass & Decorating Company in Brooklyn, New York. The factory was located at 1609 Metropolitan Avenue, corner of Fresh Pond Road.

Martin Bach, as a batch mixer at the Corona glassworks, had been in a position to learn the ingredients used in Tiffany's glass melts and lustering compounds. At his Quezal works, he continued to mix these compounds in the same way, and to keep their ingredients secret. But Bach was not a glassblower, and Thomas Johnson's skill in this art was necessary to their success.

Johnson was well acquainted with the glassmaking techniques at the Tiffany works and, as Quezal's gaffer, he patterned their productions after those he had made for Tiffany. Two other Tiffany glassworkers, Percy Britton and William Wiedebine, a decorator and a gatherer, were hired to assist Johnson. Johnson's shop produced some of Quezal's finest art glass. Unfortunately, most of his early pieces were not marked, and are now being attributed, erroneously, to other manufacturers.

When Quezal's glass appeared on the market, it looked so much like his own that Louis C. Tiffany was both angry and amazed. He immediately attempted to institute a change in his own art glass and, toward this end, Arthur J. Nash developed several new colors and decorating techniques. Mr. Tiffany would have

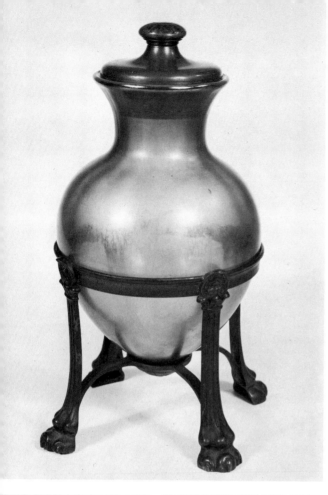

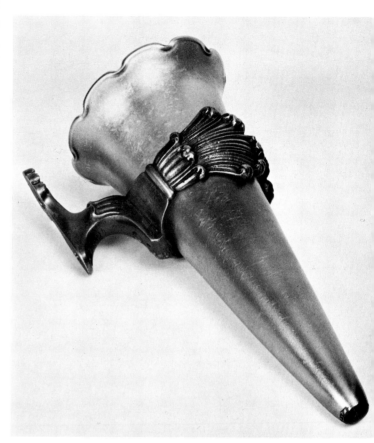

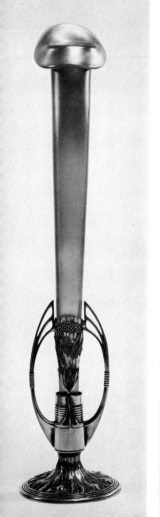

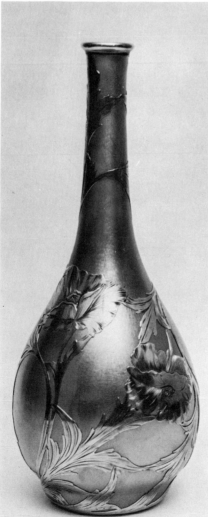

Figs. 212-213—*Left to right:* Gold Lustre glass vase with bronze stand and cover; signed "Quezal"; height 10½ inches. *Collection Mrs. A. R. Huestis.* Gold Lustre glass automobile vase in bronze holder; signed "Quezal"; height 6 inches. *Author's collection*

Figs. 214-215—*Left to right:* Gold Lustre glass vase in silver holder; signed "Quezal"; height 15 inches. *The Chrysler Art Museum of Provincetown (Mass.).* Gold Lustre glass vase with engraved silver deposit decoration; signed "Quezal"; height 9½ inches. *Collection L. A. Randolph*

116

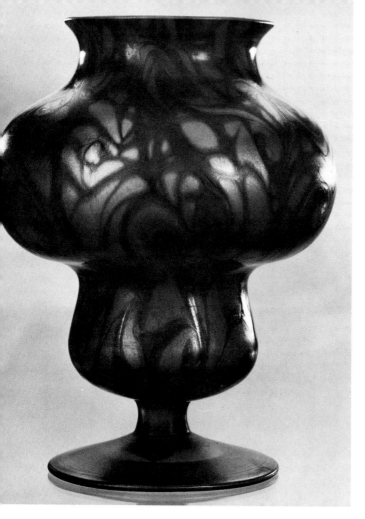

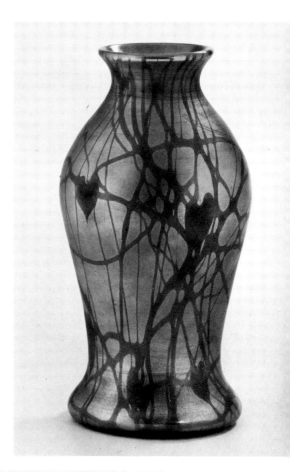

Figs. 216-217—*Left to right:* Gold Lustre glass vase with Coiled design in green; signed "Quezal"; height 7 inches. *Collection Mr. & Mrs. Victor Buck.* Gold Lustre glass vase with green Heart and Clinging Vine decoration; signed "Quezal"; height 8¼ inches. *Smithsonian Institution; gift of Mrs. Page Kirk*

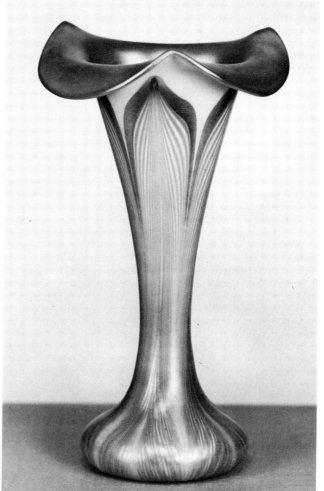

Fig. 218—Vase of opal glass with green and gold lustre leaf decoration; gold lustre lining; signed "Quezal / T / 1039"; height 7¾ inches. *Author's collection*

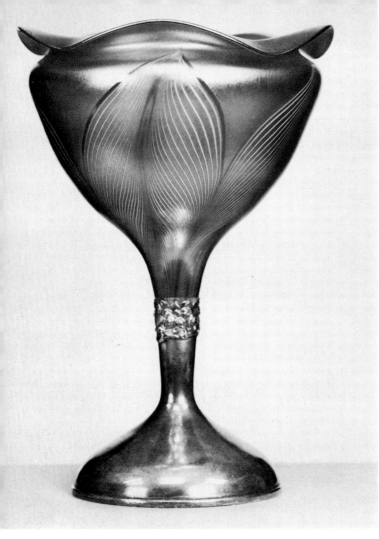

established at the Quezal plant; all of their metal fittings and mounts were purchased from outside sources.

On April 2, 1902, a corporation was formed with Martin Bach as president. Bach and Johnson each held an equal number of the company's shares; the other stockholders were Nicholas Bach—listed in *Brooklyn City Directories, 1899-1901*, as a "glassmaker" (actually he made watch crystals from

Fig. 220—Gold Lustre hock glass with leaf design in white and green threads on bowl and stem; signed "Quezal"; height 7⅞ inches. *Ruth Bryan Strauss Memorial Foundation*

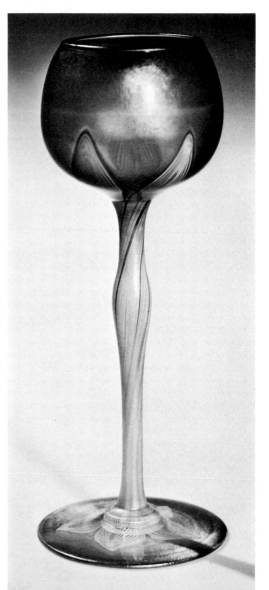

Fig. 219—Gold Lustre vase with feather decoration and silver base; signed "Quezal" at tip of inserted stem; base marked "Wm. Wise & Son / Sterling 925 / 1000"; height 10½ inches. *Author's collection*

liked to stop the production of lustred glass entirely, but the demand of it was too great, and he was more or less forced to continue its manufacture.

Quezal, on the other hand, manufactured lustred and lustre-decorated glass throughout the twenty-five years the firm was active (Figs. 212-231). In 1901–1902, they also produced a limited amount of Agate glass, which is difficult to distinguish from Tiffany's Laminated glass. No metalwares shop was

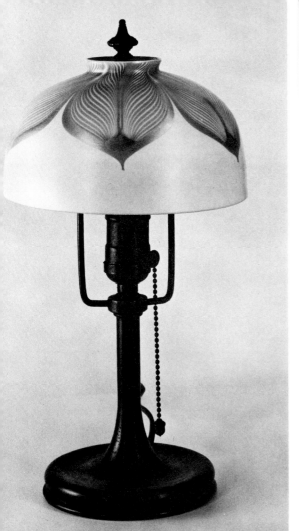

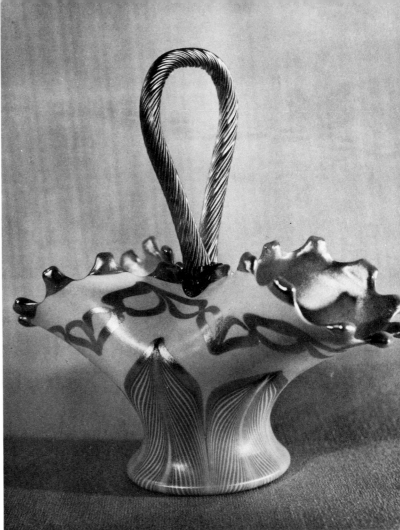

Figs. 221-222—*Left to right:* Lamp with bronze base and opal glass shade decorated in leaf pattern in pulled green and gold lustre threads; shade signed "Quezal"; height 12 inches. *Collection Mrs. A. R. Huestis.* Basket of opal glass decorated with leaf pattern in green and gold lustre pulled threads; guilloche decoration about top in gold lustre; twisted rope handle; signed "Quezal"; height to top of handle 8½ inches. *The Chrysler Art Museum of Provincetown (Mass.)*

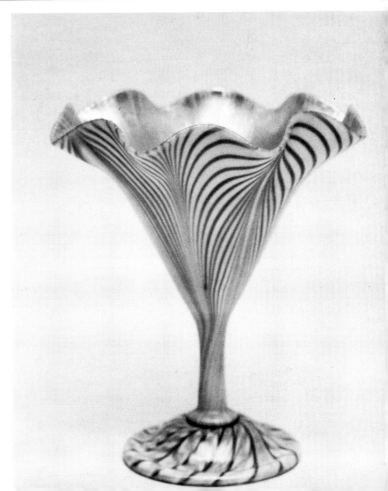

Fig. 223—Sweet-pea vase of opal glass decorated with green lustre threads in a pulled pattern; gold lustre lining; signed "Quezal / S / 262"; height 6 inches. *Collection A. L. Randolph*

Fig. 224—Opal vase with pulled patterns of green and gold lustre glass; signed "Quezal / 748"; height 8½ inches. *Collection L. A. Randolph*

bent and flat glass purchased from various glass manufacturers) —Lena Scholtz, and Adolph Demuth, both associated with the Demuth Glass Manufacturing Company (formerly Demuth Brothers) of Brooklyn, "manufacturers of all kinds of Bohemian and Fancy Glassware, artificial eyes, glass shades, etc."

Trademark papers for the name "Quezal" were issued to the company on October 28, 1902. Martin Bach signed as president, Thomas Johnson and Nicholas Bach as witnesses. Although they claimed this identification had been used on their glass since mid-February 1901, it was almost a year after that date before they began to mark their wares with a neatly engraved signature. About 1907, another trademark was used by Quezal—a bird with long plumage, purportedly representing the exotic quetzal bird of Central America from which the firm derived its name. They compared their lustred glassware to the brilliant plumes of the quetzal bird in their advertisements in trade journals and consumer magazines. We believe this mark may have been affixed with a printed paper label.

The activities of the Quezal Art Glass & Decorating Company can be traced up to 1905 without any change in its principals. But between 1905 and 1918, a period in which they

Fig. 225—Quezal vase, opal glass with pulled green and gold lustre decoration, gold lustre interior; height 6 inches. *Rockwell collection*

were experiencing financial problems, only occasional mention of the firm could be found in business directories and trade papers.

Through Edward Conlin, who was employed at Quezal after Martin Bach's death in 1924, we learned that Martin Bach had bought out his partners some years earlier; also that Nicholas Bach was not directly related to Martin, although both had been born in Alsace-Lorraine, and were "very clannish." When Mr. Conlin knew him, Nicholas Bach was again making watch crystals.

Mr. Conlin was somewhat surprised when we told him that the Demuths were once associated with Martin Bach in the Quezal business. He had been well acquainted with "the Demuth crowd," but only after the Quezal factory closed. Though he had been on friendly terms with them for many years, they had never mentioned to him their earlier association with Martin Bach.

The 1918 edition of the National Glass Budget's *Directory of Glass Factories* listed the Quezal works, its officers, and the size of its operation. Martin Bach was then president; T. C. (Conrad) Vahlsing, Bach's son-in-law, was vice-president; and Martin Bach, Jr., was secretary of the corporation. Aside from Martin Bach, there was no mention of any of the

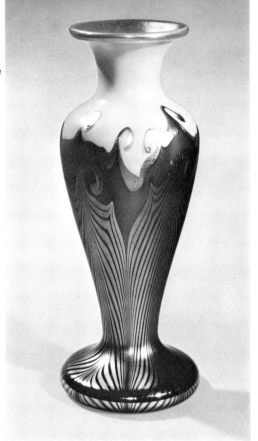

Fig. 226—Quezal vase, opal glass with pulled and applied decoration of green and gold lustre; gold lustre interior; height 11 inches. *Rockwell collection*

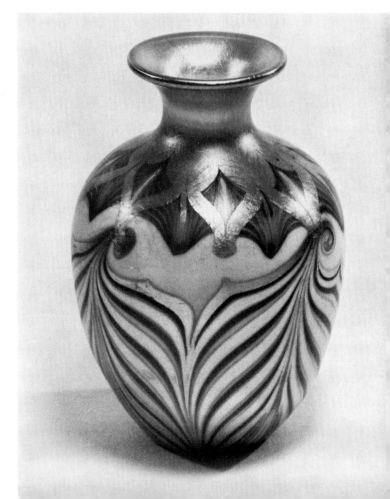

Fig. 227—Opal glass vase with green and gold lustre pulled decorations; signed "Quezal / E 444"; height 3¾ inches. *The Chrysler Art Museum of Provincetown (Mass.)*

121

remembered that William Eisler worked for Quezal as a "ball maker," that Paul Frank was the name of another Quezal gaffer, and that Conrad Vahlsing, who was also a gaffer there, may have been Thomas Johnson's immediate successor. He said that in 1920, Vahlsing and Paul Frank left Quezal and opened their own business, the Lustre Art Glass Company, making Lustre decorated glass exactly like Quezal's in every respect.

Fig. 229—Opal glass vase decorated with leaf design in pulled green and gold lustre, applied "shell" decorations; signed "Quezal"; original paper label on base reads: "Hamilton S. Clark Co., 126 W. Fourth St., Cincinnati (Ohio)"; height 10 inches. *Collection Mrs. Claranell M. Lewis*

Fig. 228—Green glass vase with pulled pattern of leaves in gold lustre; signed "Quezal"; height 9 inches. *Collection Mrs. Claranell M. Lewis*

original incorporators of the company; presumably Bach had already bought them out by 1918. Two furnaces supplied the factory with 18 pots of glass daily—not a large quantity, considering that several different colors were often used on one piece of their glass.

James Gross was a gaffer in the Quezal cane shop, making rods of colored glass. Mr. Gross told us he

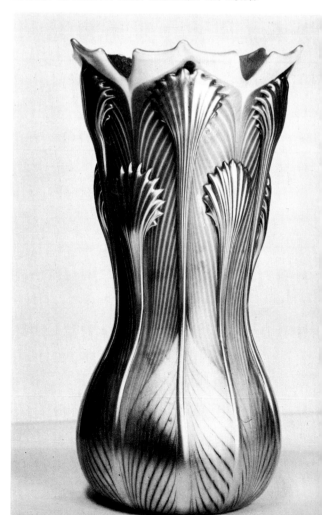

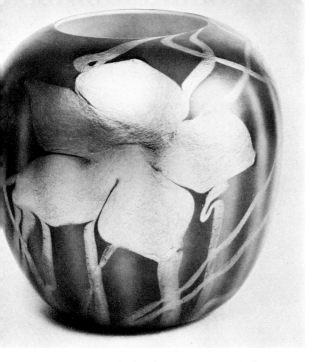

Fig. 230—Striped green on opal glass vase, with gold lustre decoration of flowers and trailing vines; signed "Quezal"; height 6 inches. *Author's collection*

From several quarters we had heard of a rift between Conrad Vahlsing and the Bachs, and reliable sources confirmed it. The passing of almost a half-century found the two families still far apart, and it was impossible to speak to either side concerning their former association in the glass trade.

When Martin Bach died in 1924, there was about $350,000 worth of unfilled orders for art glass on the company's books. The firm was in precarious financial condition, and it seemed for a while they would have to go out of business. Then Martin Bach, Jr., approached Dr. John Ferguson, the family's old friend and physician, then Commissioner of Education in New York City. Ferguson interested himself in the situation, and with three of his wealthy friends—a

contractor named Tom ———, a Long Island banker named Pettit, and Louis Kuntz, a glass jobber—raised enough money to pay off the creditors, buy the firm's property, and purchase all the outstanding stock. They gave Martin Bach, Jr., some working capital and told him if the company showed a profit of $1,000 at the end of the year, they would back him with unlimited funds to continue the business.

It was at this time that Dr. Ferguson, who was president of the firm according to a letter signed by him, placed Edward Conlin, his confidential secretary and friend, in the business to see that everything was done as he wished it to be. Conlin told us that in 1924 only one shop was at work in the manufacture of Quezal art glass, consisting of Emil Larson, Percy Britton, and William Wiedebine. (Other shops were making commercial wares—towel bars, etc.)

A man named Robert Robinson was associated with Martin Bach, Jr., before and after the company was reorganized in 1924, but Mr. Conlin could not recall what position he had held with the firm. A letter signed by Robert Robinson was written on stationery which read: "Quezal Glass Manufacturing Company, Inc., Metropolitan Avenue at Fresh Pond Road, Brooklyn, N.Y. Makers of iridescent electric shades, vases, tableware, lamp bases and novelties, colored transparent ware, towel bars, cane, tubing, mould work." This was in 1923, and at that

time they were producing mostly shades and some vases and tableware.

Emil Larson, in correspondence, confirmed that he had been hired as a gaffer at Quezal in 1923. In view of this date, he was certainly not Vahlsing's immediate successor, but we were unable to find out who filled this position in the interim.

Martin Bach, Jr., once remarked to Edward Conlin that it had cost the firm thousands of dollars to teach Larson how to make their art glass. This was not meant as a reflection on Larson's abilities as a gaffer, but to point out that the special training required to master the art of making Quezal's lustre decorated glass was a long exercise of trial and error. Larson claimed that one of the glasses used in Quezal's wares had an incompatible expansion factor with the other glasses and caused a great deal of breakage. Added to that was the burden of antiquated equipment, especially the hand-drawn coke-fired lehr in which their glass was annealed—no

Fig. 231—Large "Pansy" vase of opal glass with leaf decoration in pulled green and gold lustre threads; lined with gold lustre glass; signed "Quezal"; height 15¾ inches. Shown at right is the engraved "Quezal" signature on the base. *Collection Michele's Antiques*

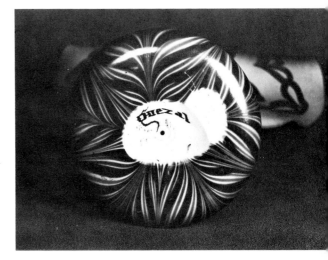

small obstacle for Larson to overcome.

Faulty equipment and the incompatibility of the glasses used by Quezal resulted in a great quantity of cracked and broken goods. Conlin said that all they had to show for their efforts after almost a year's work was a large pile of broken glass.

In 1924 and 1925, just before the firm closed completely, they discontinued making the iridescent glass, and at the very last they tried to produce some cheap black glass items.

The Quezal Art Glass & Decorating Company closed in 1925. Martin Bach, Jr., took his formulas to Victor Durand's Vineland Flint Glass Works in New Jersey where he continued to make fancy glassware in the Art Nouveau style. Britton and Wiedebine, who had gone to Corning right after Quezal closed, rejoined Bach at the Durand works. Emil Larson, after a brief stint in Bellaire, Ohio, also returned to work for Bach when Victor Durand established his art-glass shop.

Some very beautiful Art Nouveau glass was made at the Quezal factory. It should be noted, however, that Quezal never introduced anything new in design or technique, but seemed content to copy the colors and decorating techniques initiated at the Tiffany glassworks.

LUSTRE ART GLASS COMPANY

ONRAD VAHLSING and Paul Frank established the Lustre Art Glass Company in 1920. Their glassworks were located just off Grand Avenue in Maspeth, Long Island, New York. Prior to this time, Vahlsing had been associated with his father-in-law, Martin Bach, Sr., in the Quezal Art Glass & Decorating Company, and Paul Frank, a gaffer, had worked there, too. A Certificate of Incorporation was issued, on September 20, 1920, to Paul Frank, William Overend, and Henry Nold. Conrad Vahlsing was listed as a director of the corporation, along with Paul Frank and William Overend.

According to Jimmy Stewart who had worked at the Tiffany glassworks many years, Paul Frank, who was the gaffer at the Lustre Art factory, had once been employed at the Tiffany glassworks in Corona before he left to take a job with Quezal. Stewart remembered, too, that there was a "Cooney" Freidoch associated with Quezal. (Edward Conlin, of Quezal, told us that Conrad Vahlsing was also known as "Cooney" to his friends and associates when he worked for Martin Bach, Sr. Apparently "Cooney" was the familiar name for "Conrad.") Messrs. Stewart and Conlin may have been referring to the same person.

For the most part the Lustre Art Glass Company produced lamp shades and globes. These are so much like the wares made at the Quezal factory that they are indistinguishable from one another,

Fig. 232—Opal glass light shade decorated with green and gold lustre Hearts and gold lustre Spider Webbing; signed "Lustre Art"; height 6 inches. *Author's collection*

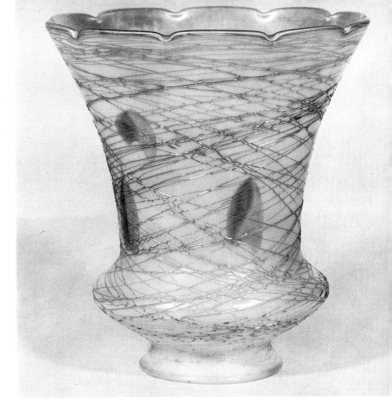

and can often be used together as matching shades for a multiple-light fixture (Fig. 232). This similarity of Vahlsing's glass to Quezal's was one of the reasons for the ill feeling between the Bach and the Vahlsing families.

The Lustre Art Glass Company lasted only a few years. Nothing concerning any of the men associated with this factory could be traced after 1923.

The corporation papers gave the following postal addresses for members of the firm: Paul Frank, 1890 DeKalb Avenue, Brooklyn, New York; William Overend, 130 North 5th Street, Brooklyn, New York; Henry Nold, 28 Fresh Pond Road, New York City (this address is very close to the location of the Quezal glassworks); and Conrad Vahlsing, 68 Elliott Place, Maspeth, Long Island, New York.

STEUBEN GLASS WORKS

THE Steuben Glass Works at Corning, New York, was incorporated on March 2, 1903, by Thomas G. Hawkes, Samuel Hawkes, Townsend deM. Hawkes, and Frederick Carder. The Corning newspaper of March 11, 1903, reported that articles of incorporation had been filed at Albany, New York, for the Steuben Glass Works, the certificate being subscribed for by Frederick Carder, William S. Reed, and Stella Reed. It stated that the business would begin with a capital investment of $50,000 and would occupy the Payne Foundry on West Erie Avenue, and that plans for enlarged facilities for glassmaking and the production of art glasswares were indicated. The new company was named "Steuben," for the county in which is was located.

Prior to that time, T. G. Hawkes & Co., a glass-cutting shop in Corning (established 1880), of which Thomas G. Hawkes was president, had been buying their glass blanks from the Corning Glass Works. When it was decided to have their own glassworks, Mr. Hawkes purchased the S. W. Payne Foundry and Machine Shop, then occupied in part by the Allen Foundry Company, installed the equipment necessary for the manufacture of glass, and prevailed upon Frederick Carder, already established in the English glass industry, to come over to take charge. The plant would manufacture the crystal and colored glass blanks for cutting at T. G. Hawkes & Co., and other art glasswares.

128

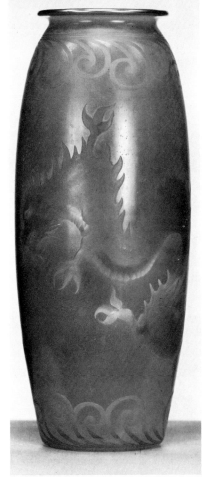
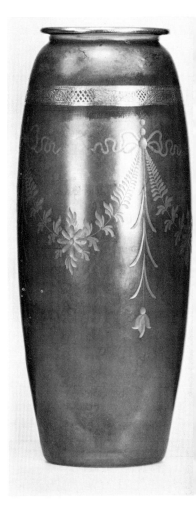

Fig. 233—Rare signed "Hawkes" decorated vases; blanks supplied by the Corning Glass Works, ca. 1920. *Left to right, top row:* Light green enamelled crystal vase with copper-wheel engraved decoration of a coiled dragon and clouds, gold rim; has T. G. Hawkes & Co.'s trademark (two hawks and a fleur-de-lis; height 12 inches. Amethyst enamelled crystal vase with copper-wheel engraved decoration of flower swags and ribbons, silver deposit decoration on rim and shoulders of vase; height 12 inches. *Bottom row:* Crystal vase with Acid Cut-Back decoration of dragon and clouds, gilded; has T. G. Hawkes & Co.'s trademark on base; height 10 inches. Opal glass vase with enamelled exterior in mottled Rockingham brown and yellow; height 10 inches. Crystal vase painted light yellow and with yellow daffodils and green leaves; height 10 inches. *Author's collection*

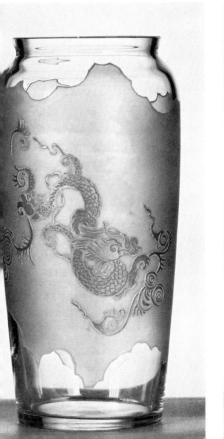

Under Mr. Carder's inspired direction, the Steuben Glass Works operated with great success. During World War I, the plant was closed for a time since its products were classified as nonessential to the war effort. In 1918, the Corning Glass Works acquired its facilities from T. G. Hawkes & Co., and when the war was over, resumed production of art glass at Steuben, as a subsidiary of the Corning Glass Works (Fig. 233). Mr. Carder remained with Steuben until 1934. Production of his successful wares did not stop with his retirement. However, their excessive cost in the face of the Depression, put them on a gradual decline. The Steuben name is still associated with fine glass in America, but the company no longer makes the colorful wares Mr. Carder initiated—these are now the province of the collector.

Records in the sub-district of Kingswinford in the county of Stafford, England, show that Frederick Carder was born September 18, 1863, in Brockmoor, the son of Caleb Carder, a stone potter and draper, and Ann (Wadelin) Carder. He was the second son in a family of five boys and one girl. His education was begun at a dame school in Wordsley, but after his involvement in a slate-throwing disturbance, was continued at a private school at Brierley Hill.

In 1877, at the age of 14, he went to work in the family pottery. At first he shoveled coal for the kilns; eventually working up to preparing clay for the potters. In the evenings he attended classes at Dudley Mechanics' Institute in Brierley Hill, studying chemistry, electricity, and metallurgy; he also studied at the Stourbridge School of Art. The latter entailed a three-mile walk each way.

Though he continued to work full time at the pottery, his school work was outstanding. He won several awards for designing and sketching. In 1881, his friend and teacher, John Northwood, suggested he put his artistic gifts to use in the glass trade. He sought employment with Stevens & Williams, Brierley Hill glass manufacturers, and was immediately hired as an artist. His work was to design shapes and applied decorations for an extensive line of glass articles for decorative and table use. In this period, Carder introduced some of Stevens & Williams' most attractive designs and colors.

All the time, he was continuing with his evening classes at art school. In 1891 he received his Art Teacher's Certificate and began his career as a teacher at Wordsley Institute. He was still employed by Stevens & Williams, of which John Northwood was then plant manager—it had been at Carder's suggestion that Northwood had been engaged. As Art Director, Carder was assuming more and more responsibility.

At the turn of the century, the glass industry in England was beset with problems. Chief among them were trade unionism, which was

Fig. 234—Gold Aurene bowl with original paper label reading "A.A.R. / Corning Tested / Spec. 69-41"; diameter 8 inches. *Author's collection*

beginning to demand more of the manufacturer than ever before, and competition with Continental glass manufacturers who were cutting deeply into their trade. Glass houses in Austria and Germany, particularly, were flooding the world market with cheap copies of English glassware.

The unhappy situation was further complicated for Stevens & Williams by the death, in 1902, of John Northwood and the necessary choice of his successor. When Carder was passed over in favor of Northwood's son, John Northwood II, he was deeply disappointed. No doubt this seeming lack of appreciation for his efforts, more than anything else, influenced his future course.

About this time, Graham Balfour, Director of Technical Instruction for Staffordshire, proposed that Frederick Carder be sent abroad to observe Continental technical

131

Fig. 235—Gold Aurene perfume bottle, marked "No. 6047"; height 12 inches. *Rockwell collection*

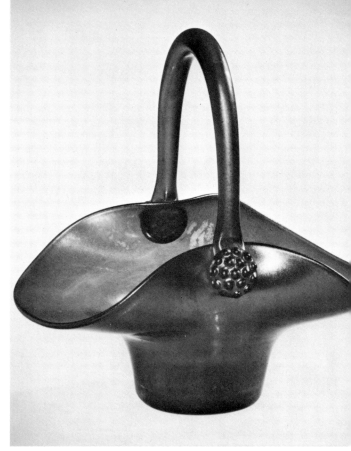

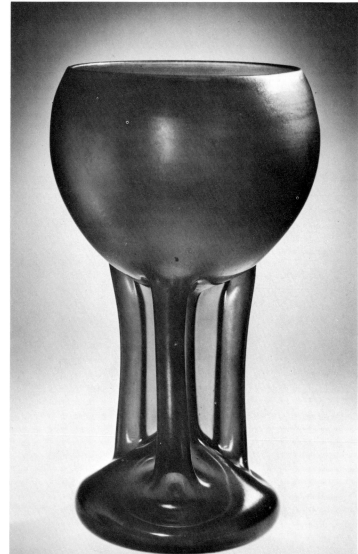

Figs. 236-237—*Left to right:* Gold Aurene cigarette holder marked "6684"; height 4 inches. Gold Aurene basket marked "Haviland" (objects marked "Haviland" were especially made for the porcelain manufacturer of that name to complement their decorated tablewares) ; height 4½ inches. *Rockwell collection*

Fig. 238—Gold Aurene "four column" vase; height 12 inches. *Collection Mr. & Mrs. George Jamison*

Fig. 239—Gold Aurene powder box, copper-wheel engraved, and with enamelled metal cover; height 4 inches. *Rockwell collection*

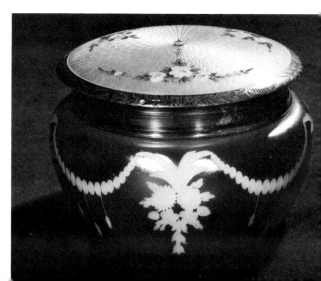

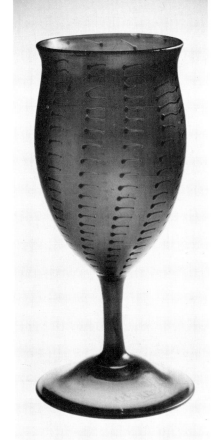
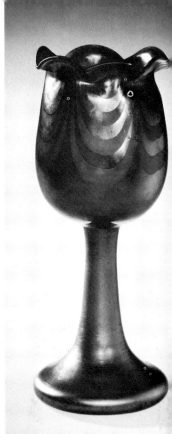

education and manufacturing processes and bring back what he could of ideas to improve English glass production and enable it to compete again in the world market. Carder set out in August 1902 for Germany and Austria. His reports, stressing the need for new design in furnaces and machinery, were reported at length in the Stourbridge *County Express*. He was sent then on a similar tour of glass houses in the United States. His report indicated American art-glass production was as badly off as English, though protected by higher tariffs. He then announced his decision to accept an offer from T. G. Hawkes & Co. in America to manage their new factory.

His decision came as a surprise, and the glass industry that had financed his tours was quick to call it traitorous. Then, a "going-away" interview with the Brierley Hill *Advertiser,* in which he criticized the local glass manufacturers for lack of enterprise and trade unionists for restrictive practices, put him on everyone's blacklist. The unions hotly accused him of pirating laborers from English glass factories, claiming the Steuben Glass Works intended to operate as a "scab factory." The industry wrote rather nasty letters to the press. Though the shouting eventually died down, the rift remained and for many years Mr. Carder had little contact with his former colleagues in England. With time, the wounds healed; those who had reviled him most either quieted,

Figs. 240-241—*Left to right:* Gold Aurene goblet-shaped vase with green Broken Thread decoration; height 7¾ inches. *Collection Mr. & Mrs. George Jamison.* Decorated Gold Aurene chalice-shaped vase with drag loop decoration; height 7 inches. *Rockwell collection*

or died. Still, Frederick Carder counted it one of his happiest recognitions when the Victoria and Albert Museum in London approached him for a specimen of his glass for their permanent collection.

Thomas Beuchner, Director of the Corning Museum of Glass, once wrote of Frederick Carder: "He worked with John Northwood and Eugene Fabergé. He knew René Lalique and Louis Tiffany. He served Carl Milles and was inspired by Émile Gallé. An academician by training, he produced in all the late

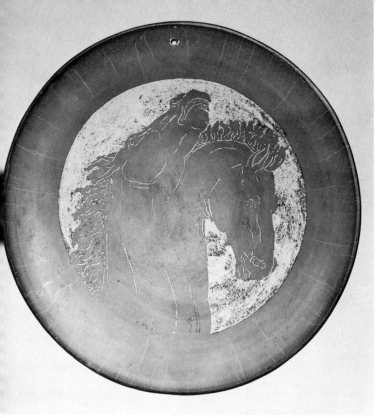

Fig. 242—Gold Aurene on crystal plaque; etched decoration of horses in center; diameter 5 inches; a unique piece executed by Arthur Janssen. *Rockwell collection*

Fig. 243—Blue Aurene vase (shape No. 7447); height 6 inches. *Rockwell collection*

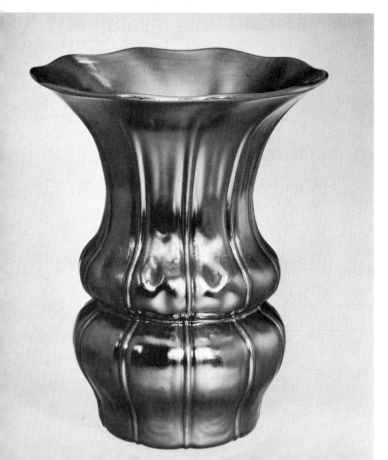

Victorian styles, including Chinese; contributed to the ever more precious oeuvre of the Art Nouveau and to the rhythmic revival of neo-classicism. The frivolous Venetian style was as at home on his drafting table as Bauhaus functionalism. No man could better personify the kaleidoscope of glassmaking during the past hundred years."

Frederick Carder lived to be just over 100 years old and remained active in the arts all his life. He died at his home in Corning, on December 10, 1963.

Aurene Ware

Of all the wares made by Steuben, none were as popular as their Aurene. A great quantity of this ware in blue and gold lustre effects was made in the several years of its production from 1904 to 1930.

The trademark "Aurene" was registered by the Steuben Glass Works on September 6, 1904. Their trademark papers stated that the term "Aurene" had been used by them "since June 20, 1904," and that this name was to be placed on their wares either with "a printed label . . . or by cutting or engraving or otherwise forming the said mark upon the article itself." The name "Aurene" was coined by Mr. Carder, and has its origin in the Latin word *aureatus*, "like gold in resplendence."

The designation "Aurene" was used for all of Steuben's lustred wares—all blue, all gold, or decorated Aurene—but in their

134

Fig. 244—Blue Aurene footed vase with three applied handles; height 6 inches. *Rockwell collection*

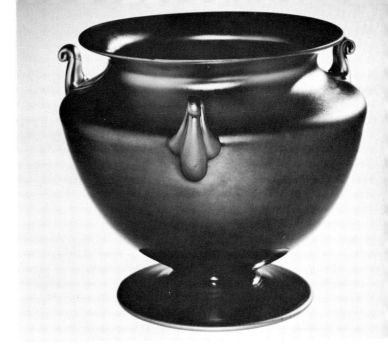

Figs. 245-246—*Left to right:* Blue Aurene compote, scalloped rim, twisted stem; height 8 inches. Blue Aurene decanter, swirled Optic Rib pattern; height 10 inches. *Rockwell collection*

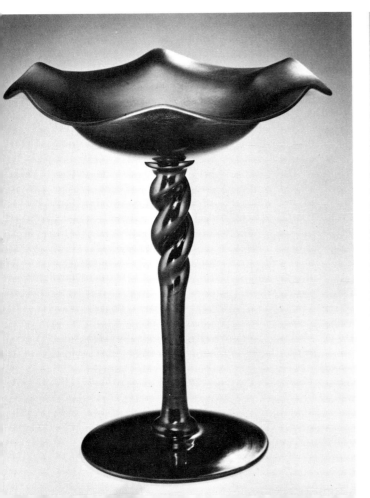
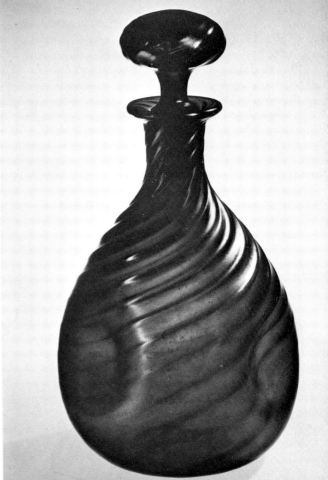

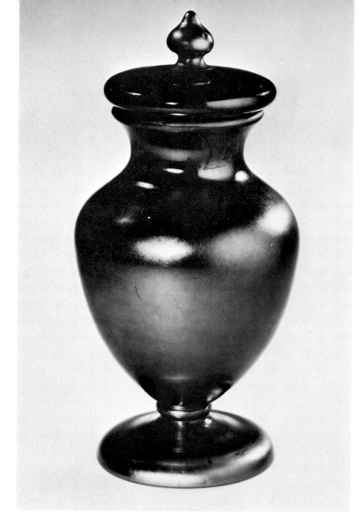

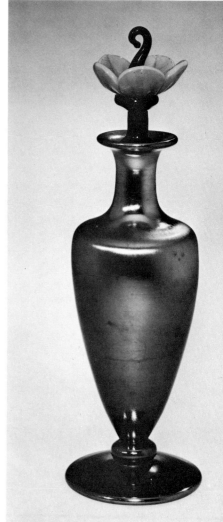

Figs. 247-248—*Left to right:* Blue Aurene covered, footed jar; height 5½ inches. Blue Aurene perfume bottle with flower-form stopper; height 7 inches. *Rockwell collection*

Fig. 250—Blue Aurene cigarette lighter; height 5 inches. *Rockwell collection*

Fig. 249—Blue Aurene ashtray; diameter 5 inches. *Rockwell collection*

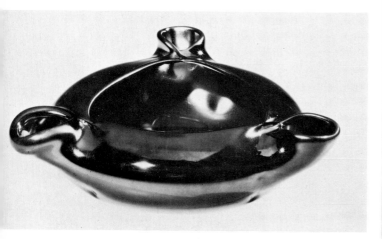

catalogs and brochures, they did differentiate between these variations by using the terms "Aurene" or "Gold Aurene" for their gold lustred wares (Figs. 234-242); "Blue Aurene" for their blue lustred wares (Figs. 243-253); and "Decorated Aurene" for their wares which were a combination of colored glasses and lustre decoration.

In May 1959, Frederick Carder gave the author his explanation of the manufacture of his Aurene glass. "Aurene and Tiffany glasses," he wrote, "are not only iridescent but also metallic glasses. Salts of rare metals are dissolved in the glass and kept in an oxidized state. When a vase is made of this glass, and [while it is still] on the punty [rod], it is subjected to a reducing flame. This brings to the surface a metallic coating. When developed in intensity, it is then sprayed with another metal chloride [tin salts dissolved in sterile water]. This puckers the surface [of the glass] into thousands of fine lines which reflect and refract light, giving it a luminous quality."

Some months later, Mr. Carder confirmed our observation that it was the metallic spray applied to the object that gave it its lustre, and that without this applied lustre, it would not have been possible for him—or anyone else—to produce these luminous effects. The highlights of blue, red, and silver found on Aurene wares is caused by the burning of the metallic lustre.

Mr. Carder also confirmed the fact that the color of the body glass

Fig. 251—Pate de Verre plaque on Blue Aurene; diameter 12 inches. *Rockwell collection*

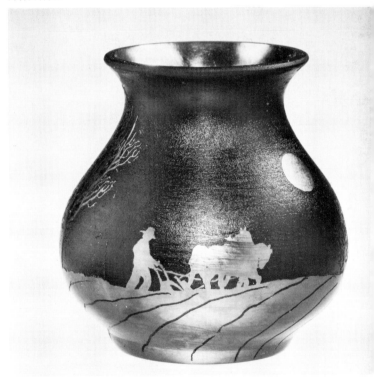

Fig. 252—Blue Aurene vase with etched design; an experimental piece designed by Arthur Janssen; height 2½ inches. *Rockwell collection*

Fig. 253—Blue Aurene sock darner; length 6 inches. *Rockwell collection*

Fig. 254—Decorated Aurene vase, green and gold Aurene decoration; gold Aurene foot; height 10 inches. *Rockwell collection.*

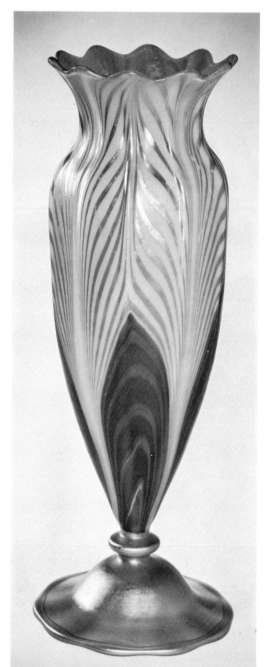

had a great deal to do with the color of the lustre finish; also that the glass had to be transparent or it would not give off a brilliant iridescence. "Opaque glass," he said, "will not reflect light sufficiently to obtain the highly iridescent effects we obtained with our Aurene."

Gold and Blue Aurene

Gold and Blue Aurene wares covered a wide range of useful and decorative objects, from tablewares to lamp shades. Variations were obtained by etching or engraving designs on the surface of the glass, or by giving the surface a textured effect with optic patterns—"Diamond Optic," "Twist Optic," "Prism Optic," "Ogival Optic," "Panel Optic," "Ripple Optic," and so forth—by blowing the glasses in pattern molds.

Decorated Aurene

Decorated Aurene glass was also produced in 1904. These wares can be found in many colors and color combinations, all with lustrous effects of one kind or another.

Sometimes the body glass was Gold or Blue Aurene with applied decorations—"Guilloche," "Leaf and Vine" (perhaps with millefiori florettes added to heighten the illusion of flowering vines), "Peacock Feather," "Drag Loop," "Broken Thread," and others.

Decorated Aurene wares having two or more layers of opaque glass— often white with red, green, or brown—were worked at the furnace

138

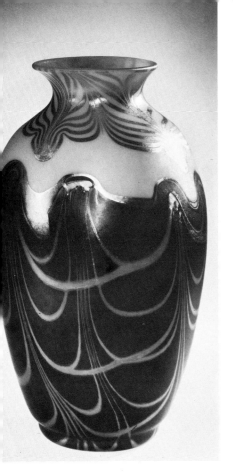 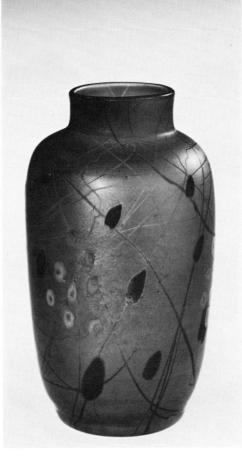 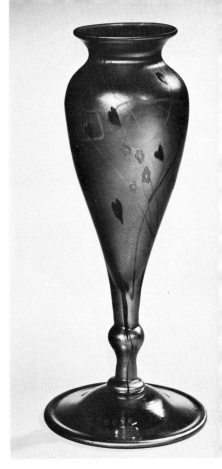

Figs. 255-256-257—*Left to right:* Decorated Aurene vase, green and gold Aurene on opal body; height 9 inches. *Collection Mr. & Mrs. George Jamison.* Decorated Aurene vase, gold Aurene with decoration of green leaves and vines and millefiori florettes; height 5½ inches. Decorated Aurene vase, greenish-gold body with millefiori florettes and green leaves and vines; height 8 inches. *Rockwell collection*

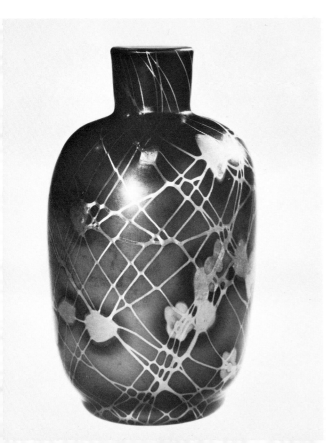

Fig. 258—Decorated Aurene vase, brown body with gold Aurene decoration of leaves, vines, and flowers; height 4 inches. *Rockwell collection*

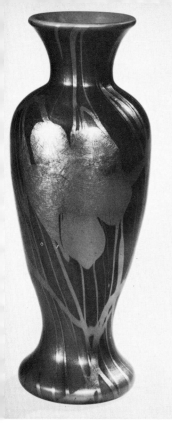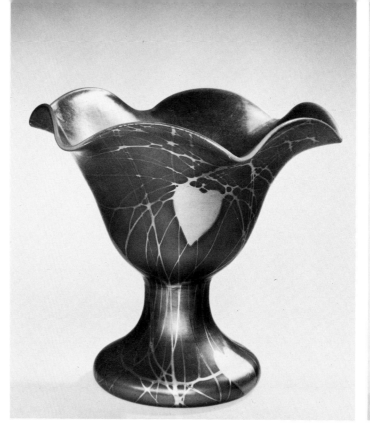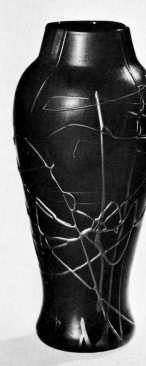

Figs. 259-260-261—*Left to right:* Decorated Aurene vase, red body with silvery-gold decoration of flowers and vines; height 7½ inches. Decorated Aurene vase; greenish-gold body with gold Aurene decoration of leaves and vines; height 6 inches. Decorated Aurene vase; greenish-blue body with gold threaded decoration; height 5½ inches. *Rockwell collection*

Fig. 263—Decorated Aurene vase (an experimental piece) ; pink body with guilloche decoration of greenish-gold; height 6½ inches. *Rockwell collection*

Fig. 262—Decorated Aurene bowl; Blue Aurene body with cream-colored guilloche decoration; diameter 8 inches. *Rockwell collection*

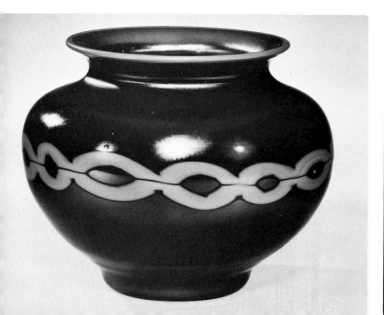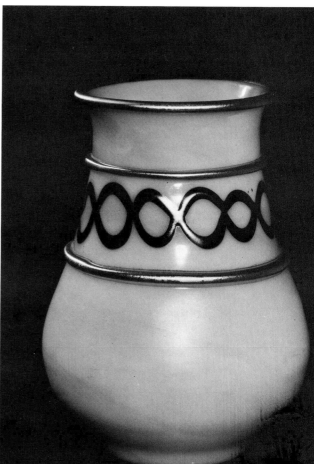

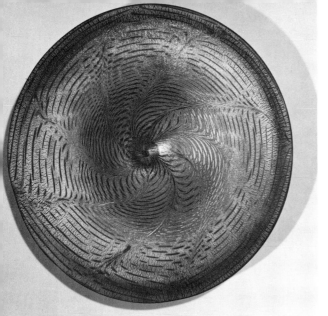

Fig. 264—Blue and Gold Decorated
Aurene plaque; diameter 15 inches.
Rockwell collection

and pulled into patterns representing
peacock feathers, leaves, and several
other designs. Our illustrations show
most of the designs in which
Carder's Decorated Aurene wares
can be found (Figs. 254-267).

Tyrian Glass

Steuben's Tyrian glass should
really be classified as one of their
Decorated Aurene wares; however,
the color—which Mr. Carder
happened upon accidentally—was
such a distinctive one that it seemed
to justify a special name of its own.

The opaque body glass is a strange
combination of grayish green,
grayish blue, and grayish purple, all
flowing together like an Agate glass.
It was an unstable metal and the
workers experienced considerable
difficulty in keeping the greenish
color at the top of the article and the
purple color at the bottom. Gold
Aurene decorations, usually leaves
and vines, cover most of the
surface of Tyrian wares; occasionally

141

the interior of an article was given
a lustre finish.

All of the Tyrian glass we
examined had the name "Tyrian"
engraved on the base of the object.
Mr. Carder told us that he chose
the name for his ware because it
closely approximated the definition
of "Tyrian Blue" found in Webster's
Dictionary. Not many pieces were
made because of the difficulties
encountered in its manufacture.

Verre de Soie

According to Mr. Carder,
Steuben's Verre de Soie first made
its appearance in 1905—largely as
table glass and small decorative
objects. It is characterized by a faint
rainbow-like veil of iridescence,
caused by spraying the surface of
the glass, while hot, with a solution
of stannous chloride. Usually the
objects are made of crystal glass, but
color is introduced in applied
decorations, handles, stems, etc.
Several handsome pieces with colored
fruit and flower clusters serving as
knobs, handles, and finials were
made, too—mostly in the Venetian
style. One piece in our own collection

Fig. 265—Decorated Aurene footed bowl;
greenish-gold body with decorations of
opal and gold; berry pontil prunt on inside
of bowl; diameter 8½ inches. *Rockwell
collection*

Fig. 266—Decorated Aurene lamp; opal body glass with gold Aurene decoration; height 15 inches. *Rockwell collection*

has mica flecks throughout the crystal glass. The possibilities for variations in Verre de Soie are numerous, and apparently everything known to the Steuben factory was employed to make something just a little bit different.

Again, we must report that Carder's Verre de Soie was not solely his idea. Very similar wares were made by glass factories in Italy, Austria, Germany, Belgium, France,

and England. Unless a piece is marked, or is undeniably a Steuben form or design, collectors will be hard pressed to separate Mr. Carder's Verre de Soie from similar wares made abroad.

The forms of the earlier pieces of Mr. Carder's Verre de Soie are, for the most part, somewhat sterile. Usually they are decorated with etched or engraved designs—flower swags, garlands of leaves, geometric, and curvilinear patterns (Figs. 268-277). Many of these earlier pieces of Verre de Soie have the name "Hawkes" etched in the base.

Jade Glasses

Steuben's Jade glasses were actually nothing more than colored opalines. By calling these translucent colored wares "Jade Glasses," Mr. Carder lifted them out of the commonplace to a more exalted position. The various colors in which these wares were produced can be found in the opaline glasses made in glass factories in Europe and America in the first half of the nineteenth century.

Rosaline: a beautiful shade of light rose-colored opaline. It was often used in combination with Steuben's Alabaster glass.

Alabaster: a translucent white opaline glass.

Blue Jade: produced in light and dark shades of blue. The dark blue color seems to be more difficult to find.

Jade (Green Jade): a true jade-green color.

Left to right: Cintra cream pitcher, green and orange. Clouded glass vase (Oriental Jade). Verre de Soie sugar bowl with Celeste Blue handles and pear and leaf knob. Ruby Opalescent glass goblet, light ruby with opalescent stem and foot. Florentia vase, green leaf decoration.—*Rockwell collection*

Left to right: Acid Cut-Back vase, rose-colored Quartz with green Thistle decoration. Acid Cut-Back vase, Yellow Jade with Aurene decoration. Rouge Flambe vase with Gold Aurene decoration. Peach Blow vase. Tyrian vase with Aurene decoration.— *Rockwell collection*

Top, left to right: Green Jade compote with Alabaster stem and foot. Mandarin Yellow vase. Yellow Jade perfume bottle. Dark Blue Jade vase. Blue Jade fan vase with Alabaster stem and foot. *Bottom, left to right:* Ivory vase. Ivorene candlestick. Pate de Verre plaque. Rosaline vase with Alabaster foot. Rosaline goblet, engraved design on bowl, Alabaster stem and foot.— *Rockwell collection*

Left to right: Blue Cluthra vase. Heavy Cologne bottle with internal decoration of green Cluthra and bubbles. Moss Agate vase. Decorated Cintra vase. Intarsia vase with applied decoration of cut and engraved crystal leaves.—*Rockwell collection*

Decorated Aurene vases.—*Rockwell collection*

Top, left to right: Gold Ruby fan vase. Gold Ruby bud vase with crystal stem and foot. Grenadine wine glass with crystal stem and foot. Pomona Green covered jar with pear and leaf knob. Selenium Ruby goblet with engraved Grape and Leaf decoration. *Bottom, left to right:* Bristol Yellow goblet. Topaz compote. Celeste Blue goblet with crystal stem and Celeste Blue foot. Amethyst perfume bottle. French Blue Pilsner glass with amber foot. Wisteria fan vase.—*Rockwell collection*

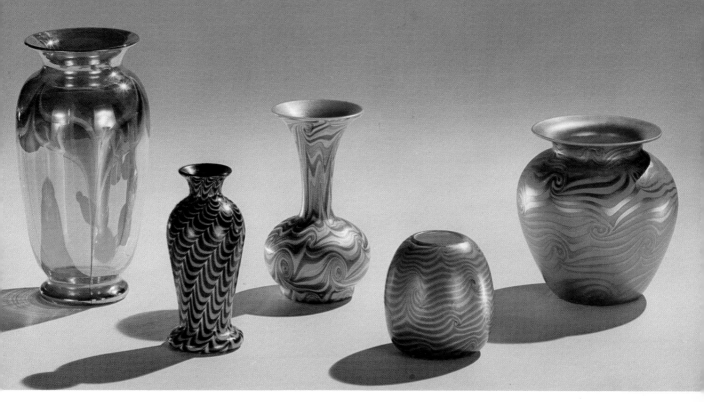

Left to right: Silver lustre Ambergris vase with pulled blue and opal decoration; signed "V.Durand / 17-5"; height 9⅜ inches. Blue lustre vase with opal zigzag decoration; original paper label on base reads: "Durand Art Glass"; height 6 inches. Opal vase with blue and gold lustre decoration in King Tut pattern, gold lining; height 6¾ inches. Rose bowl of yellow glass with green King Tut decoration, lustred; signed "V.Durand / 1995-4"; height 4 inches. Apple green vase with gold lustre King Tut decoration; signed "V.Durand / 1716-6"; height 6 inches.—*Author's collection*

Left to right: Golden-yellow vase with blue coiled decoration; signed "Durand"; height 10 inches. Opal vase with blue and gold Heart and Clinging Vine decoration, Spider Webbing all over, lustred interior and foot; signed "V.Durand / 2011-13"; height 12¼ inches. Cased green over opal vase with opal Heart and Clinging Vine decoration, lustred; height 6¼ inches. Blue lustre vase, opal Heart and Clinging Vine decoration; signed "V.Durand / 1970-8"; height 8 inches.—*Author's collection*

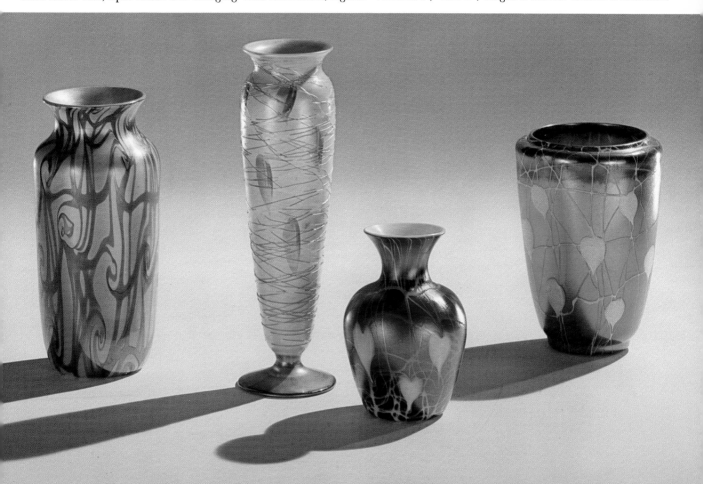

Left to right: Cut green and crystal overlay decanter; height 11¾ inches. Footed dish in Spanish Yellow **with green rim;** height 2½ inches. Peacock sherbet glass, ruby with opal decoration, Spanish Yellow foot, and cut decoration at top; heigh; 5½ inches. Pair of Amethyst covered jars, Optic Rib pattern; signed "V.Durand / 1994-8"; height 10½ inches.—*Author's collection*

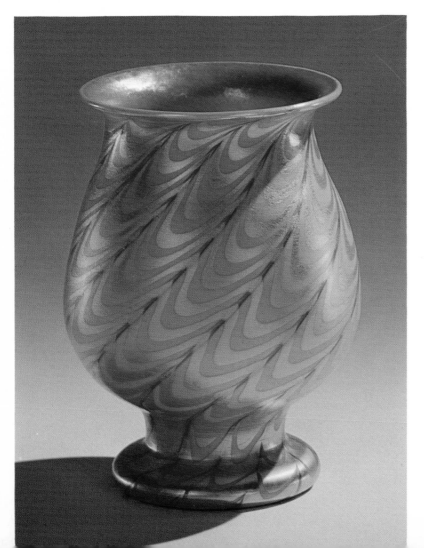

Lady Gay Rose vase with pulled lustre decoration and gold lustre lining; Vineland Flint Glass Works, ca. 1928; height 7⅜ inches.—*Author's collection*

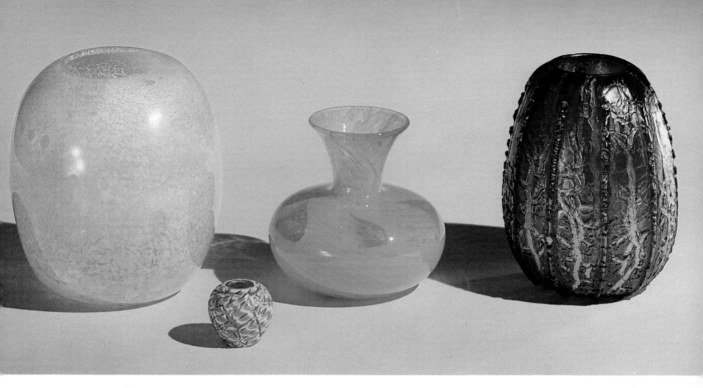

Left to right: Yellow Cluthra vase; signed "1995-9 / K"; height 7¾ inches. Miniature vase in green and white Egyptian Crackle; height 2½ inches. Blue Cluthra vase with yellow spots; signed "K / 1986-6 / Dec. 8"; height 5½ inches. Moorish Crackle vase, ruby over Ambergris, lustred; signed "V.Durand / 1996-8"; height 7½ inches.—*Author's collection*

Free Hand lustred glass vases made by the Imperial Glass Company, ca. 1923.—*Photo courtesy of the Imperial Glass Corporation, Bellaire, Ohio*

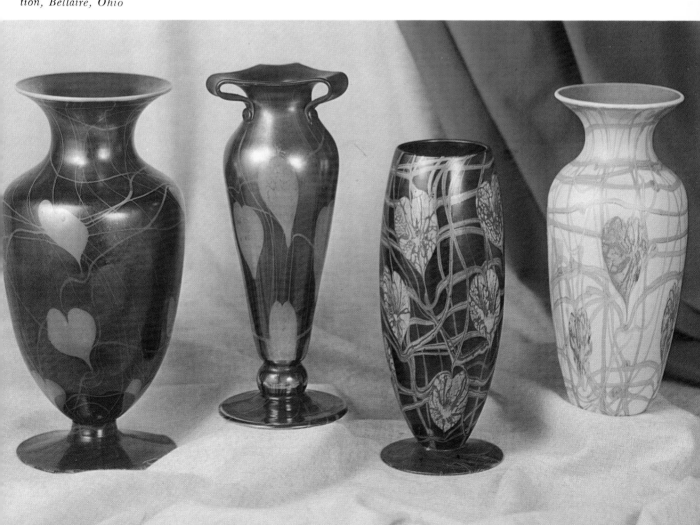

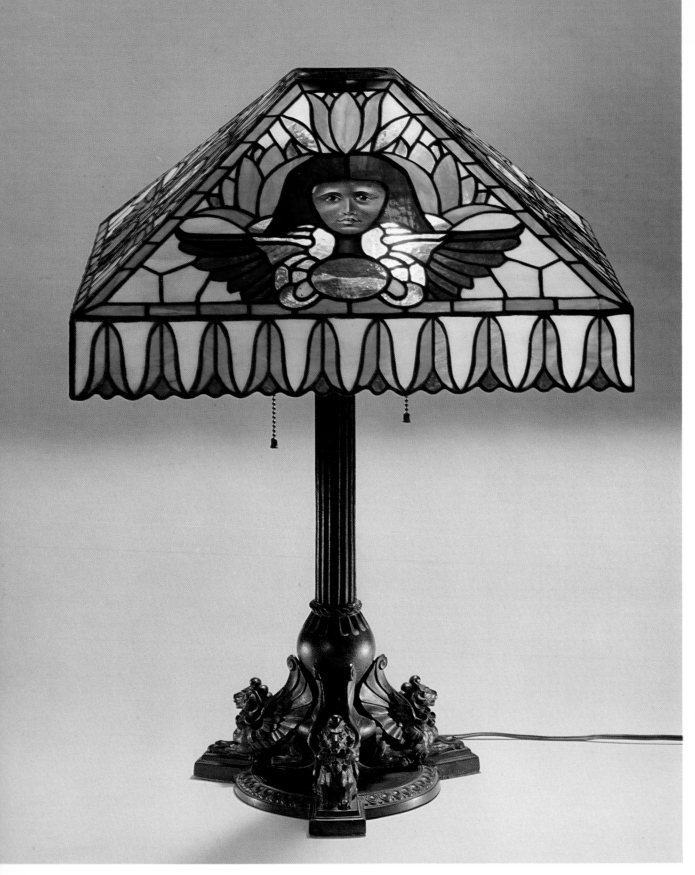

"Egyptian" lamp; leaded art-glass shade and bronze base signed "Handel"; height 27 inches.—*Author's collection*

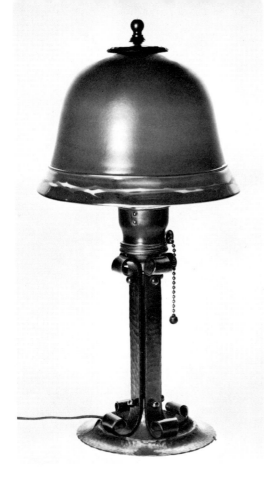

Fig. 267—Decorated Aurene desk lamp; brown shade with opal, brown, and gold decoration on rim; bronze stem and foot; height 15 inches. *Collection Mr. & Mrs. Howard Decker*

Fig. 269—Verre de Soie basket with copper-wheel engraved decoration; height 12 inches to top of handle. *Rockwell collection*

Fig. 268—Verre de Soie vase, copper-wheel engraved decoration; signed "Hawkes" (blank produced by the Steuben Glass Works); height 6¼ inches. *Collection Mr. & Mrs. Ted Lagerberg*

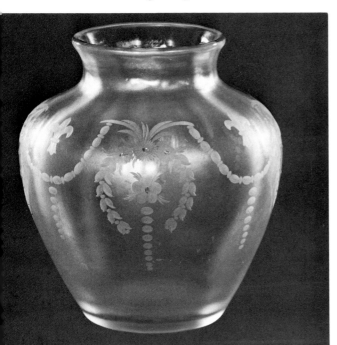

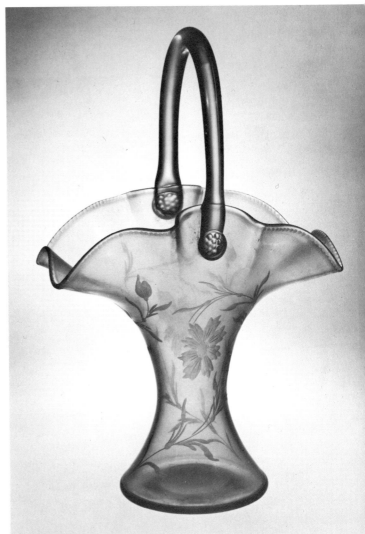

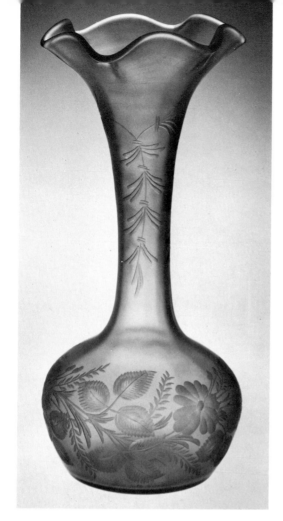

Figs. 270-271—*Left to Right:* Verre de Soie vase, copper-wheel engraved decoration; height 9½ inches. Verre de Soie vase, Diamond Optic pattern; green Reeded decoration; height 6½ inches. *Rockwell collection*

Fig. 273—Verre de Soie footed sherbet, opaque blue prunts and threaded decoration; signed "F. Carder"; height 4 inches. *Rockwell collection*

Fig. 272—Verre de Soie bowl, Reeded decoration and flower frog in green glass; diameter 8 inches. *Rockwell collection*

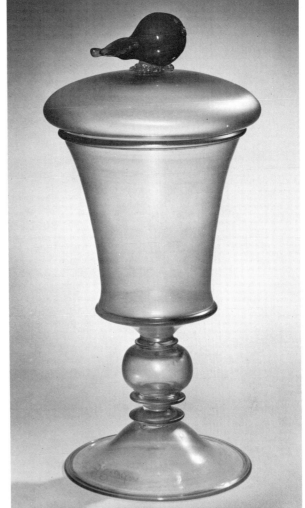

Figs. 274-275—*Left to right:* Verre de Soie goblet with pink Broken Thread decoration; signed "F. Carder"; height 7 inches. Verre de Soie covered jar with applied green pear finial; height 12 inches. *Rockwell collection*

Figs. 276-277—*Left to right:* A cup of thick transparent glass, frosted on the inside and enamelled outside with a design of a dragon encircling the cup in opaque green, blue, red, and black; the fret border of the cup is decorated in shades of greenish-yellow and dark green; made at the Steuben Glass Works in 1915; height 2¼ inches. *Photo courtesy The Corning Museum of Glass.* Verre de Soie bowl-vase with enamelled blue and red dragon encircling the body; other decorations of greenish-yellow, blue, green, and red enamel; height 2⅛ inches. *Collection Mr. & Mrs. George Jamison*

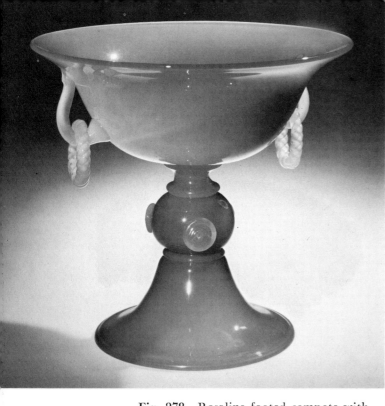

Amethyst Jade: an opaline glass of a somewhat muddy shade of amethyst.

Variations of the colors mentioned above do not place them in a separate color category; the difference in each case may be hardly noticeable and can easily be explained as the result of a slight change in the amount of colorant used for each batch of glass, or by the thickness of the glass itself (Figs. 278-288).

Rouge Flambe

Frederick Carder claimed that he produced Rouge Flambe, a vibrant shade of red, by using selenium and cadmium sulphate in the glass melts. He also said that Rouge Flambe was one of the most difficult glasses he ever made. This is quite understandable, for a change in temperature could easily upset the chemical reaction taking place in the glass and change its color. It is quite obvious that there was some chrome oxide in the batch, too, and a close examination will reveal what appears to be tiny flecks throughout the metal. These tiny flecks, which give Rouge Flambe glass a pearly texture, are the molecules of chrome oxide adhering to one another and forming larger crystals that reflect light. The same chemical reaction takes place in the manufacture of Aventurine glass.

Stevens & Williams of Brierley Hill, England, was experimenting with this color before Mr. Carder came to America. A specimen of

Fig. 278—Rosaline footed compote with Alabaster handles and free-standing Alabaster rings; height 8½ inches. *Rockwell collection*

Yellow Jade: a beautiful shade of translucent yellow opaline.

Mandarin Yellow: a deep and glowing yellow color which was difficult to produce. Very often pieces of Carder's Mandarin Yellow will crack without any apparent reason. Obviously the glass is sensitive to temperature changes, and this may account for so little of it being found today.

Fig. 279—Rosaline bowl with Alabaster foot; diameter 13 inches. *Collection Mrs. L. G. Wagner*

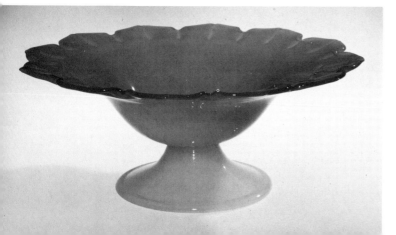

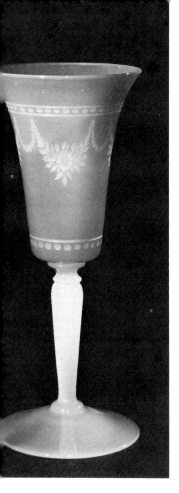
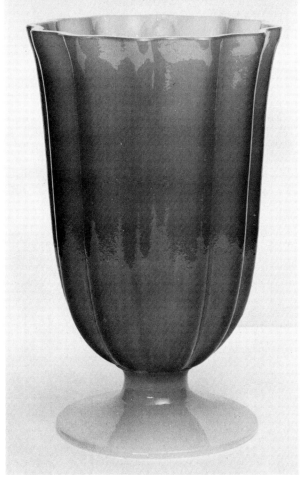
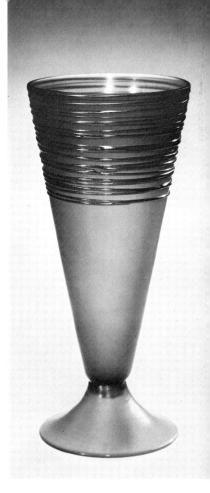

Figs. 280-281-282—*Left to right:* Rosaline goblet with Alabaster stem and foot; copper-wheel engraved design; height 8½ inches. *Rockwell collection.* Green Jade vase with Alabaster foot (shape No. 7331); height 12 inches. *Privately owned.* Lustred Green Jade vase (shape No. 6034) with applied threaded decoration of gold Aurene; height 10 inches. *Rockwell collection*

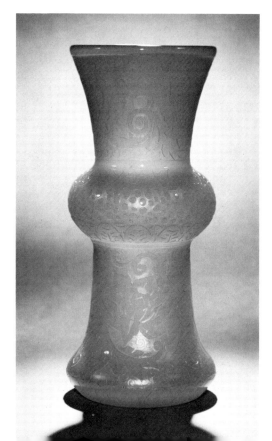

Fig. 283—Yellow Jade vase with etched Chinoiserie decoration; height 10 inches. *Rockwell collection*

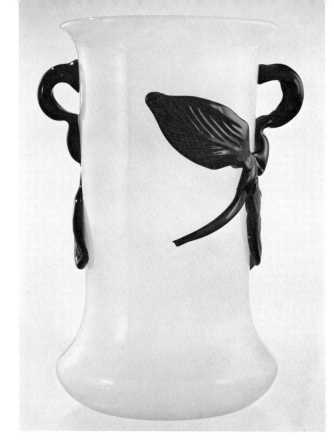

Figs. 284-285—*Left to right:* Alabaster and black vase (shape No. 7464) ; height 8 inches. *Collection Mr. & Mrs. Victor Buck.* Black ice bucket with light blue Jade bands; marked "Steuben"; height 6½ inches. *Rockwell collection*

Figs. 286-287-288—*Left to right:* Teal-blue Jade wine glass; height 5 inches. Opaline vase with crystal handles and free-standing rings; foot and rim of vase decorated with thin line of orchid-colored opaline; height 6 inches. *Rockwell collection.* Amethyst vase, Optic Rib pattern, copper-wheel engraved; sterling silver base marked "Hawkes"; Steuben glass blank; height 8 inches. *Author's collection*

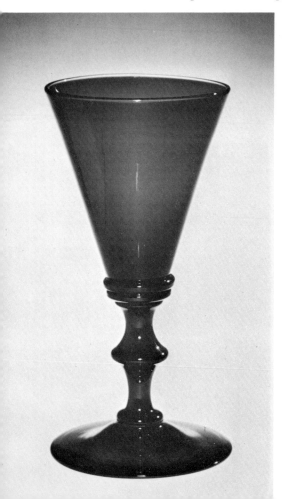
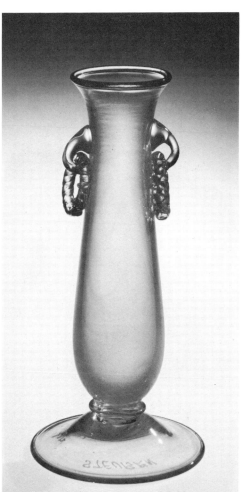
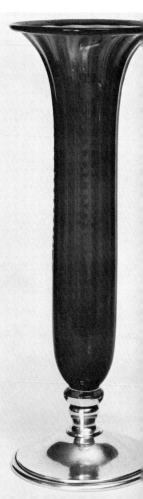

their Rouge Flambe was given to the author by John Northwood II several years ago. Mr. Northwood told us that Stevens & Williams' Rouge Flambe was so difficult to work with that none of it was ever made for public distribution. Mr. Carder said that he didn't think more than fifty or a hundred pieces of Rouge Flambe were made at Steuben.

Transparent Colored Glasses

Steuben's line of transparent colored glasses was rather wide, and each color was given a specific name. Without their color plate as a guide, collectors will be hard pressed to determine the proper name for each of the several shades of red, green, blue, purple, and yellow.

Gold Ruby: a light shade of ruby glass, more pink than red in transmitted light.

Selenium Red: an intense red color, slightly orange in transmitted light; it is closely related to the old Bohemian Red color.

Rosa: the name for this color was suggested by its resemblance to the color of Rosé wine—a pinkish amber hue.

Cerise Ruby: bright shade of a pinkish red.

Antique Green: a pale yellow-green color.

Pomona Green: a darker, somewhat less yellow-green than Steuben's Antique Green.

Celeste Blue: a copper-blue glass of medium saturation.

Marina Blue: a light shade of blue with a trace of green, approximating the color of a gemstone Aquamarine.

French Blue: a grayish-blue color.

Flemish Blue: dark cobalt blue.

Amethyst: a rich reddish-purple color.

Orchid: a light shade of Amethyst.

Wisteria: a lighter bluish-purple color.

Gold Purple: a deeper shade of Wisteria.

Amber: a true light amber color.

Bristol Yellow: a tawny shade of golden yellow. Mr. Carder claimed this color was produced by using silver in his melt. He used this unusual shade of yellow to cast a relief design for a memorial window, now on the second floor of the Corning Public Library. Among the names listed on it of those who gave their lives for our country in World War I is that of Mr. Carder's son, Cyril.

Topaz: a medium brownish-amber —name derived from the gemstone.

It should be remembered that these colors will vary according to how thick or how thin the glass happens to be blown. Shades of the same color will appear deeper in relatively thick pieces, and much lighter in thin-walled wares. This is clearly illustrated in the deep shade of color one finds in the stem or foot of a goblet as compared to the lighter shade of the same color evidenced in the bowl of the goblet (Figs. 289-304).

Peach Blow Glass

Steuben produced two kinds of Peach Blow glass, each type different

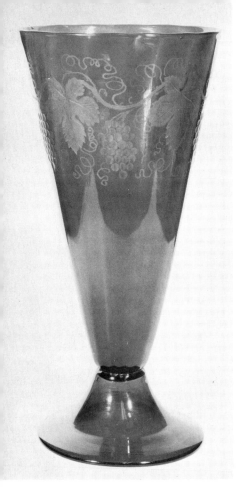
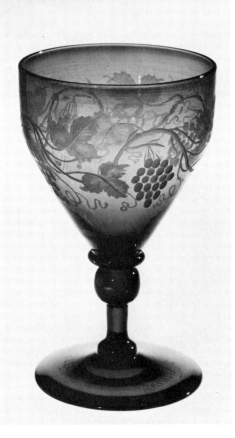
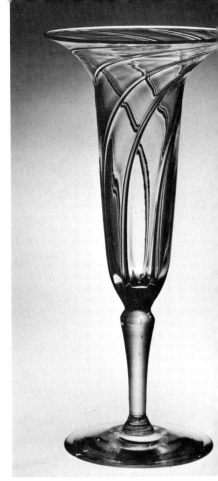

Figs. 289-290-291—*Left to right:* Selenium-Ruby vase (shape No. 6034) with Grape decoration; height 12 inches. *Author's collection.* Selenium-Ruby goblet; copper-wheel engraved Vineyard pattern; height 5 inches. *Rockwell collection.* Crystal and green glass goblet-shaped vase, height 8½ inches. *Collection Mr. & Mrs. George Jamison*

Figs. 292-293—*Left to right:* Crystal ashtray, Celeste Blue handle; diameter 5 inches. Pomona Green and Amber candlestick; height 12 inches. *Rockwell collection*

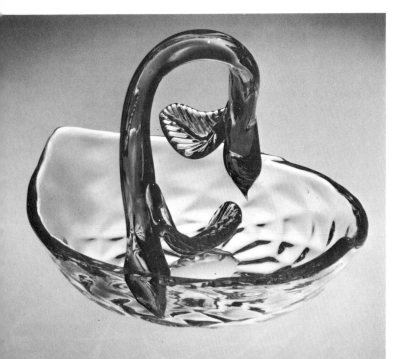
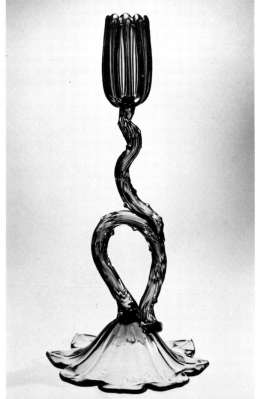

Figs. 294-295-296—*Left to right:* Crystal
goblet with green stem and foot; copper-
wheel engraved in the Van Dyke pattern;
height 8 inches. Decanter of amber and
blue glass; copper-wheel engraved in the
Regal pattern; height 9 inches. Decanter
of crystal glass with green prunts and
flower decorated stopper; height 15 inches.
Rockwell collection

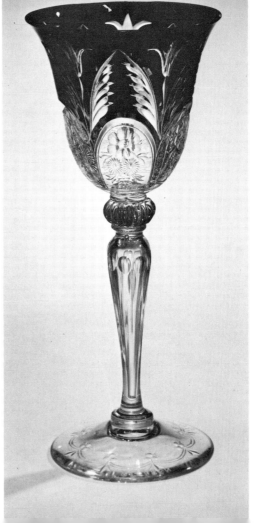

Fig. 297—Crystal flashed with black goblet
(shape No. 6844), deep cut in the Poussin
pattern; height 10 inches. *Rockwell
collection*

151

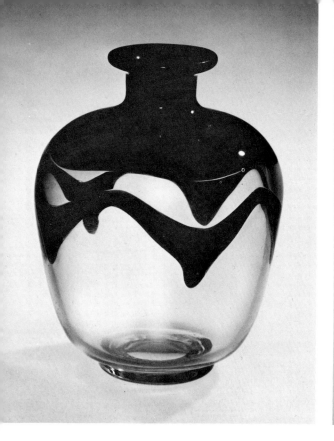
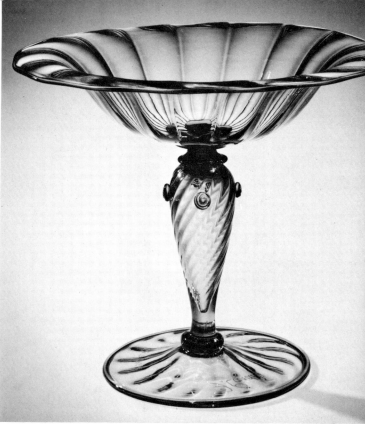

Figs. 298-299—*Left to right:* Crystal vase with black decoration; height 4½ inches. Amber compote with blue prunts on stem, blue rim on foot; height 7 inches. *Rockwell collection*

Figs. 300-301—*Left to right:* Compote of blue and Rosa glass, Silverine stem, Optic Twist top and foot; height 7 inches. Amethyst glass vase with opal stripes; height 10 inches. *Rockwell collection*

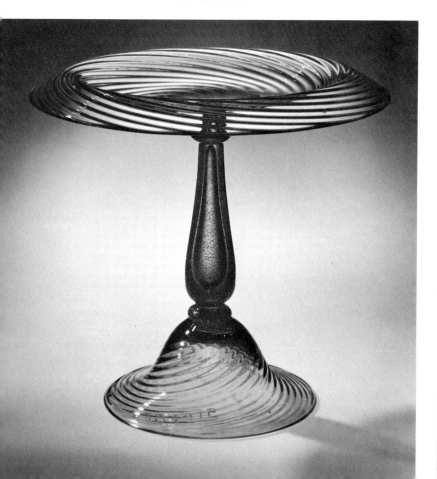

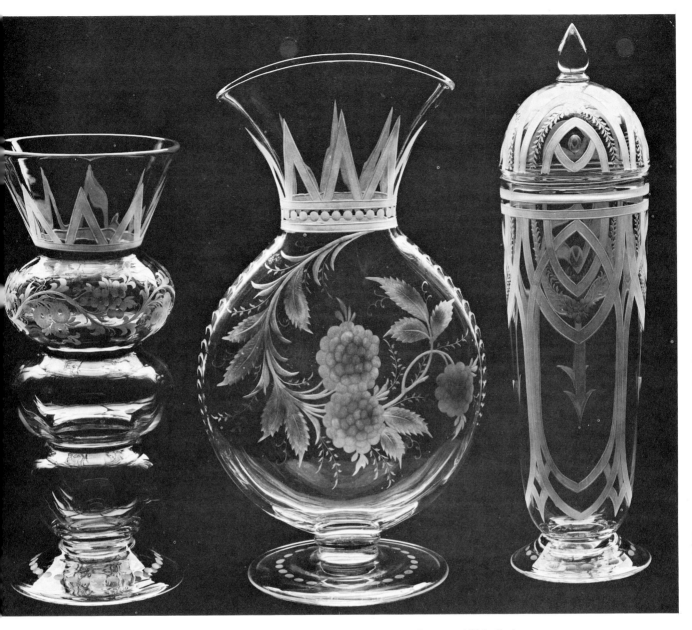

Fig. 302—Engraved crystal vases from an original Steuben catalog, ca. 1918. *Left to right:* Duveen pattern; oval vase Elaine pattern; covered jar Wield pattern.

in color from the other. One type of Peach Blow glass was a cased ware —opal glass heavily cased with a deep brownish-red ruby glass. In many ways the color is similar to Webb's Peach Blow and to the Peach Blow glass made by Hobbs, Brockunier & Company in Wheeling, West Virginia, but it did not shade from red to yellow.

The other Peach Blow glass produced at Steuben looks very much like Frederick Shirley's "Burmese" glass. It shades from a deep peach color to yellow and is also quite opaque. This Peach Blow was made from a sensitive uranium and gold ruby glass melt, the peach color being brought out by reheating one extremity of the object—usually the

153

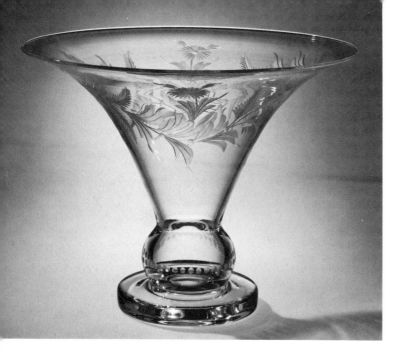

Fig. 303—Engraved crystal vase with Marguerite decoration; signed "Steuben"; height 9 inches; diameter 12 inches. *Collection Mrs. L. G. Wagner*

Fig. 304—Crystal Tumble-up engraved floral and geometric decorations; height 6 inches. *Rockwell collection*

top of a vase. Those pieces we have examined have been drilled for lamp vases, and it's quite possible that this was the only use made of Carder's shaded Peach Blow glass. Mr. Carder set the dates for the production of both types from 1908 to about 1930.

Cluthra Glass

Tapioca was the "secret ingredient" Mr. Carder used to produce the bubbly texture characteristic of his Cluthra glass. A gather of Alabaster glass was first rolled over a marver strewn with fine particles of Carder's Rosaline, Green Jade, Wisteria, Amethyst, Yellow Jade, or some other opaline glass used by the Steuben factory. Immediately thereafter it was rolled over another marver covered with small pieces of tapioca which caused an effervescence and bubbling reaction in the hot glass. While the glass was still bubbling it was blown into a cup of crystal glass, then blown out to the desired size and shape and finished with hand tools. Blowing out the bulb of glass enlarged the bubbles greatly; sometimes they are almost a full inch in diameter.

Handles or a foot were made for these Cluthra wares from any of the several colored glasses used at Steuben—Rosaline, Green Jade, Alabaster, colored crystal—whatever the worker was ordered to use for a particular design to comply with Mr. Carder's wishes.

Cluthra first appeared in the Steuben line in 1920 and was made in several colors and combinations

of colors—rose, light and dark blue, purple, gold ruby, yellow, brown, black (usually flecked with white or shaded to white) , Alabaster, rose shading to Alabaster, green shading to Alabaster, and many more. If these wares are marked, and some of them are not, it will be with the fleur-de-lis in combination with the name "Steuben" (Figs. 305-310) .

James Couper & Sons of Glasgow, Scotland, produced a ware similar to Carder's Cluthra glass, about 1895. "Clutha," as it was called by Couper & Sons, was full of character and quaintness, with little specks of color, mica flecks, and bubbles throughout the glass. While the names are almost the same—there is only the slight difference in the spelling—Carder's Cluthra was not exactly like Couper & Sons' Clutha wares. The term "clutha" is an old Scottish word meaning "cloudy."

Cintra Glass

Mr. Carder coined the name "Cintra" from the word "sinter," which Webster defines as "to become or cause to become a coherent mass by heating without thoroughly melting." This definition commonly applies to powdered or earthy substances. Mr. Carder applied it to powdered glass, and in essence it describes the manufacturing process used at Steuben to make their Cintra glass.

A bulb of hot glass was rolled over a marver strewn with fine particles of colored ground glass. When the plastic bulb had been completely

Fig. 305—Black Cluthra bowl; signed "Steuben"; diameter 8 inches. *Rockwell collection*

Fig. 306—Lavender Cluthra vase (shape No. 8508) with Alabaster handles; height 10 inches. *Rockwell collection*

Fig. 307—Rose Cluthra boudoir set with crystal finials; bottle 5 inches tall. *Rockwell collection*

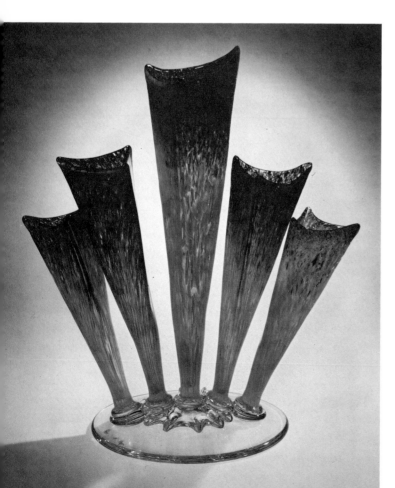

Fig. 308—Five-prong vase of shaded black to white Cluthra, crystal base; height 12 inches. *Rockwell collection*

156

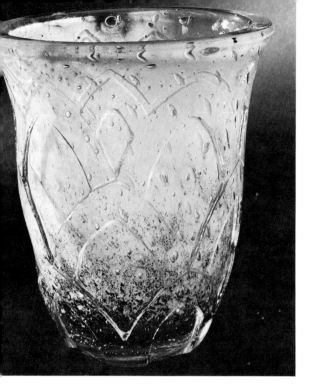

Fig. 309—Sculptured Cluthra vase, shaded black to white; height 8½ inches. *Corning Museum of Glass*

Fig. 310—Rose and green Cluthra lamp vase with etched crystal handles and Acid Cut-Back in the Chang decoration; metal base and cap; height of lamp vase 12 inches. *Rockwell collection*

Fig. 311—Blue Cintra candlestick trimmed with amber glass; height 11 inches. *Rockwell collection*

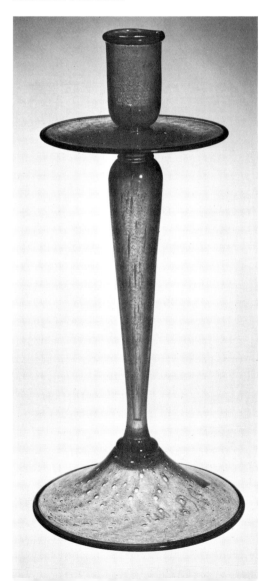

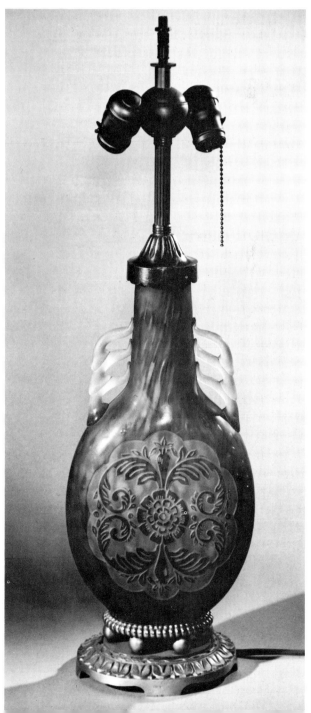

covered with the powdered glass, it was reheated—but not enough to destroy the granular effect as evidenced in Cintra wares—and blown into a cup of crystal to completely envelop the colored decoration.

Cintra wares with vari-colored designs, usually in stripes, were similarly made, but here the bulb of crystal glass was first blown into a pattern mold to produce a design of raised ribs on its surface. Then, when it was rolled over the marver, only the prominent portions of the mass—the raised ribs—picked up the ground glass. The parison was rolled on the marver to make it smooth again. It was blown into another rib mold, rolled over powdered glass of a different color, smoothed out, and the process repeated until the coloring was complete. It was then blown into a cup of clear crystal, and finally fashioned into the article desired (Figs. 311-315).

Mr. Carder made about ten pieces of Cintra with very intricate designs, such as the vase decorated with a bird and flowers shown in our color illustrations. These designs were painted on special paper with powdered colored glass and picked up on the parison. The paper quickly burned up from the heat of the molten glass, but the colored designs adhered to the surface of the parison.

There are many small bubbles throughout pieces of Cintra glass. The powdered glass, used to decorate these wares, leaves an irregular or roughened surface on the glass. After

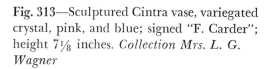

Fig. 312—Controlled Cintra tazza of blue and yellow, signed "Steuben"; height 7 inches. *Rockwell collection*

Fig. 313—Sculptured Cintra vase, variegated crystal, pink, and blue; signed "F. Carder"; height 7⅛ inches. *Collection Mrs. L. G. Wagner*

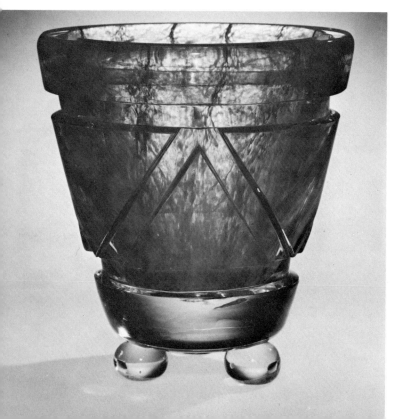

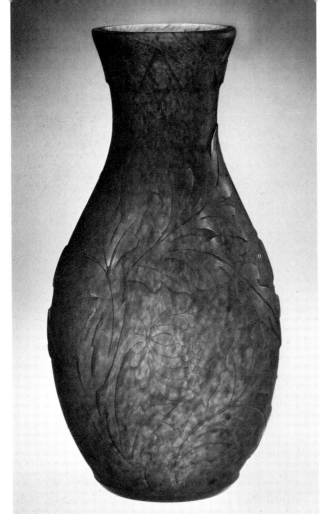

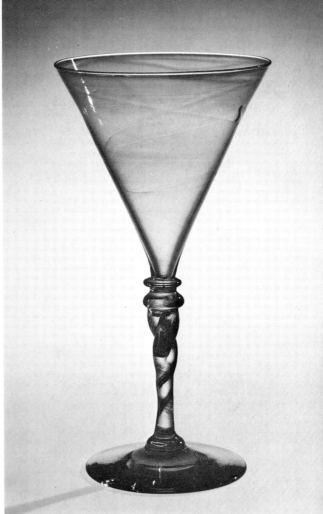

Figs. 314-315—*Left to right:* Rose Cintra vase with Acid Cut-Back design of chrysanthemums; signed in the design, "Steuben"; height 12⅝ inches. *Collection Mrs. L. G. Wagner.* Opaline wine glass with twisted stem of blue Cintra; height 7 inches. *Rockwell collection*

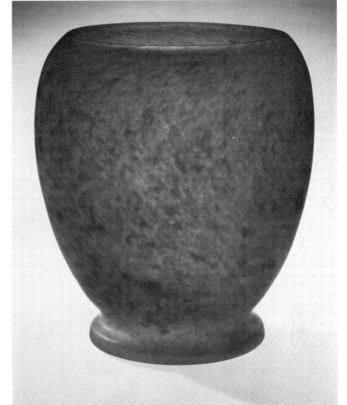

Fig. 316—Rose Quartz vase; height 7 inches. *Rockwell collection*

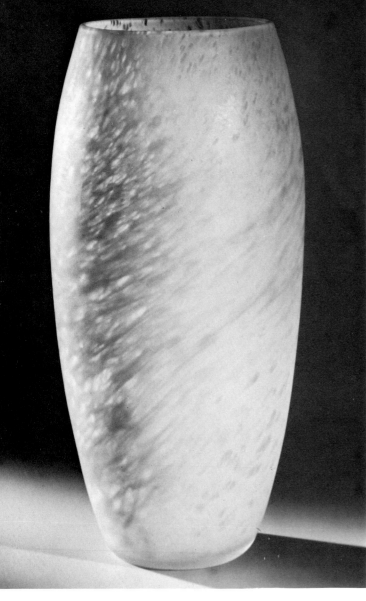

Fig. 317—Blue Quartz vase (shape No. 6763); height 10 inches. *Rockwell collection*

it has been blown into a cup of crystal glass, this uneven texture results in small bubbles between the two layers of glass.

Quartz Glass

Steuben's Quartz glass is actually their Cintra or Cluthra ware with an acid (mat) finish; each piece of Quartz glass is satin smooth to the touch. Some examples of Quartz glass have tiny bubbles throughout the

Fig. 318—Lamp with Acid Cut-Back design of Pegasus in black on a greenish-gold ground; gold Aurene decoration at top of lamp vase; gilded bronze base and cap; height of lamp vase 12 inches. *Rockwell collection*

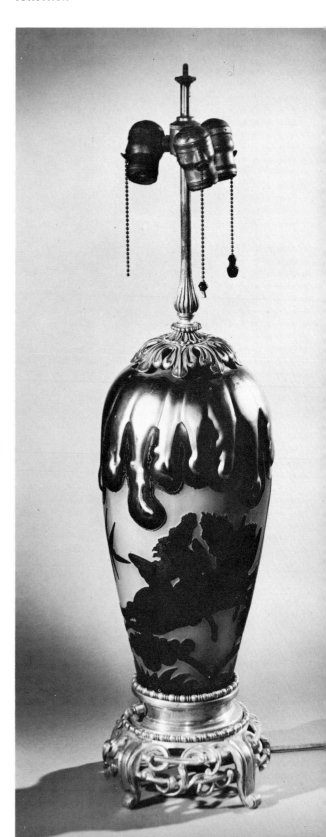

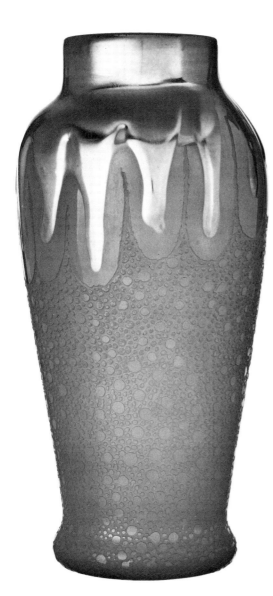

Sometimes their catalogs referred to Quartz glass as "Cluthra"; this happened several times when they were describing some of their Acid Cut-Backs made with Quartz glass bodies.

Quartz glass came in various colors. Rose, blue, green, and yellow are more often found than any others (Figs. 316-317).

Acid Cut-Backs

We could enumerate a prodigious list of variations on the theme of acid-etched designs on variously colored and cased glass blanks that Mr. Carder's fertile mind created for Steuben. Carder's Acid Cut-Backs are

Fig. 320—Acid Cut-Back vase, rose on bluish-white; Hunting decoration; height 12 inches. *Rockwell collection*

Fig. 319—Yellow Jade Acid Cut-Back vase with blue Aurene decoration at top; height 9¾ inches. *Collection Mr. & Mrs. Victor Buck*

metal; these would have been made from Steuben's Cintra glass. Other pieces of Quartz glass have rather large bubbles throughout the metal, and obviously these were made from Steuben's Cluthra glass.

Apparently even Steuben was confused at times about the correct designation for their Quartz glass.

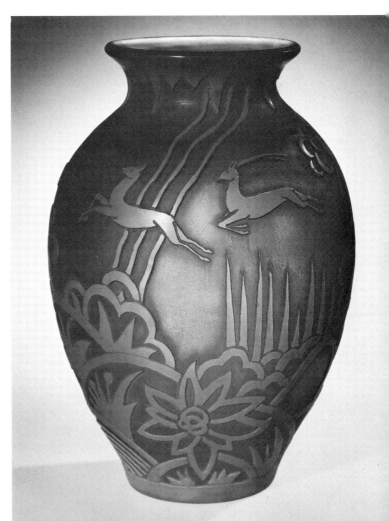

Fig. 321—Plum Jade bowl (shape No. 2687) with Acid Cut-Back in the Canton decoration; diameter 8 inches. *Author's collection*

closely related to the etched and carved cameo-glass productions made in France during the Art Nouveau period. Illustrations of most of Steuben's Acid Cut-Back designs— "Winton," "Thistle," "Marlene," "Acanthus," "Mansard," "Fircone," "Nedra," and "Canton," to name a few—can be found in the Steuben catalog pages reproduced in Appendix A of this book.

Apparently Steuben's Acid Cut-Backs were in production for some years. This is evidenced by their use of Jade, Aurene, Cintra, and Cluthra glasses in Acid Cut-Back wares (Figs. 318-330).

Bolas Manikowsky did most of the etching of the Acid Cut-Backs at the Steuben factory.

The glass-chipping process patented by Philip J. Handel (Handel & Company, Meriden, Connecticut) was also used at the Steuben works. Mr. Carder always referred to this technique as "glue chip." Since Handel's process was used at Steuben, we can naturally expect the same physical results—a frosted or iced effect on the surface of the glass.

Fig. 322—Acid Cut-Back bowl (shape No. 2687), blue Aurene on Alabaster; diameter 8 inches. *Rockwell collection*

Fig. 323—Acid Cut-Back vase (shape No. 6078), Green Jade on Alabaster; Floral decoration; height 8 inches. *Rockwell collection*

Steuben Glass Works

Fig. 324—Acid Cut-Back vase (shape No. 938), Jade Green to Alabaster, in the Bird decoration; height 9 inches. *Rockwell collection*

Figs. 325-326-327—*Left to right:* Acid Cut-Back lamp vase, double etched black to blue glass; height 15 inches. *Rockwell collection.* Brown Jade vase with Acid Cut-Back design in Blue Jade; height 12 inches. *Collection Mr. & Mrs. Victor Buck.* Acid Cut-Back vase, black and turquoise-blue Jade; signed "F. Carder"; height 12 inches. *Collection Mrs. L. G. Wagner*

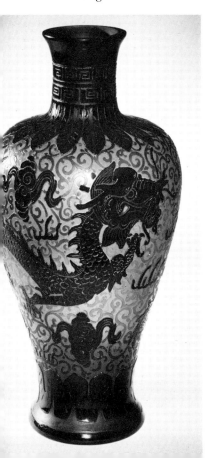 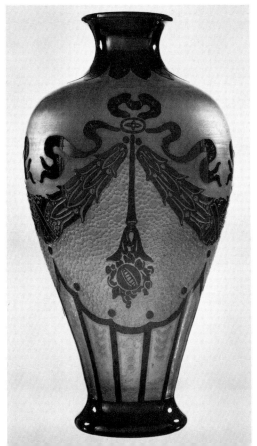 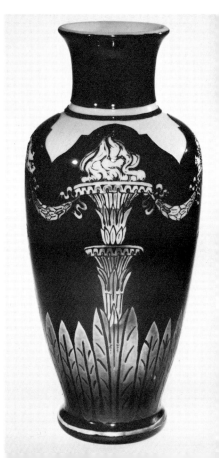

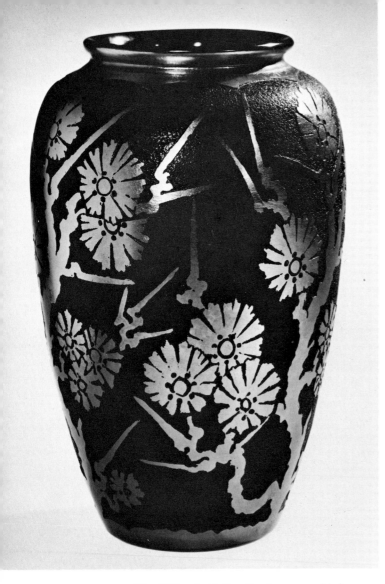

Bubbly Glass

Steuben's Bubbly glassware was produced in the same way as their Cluthra glass—by adding vegetable matter to the molten glass just before it was worked. However, for the Bubbly ware, crystal and transparent colored glasses were used—yellow, green, blue, rose, and so on. Often the Bubbly glassware was decorated with applied glass threads in a seemingly haphazard fashion. This was called "Reeded" decoration (Fig. 331).

Some pieces of Steuben's glass, other than the Bubbly wares, also were decorated with colored threads of glass. These were referred to in Steuben's catalogs as "Reeded Glassware" (Figs. 332-333). The distinctive finish of hand-applied threading is more desirable than the machine-threaded wares made by other glass factories in Europe and America.

Florentia

Florentia glass was described in Steuben's catalogs and advertisements as "frost-like beauty in white (Alabaster glass) Florentia glass decorated in green and rose." This ware was made with Steuben's Alabaster glass and decorated in the characteristic leaf design about the base of the object (or the center of the object if it were a bowl, tazza, or plate) with their Rosaline or Green Jade opaline glass. There are tiny mica flecks throughout the glass, and it has been given a roughened or mat finish with acids, which adds to its "frost-like" appearance.

Fig. 328—Acid Cut-Back vase, gold Aurene over black glass; Fircone decoration; height 8 inches. *Rockwell collection*

Fig. 329—Libation cup, Acid Cut-Back in light blue and crystal; Lion decoration; height 5½ inches. *Rockwell collection*

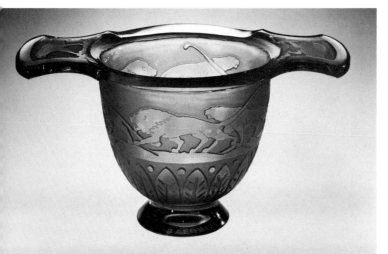

164

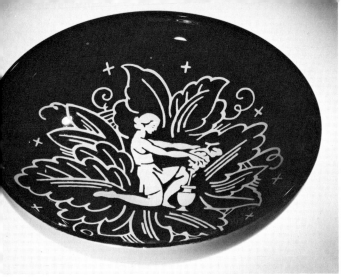

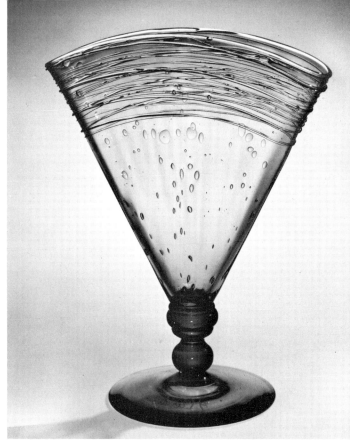

Figs. 330-331—*Left to right:* Acid Cut-Back bowl, black on white glass; diameter 10 inches. Fan-vase of Bubbly green glass with Reeded decoration at top; height 8½ inches. *Rockwell collection*

Figs. 332-333—*Left to right:* Covered crystal jar, pink Reeded decoration and flower stopper; height 6 inches. Crystal goblet, bowl in Diamond Optic pattern with blue Reeded decoration; Bristol yellow stem in Optic Twist pattern; height 8 inches. *Rockwell collection*

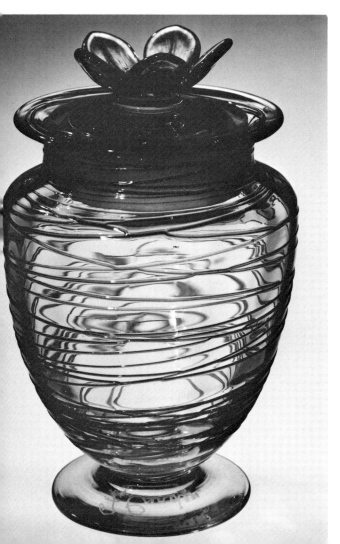

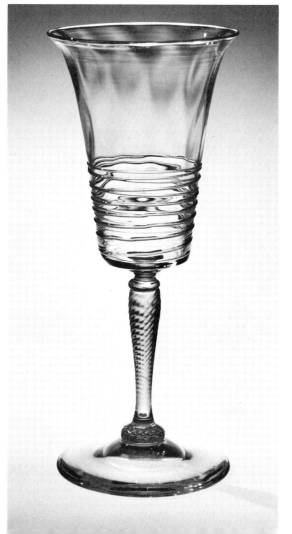

Fig. 334—Opalescent green, Optic Twist, candlestick; height 6½ inches. *Rockwell collection*

Opalescent Glass

Steuben's Opalescent wares were produced by plating a light bulb of colored glass with a transparent crystal made sensitive to temperature changes with the addition of an opacifying oxide—arsenic or bone ash. The article was blown into a pattern mold (usually vertical rib) and reheated to bring out an opalescence on the raised design. By twisting the parison right after it had been reheated to bring out the opalescence in the glass, a design of opalescent spirals was produced (Fig. 334). It was then rolled on a marver to smooth out the glass and ultimately formed into the desired article.

Carder's Opalescent wares came in at least three colors—light ruby, light green, and orchid. There may

have been other colors produced in this ware, too.

Clouded Glass

In an old Steuben Glass Works brochure, we found illustrations of their "Clouded Glass," which they produced in "Poppy" (rose-colored glass with vertical opalescent white stripes), "Jade" (green-colored glass with vertical opalescent white stripes), and "Orchid" (opalescent orchid-colored glass with vertical opalescent white stripes). These wares were also called "Oriental Poppy" (Figs. 335-336), "Oriental Jade," and "Oriental Orchid." Each variation of Steuben's Clouded glass was finished inside and out with a light haze of lustre that gives off a pearly iridescence.

Actually, Steuben's Clouded glass was nothing more than their Opalescent glass with a lustre finish. None of the pieces of their Clouded glass that we have examined to date bears a signature or mark of any kind. Since comparatively few pieces have come to light, it is impossible to say whether or not any of this ware was ever marked.

Ivrene, Calcite, and Ivory Wares

Steuben's Ivrene, Calcite, and Ivory glasses were essentially variations of a very old formula for an opaque white glass called "Opal" in the trade.

Ivrene glass was originally used for lighting fixtures—globes, ceiling fixtures, and lamp shades. Its pure white color and haze of pearly

Figs. 335-336—*Left to right:* Oriental Poppy vase; unsigned; height 6 inches. *Author's collection.* Oriental Poppy vase (shape No. 6030) ; height 7 inches. *Rockwell collection*

Figs. 337-338—*Left to right:* Ivrene Cornucopia footed vase, signed "Steuben"; height 8 inches. Ivrene tri-lily vase; height 12 inches. *Rockwell collection*

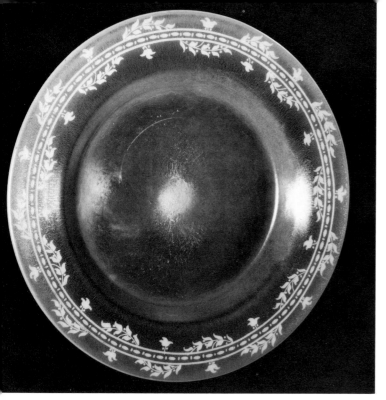
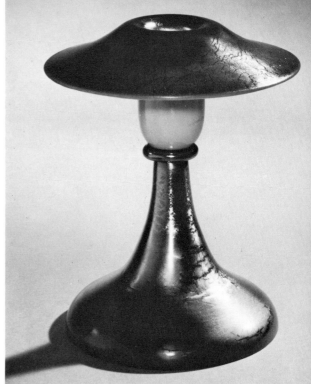

Figs. 339-340—*Left to right:* Gold Aurene on Calcite plate, copper-wheel engraved design around rim; diameter 8 inches. Blue Aurene on Calcite candlestick; height 6½ inches. *Rockwell collection*

iridescence produced a soft luminous effect well suited for illuminating glassware. The pearly iridescence was the result of a lustre that was sprayed on the surface of the opaque white glass. Sometimes this was etched and engraved with designs, revealing the flat white color of the glass itself (Figs. 337-338).

Mr. Carder also plated or cased his Ivrene glass with Gold or Blue Aurene. These wares were listed in Steuben catalogs as "Gold Aurene on Calcite" or "Blue Aurene on Calcite" (Figs. 339-342).

The Steuben Glass Works registered the trademark "Calcite" on June 1, 1915 (Fig. 343). The mark was a combination of their fleur-de-lis mark with a ribbon across the front and the word "Calcite." The papers stated it had been in use by them since June 1910.

By adding a small amount of

Figs. 341-342—*Left to right:* Blue Aurene on Calcite saucer; diameter 6 inches. Gold Aurene on Calcite ashtray, leaf decoration; length 6 inches. *Rockwell collection*

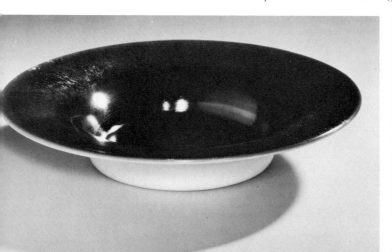
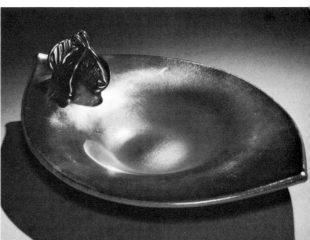

Fig. 343—Trade mark for Calcite wares issued to the Steuben Glass Works, Corning, N.Y., June 1, 1915.

uranium salts to an Opal glass melt, Carder produced a pale yellow glass which he named "Ivory." He obtained some interesting color effects by decorating his Ivory glass with jet black glass (Figs. 344-345).

Silverine Glass

Silverine glass was made by rolling a gather of transparent colored or crystal glass over a marver lightly strewn with tiny mica flecks. The plastic glass picked up the mica flecks and was then blown into a pattern mold which formed diamond-shaped indentations on the blow. Next, the glass worker blew the gather into a cup of transparent colored or crystal glass and finally blew the parison into the desired shape.

Sometimes Silverine glassware was given a mat finish, and occasionally it was also lightly lustred. The colors used are usually pastel shades; deep shades would tend to obscure the flecks of mica in the glass. Tablewares, center bowls and matching candlesticks, and many

other decorative objects were produced in Steuben's Silverine glass (Figs. 346-348).

Moss Agate Glass

The Moss Agate glass Mr. Carder made at Steuben was much more colorful than the Moss Agate he designed for Stevens & Williams of Brierley Hill, England. Vivid shades of green, yellow, blue, orange, and purple are to be found in this ware. The various colors were picked up by rolling the glass over a marver on which pulverized glass of different shades had been strewn and pulled, with a pointed hook, to imitate the

Fig. 344—Ivory glass pear; height 5½ inches. *Collection Mr. & Mrs. Victor Buck*

Fig. 345—Chess men in black and ivory glass; height of kings 3⅝ inches. *Collection Mrs. L. G. Wagner*

Fig. 346—Amethyst Silverine vase (shape No. 938); height 9 inches. *Rockwell collection*

Fig. 347—Blue Silverine bowl; diameter 11 inches. *Rockwell collection*

Figs. 348-349-350—*Left to right:* Silverine goblet, crystal; height 7 inches. *Library collection, Corning, N.Y.* Moss Agate vase, multicolored; height 11 inches. *Rockwell collection.* Intarsia vase, crystal with blue decoration; signed "Fred'k Carder"; height 6 inches. *Author's collection*

appearance of Moss Agate. Vases and lamp shades are all the author has encountered in this kind of glass (Fig. 349). It appears to be difficult to find today; quite likely not much of it was produced.

Intarsia Glass

Between 1916 and 1923 Frederick Carder produced about fifty pieces of Intarsia glass. This ware he considered one of his finest achievements, and honored it with his signature. "Fred'k Carder" was

beautifully engraved in a prominent place on most of the pieces made at the Steuben plant. Intarsia was not a new technique; similar ware had been produced in Sweden at the Orrefors glass works, where it was called "Graal" glass.

In making a piece of Intarsia glass, a bulb of crystal was plated with a colored glass and allowed to cool and anneal. The colored "show" was painted with a design in acid-resist (a mixture of asphaltum and wax), and the superfluous glass was etched

away, leaving the protected design in very shallow relief. Thereafter, the decorated "show" was slowly reheated, picked up on the blowpipe, and blown into a cup of crystal glass made to receive it. It was again reheated and blown out with great care so as not to distort the colored decoration. After the stem or foot had been added to the article, it was placed in the annealing oven and slowly cooled. The finished product had a design of colored glass sandwiched between two layers of crystal (Figs. 350-352).

Mr. Carder had only one man at the Steuben works who was competent enough to make his Intarsia wares—Johnny Jensen, a Swede. Mr. Carder had groomed Jensen for the glass trade from the time he entered Steuben's employ as a carry-in boy. Mr. Carder personally painted and etched the designs on the colored casing, and stood by in a supervisory capacity while Jensen performed the rest of the operation.

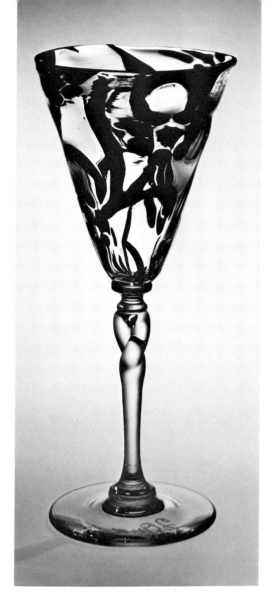

Fig. 351—Intarsia goblet, crystal with black decoration; height 8 inches. *Rockwell collection*

Fig. 352—Intarsia vases and bowls, Bubble-balls on stands, and a large Millefiori plaque in center. *From a photograph of a Steuben exhibition at the Metropolitan Museum of Art, New York City, ca. 1925.*

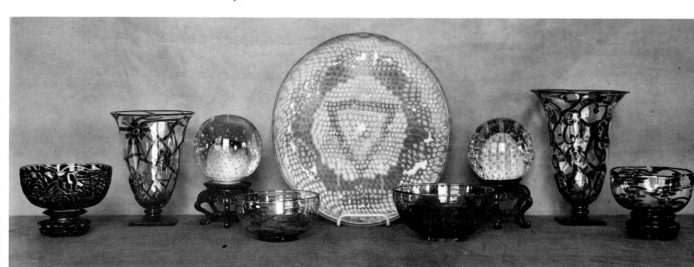

Millefiori Tessera Glassware

In referring to his Millefiori glass productions, first made in 1910, Mr. Carder often used the term "Tessera" (tile or mosaic work). Most of these wares made at Steuben were fashioned in the same way the ancients made Millefiori glass.

First, several different kinds of glass rods, in a wide variety of color combinations and patterns, were made, then cut in sections a quarter of an inch long. These millefiori rod sections were placed side by side in a mold and reheated in a muffle until the edges of the rods were fused together. The whole was then removed from the kiln and worked, in another mold, into a coupe-shaped plate (Fig. 353) or a shallow bowl. Small plaques and other articles also were made this way; some were mounted as decorations for metalwares, such as lids for boxes.

Sometimes the fused rods were picked up on a gather of clear glass and blown and shaped into bowls, vases, and plaques.

Mr. Carder designed his own Millefiori patterns, and some of his rods contain examples of his transparent and opaque colored glasses. Not many pieces of Millefiori were made due to the difficulty of the procedure.

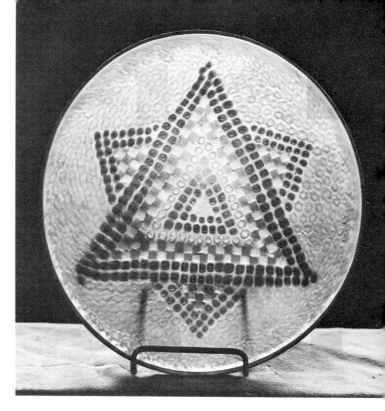

Fig. 353—Millefiori plate; from an old photograph with handwritten notation, "Millefiori or Glass Mosaic," and initialed "F.C." (F. Carder).

Fig. 354—Sculptured crystal vase (shape No. 7479) with high relief design of flowers and leaves; Millefiori decoration in center of each blossom; height 12 inches. (Vases of this description were offered in a Steuben catalog, ca. 1932, for $19.00 each f.o.b. Corning, N.Y.) *Photo from an original Steuben catalog*

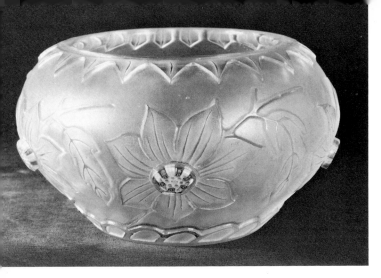

Fig. 355—Sculptured crystal bowl (shape No. 7480) with high relief design of flowers and leaves; Millefiori decoration in the center of each flower; diameter 10 inches. *Photo from an original Steuben catalog, ca. 1932*

Millefiori Decorated Sculptured Vases

A few years ago we came upon a most interesting piece of Steuben Millefiori decorated glass—a vase of sculptured crystal, decorated with cameo-relief designs of flowers and leaves with the center of each flower represented by a roundel of millefiori rods. Original Steuben photographs of two similar vases were lent the author by Mr. Bob Rockwell (Figs. 354-355). The vase we examined was in the collection of the Alfred University Museum, Alfred, New York, and had been presented to that museum by the late Dr. Alexander Silverman. Undoubtedly there are only a few such pieces extant. The workmanship is of the finest quality, both in the carving of the crystal glass and in the design of the millefiori decorations.

Matsu-No-Ke Cactus Glassware

Frederick Carder patented very few designs for glassware, but in one instance he filed eleven separate

registrations for objects embellished with a type of applied decoration, known in England as "Matsu-No-Ke." Its obvious relationship to Stevens & Williams' Matsu-No-Ke wares, made prior to the turn of the century, cannot be denied. However, since Mr. Carder originated this design for Stevens & Williams, it is not difficult to see how he felt justified in revamping it somewhat and using it again for his own wares in later years.

The design patents were all filed on May 11, 1922, but they were validated at different times: eight were issued on February 13, 1923; one each on March 6, 1923, May 8, 1923, and June 12, 1923. Obviously these wares were in production at the time the patents were issued, and quite likely the year before. So far, no signed pieces have been found; perhaps this seeming indifference to identifying these wares with Steuben was intentional.

Mr. Carder was surprised to see these design patents when we showed them to him in 1962; he had completely forgotten he had made such things. He immediately referred to the decoration as Matsu-No-Ke, but later in the conversation he called it "Cactus." Contemporary Steuben catalogs illustrated etched designs of a similar character, which were called "Matzu" and "Fircone."

Steuben's Matsu-No-Ke wares were made in clear crystal with applied decorations and handles in transparent colors—blue, green, rose, amber, and "Rosa" (Figs. 356-358). Some pieces have applied decorations

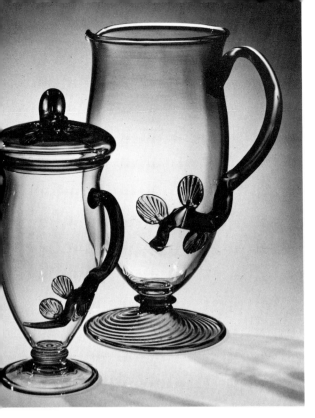

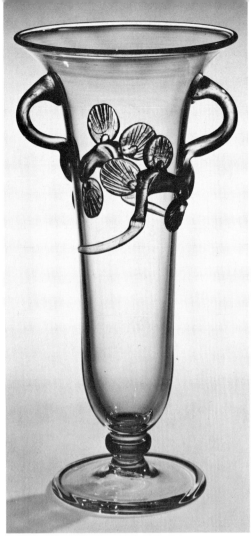

Figs. 356-357—*Left to right:* Matsu-No-Ke pitchers, crystal with Celeste Blue decorations; the taller, 9 inches high, has an optic twisted foot; the shorter, 8 inches high, is covered. Matsu-No-Ke footed vase, crystal with Amethyst decoration; height 8 inches. *Rockwell collection*

Fig. 358—Matsu-No-Ke cream and sugar set, crystal with Rosa decoration; height of creamer 4 inches. *Rockwell collection*

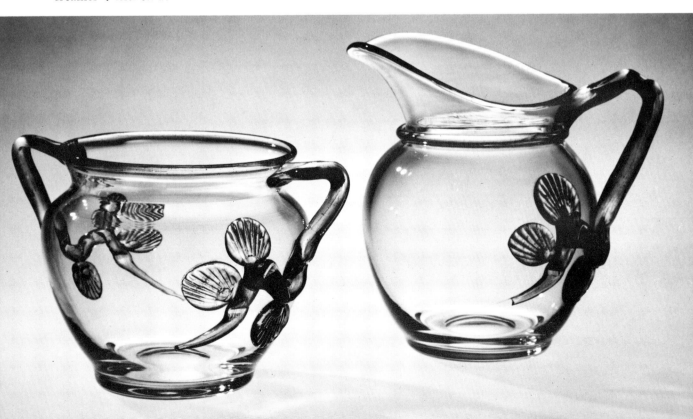

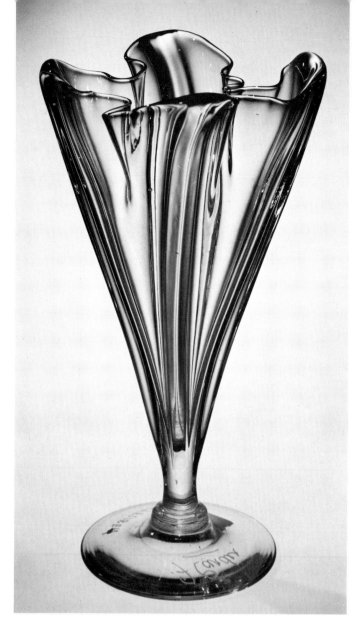

of other of the transparent or translucent colored glasses made at Steuben.

Grotesque Glassware

The name "Grotesque" was applied to the *form* of certain vases and bowls produced at the Steuben factory. It did not relate to any particular kind of glass used in their production. Mr. Carder's strict adherence to classical shapes for his wares was only slightly adulterated in his Grotesque shapes. Actually these pieces were well designed and as symmetrical in their form as any of his other objects.

The studied distortion of Carder's Grotesque glassware was not entirely original. It can be found in early examples of Venetian glass; Powell & Sons made a similar shape at their Whitefriar's Glass Works in London shortly before 1900, when Whitefriar's was making glass in the Venetian style.

The so-called "handkerchief" form of the vases and bowls made in Steuben's Grotesque shapes were relatively simple to execute. After the object had been formed, and the rim flared out in an exaggerated manner, it was turned upside down while it was still very plastic. Naturally, the flared rim collapsed. This was the "handkerchief" shape. If the desired effect was not fully obtained by this "upside-downing," the glassworker could "tease" the flared rim into more symmetrical folds and points.

Steuben's Grotesque wares are

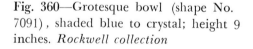

Fig. 359—Grotesque vase, shaded rose to crystal; height 11 inches. *Rockwell collection*

Fig. 360—Grotesque bowl (shape No. 7091), shaded blue to crystal; height 9 inches. *Rockwell collection*

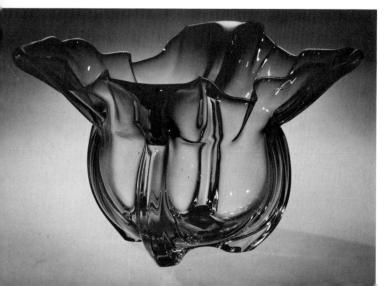

Fig. 361—Grotesque vase, shaded Rosaline to Alabaster; height 4½ inches. *Collection Mrs. L. G. Wagner*

distinctive for several reasons, but chiefly for the subtle gradations of transparent color—blue, rose, green, yellow, amber, or purple—into brilliantly clear crystal. Some Grotesque wares were produced also in plain crystal, in colored crystal, and in some opaque glasses.

In many instances, particularly with bowls and heavy-based vases, it is obvious that the foot is molded. (The shapes can be seen in our illustrations; Figs. 359-361). After the object had properly annealed, the base was ground and polished to a smooth finish so that no marks or pontil scars are visible. Stemmed vases required a foot attached in the usual fashion.

Paperweights and Bubble-Balls

Prior to the 1940s, a man named John Sporer produced some lily-type flower paperweights for Steuben. These weights are brilliantly colored

—red, blue, green, yellow, and purple—with an air-bleb rising from the center of the flower to form the pistil. Some of them have the name Steuben and the fleur-de-lis mark lightly etched in the base or along the lower side near the base (Fig. 362). After Mr. Sporer died, early in the 1940s, paperweights of this type were no longer made.

Bubble-balls, large and small, were produced at Steuben. Some have large air-blebs included as part of the interior decoration. These were made in the 1930s and 1940s, and were sometimes mounted on metal or glass bases to be used as Luminors (Fig. 363).

Fig. 362—Paperweight with green and lavender flower, signed "Steuben"; diameter 3¼ inches. *Collection Paul Jokelson*

Heavy Cologne Bottles

For some years collectors have referred to Steuben's Heavy Cologne Bottles as "paperweight bottles." The term is not entirely incorrect, but they were not called that at Steuben. These bottles, as their name given by Steuben implies, are extremely thick and heavy; the enclosed decorations run the gamut from Cluthra glass through air-trap spiral and bubble formations (Fig. 364). The bottles are usually marked with Steuben's fleur-de-lis and the name.

We know of only one instance where Mr. Carder had his signature engraved on a bottle; this was done as a special favor for a very fine lady of his acquaintance. When this lady and her husband were visiting Mr. Carder some years ago she asked him if it would be possible to replace the broken stopper to her Heavy Cologne Bottle. Mr. Carder obligingly made another stopper for her, one that was somewhat larger than the original which he always felt was too small in relation to the size of the bottle.

Pressed Glassware

Steuben made many articles in pressed glass—ashtrays; Lincoln and Washington Head plaques with metal bases; eagle, pheasant, gazelle, duck, and pigeon figurines (later cut and polished to remove the mold marks); "Luminors" (decorative plaques or figurines lighted from beneath to bring out the reflected designs); and fancy stems and feet for candlesticks and centerpiece bowls

Fig. 363—Crystal Bubble-ball lamp on heavy brass base; height 9½ inches. *Author's collection*

Fig. 364—Heavy Cologne bottle with internal decoration of black and white Cluthra and air-blebs; height 8 inches. *Rockwell collection*

FIG. 1.

FIG. 3.

FIG. 2.

FIG. 4.

Fig. 365—Frederick Carder's design for a flower holder (issued Oct. 4, 1921).

which were afterward joined to blown-glass fittings and bodies.

Many of Steuben's centerpiece bowls were fitted with Frederick Carder's patented design for a flower block (U.S. Design Patent No. 59,186), dated October 4, 1921 (Fig. 365). The form of this flower holder is quite like one patented for Tiffany Furnaces by Arthur J. Nash on April 24, 1917. Some of Steuben's flower blocks were topped by pressed-glass figures—a kneeling girl, an elephant, and a fish are illustrated in one of their catalogs.

Design patents for a cream pitcher and matching sugar bowl were issued to Frederick Carder on November 13, 1923, and February 26, 1924 (Fig. 366). Mr. Carder identified them for the author some years ago as having

been especially made for the Macbeth-Evans Glass Company of Charleroi, Pennsylvania. He said that these articles were pressed in an ivory-colored glass, by Steuben and by Macbeth-Evans in other opaque colored glasses. In many respects the designs resemble contemporary silverware which, in the mid-1920s, tended to be simple and straightforward.

A design for a pressed-glass teapot made of Corning's famous Pyrex was issued to Mr. Carder on February 13, 1923.

Fig. 366—Frederick Carder's designs for a pressed glass sugar bowl (issued Nov. 13, 1923) and a cream pitcher (issued Feb. 26, 1924).

Prior to Frederick Carder's retirement in 1934, he had been experimenting with casting large pieces of glass to be used as architectural decorations. Some of his cast glass was used as elevator grilles, some as decorative sectional pieces which were fitted together to form a repeat frieze. From his retirement until 1959, when he closed his studio, Carder, on his own, devoted the greater part of his time, energies, and talents to casting glass objects.

At first, he made heavy bowls and ashtrays with relief decorations in the manner of Lalique's work in the 1930s. Then, in the 1940s, he worked on figures in the round, high-relief portraits of famous people and

Fig. 368—"Triton"; a Cire Perdue sculpture in crystal; signed "F.C."; height 13 inches. *Rockwell collection*

Steuben made pressed wares (cheap things) from molds supplied by other companies; they also designed molds for pressed wares which were manufactured and sold by other firms and do not bear Steuben's identifying marks. Among the more distinguished pressed ware made at Steuben were their chessman sets which were made in various colors.

Cast and Sculptured Glass, Cire Perdu, and Diatreta

All these techniques—cast and sculptured glass, Cire Perdu, and Diatreta—have one thing in common: they were produced by a form of invest casting.

Fig. 367—Pate de Verre plaque, Rosaline head on Alabaster square; signed on back "Fred. Carder"; length 4 inches, width 2⅝ inches. (Note textured surface of this piece which is typical of most Pate de Verre productions.) *Author's collection*

Fig. 370—Sculptured crystal head (Cire Perdue) by Fred Carder, 1946, height 7⅞ inches. *Corning Museum of Glass*

Fig. 369—Lion in sculptured crystal (Cire Perdue) by F. Carder, 1943; length 8½ inches. *Corning Museum of Glass*

Fig. 371—Compote of sculptured crystal (Cire Perdue); diameter 12 inches. *Rockwell collection; ex-coll. Frederick Carder*

friends, and models of athletes in action. Between 1950 and 1959, he began to replace the frosted crystal glass he had been using for his cast and sculptured works with color (Fig. 367).

To produce even more intricate relief designs, he resorted to the Cire Perdu or "lost wax" process (Figs. 368-371). Here, his model was fashioned in wax, then covered with a ceramic paste (a combination of plaster-of-Paris, silica, and clay), which hardened about the model. It was then placed in a kiln to melt out the wax. When this was completed, there remained a hollow mold, to be used for a single object. Into this mold finely ground crystal and/or colored glass was poured. The mold was again put in the kiln, the temperature gradually brought up sufficient to melt the ground glass, then allowed to cool slowly. When the glass had cooled, the ceramic paste mold was chipped away, freeing the glass object it had formed.

Perhaps the most difficult of all glass techniques was the Diatretas produced in ancient times. By the "lost wax" process, Frederick Carder reproduced this form. Most of Carder's Diatretas were made in the last five or six years that he worked in his studio. Not many of them were produced, and each one was made entirely by Mr. Carder himself, from the designing and modelling through the casting to the final chipping away of the mold (Figs. 372-374).

Figs. 372-373—*Left to right:* Diatreta vase, variegated green, blue, and crystal, mat finish; signed "Fred Carder/1953"; height 10 inches. *Author's collection.* Diatreta vase, translucent rose-colored glass; mat finish; signed "F. Carder/1952"; height 7 inches. *Smithsonian Institution*

Fig. 374—Diatreta vase, crystal, mat finish; signed "F. Carder"; height 8 inches. *Rockwell collection*

VINELAND FLINT GLASS WORKS

VICTOR DURAND was born in 1870 in Baccarat, France, where Durands had lived for generations. His father, grandfather, and great-grandfather before him had all worked at the famous Cristalleries de Baccarat, and young Victor, following their footsteps, went into the glassworks when he was 12 years old. His father's decision to move his family to America caused much consternation and aroused many doubts and fears, and to pave the way, the senior Durand, also named Victor, went ahead to the United States by himself. He located at Millville, New Jersey, where he worked both at the Wheaton Glass Works and at Whitall-Tatum & Company.

Two years later, in 1884, his family joined him, and young Victor, then 14, went to work at the Whitall-Tatum factory. Within the next few years he began to move about to other glass factories, learning various glass techniques on each new job. His wanderings took him to glass factories in Pennsylvania, Ohio, West Virginia, and even to Canada.

In 1897, Victor Durand was back in New Jersey and with his father leased the glassworks formerly occupied by The Vineland Glass Manufacturing Company in Vineland. (This firm had been established in April 1892, by Joseph H. C. Applegate, Millard F. Applegate, David C. Applegate, Louis S. Johnson, William M. Manks, Samuel C. Sherry, and Samuel Peacock, and the factory had

produced what is known in the trade as "greenware"—common bottles and jars.) The Durands built a new furnace and engaged in the making of glass tubing and rods, specializing, too, in the manufacture of clinical and thermometer tubes.

In the beginning, Victor Durand, Sr., was president of the company and Victor Durand, Jr., the secretary. Some years later, Victor Durand, Jr., became the sole owner of the company. His father stayed on in a semi-retired position for several years, teaching the men how to make the various wares the company was producing at that time.

Victor's brothers—Henry, Charles, and Paul—worked at the glass factory in various capacities, but none of them ever held an executive position. (In August 1916, Charles and Paul Durand, together with Louis J. Koering and George Deleruyelle, formed the Durand-Koering Glass Company, manufacturing glass tubing and rods, chemical glassware, and light bulbs.)

In October 1920, the Vineland Chamber of Commerce reported that the Durand interests constituted a very large part of the all-important glass industry in Vineland, covering four distinct enterprises: the VINELAND FLINT GLASS WORKS, the Vineland Scientific Glass Company, the Newfield Glass Company, and the New Jersey Clay Pot Company. The combined factories gave employment to more than 700 workers. Victor Durand was the sole owner of the Vineland Flint Glass Works, and the majority stockholder in the three other concerns.

The Vineland Flint Glass Works became one of the most successful privately-owned factories in the country. Their daily production of thermos bottles alone exceeded 40,000 units, and from 10,000 to 15,000 pounds of glass tubing were turned out each day.

Victor Durand had always dreamed of someday producing artistic as well as commercial glassware and, in 1924, after an exchange of correspondence with Martin Bach, Jr., who had grown up in the Quezal Art Glass Company, he was ready to go ahead in the fulfillment of this dream.

Martin Bach, Jr., after his father's death, had had many difficulties trying to keep the Quezal Art Glass & Decorating Company in business. It had finally failed, and Bach had gone to work for the Imperial Glass Company, in Bellaire, Ohio, taking with him some of the men who had worked for him in Brooklyn. He was in Toledo, Ohio, preparing to combine his knowledge in the manufacture of art glass with a firm then manufacturing medical glassware, when Victor Durand began contacting him.

Durand wrote in one of his letters: "If you would come to Vineland and show us how all this work is done, I would be willing to pay you what it was worth, or if you could work for us, I would like to have you very much. We are going into this line as we have some very good glass blowers in our employ at this time.

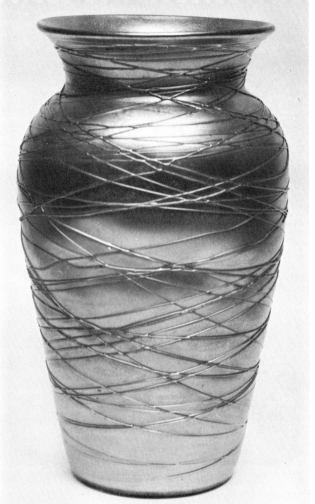

Figs. 375-376—*Left to right:* Gold lustre vase; signed "V-Durand 1974-6"; height 6 inches. *Rockwell collection.* Gold lustre vase with Spider Webbing decoration; signed "V-Durand 1812-8"; height 8 inches. *Collection L. A. Randolph*

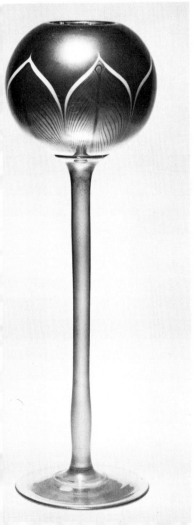

Figs. 377-378-379—*Left to right:* Hock glass with ruby bowl decorated with white and gold lustre Peacock Feather design; Ambergris lustred stem and foot; height 11 inches. *Collection Sam Farber.* Lustred Ambergris glass vase with pulled decoration in opal and brown; height 7 inches. *Rockwell collection.* Tobacco jar of blue lustre glass with white Peacock Feather design; height 6½ inches. *Durand-Cunningham collection*

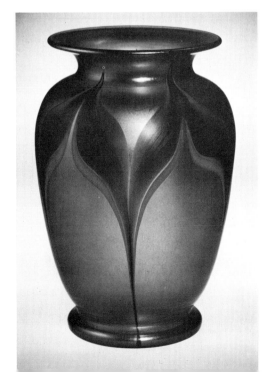

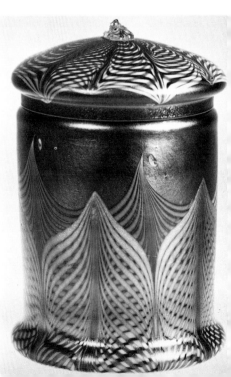

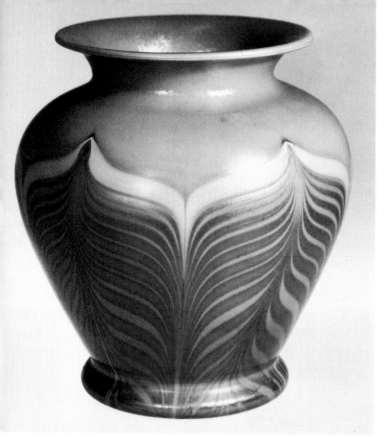

Fig. 380—Vase of opaque pink glass with pulled threaded decoration in opal and gold lustre glass; height 8½ inches. *Collection Sam Farber*

first-prize gold medal at the Sesquicentennial International Exposition at Philadelphia.

Only one shop at the Durand factory produced art glass. It consisted entirely of men who had worked for Bach at Quezal in earlier years. Emil J. Larson was the gaffer; William Wiedebine, decorator; Henry Britton, servitor; Percy Britton, gatherer. Three or four boys assisted the men as bit boy,

"If you care to come to Vineland to talk the matter over, I am willing to pay your expenses, or if you prefer, I can arrange to come to Toledo sometime in the near future. Please advise me before doing anything, as I am away a good deal of the time."

In December 1924, Martin Bach, Jr., established an art glass shop at the Durand factory, and the manufacture of Durand art glass was commenced shortly thereafter. Two years later, in 1926, to Victor Durand's deepest satisfaction, DURAND ART GLASS was awarded the

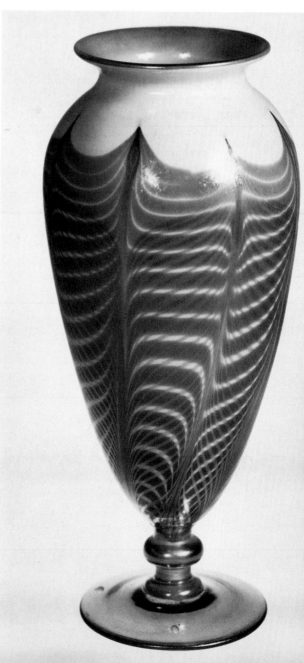

Fig. 381—Vase of opal glass with blue and green threaded and pulled decoration; amber foot; lustred; height 11 inches. *Durand-Cunningham collection*

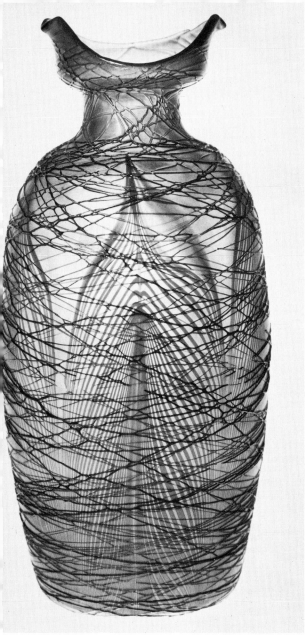

pieces of Durand art glass looked very much like Quezal in color and decoration. However, the Quezal colors and designs were soon replaced by new ones created by Martin Bach and a staff of artist assistants. Not only new designs, but new color effects were developed for Durand Art Glass.

In 1931, Victor Durand suffered a fatal automobile accident. A sporty-type man, he had always loved automobiles, and drove only the latest, most high-powered and beautifully appointed models. On the day of his accident he was returning from his dentist's, and it was thought the effects of the anesthesia he had taken had not completely worn off.

Fig. 383—Covered jar of gold lustre glass with opal and gold lustre Peacock Feather pattern and all-over Spider Webbing in gold lustre; finial made of Ambergris glass; signed "Durand"; height 11 inches. *The Chrysler Art Museum of Provincetown (Mass.)*

Fig. 382—Gold lustre glass vase with opal Peacock Feather and gold lustre Spider Webbing decorations; height 8½ inches. *Durand-Cunningham collection*

sticking-up boy, mold boy, and carry-in boy.

To produce the colored glasses needed for the art work, Martin Bach used the formulas handed down to him by his father. Since these had been originally used for the wares made at his father's factory, the first

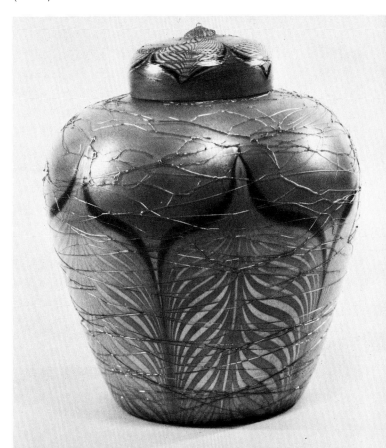

187

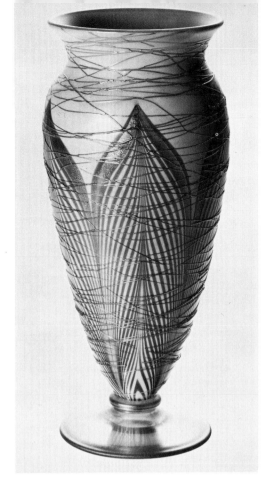
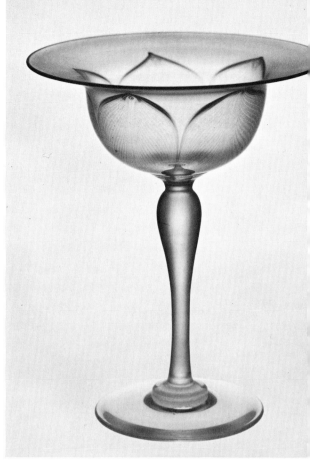

Figs. 384-385—*Left to right:* Opal glass vase with Peacock Feather design in blue and gold lustre; oil lustre foot; signed "V-Durand, 2028½–8"; height 8½ inches. *Collection Mr. & Mrs. Howard Decker.* Compote of crystal glass with pink Peacock Feather decoration in bowl; lustred all over; height 6½ inches. *Durand-Cunningham collection*

Figs. 386-387—*Left to right:* Low compote of shaded clear to amber glass with Peacock Feather decoration; lustred; diameter 8 inches. Opal glass vase with blue lustre top and gold lustre foot and stem; height 8½ inches. *Durand-Cunningham collection*

He crashed into an abutment, the impact throwing him through the windshield. He was terribly cut about the face and throat. When the news came swiftly to the factory that Mr. Durand was in the hospital, every man there laid aside his work and went directly to donate blood for the man they held in such high esteem. Mrs. Durand and her family were deeply moved by this show of love and sincere admiration. Mr. Durand lived only twenty hours.

At the time of Victor Durand's death, the Vineland Flint Glass Works was in the process of merging with the Kimble Glass Company. Actually, these two firms had merged before, in 1911, but had become individual enterprises again in 1918. The second merger was eventually completed in 1931, and the company thereafter was known as the KIMBLE GLASS COMPANY.

The production of art glass continued only a short period after Mr. Durand's death. Old-time residents in the Vineland area recalled that the art-glass remainder stock was either sold for a fraction of its cost or broken up and carted off to dumps.

Lustred Glassware

Lustred glass was produced at the Durand factory in the same way it was made at Tiffany, Steuben, Quezal, and all the other art-glass shops. At the Durand factory the pale yellow glass necessary for producing lustred effects was officially called "Ambergris"; the workers called it "Oil Glass" (Figs. 375-414).

Fig. 388—Trumpet vase of opal glass decorated with blue and gold lustre; made by Victor Durand for his wife; height 9 inches. *Durand-Cunningham collection*

Fig. 389—Blue rose-bowl vase; etched designs of flower and neo-classical motifs; height 7½ inches. *Durand-Cunningham collection*

Figs. 390-391—*Left to right:* Blue lustre vase with cameo-etched designs; applied Ambergris handles; height 11 inches. Gold lustre vase with cameo- and intaglio-etched floral and neo-classical designs; height 12½ inches. *Durand-Cunningham collection*

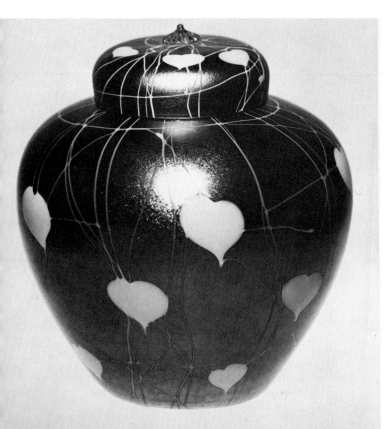

Fig. 392—Blue lustre glass covered jar with white Heart and Clinging Vine decoration; signed "V-Durand 1964-8"; height 8 inches. *Collection Sam Farber*

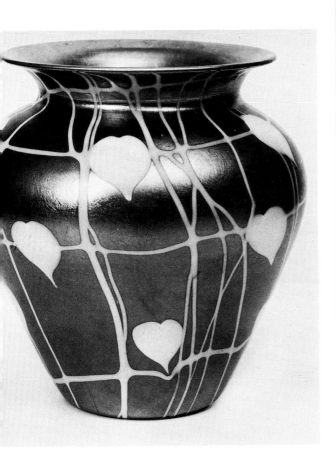

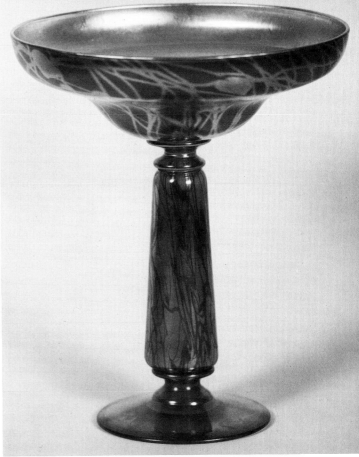

Figs. 393-394—*Left to right:* Blue lustre vase with white Heart and Clinging Vine decoration; signed "V-Durand 1710-6"; height 6 inches. *Author's collection.* "Special Compote" in blue lustre with silver-blue Heart and Clinging Vine decoration, Ambergris lustred foot; signed "Durand"; height 8½ inches. *Collection Dr. Irving P. Tuttle*

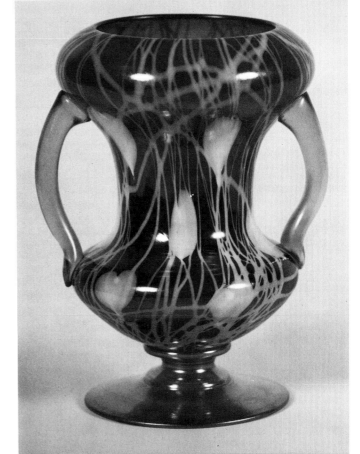

Fig. 395—Blue lustre handled vase with white Heart and Clinging Vine decoration, gold lustre foot, Ambergris handles; height 6½ inches. *Collection Dr. Irving P. Tuttle*

191

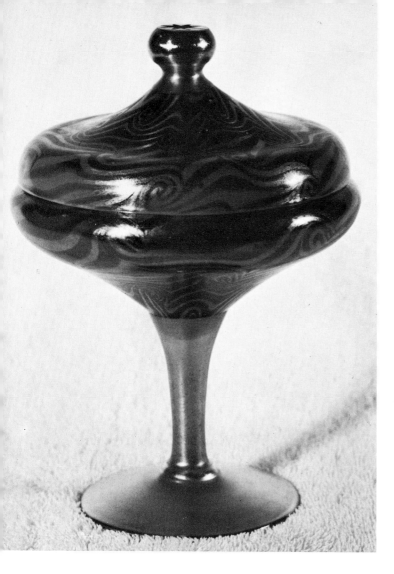

Fig. 396—Covered compote of blue lustre glass with gold lustre King Tut decoration; stem and foot in oil lustre; height 6½ inches. *Collection Minna Rosenblatt*

Fig. 397—Opal vase with blue and gold Hearts and gold Spider Webbing; height 10 inches. *Collection Sam Farber*

Martin Bach, Jr., elaborated on this old technique by using applied decorations—many of them repeating designs used at the Quezal glassworks.

The "Heart" design was made by placing a small blob of glass on an object and pulling it into shape with a hook-like tool. It was almost always used in combination with a vine-like decoration known as their "Clinging Vine" or "Vine" design.

Trailings of fine glass threads all over a glass body was called "Spider Webbing," "Spider," "Webbing," or "Broken Threads."

The "King Tut" (Figs. 396, 401)

and "Coiled" patterns are much alike, except that the "King Tut" design is more regular. After laying on heavy threads of glass to a glass body, the worker pulled the threads into hooked designs all over the object. This decorating technique was used years before at the Quezal factory.

In several Durand catalogs, the terms "Peacock" and "Feather" were used interchangeably for the "Peacock Feather" pattern. In only one instance—when the "Peacock Feather" pattern in Opal glass was used to decorate Flashed Ruby, Blue, and Green wares—was the term

Fig. 398—Opal glass vase with blue and gold lustre Hearts and gold lustre Clinging Vine decoration; signed "Durand/7-1A"; height 16½ inches. *Collection L. A. Randolph*

Fig. 399—Ambergris vase with opal Heart and Clinging Vine decoration, silver lustred; Vineland Flint Glass Works, ca. 1930; height 9½ inches. *Author's collection*

Fig. 400—Gold lustre vase with green Heart and Clinging Vine decoration; signed "V-Durand 20120-12"; height 12 inches. *Collection L. A. Randolph*

"Peacock" used consistently as a pattern or design designation.

A mirror-like lustre was used on some Durand art glass; it was referred to as their "Silver Lustre Ware." Those pieces we have seen and examined were all made of Durand's Ambergris glass; some were decorated with white Hearts and Clinging Vines.

Peacock Glassware

As we have previously noted, the terms "Peacock," "Feather," and "Peacock Feather" were used interchangeably to describe the featherlike patterns found on much of Durand's art glass, but the term "Peacock" was consistently used to describe the Flashed Ruby, Blue, and Green glass, decorated with a feather-like pattern in *Opal* glass.

To produce this ware, the worker wound a fine thread of Opal glass around the colored parison and, while it was still in a plastic state, he pulled the Opal threads into peacock feather patterns. Sometimes two or more different colored threads were used to decorate these wares.

Applied feet or handles were made either of the same color glass as used for the body, or of a contrasting color. The most popular color for these applied features was Durand's Spanish Yellow.

Peacock glassware was often decorated with beautiful cut and

Fig. 401—Plate of lustred crystal glass with opal King Tut design in pulled threads all over; diameter 10 inches. *Collection Mr. & Mrs. Ted Lagerberg*

Fig. 402—Venetian Lace bowl; topaz-colored glass with opal threaded design in the Venetian style; blue rim; made by Ralph Barber in 1928 for Mrs. Charles Reed; diameter 10 inches. *Collection Mr. & Mrs. Charles Reed*

Fig. 403—Vase of opal glass overlaid with ruby glass, optic pattern in Hard Rib design; gold lustre lining; signed "Durand"; height 8 inches. *Collection Dr. Irving P. Tuttle*

engraved designs. A double tone effect was produced by cutting away the outer layer of colored glass to expose the crystal glass beneath it. Floral patterns were the most popular at that time (1926), but several geometric patterns, similar to those used in the earlier cut-glass period, can be found, too. Butterflies and garlands of leaves and flowers were also favorite cut patterns used for these wares.

For several years John (Jack) Trevethan was in charge of Durand's grinding and polishing shop.

Fig. 404—Moorish Crackle vase with Lava decoration; ruby glass over Ambergris, with Lava decoration in silvery lustre; height 8 inches. *Collection Carol Durand*

Fig. 405—Moorish Crackle glass vase; ruby over Ambergris; signed "V-Durand"; height 12 inches. *Collection Charles Knight*

Charles Link was one of their best cutters. Formerly he had been in business with his brother, George Link, in the Acme Cut Glass Company in Bridgeton, New Jersey. Mr. Link repeated his famous "Bridgeton Rose" pattern (Fig. 412) on Durand's Peacock glassware.

Egyptian and Moorish Crackle Glass

Crackle glass was produced at Durand's factory about 1928. It was initially used in the production of

lamp shades and globes for wrought iron lighting fixtures, but so enthusiastic was public response to this art glass that vases and other decorative objects were soon being made of it, too.

Among Mrs. Martin Bach's possessions is a copy of a talk which her husband gave to the Vineland Woman's Club, in which he explained the development of glass through the centuries and outlined some of the intricate processes of Durand glass. He claimed here that his Moorish and Egyptian Crackle glasswares were reproductions of pieces of ancient glass unearthed in the eighteenth century.

Egyptian and Moorish Crackle glass was produced in a variety of colors and combinations of colors. Usually the body glass was Ambergris. This was encased or threaded with heavy coils of Opal,

Fig. 407—Ruby Optic footed tumbler; one of a set presented to Col. Evan E. Kimble by Victor Durand; height 6 inches. *Collection Mr. & Mrs. E. Benson Dennis, Jr.*

Fig. 406—Egyptian Crackle vase; opal body with pink and white overlay; lustred; height 7 inches. *Collection Sam Farber*

ruby, green, or blue glass, and sometimes triple-cased with Opal glass. After the parison had been formed on the blowpipe and plated over with the various colored glasses, it was dipped into a vat of water, which crackled the outer layers of glass and formed fissures and cracks all over the blow. The worker then reheated the parison and blew it out, causing the cracks in the outer layers of glass to spread apart, and producing the rough textured effect common to crackled glasswares. After

the object had been formed, and before it was removed from the blowpipe, it was sprayed with a lustering compound.

Our study of the Durand catalogs indicates that the objects encased in Opal glass were called "Egyptian Crackle" or "Mutual"; those not plated with Opal glass were referred to as "Moorish Crackle" (Figs. 404-406).

Acid Cut-Back and Cameo Glass

A limited amount of Acid Cut-Back work was done at the Durand factory. Most of the designs were floral or rococo decorations, and are almost always found on lustred glass objects. Large vases and bowls have been more easily located than smaller pieces. Lamp vases and lamp shades in lustred glass were also decorated with Acid Cut-Back designs, and these appear to be more readily found now than any other of Durand's Cut-Back wares.

Cameo pieces, too, were produced by Durand. The work was done with acid etching and some copper-wheel engraving on very heavy triple-cased blanks—Opal glass on Flashed Blue, Green, or Ruby. The work is rather crude when compared with the Cameo glass made by Tiffany, but it compares favorably with the acid-etched Cameo glass made at the Steuben factory. There are relatively few pieces of Durand Cameo glass in existence; for that reason they are considered rare and desirable examples of Durand art glass.

Elegantly cut and engraved crystal and cut and engraved cased colored glass were also made at the Durand factory. The designs resemble those produced in the late period of American cut and engraved glass.

Venetian Lace Glass

Venetian Vitro di Trina glass was made in the Durand factory, and according to Mr. and Mrs. Charles Reed, retail distributors of Durand art glass, many of these pieces were made by Ralph Barber. (Mr. Barber was famous for his Millville Rose paperweights.) The threads of white Opal glass were laid on a ground of Ambergris glass; a thin line of blue glass usually is found on the rim of such objects (Fig. 402). The Reeds believed that some of the Venetian Lace Glass was made by the art-glass shop headed by Emil Larson.

For some years Barber was plant superintendent of Durand's Vineland Flint Glass Works—in charge of the thermos-bottle blank section.

Durand Lamps and Lamp Shades

The production of Durand fancy lamps began about 1928. Prior to that time, Ernest Dorrell and Martin Bach, Jr., had formed a small company, known as the L & S Lamp & Shade Company, and were making fancy lamps using Durand seconds or rejects for lamp vases (Fig. 413). The shop was located in Mr. Dorrell's home in Alloway, New Jersey, not far from Vineland. Orders for their lamps came from all over the country, and business was so good that Bach and Dorrell, in partnership

with Durand's New York City representative, Emil S. Larsen, opened a lamp showroom in the Imperial Hotel in New York City.

The L & S shop began to place such large orders for vase rejects that Durand sent the secretary of the company, Mr. Smith, to find out how they were being used. When he heard the report, Mr. Durand decided he had better make lamps himself. The L & S Company went out of business, but Mr. Dorrell was kept busy supplying Durand with parchment shades decorated to match or harmonize with the lamp vases. Durand's lamp business proved very successful, and the department was expanded. The foreman of this busy lamp shop was a Mr. Everingham.

Lamp vases turn up occasionally which can be identified as Durand. Sometimes the whole top and bottom of vases were cut to accommodate the metal foot and cap of the lamp. It was known that the lovely effects could be obtained with lighting from within the lamp vases; accordingly, a great many of them were equipped in this fashion. Large covered rose jars and similar pieces were illuminated from within, too, with delightful results. Tiffany had used this same idea and many pieces of Tiffany glass can be found with drilled apertures in the bottoms of vases which had originally been mounted on handsome carved wooden stands fitted with small lights.

When the production of lamps at

Fig. 408—Overlay vase, ruby cut to crystal; won First Prize award at the Sesqui-Centennial International Exposition, Philadelphia, Pa., 1926; height 11 inches. *Durand-Cunningham collection*

Fig. 409—Overlay vase, cut ruby to crystal; made especially for Mr. Thomas Logan; height 6½ inches. *Collection Mr. & Mrs. E. Benson Dennis, Jr.*

the Durand factory reached a high level, it became necessary to manufacture specially designed mountings for them. Those they first used were not really suited to their glass or their decorations. Many times the fixtures had required an adaptation of their lamp vases to make them fit; often it had been necessary to cut the whole top and bottom from the vase. A similar problem involving torchieres was solved by the designing of wrought-iron stands, made exclusively for Durand's Egyptian and Moorish Crackle glass shades.

In addition to the hand-decorated parchment shades which Mr. Dorrell supplied for a time, some of the finest decorated parchment shades were made for Durand by Mrs. C. E. (Violet) Reed and her husband, who operated a Durand glass and lamp shop in Atlantic City, New Jersey.

Bubble-balls, set on a small stand with a light in the base, and sold as decorative night lights, were also made in the Durand factory (Fig. 414). These were in various sizes, and similar to those produced at the Steuben glassworks. Durand made them in crystal, blue, and amber glass. Most were round, though some were made in a pear shape. Stacks of Bubble-balls were made up for aquariums; and Durand even made lamp standards consisting of a graduated stack of Bubble-balls.

Hollow glass balls, about the size of a large orange, were produced in Flashed Blue, Green, and Ruby, and in Gold and Blue Lustre, and

Fig. 410—Overlay vase, green cut to crystal, amber foot and stem; height 11 inches. *Collection Sam Farber*

decorated with star cutting, these were used in fixtures similar to those made for the Bubble-ball night lights.

In one collection of Durand glass we found a lamp vase of Flashed Blue Peacock glass that had been silvered inside, like the silvered

glass made in the mid-nineteenth century. This was not at all surprising since Durand had been manufacturing silvered thermos bottles for several years before the art-glass shop was established.

Kimble's Cluthra Glass

From Victor Durand's daughter Lorraine, now Mrs. Charles Cunningham, we learned that the Cluthra-like glass made at the Vineland factory was not produced until after her father's death; also, that it was not made by Emil J. Larson and his crew of workers.

At the time this glass was made, Col. Evan E. Kimble had practically decided to discontinue the making of Durand art glass. Then, one of his glassblowers, who had been experimenting with this decorating technique, brought some samples of his work to Kimble's attention, and Kimble put it into production.

Fig. 411—Overlay vase, ruby and crystal cut design; signed "V-Durand g 12-2"; height 10½ inches. *Collection L. A. Randolph*

Fig. 412—Cut crystal cream and sugar set in the Bridgeton Rose pattern; cut by Charles Link on blanks made at the Durand glassworks; height 4 inches. *Collection Carol Durand*

Kimble's Cluthra glass was made only for a short period. A few of the early pieces were marked "DURAND." However, most of these wares are signed with the letter "K," a series of numbers, and a letters-and-number mark. As an example, a Cluthra vase marked "1970-8/K/Dec. 32" would mean that the vase form was their "1970" shape; that it was "8" inches tall; the "K" stood for Kimble; and the letters and number combination, "Dec. 32" stood for the color, which in this case was green. ("Dec." was the abbreviation for "Decoration," not "December," as sometimes thought.) "Dec. 8" indicated blue; "Dec. 0," white, and so forth.

Kimble's Cluthra glass was made somewhat like Steuben's ware of the same name except that there are fewer bubbles in the Kimble productions. It can be found in

Fig. 413—Lamp vase of golden-orange lustre over opal glass; mountings and fixtures executed by the L & S Lamp and Shade Company once jointly owned by Martin Bach, Jr., and Mr. Dorrell; height to top of lamp vase 15 inches. *Author's collection*

Fig. 414—Bubble-ball lamp with cut frosted crystal and metal base; hand-painted flowers; height 9 inches. *Collection Sam Farber*

yellow, blue, green, pink, and white;
only a few examples have been found
in two colors (Figs. 415-417) .

Outlets for Durand Art Glass

Durand art glass was well
represented throughout the country.
In New York City, the line was
carried by Emil S. Larsen (not
related to the glass blower of nearly
the same name) , 225 Fifth Avenue.
In Philadelphia, the representative
was Louis Carter, Commonwealth
Building. Mr. & Mrs. Charles Reed
operated Reed's Lamp & Glass Shop
in the Hotel Dennis, Boardwalk and
Michigan Avenue, Atlantic City,
New Jersey. On the Pacific Coast,
Shaw-Newell of Los Angeles handled
the Durand line. There was also a
representative in Florida, Charles
W. Wilcken, of Orlando.

Mr. & Mrs. Charles Reed informed
us that Durand art glass was also
sold at Macy's in New York;
Bamberger's in Newark, New Jersey;
Wanamaker's in Philadelphia and
New York City; Marshall Field's in
Chicago, Illinois; Bailey, Banks &
Biddle's in Philadelphia; and several
other good department stores and
jewelry shops.

According to the Reeds, Durand
art glass plates sold for $110 a dozen;
vases ranged in price from $7.50 to
$60; a Flashed Ruby vase, 8 inches
tall, sold for $7.50. They recalled that
the Lady Gay Rose and Transparent
Amethyst wares were not very
popular, though Durand's Flashed
Blue, Green, and Ruby were good
sellers. When the art-glass production

Fig. 415—Blue Cluthra vase; signed "K/
20177-6½/Dec. 8"; height 8 inches. *Collection Mr. & Mrs. E. Benson Dennis, Jr.*

was discontinued, the Reeds bought
as much of the remainder stock in
lamp vases and shades as possible,
paying only 10¢ apiece for each item
regardless of size or shape.

Durand Colors and Code Letters Used for Decorations and Colors

After studying several catalogs
and brochures published by the
Vineland Flint Glass Company for
their art-glass wares we were able to
compile a list of color names and
design descriptions. There were a
few instances when the same design
or color had two names assigned to it,
but in the main, their nomenclatures
were not complicated—perhaps
because there were relatively few as

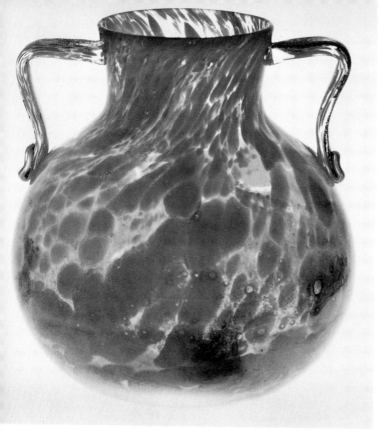

Fig. 416—Kimble Cluthra vase, blue mottled with green and yellow; height 8 inches. *Durand-Cunningham collection*

compared to Tiffany and Steuben wares. At times, when two names had been used for a certain decoration or color, one of the names was put in parentheses, indicating that the two names actually described the same thing. In the lists that follow, the author's description of the designs and colors are in italics; the rest has been taken verbatim, including inconsistencies, from the Durand catalogs.

Ambergris: Body glass for lustre effects. *Also called "Oil Glass" at the Durand factory. The reference to this color as "Oil Glass" would indicate that it was the same transparent yellow glass used*

by Tiffany, Steuben, and others for their lustered glasses.

Flashed Blue: Sapphire Blue over crystal.

Flashed Green: Emerald Green over crystal.

Flashed Ruby: Ruby flashed over crystal.

Solid Ruby: a deep shade of Ruby glass.

Spanish Yellow: a light shade of Citron.

Optic Glass: obtainable either clear or frosted in Amethyst, Crystal, Rose, Green, or Amber. *These were pattern-molded wares.*

"Cased Glass" [the catalogs stated] "is the finest achievement of the glassmaker's art. It consists of casings or layers of various colors of glass (either transparent or opaque), one above the other. As an example of double casing, a Sapphire layer may be entirely imposed over crystal and in the regular design the Sapphire is cut away till the crystal is reached, thus giving a double tone effect. It may be had in crystal with Ruby, Emerald, Topaz, or Sapphire, with or without an extra casing of Opal on the outside."

Lady Gay Rose: Soft rose color. *This was an opaque cased glass—thin skin of ruby over an Opal glass body, it was not very popular in its day.*

Iridescent Glass: one of the highest grades of glass made—retains its iridescent effect forever. Hand wrought. *This was also*

referred to as "Lustre" in several catalogs and brochures.

Silver Blue Lustre: Medium blue in color with silvery lustre.

Code letters were used in Durand catalogs to describe various colors and decorations used on their art-glass wares. Some of the catalogs, in the back of the book, enumerated in detail what the letters stood for; the list below quotes these details verbatim. In some instances the letter designations had more than one meaning; in such cases we have included both descriptions.

A: Gold Lustre Body; Semi-Transparent. No decoration.

AA: Lustre In and Out, White Leaf (Peacock), Green Band, Spider (Webbing).

AA: Golden Yellow with White Feather (Peacock) with Blue Band to trim off the Blue and with a Gold Webbing (Spider).

AA: Golden Yellow, White Feather (Peacock) Design, Blue Band, Gold Webbing (Spider).

B: Silver Blue, White Clinging Vine, White Hearts.

B: Silver Blue with White Hearts and White Vines.

BB: Blue Lustre, Clinging Vine. (Blue Lustre Body with Silver Blue Clinging Vine Decoration.)

C: Golden Yellow Body with Blue Hearts and Vines.

C: Lustre In and Out, Blue Clinging Vine, Blue Hearts.

D: Silver Blue.

D: Silver Blue Body. No Design.

D Spider: Silver Blue Body with Gold Webbing (Spider).

E: Lustre In and Out.

E Spider: Lustre In and Out, Spider Webbing (Gold Lustre Opaque Body) with Gold Lustre Broken Threads or Webbing.

E: Golden Yellow. No Design.

FF: Opal Spider with Blue and Gold. (Opal body with gold tendrils and blue and gold hearts.)

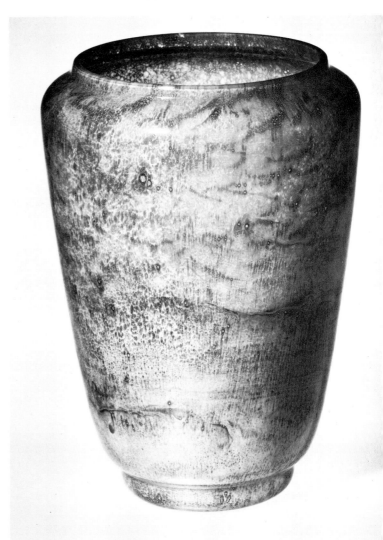

Fig. 417—Kimble Cluthra vase; variegated light green mottling; signed "1970-8/K/ Dec. 32"; height 8 inches. *Collection Mr. & Mrs. E. Benson Dennis, Jr.*

G: Opal Body, Gold Lined, Silver Lustre King Tut Pattern.

H: Opal, Gold Clinging Vine, Gold Lined. (Decoration like FF with Gold Hearts.)

K: Golden Yellow Body with Blue Coiled Design.

KK: Green Body with Gold Coiled Design.

L: Opal, Blue and Gold King Tut. (Opal Body, blue and gold King Tut decoration.)

LGR: Lady Gay Rose Body with Gold Coiled Design.

M: Opal Spider, Blue and Gold Hearts, Gold Lined.

M: Opal with Gold and Blue Hearts and Clinging Vine.

N: Opal Gold Lined, Gold King Tut Decoration.

OG Cup: Green Body with Hard Rib, Gold Lined.

OG Lined: Opal, Hard Ribbed, with Green Lining.

OR Cup: Rose Body with Hard Rib, Gold Lined.

OR Lined: Opal, Hard Ribbed, with Rose Lining.

R: Silver Blue, White King Tut Decoration.

R: Silver Blue, White Coil Design.

R: Silver Blue Body with White Coiled Design.

Special: Lustre Opal and Blue with Lustre King Tut. (Blue Lustre Body with light Blue [Silver Blue] King Tut Decoration, Gold Lustre Lined.)

SG: Gold Double Decoration, Blue Band. (Crystal body with opal top pulled in swags; also band of blue in opal top. Crystal lower body in Ruby Peacock design. Blue Lustre stem and foot.)

SB: Blue, Green, or Ruby. This glass when used in Torchier lamps or vases, with an inner glow light, shows a very mellow light with a blue, green, or ruby design over the white and just enough of the yellow to make an attractive contrasting color. Also crackled.

Mutual: Soft Yellow Body with White and Blue; White and Green, or White and Ruby design all over. Moorish Crackled.

Note: Regular decorations take the low price (single letter designation). Special decorations take a higher price (two or more letter designations.)

The Durand factory produced a large assortment of lamps, lamp vases, and lamp shades; they also manufactured floor, ceiling, and wall fixtures. Some of their catalogs featured "Wrought Iron Lamps" and "Old Rusty Iron Lamps with glass shades inserted in metal frame work." The iron lamps were fitted with "Moorish" or "Egyptian Crackle" shades in many colors and combinations of colors. Collectors will recognize many of the old Quezal designs in their lustre and lustre-decorated shades. Lamp globes and stalactites in a type of Verre de Soie glass, with etched and engraved

decorations were also produced at the Vineland works.

Parchment shades were hand decorated, some with gold and silver appliqué; all were designed to match or harmonize with the colors used in the lamp vases.

The following code letter designations, taken verbatim from an old catalog, were used to describe the various decorated glass shades made by Durand.

XA: Lustre—Plain gold lustre with ribs.

XB: T. S. G. Spider, Blue and Gold Hearts.

XD: Opal, Gold Lined, 8 to 16 Rib. (Plain blue lustre, gold lustre lining.)

XDD: Opal, Gold Leaf and Gold Lined. (Pulled Peacock Feather decoration on an opal body.)

XEE: Gold, Opal Lined. (Plain gold lustre, opal lining.)

XG: A. O. S. Lustre White Leaf, Green Band. (Gold Peacock design, edged with Blue Lustre, on Opal body, Gold lined.)

XH: A. O. S. Lustre White Leaf, Green Band. (Gold Peacock design edged with Blue Lustre, on Opal body, gold lined.)

XK: Ruby Leaf, Gold Band, Gold Lined. (Pink plated on Opal, with Gold King Tut decoration, gold lined.)

XM: Gold Leaf, Green Band, Gold Lined. (Peacock design in Gold Lustre, edged with Blue

Lustre, on an Opal Body. Rest of shade in Gold Lustre, Gold Lustre lining.)

XP: White and Green Frill on Lustre. (Pulled wavy pattern on Opal ground.)

XS: T.S.G. Spider, Blue and Gold Hearts. (Opal body with Blue and Gold Hearts, Spider Webbing all over, Gold Lustre lining.)

XJ: Opal with Blue or Green Feather (Peacock) design.

XJ: Opal with Blue or Green Feather. (Peacock design with gold band to trim off the blue or green, and with Gold Webbing.)

Durand Marks

Durand glass is signed in one of two ways: either the name "Durand" in script, or "Durand" in script running across a large "V." The numbers that sometimes appear along with the signature indicate the shape and the height of the object. Thus "1710-8" would mean "Shape 1710, 8 inches tall." (See Appendix B.)

Mr. Charles Reed, one of the retailers of Durand's art glass, believed that the engraved signatures were traced over with an aluminum pencil, leaving a silver finish to the signature. Little of the early glass was signed—not until just before the end was the signature commonplace.

Pieces of glass quite similar to Durand's lustered wares have been found bearing a black and silver

paper label with the words, "Durand" and "Chicago." It is quite possible that these are early pieces of Durand glass for they closely resemble Quezal's wares. Unfortunately, we could not trace any connection between Victor Durand and a Chicago firm of the same name.

THE UNION GLASS COMPANY

THE Union Glass Company in Somerville, Massachusetts, was established in 1851 by Amory and Francis Houghton. Their factory was on Webster Avenue near the railroad tracks, and initially the company was a great success. In 1860, effected by the Panic of 1857, the company failed, but was immediately reorganized with Charles S. Chafflin the new president, Amory Houghton, treasurer, and John P. Gregory, company agent. Amory Houghton, Sr., and his son, Amory, Jr., left the company about 1864, after they had acquired the controlling interest in the Brooklyn Flint Glass Company, established in 1823 by John Gilliland. The Union Glass Company moved along under the competent management of a new owner, a Mr. Dana, and was at its peak in production and prosperity between 1870 and 1885. Its products were chiefly pressed glass, blanks for cut glass, and silvered glasswares.

When Mr. Dana died, around the turn of the century, his son-in-law, Julian de Cordova, took over the works. He spent money to improve the physical plant and, under his direction, the company began making the art glass for which it became justly famous. The factory closed in 1924.

The Union Glass Company's production of Art Nouveau glass was limited. "Kew Blas," introduced about 1893, was its only concession to that new style (Figs. 418-422). This seeming lack of interest in Art Nouveau may have come about

because, at the time other companies were experimenting with new styles and forms, the Union Glass Company was expending most of its energies in the manufacture of high-grade crystal blanks for glass-cutting shops all over the country.

The art-glass wares they did make, with the exception of Kew Blas, were mainly inspired by Venetian techniques and forms. These art productions had real merit, but they did not follow the accepted style of the Art Nouveau period. Instead, they more nearly resembled their Italian counterparts in form, color, and decoration. In February 1905, Julian de Cordova, president of the Union Glass Company, presented the Smithsonian Institution in Washington, D.C., with several pieces of Union's fine glassware in the Venetian style (Figs. 423-424).

Fig. 419—Kew Blas ashtray of gold lustre glass; height 4¾ inches. *The Chrysler Art Museum of Provincetown* (Mass.)

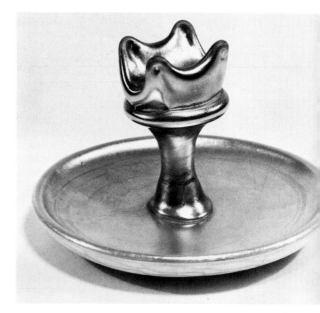

Fig. 418—Kew Blas lily vase of gold lustre glass; height 10 inches. *Collection Mrs. Claranell M. Lewis*

The Union Glass Company

Fig. 421—Kew Blas handled vase; opal glass body with green and gold lustre decoration, lustred shell handles and lining; height 5 inches. *Collection Mr. & Mrs. Ned Stinnett*

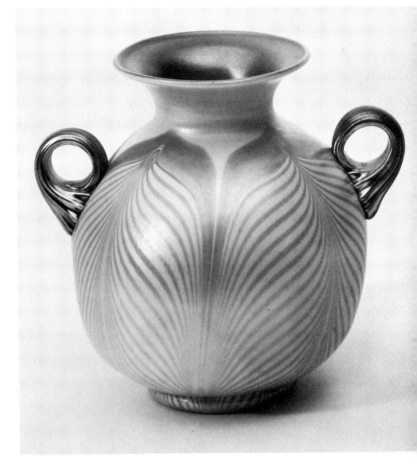

Fig. 420—*Left to Right:* Kew Blas vase, opal glass with gold lustre leaf decorations and lining; height 6 inches. Sweet-pea vase, opal glass with pulled green and gold lustre leaf decoration; gold lustre interior; height 8 inches. Gold lustre tumbler; height 4 inches. *Collection Mr. & Mrs. Ted Lagerberg*

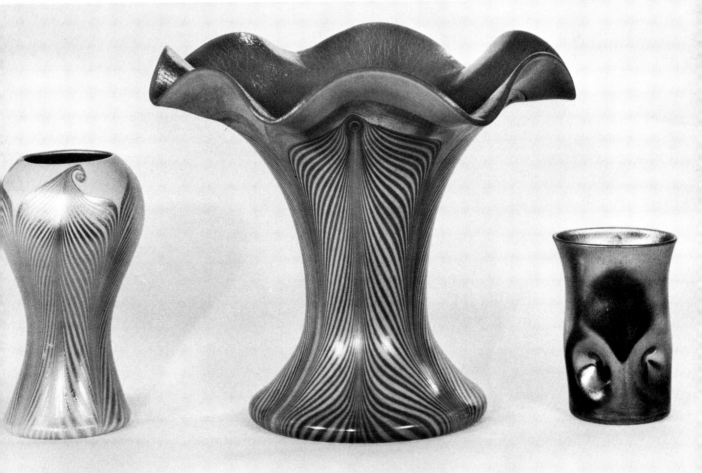

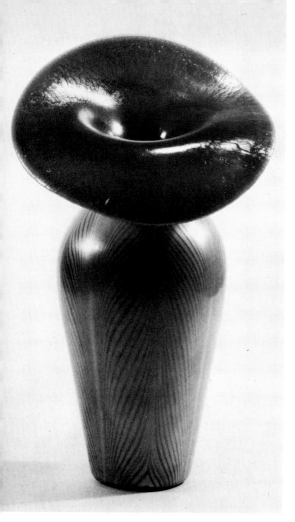 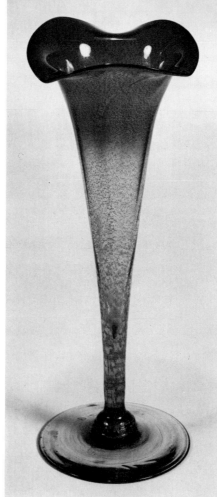 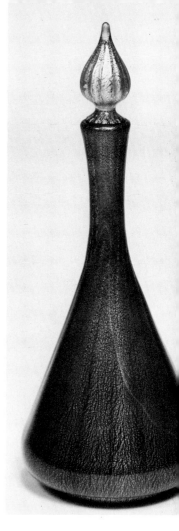

Figs. 422-423-424—*Left to right:* Kew Blas vase, opal glass body with gold lustre leaf decorations; interior gold lustre; height 10½ inches. *The Chrysler Art Museum of Provincetown (Mass.)*. Lily vase, shaded from light amber base to ruby top with gold flecks throughout the glass; Union Glass Co., ca. 1885; height 8½ inches. Decanter, shaded from deep blue base to ruby top with gold flecks; light amber stopper gold flecked; Union Glass Co., ca. 1905; height 8¾ inches. *Smithsonian Institution*

The comparatively small production of lustered or lustre-decorated art glass made by the Union Glass Works can usually be identified by a beautifully engraved designation, "Kew Blas." Unfortunately, Kew Blas wares are for the most part uninspired in form, merely mirroring the wares made by other American Art Nouveau glass manufacturers such as Durand, Quezal, and Tiffany.

There are, of course, exceptions to this critical pronouncement on

Kew Blas, but they are few and far between. Only when Kew Blas wares were made in the accepted classical forms of ancient glass objects can they be considered truly beautiful; when they deviate from these classical forms, they are invariably awkward.

The scarcity of signed Kew Blas wares has precipitated forged signatures, put on with acid etching and touched with gold to hide the obvious difference between acid etching and the professional engraving of the true Kew Blas mark.

FOSTORIA GLASS SPECIALTY COMPANY

THE Fostoria Glass Specialty Company was established in 1899 by J. B. Crouse, Henry A. Tremaine, B. G. Tremaine, and J. Robert Crouse, son of Mr. J. B. Crouse, in Fostoria, Ohio. The factory was located on an extension of Railroad Street (now 4th Street) and South Poplar, adjacent to the B & O Railroad track, in a one-story brick building with a large floor space. They produced their first glass in 1901.

By 1907, the company had prospered and two factories were in operation, having a daily capacity of 5,000 pounds of glass each. The company employed 700 men and their monthly payroll exceeded $30,000—a goodly sum in those days. At this time the company was building another glass factory in Fostoria at a cost of $75,000. Mr. E. O. Cross was a general manager of the company and his assistant was Homer Black. James Goggin supervised the manufacture of the glass and J. A. Ryan had charge of the finishing.

On August 6, 1912, a trademark for a certain glassware known as "Iris" was issued to The Fostoria Glass Specialty Company of Fostoria, Ohio. The name was applied to a very fine line of lustered glassware which this company had been producing since November 1910. Iris glassware is comparable in every way to the fine lustred glasses made by Tiffany Furnaces and the Steuben Glass Works (Figs. 425-431).

A close examination of Iris glass

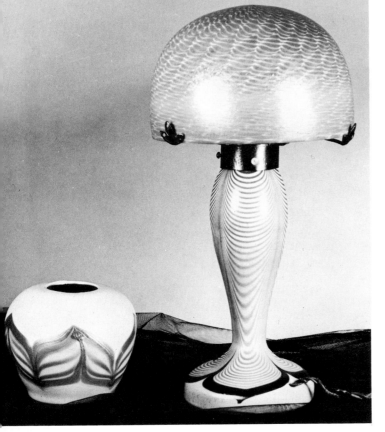

Fig. 425—Iris rose bowl, opal glass with gold lustre decoration in leaf design. Iris lamp, opal glass with pulled threaded design in gold lustre and green; height 15 inches. *Collection Mrs. Arthur Peter*

about an article in a haphazard fashion which had pleasing results in the finished product.

One thing all Iris glass had in common—it was beautifully iridescent. The range of colors in this ware run the full gamut—several shades of green, blue, yellow, rose, tan, white, and black. Old-timers who once worked for this concern spoke of the large amount of gold used in the manufacture of Iris glass; some considered the high cost of this element the reason that the glass was not made for very long at Fostoria. The prodigious amount of shards found on the factory site would indicate that the manufacturers of Iris glass experienced some difficulties with coefficents of expansion or an incompatibility of one or more of the glasses used with others.

If any comparison can be made between Fostoria's Iris glassware and the lustred glasses made by Steuben and Tiffany, we would have to concede that Tiffany forms show more imagination and originality, and were obviously aimed at a sophisticated clientele who were very much aware of the Art Nouveau. Fostoria's Iris glass resembles the more prosaic forms produced by the Steuben Glass Works.

The Fostoria Glass Specialty Company manufactured a great deal of lighting equipment—bulbs for incandescent lamps, glass tubing, inner globes for enclosed arc lamps, and a complete line of globes and chimneys. For this reason their major output in Iris glass was lighting

shards unearthed at the old factory site indicates that in most cases two or three layers of different colored glass were used in these products; quite often these layers of glass were further embellished with threads of glass which were pulled into feather-like designs by machines that must have resembled those patented by John Northwood, Sr., and others, in England in the last quarter of the nineteenth century. Pads of colored glass were sometimes placed on an article and tooled at the furnace while the metal was still plastic, to form leaves, flowers, and tendrils. Trailings or drippings of colored glass were occasionally allowed to wind

Fig. 426—Iris glass. Gold lustre vase, 4½ inches high. Lamp shade, pearly white with gold and green lustred leaves and tendrils, all-over threading in gold lustre; gold lustre lining. Large lamp shade, pearly white body with gold lustre tendrils and leaves touched with green; shade lined with gold lustre. *Collection Mrs. Maxine Godsey*

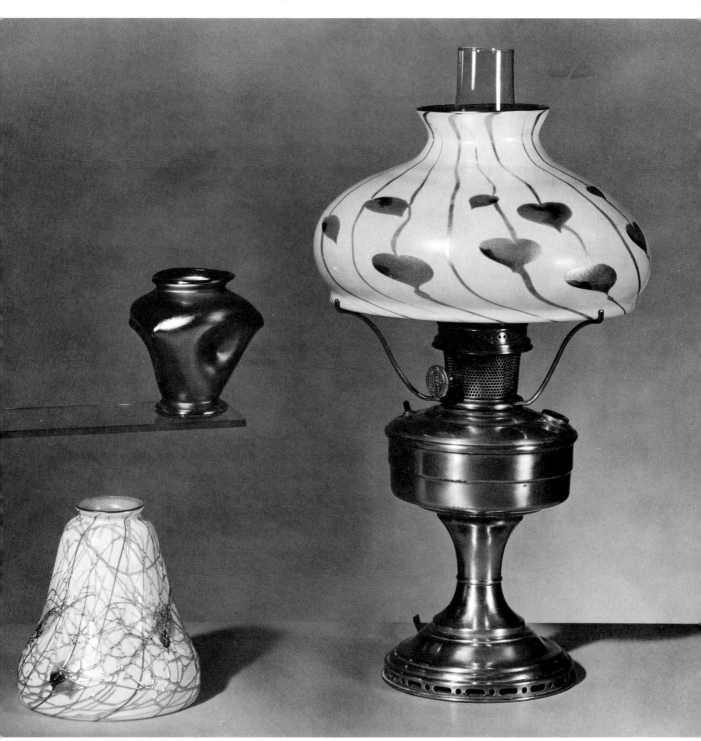

fixtures—lamps and lamp shades. They also produced fancy vases, bowls, bonbon dishes, finger bowls and plates, and other table and decorative wares, though not on a scale to compare with the variety manufactured by Tiffany and Steuben.

The Fostoria Glass Specialty Company affixed small oval-shaped gummed labels to their wares with the legend "Iris, Fostoria, O." printed thereon; only a few objects with original paper labels have been found to date. Those Iris wares not

Fig. 427—Opal glass lamp shade decorated with blue and gold lustre design in pulled feather pattern; original paper label identifies this as Iris glass. *Collection Charles K. Bassett*

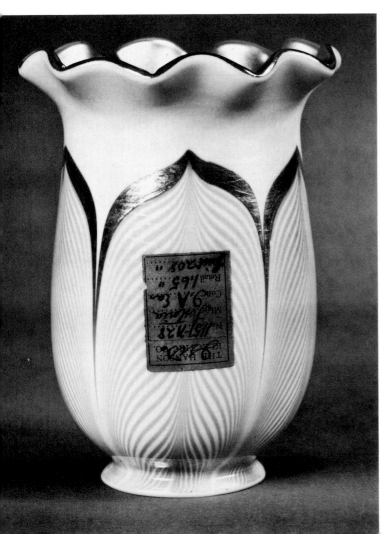

identified by an original trademark label have probably ended up in collections as "unsigned Tiffany" or "unsigned Aurene." Indeed, it would be almost impossible for anyone to differentiate between Tiffany, Steuben, and Fostoria's lustred wares unless they bear original marks or signatures.

The formulas for the lustrous effects produced on Iris glassware have been attributed to an "easterner" by some of the workers still living in Fostoria, Ohio. Miss Hannah L. Ryan, who used to work in the company's office, told the author that they started to make Iris glassware about 1902 or 1904 under the direction of "a man from the East." An old photograph of the sales

Fig. 428—Iris glass lamp shades; shades identified from shards unearthed at factory site. *Left to right, top row:* Opal glass with green and gold lustre Heart and straight Vine decoration; gold lustre lining. Opal glass decorated with green and gold lustre dots; gold lining. Opal glass decorated with green and gold lustre Hearts and gold lustre Spider Webbing. *Middle row:* Opal glass with Heart and straight Vine decorations; gold lining. Opal glass decorated with pulled pattern of gold lustre threads, gold lustre lining. Opal glass decorated with gold Heart and Spider Webbing, gold lustre lining. *Bottom row:* Opal glass decorated with green and gold Hearts and gold lustre lines. Opal glass decorated with green and gold lustre dots, gold lustre lining. Opal glass decorated with green and gold Heart and Vine design with heavy gold Spider Webbing, gold lining. *Collection Charles K. Bassett*

216

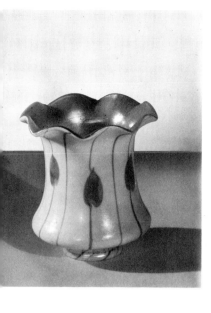 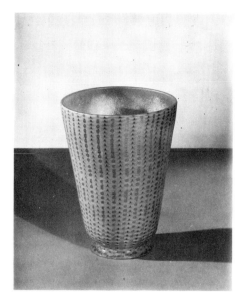 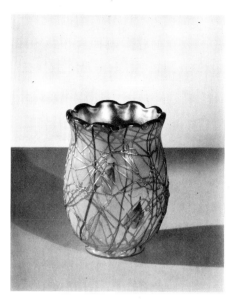

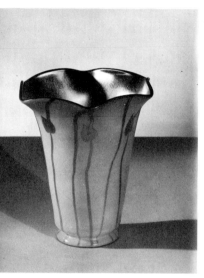 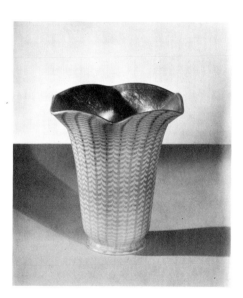 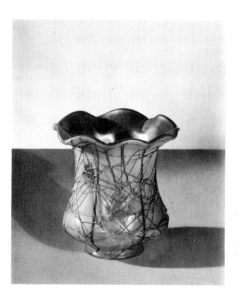

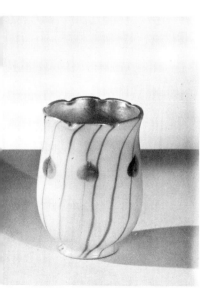 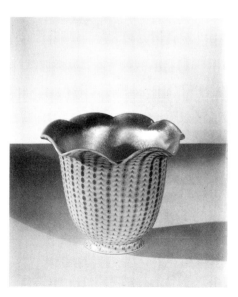 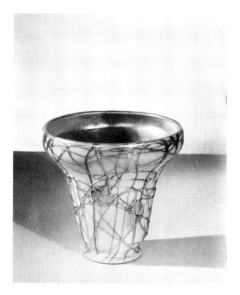

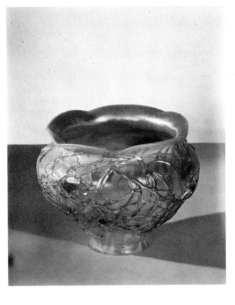 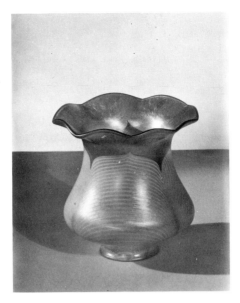 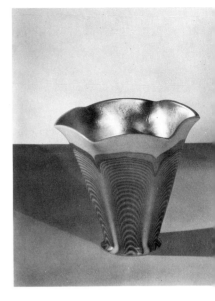

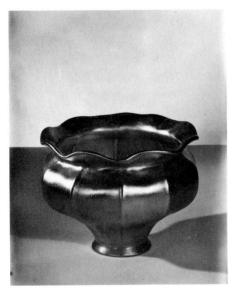 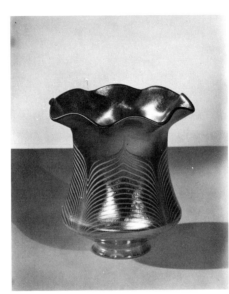 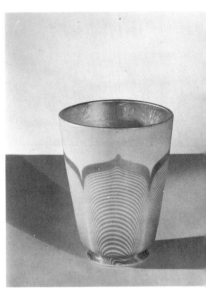

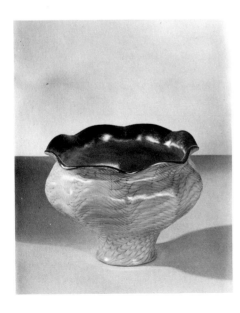

office shows some Iris glass articles, shades mostly, and a good likeness of James Goggin, the supervisor of the glass factory, with two young women who worked in the office. The attire of these people would indicate a period somewhere between 1902 and 1910. A Miss Grant from Maine was in charge of the designing, according to Miss Ryan.

A catalog of the firm's wares illustrated a line of "clearcut" shades for electric lights and lamps in frosted crystal with bright-cut designs. The company also made beautiful cut-glass punch bowls, compotes, bowls, and other table and decorative wares in the traditional manner of the American cut-glass shops of this same period. The cutting shop was under the direction of Mr. John Valley, who later went to Toledo, Ohio, where he manufactured fancy engraved and decorated mirrors.

Fig. 429—Iris glass lamp shades; shades identified from shards unearthed from factory site. *Left to right, top row:* Opal glass with green and gold Heart and Vine decoration and gold Spider Webbing. Amber glass with Peacock Feather design in gold lustre and opal glass. Opal glass decorated with gold lustre and olive-green pulled threads in leaf design. *Middle row:* Gold lustre glass. Gold lustre with pulled pattern of leaves in white and gold lustre. Opal glass with gold lustre and olive-green threads in pulled decoration. *Bottom Row:* Opal glass with light green pulled decoration, gold lining. Amber glass with lustred white and gold decoration. Opal glass with pulled threads of gold lustre glass and pale green glass. *Collection Charles K. Bassett*

Fig. 430—Paper label found on Iris glass.

Fig. 431—Trademark for Iris glassware, from the original trademark registration papers.

Mr. John Vidoni was in charge of the manufacture of Iris glass, and Mr. Ray Apger headed the finishing department. According to Mr. Apger, the colored glass was made in different pots, the gaffer dipping his blowpipe into various pots to produce a parison cased or plated with different colors. While it was still in a plastic state, the worker tooled it into the desired shape and design.

Subsequent trademarks issued to this firm indicate that they were in the process of being absorbed by the General Electric Company as early as 1912. At this time Mr. E. O. Cross was the president of The Fostoria Glass Specialty Company, and all patents and trademarks issued to the firm in his name were assigned to the General Electric Company of New York City. Eventually, General Electric took over the works and moved them to Cleveland, Ohio, and Niles, Ohio; this occurred about 1917.

THE HONESDALE DECORATING COMPANY

THE Honesdale Decorating Company was established in January, 1901, by C. DORFLINGER & SONS, well-known glass manufacturers of White Mills, Pennsylvania. The decorating shop was located in nearby Honesdale, Pennsylvania, and occupied a two-story building on Main Street which C. Dorflinger & Sons owned. Carl F. Prosch came from New York to manage this new enterprise. In 1916, he purchased the business outright from C. Dorflinger & Sons and operated it, as sole owner, until it closed in 1932.

Carl Francis Prosch was born in Vienna, Austria, April 28, 1864, and was educated at Melk-on-the-Danube at a school conducted by Benedictine monks. A designer by profession, he worked for several years as a decorator of glass and chinawares for Bawo & Dotter, New York importers, in their factories in Bohemia—their main office was at Kötzschenbroda bei Dresden.

In 1890, Bawo & Dotter sent him to New York as their sales representative, and he remained with the firm for ten years, when he went to Honesdale. In New York, he married Carolina D. Henry, December 15, 1892. He continued his artistic studies, and was elected a member of the Art Students League of New York on October 13, 1897; in 1907 he was made a life member.

Entering into agreement with C. Dorflinger & Sons to operate their new decorating shop, Mr. Prosch moved his family to Honesdale, Pennsylvania, in December 1900.

The shop opened the following month and continued under his management, and after 1916, under his ownership, until poor health forced him to close in 1932. In retirement, he continued to express his artistic nature. Several of the pen and ink sketches he made at that time were accepted for publication in magazines. He was keenly interested in world affairs, avidly reading and discussing current events with friends and neighbors. He died on June 25, 1937, at his home at 622 Church Street in Honesdale, following a heart attack.

Originally The Honesdale Decorating Company's principal function was to decorate C. Dorflinger & Sons' wares with etched, engraved, and gilded designs. Printed transfer patterns of acid resist were placed on glass blanks before they were dipped in the etching fluid. Then the etched designs were decorated with real gold and fired in a kiln at 900° Fahrenheit.

Nicholas Stegner, a decorator who had been with Prosch from the time the factory opened until it closed in 1932, told us in an interview, that sometimes Dorflinger's lead-glass blanks collapsed in the heat generated by the kilns. This was particularly true of their delicate stemware and other thin-blown objects. When Prosch took over the factory in 1916 he switched to lime-glass blanks which could withstand the heat of the decorating kilns; these lime-glass blanks he procured from A. H.

Heisey & Company, Fostoria Glass Company, and others.

An original C. Dorflinger catalog of the 1910 period illustrated pressed and blown Gold Decorated glassware, produced by The Honesdale Decorating Company on fine quality crystal blanks. (See Appendix C.) All of the patterns were given specific name or number designations; unfortunately many of the catalog illustrations were not distinct enough to enable us to describe the details of some of the designs. Those which could be clearly identified are listed here.

Adams: an ornate pattern consisting of decorated ovals, pendants, bowknots, and flower swags, in a design obviously influenced by the elaborately painted furniture of the Adams Period, ca. 1800.

Cross Stitch: this pattern resembles the simple embroidery stitch of the same name.

Gold Band (also called *Gold Border* in their catalog) : a band of plain gold, encircling the rim of each object.

Greek Key: a wide band in the well-known Greek Key design, etched and gilded.

Laurel: a band of etched and gilded laurel leaves.

Wide Laurel: a broader representation of their *Laurel* pattern.

St. Regis: a design of flowers and rococo scrolls in a wide band; also known as their *# 905* pattern.

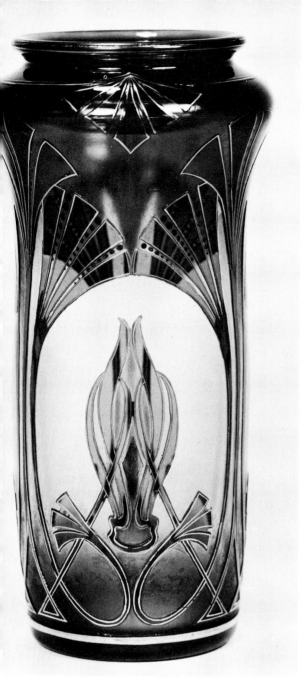

Fig. 432—Signed "Honesdale" vase; cased amethyst on crystal, with etched and gilded decoration; height 11 inches. *Collection Astrid Tutt*

Versailles: the *St. Regis* pattern combined with a center design of laurel wreaths and ribbons, flower swags, and rococo scrolls; this pattern was used on service plates, trays, compotes, and vases.

Tiffany: a design simulating the conventional engine-turned engraved patterns on gold objects.

Double Tiffany: the *Tiffany* pattern applied in two parallel lines around the object.

Tiffany Star: the *Tiffany* pattern combined with a paisley-like design in the center of plates, trays and compotes.

1014: a delicate Art Nouveau design used in combination with other patterns on objects that would otherwise have large undecorated areas.

The patterns we are unable to define because of the poor quality of the illustrations were called: *Cataract, Cauldon, Claridge, M F #1, Renaissance* and *#s 904, 907, 908, 910,* and *911.*

On June 13, 1911, Carl F. Prosch patented a design for a wine glass which appears to be decorated with one of his etched and gilded designs. The pattern is unlike any we found illustrated in the 1910 catalog of these wares, and no name or number for it was included in his patent enumerations.

Carl Prosch's daughter, Mrs. George S. (Elsa) Murray, told us that the "Gold Decorated" glassware was produced in great quantities as a "stopgap" to keep the plant going during the war years—1914 to 1918.

One page in the Dorflinger-Honesdale catalog (see Appendix C) was devoted to illustrations of cocktail glasses and a large "mixing tumbler" with engraved,

etched, gilded, and enameled designs of roosters and fighting cocks. These, too, were specifically named: *Enameled Black and White Rooster; Two Enameled Cocks; Gilded Rooster C S & S* (cut stem and star-cut foot) ; *Gilded R & R S* (gilded rooster and rising sun) ; *Two Gilded Fight Cocks;* and *Engraved Cock.* The last named is the only pattern shown that was not gilded or enameled.

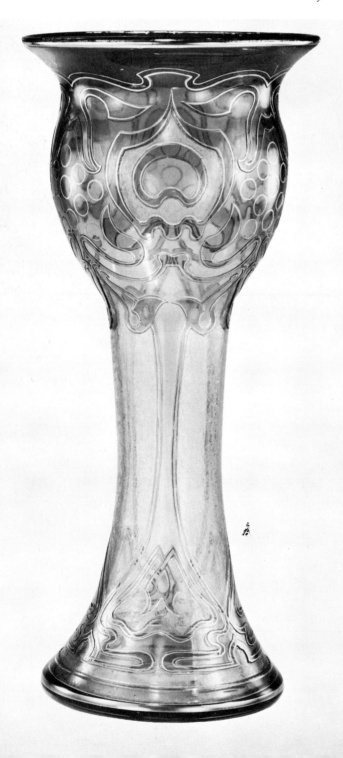

Fig. 433—Signed "Honesdale" vase; cased green and topaz over crystal with etched and gilded decoration; height 14 inches. *Collection Mrs. Elsa Prosch Murray*

Double- and triple-cased blanks supplied by the Dorflinger works were handsomely decorated by etching away successive layers of the variously tinted glass in cameo designs which were distinctively Art Nouveau in character. The etched patterns were defined with a slight tracery of gold, and some were decorated with transparent colored stains and lustres. Nicholas Stegner explained that the lustering fluid had to be of a consistency called "medium flow"—neither too thin nor too thick. The amber-colored fluid (a dilute nitrate of silver) was applied with a soft brush and allowed to flow down the inside or outside of the object to coat it evenly throughout. Mr. Stegner's favorite design was one of red roses and green leaves on an etched crystal ground.

Another Dorflinger catalog in our possession referred to these cameo etched wares as "hand-wrought glass; with a surface of gold lustre or other iridescent tints used for single pieces designed solely for decoration." The objects illustrated in this catalog appear to be of the type just discussed, and we believe the reference to "gold lustre" does not allude to anything like Tiffany Gold Lustre wares, or Steuben's Aurene.

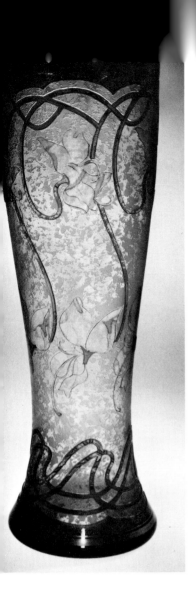

Figs. 434-435-436—*Left to right:* Signed "Honesdale" vase; cased green on crystal with tinted yellow flowers and gilt decoration; height 13⅝ inches. *Collection Mr. & Mrs. George Jamison.* Signed "Honesdale" vase; cased ruby on crystal, with internal lustre and etched and gilded decoration; height 10½ inches. Signed "Honesdale" vase; cased green on crystal with etched, gilded, and tinted design of landscape and rising sun; height 10¾ inches. *Collection Wayne County Historical Society (Honesdale, Pa.)*

Etched cased-glass vases, some as large as thirty inches tall, and a host of other fancy wares were produced by The Honesdale Decorating Company between 1901 and 1915 (Figs. 432-444). Most of these articles are signed "Honesdale" in script letters on the bottom of the object. Without this means of identification, one would be hard pressed to differentiate between Prosch's wares and some, almost identical, made by the Val St. Lambert glassworks in Belgium and the Baccarat factory in France.

Identification Marks

Three identification marks were used by The Honesdale Decorating Company during the thirty-one years

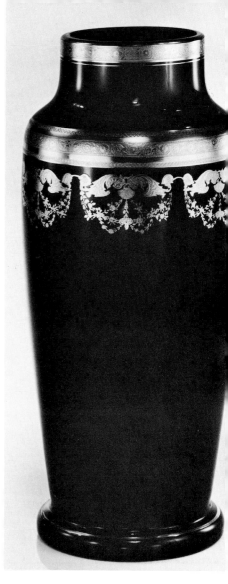

Figs. 437-438-439—*Left to right:* Signed "Honesdale" vase; cased topaz over crystal, etched and gilded decoration; height 12 inches. *Collection Mrs. Elsa Prosch Murray.* Signed "Honesdale" vase; frosted crystal with internal lustre, decorated with blue and yellow translucent enamel; height 10 inches. *Collection Mr. & Mrs. George Jamison.* Signed "Honesdale" black glass vase with etched and gilded decoration in the Versailles pattern; height 14½ inches. *Collection Mrs. Elsa Prosch Murray*

they operated. The first was a cipher of their initials "H. D. C.," superimposed over a representation of a goblet. It was printed on paper labels which were affixed to their Gold Decorated glassware. According to the *Jeweler's Manual of Trademarks*, they used this mark on their wares until 1920. At that same time they also used the name "Honesdale" in gold script on their etched and colored art glass. After 1916, Prosch adopted another mark for his wares which consisted of the letter "P" within a keystone-shaped shield.

Gold Decorated wares produced after 1916 on pressed and blown

blanks supplied to Prosch by A. H. Heisey & Company sometimes bear the Heisey trademark—the letter "H" within a diamond-shaped shield.

During the last few years of the firm's existence, Mr. Prosch introduced a line of elaborately decorated porcelain service plates and other porcelain pieces. The service plates sold for upwards of $50 a dozen and were marked "The Honesdale, Pa., Decorating Co., Prosch-Ware." Some of the large service plates we examined also bore the name and mark of Heinrich & Company, Selb, Bavaria, but that company was not the sole source of Prosch's supply of undecorated porcelain blanks.

Honesdale Workers

When we interviewed Nicholas (Nick) Stegner in June 1965, his appreciation of Carl Prosch, both as a man and as an artist, was heartwarming. We asked Mr. Stegner for the names of the various workers in the factory and the positions they filled. With no apparent effort he supplied the information. His recall was remarkable, for none of the men, besides himself, had been active during the whole Honesdale operation. Others had come and gone, but he remembered them, by name and by position, though not all worked at the same time. Often he could tell why they left—to go back to Bohemia, to buy a farm, or to be married. He knew which ones came from Bohemia, where many were living now—which ones had died,

and the married names of the lady workers. He even sketched a floor plan of the original shop, indicating the various stations. The list which follows, naming names and also job titles, gives an excellent idea of the various work processes throughout the plant.

Glass engravers who worked at Honesdale were Alexander Linke, Herman Neugebauer, Joseph Hocky, Frank Milde, and Francis Fritchie.

Decorators were Joseph Bischop, his son, Joseph Bischop, Jr., and his son-in-law ———— Michaels, Gustave Kettel, John Johns, Adolph Linke,

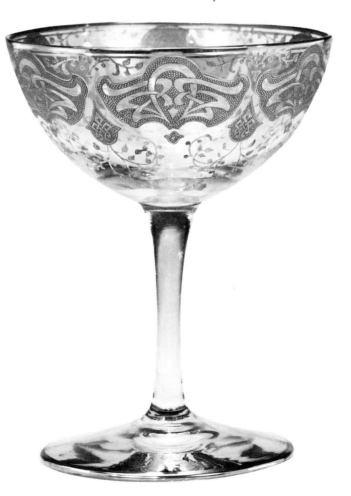

Fig. 440—Crystal champagne glass with elaborate gold decoration, made by The Honesdale Decorating Co.; height 5 inches. *Collection Mrs. Elsa Prosch Murray*

———— Crybick, Frank Leisel, ———— Wolf, Fred Martin, Hugo Papert, and Nicholas Stegner.

Thomas Jones, Alfred Kretschmer, William Varcoe, and Frank Milde printed acid-resist paper transfers.

John Villaume, Andrew Cowles, William Maisey, Rudolph Bates, and Alexander LaTournous placed the acid-resist transfers on glassware. Fred Crist was a transfer and gold helper.

Acid dippers were Harry DeReamer and Howard Miller. Chore boys and acid dipper helpers were Charles LaTournous, Frank Artman, and Fred Miller. (Fred Miller, in 1965, was manager of the Pennsylvania Power & Light Company in Honesdale). Charles Seward was an acid dipper and part-time fireman for the china kiln.

Edward Welsch, Robert Willer, George Copper, and Raymond

Fig. 441—Gold decorated crystal tablewares; Honesdale Decorating Co. *Left to right:* Cordial and tumbler, St. Regis pattern. Water goblet, Laurel pattern. Tumbler, Cataract pattern. *Center, foreground:* Amethyst plate, Wide Laurel pattern. *Collection Mrs. Elsa Prosch Murray*

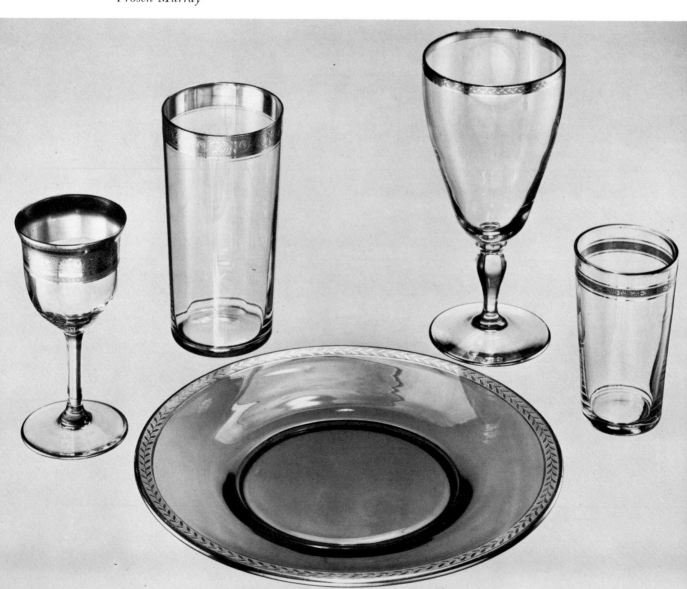

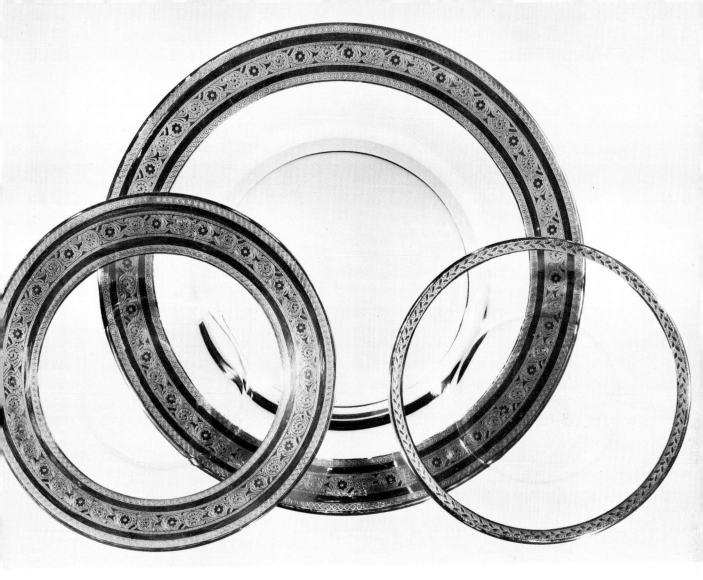

Fig. 442—Gold decorated crystal plates; Honesdale Decorating Co. *Left and center:* St. Regis pattern. *Right:* Wide Laurel pattern. *Collection Mrs. Elsa Prosch Murray*

Stegner (Nicholas Stegner's nephew) attended the decorating kilns. Edward Leine was a chore boy, and Christopher Hook polished out chips on glassware.

Raymond Fyer and William Cunningham were boys who unpacked glass blanks. George Rippel was shipping clerk.

The gold burnishers were Mrs. Mae Dennis, Mrs. Mabel Spy, Rose Haun, Mabel Secor, Florence Secor, Ethel Hawker, Elsie Kretschmer,

Mabel Reinhard, Anna Ordnung, Mae Lewis, Amelia Linke, Mary Williams, Helen Williams, Mary Bell, Mary Van Driesen, Mrs. Yarnis, Miss Smith, and Miss Bonham. Mr. Stegner described Helen Pragnel as a "gold worker."

The women who painted varnish-resist designs on glassware were Laura and Lillian Hoey, Carrie Hill, Millie Moules, and Mrs. Amelia Bartheimess. Glass washers were Laura Pragnel, Carrie

Novinenmacher, Anna Rippel, and
Emily Holland. Bookkeepers
employed at different periods were
Edna Hawker, Mae Finnerty,
Gertrude Stone, and Carl Prosch's
daughter, Elsa Prosch.

Dorflinger's Products

Dorflinger's 1910 catalog contained
several colored photo-illustrations of
their reproduction Venetian
glassware, which was produced in
transparent "Amber," "Amethyst,"
and "Turquoise," with applied glass
"trimmings"—crimped trailings,
elongated blobs of glass, rings, and
prunts representing raspberries and
lion heads.

Several designs for Aquariums,
with capacities of from one and a
half to ten gallons were illustrated
along with "Ring-," "Barrel-," and
"Bell-"shaped beakers, compotes,
ginger jars, nut dishes, covered
bonbons, flower compotes and pans
(in which flowers were floated),

Fig. 444—Trademark of Honesdale
Decorating Co., Honesdale, Pa.

fruit bowls, covered puff boxes,
candlesticks, vases, and three
complete sets of tableware.

Dorflinger's Opal glassware
(opalescent crystal flashed with
"Rose," "Amber," "Green," and
"Lilac") were also shown in the
catalog's tinted photo-illustrations.
All of these wares were made in the
Venetian style, but without any of the
applied decorations used on their
reproduction Venetian glassware.
The similarity of Dorflinger's Opal
glassware to opalescent wares made
by Tiffany and Steuben is obvious,
and collectors will find it difficult
to distinguish one from the other.
The problem of attribution is
magnified by the fact that C.
Dorflinger & Sons did not sign their
wares, and the paper labels they did
use as a means of identification were
easily removed or washed away.

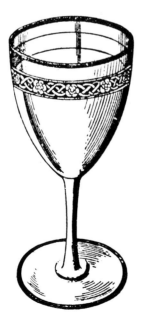

Fig. 443—Design Patent No. 41,465 for
stemware issued to Carl F. Prosch on June
13, 1911.

THE
IMPERIAL
GLASS
COMPANY

THE Imperial Glass Company of Bellaire, Ohio, just across the river from Wheeling, West Virginia, was organized in 1901 by J. N. Vance, Ed Muhleman, Lawrence E. Sands, Morris Herkheimer, and James F. Anderson, all of them prominent citizens of Wheeling. At the first stockholders' meeting, held December 11, 1901, a board of directors was elected which included the five men just named and Joseph Speidel, Lawrence Schenk, Frank C. Hoffman, and A. P. Tallman. When the Board met the following day, Mr. J. N. Vance was elected president of the company, and "Captain" Ed Muhleman, who was back of the whole idea of a new glassworks, was made secretary. Mr. Vance served as president until he died in 1913, with the exception of one early year when he was ill and Mr. Muhleman, as the company's second president, served in his stead.

Ed Muhleman was not a young man when Imperial was organized, but he was energetic and far sighted, and had keen business judgment. Most of his time with Imperial was spent as general manager of the company, and it was his promotion of the firm's wares that started Imperial on the road to its present enviably high place among glass manufacturers in this country. Mr. Muhleman retired from active participation in the company in 1910; he died in 1924.

Prior to his involvement with Imperial, "Captain" Ed had been

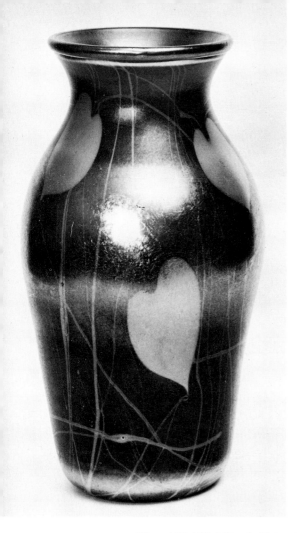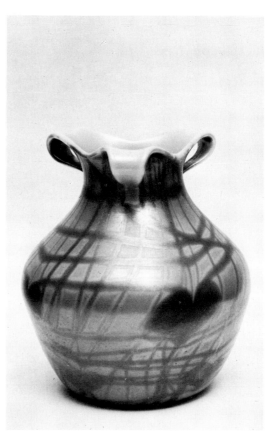

Figs. 445-446-447—*Left to right:* Imperial Free Hand vase, lustred blackish-brown with gold lustre leaves and tendrils; original paper label on base; height 8 inches. *Author's collection.* Imperial Free Hand vase, lustred gold body with green and gold lustre **Heart and Trailing Vine** decoration; original paper label on base; height 6¼ inches. *Collection L. A. Randolph.* Imperial Free Hand vase, dark blue with opal **Heart and Vine** decoration, lustred; height 10½ inches. *Oglebay Mansion Museum collection, Wheeling, W.Va.*

an official of the Elson Glass Works in Martins Ferry, Ohio, leaving there about 1885 to operate the Crystal Glass Company in Bridgeport, Ohio. Soon after Crystal Glass joined with several other companies to form the National Glass Company of Pittsburgh, Pennsylvania, Mr. Muhleman left the organization. He later engaged himself with the idea of a new glass company and spent more than two years planning,

organizing, and getting influential people interested in the project, before the Imperial Glass Company was finally formed. His courtesy title, "Captain," had been won obliquely —as a boy he had been the clerk on the Ohio River steamer *Andes,* of which his brother was captain.

Imperial's third president was Victor G. Wicke. Mr. Wicke was born in Potsdam, Germany. Before he came to America to work for H. G.

The Imperial Glass Company

McFadden & Company, importers of illuminating glassware, he and his brother had been representing various German manufacturers in Spain. As a manufacturer's agent in New York, Mr. Wicke became acquainted with "Captain" Ed Muhleman, and handled the Crystal Glass Company's line for him in New York. When Imperial was organized, "Captain" Ed brought Mr. Wicke into the company to manage their

Fig. 448—Vase of celadon-green glass with brown interior and brown Heart and Vine decoration: Imperial Glass Co., ca. 1924; height 10 inches. *Collection Mr. & Mrs. Richard Ross; photo courtesy Mansion Museum, Oglebay Park, Wheeling, W.Va.*

Fig. 449—Imperial Free Hand vase, cobalt blue with opal Heart and Vine decoration (not lustred); height 8¼ inches. *Oglebay Mansion Museum collection, Wheeling, W.Va.*

sales. It was Victor Wicke who sold the first glassware made by the Imperial Glass Company—a large order to F. W. Woolworth. During the first several months of Imperial operations, Woolworth took practically its entire production. Wicke established sales agencies all over the country and initiated exports to the West Indies, Mexico, South America, Australia, New Zealand, British South Africa, and Germany. He died in December 1929.

J. Morris Dubois followed him as president, and capably saw the

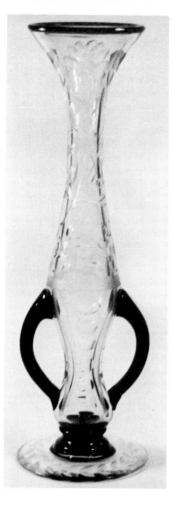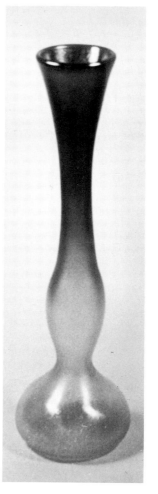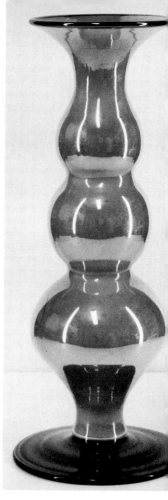

Figs. 450-451-452-453—*Left to right:* Imperial Free Hand handled vase, opal body with drag loop decorations, handles and knop in dark blue; original paper label; height 11⅜ inches. *The Chrysler Art Museum of Provincetown (Mass.)*. Crystal vase with cobalt-blue handles, rim, and knop stem; cut and engraved decoration; Imperial Glass Co., ca. 1924; height 14 inches. Frosted crystal vase lustred inside and out and shading from reddish-purple at top to pearly iridescence in base; Imperial Glass Co., ca. 1924; height 10¾ inches. *Collection Mr. & Mrs. Richard Ross; photo courtesy Mansion Museum, Oglebay Park, Wheeling, W.Va.* Imperial Free Hand vase, opal body and blue foot, Mirror Lustred; original paper label on base; height 12 inches. *Oglebay Mansion Museum collection, Wheeling, W.Va.*

company through a hard time. In February 1931, the Imperial Glass Company went into bankruptcy, a victim of the country-wide Depression. Through Mr. Dubois' legal efforts, the plant was allowed to continue operation during the proceedings. Reorganization followed in August of that same year, and the IMPERIAL GLASS CORPORATION was formed. Mr. Dubois retired shortly after the incorporation, but

it had been through his efforts that the capital necessary to continue the business had been subscribed. Aware of the effect Imperial's payroll had on the community, Mr. Dubois, whose influence was considerable, encouraged prominent and wealthy citizens of Wheeling and Bellaire to invest in the business as a safeguard to the economy and well-being of the area.

Imperial's fifth president was

The Imperial Glass Company

Fig. 455—Imperial Free Hand candle-sticks, crystal with selenium-red knops and threaded decoration on stem; original paper label on bases; height 11¾ inches. *Oglebay Mansion Museum collection, Wheeling, W.Va.*

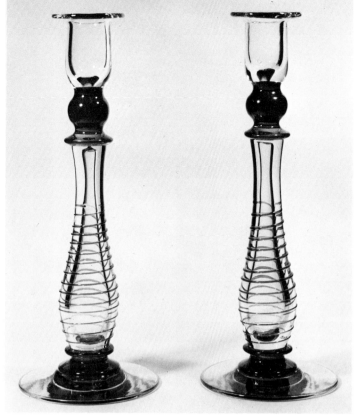

Fig. 454—Imperial Free Hand vase, opal body cased with light yellow (not lustred); height 11 inches. *Author's collection*

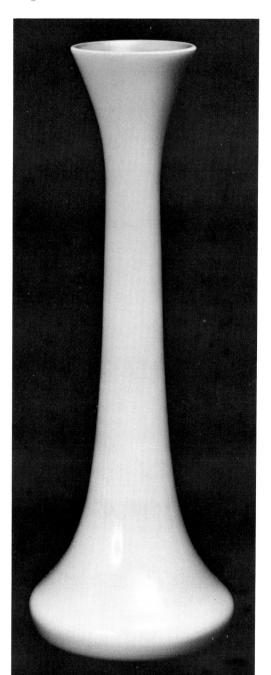

Earl W. Newton. He was the man who had kept Imperial busy during the "bankruptcy" days by selling the Quaker Oats Company on a glass premium idea and getting a contract for carloads of premium glass pieces. To him goes the credit for designing and developing Imperial's most popular tableware patterns, "Cape Cod" and "Candlewick." Both patterns are still in production and still in popular demand. Under his regime, too, the quality of glass now associated with Imperial was established. Mr. Newton, a dean among glassware salesmen, secured able personnel for Imperial's sales agencies all over the country, retaining personal control of the Chicago and mid-western area himself. He retired in 1940 to return to his own business in Chicago.

Carl Gustkey, who had been chief executive officer of the firm for

some time, succeeded Mr. Newton as president of Imperial in 1940, and was still active in that post in 1967.

About 1910, Imperial began producing pressed colored crystal with a lustrous finish—this to compete with the fine iridescent glasses being made by other American firms. Their advertisements referred to "Azur," "Red Iridescent," and "Helios" wares. These wares are now called "Carnival" glass. Imperial produced it in large quantities. Their lustering compound was purportedly the close-guarded secret of a German glassworker who had been brought to Imperial expressly for the production of this lustered ware. The workers in the factory referred to the iridescent finish as "triple doped," and it is still called by that name today. A vintage design of grapes and leaves was quite popular in the 1910 to 1915 period;

Figs. 456-457-458—*Left to right:* Vase of dark jade-green glass over opal, lined with crackled orange lustre; Imperial Glass Co., ca. 1924; height 10¼ inches. Vase of blue and opal mosaic glass with golden orange lustred interior; Imperial Glass Co., ca. 1924; height 10 inches. Crystal vase with Marigold Lustre finish, cut and engraved decoration; Imperial Glass Co., ca. 1924; height 9 inches. *Collection Mr. & Mrs. Richard Ross; photo courtesy Mansion Museum, Oglebay Park, Wheeling, W.Va.*

so was a design of irregular horizontal ribs. At that time, the three men who applied the lustre finish were Oscar Ecksted, Daniel Woods, and ——— Peterson. Recently Imperial has revived their Carnival glass production, using their old molds and designs, and marking each piece with the impressed IG cipher.

On June 2, 1914, two trademarks were issued to the Imperial Glass Company, one consisting of the firm's name, "Imperial," the other of a cross formed by double-pointed arrows. (See Fig. 465.) On September 15, 1914, the latter trademark was modified by changing the arrow cross to what was known as a "German" cross.

Fig. 459—Covered jar of canary-colored (uranium-yellow) glass with cut and engraved decoration; Imperial Glass Co., ca. 1924; height 12½ inches. *Collection Mr. & Mrs. Richard Ross; photo courtesy Mansion Museum, Oglebay Park, Wheeling, W.Va.*

Fig. 460—The Imperial Glass Co.'s advertisement of their Imperial Art Glass (Imperial Jewels) from *The Pottery, Glass and Brass Salesman*, Dec. 14, 1916.

IMPERIAL ART GLASS

Imperial glass company
Bellaire, Ohio

REPRESENTED BY THE FOLLOWING:
Cox & Lafferty, 1140 Broadway, New York M. E. Lafferty, 402-403 Equitable Bldg., St. Louis, Mo.
Earl W. Newton, 706 Heyworth Building, Chicago, Ill.
Himmelstern Bros., 718 Mission St., San Francisco, Cal.

The ADVERTISER wants to know that you saw his AD—tell him.

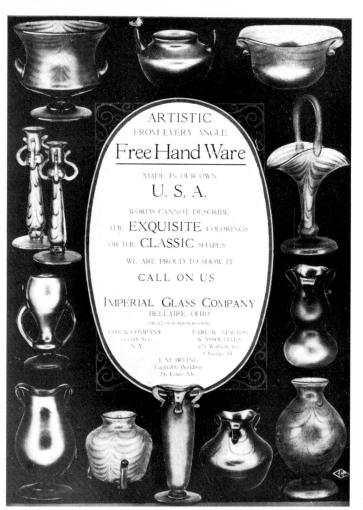

Figs. 461-462—*Left to right:* The Imperial Glass Co.'s advertisement of their Free Hand ware from *The Crockery and Glass Journal,* July 5, 1923. The Imperial Glass Co.'s advertisement from *The Crockery and Glass Journal,* Dec. 18, 1924.

Fig. 463—Imperial Jewel bowl, "pearl amethyst" color; impressed in the base with Imperial's name and German Cross mark; height 5¼ inches. *The Chrysler Art Museum of Provincetown (Mass.)*

In 1916, the firm introduced a line called "Imperial Jewels," a high quality pressed and blown ware with iridescent finish. The name was derived from the jewel-tone colors used and had no relation to design or shape. Even in color, no two pieces were exactly alike. The gem-like colors in which this ware was made are glowingly described in Imperial advertisements in various trade journals as "glowing pearl ruby," "delicate pearl white," "shimmering pearl green," and "the deep rich tones of pearl amethyst." Their advertisements also proclaimed that

these designs had been "inspired by models of antiquity and aided by every modern facility." No doubt the "modern facility" referred to the lustrous finish Imperial developed for these wares.

According to Mr. Carl Gustkey, the term "Nu-Art" was registered by his company about 1920. On August 16, 1921, the Imperial trademark was again revised to combine, in a different form, the German cross with the firm name. (See Fig. 466.)

Fig. 465—The Imperial Glass Co.'s trademark, registered June 2, 1914.

Fig. 466—The Imperial Glass Co.'s trademark, registered Aug. 16, 1921.

Fig. 467—The Imperial Glass Co.'s trademark for Free Hand wares, registered Feb. 19, 1924.

Fig. 464—Imperial Jewel vase, gold lustre; impressed in the base with Imperial's name and German Cross mark; height 6 inches. *Author's collection*

Both of these trademarks had been in use several years before the date of the trademark papers.

On February 19, 1924, Imperial's trademark "Free Hand" was registered, although in 1923 the company had advertised "Free Hand Ware" as their finest line of lustred glassware. (See Fig. 467.) Paper labels combining the Imperial name and German cross with the newly designed Free Hand trademark were used for these wares. Undecorated pieces of Free Hand usually have a mirror-like finish; decorated wares are almost always finished with a soft veil of iridescence. This line was made in a wide variety of colors—

dark blue, golden bronze, yellow, and opal (milk white), and with decorations in the "Drag Loop" design or leaves and vines. Not all of Imperial's Free Hand wares were iridescent. Some were produced in crystal and colored glass, and with applied decoration—usually threads of colored glass applied to a crystal body (Figs. 445-467).

THE FENTON ART GLASS COMPANY

N 1905, Frank Leslie Fenton, an ambitious young man with good ideas, glassmaking experience, and $248, started the Fenton Art Glass Company at Martins Ferry, Ohio. He had worked for five different glass companies, mostly in their decorating shops, and had been a foreman at the age of eighteen.

The company began as a decorating concern, with glass blanks being purchased from various glass houses and decorated with Frank Fenton's designs. Two of his brothers, John and Charles, joined in the enterprise. Soon it became apparent that the company would benefit by making its own glass, and Mr. Fenton began looking about for a site for a factory. He had almost decided on Shadyside, Ohio, when a group of citizens from Williamstown, West Virginia, headed by W. P. Beeson, convinced him that their town, with its abundance of cheap natural gas for fuel, would be the ideal location. Ground was broken for the Williamstown plant in October 1906. (Mr. Beeson, who had headed the citizens' committee, later became a vice-president of the firm.)

Shortly after operations at Williamstown began, another Fenton brother, James, joined the ranks. He was followed, several years later, by still another brother, Robert. John Fenton left the company to establish a glass plant in Millersburg, Ohio, but the other four brothers remained at Williamstown. Frank Fenton had

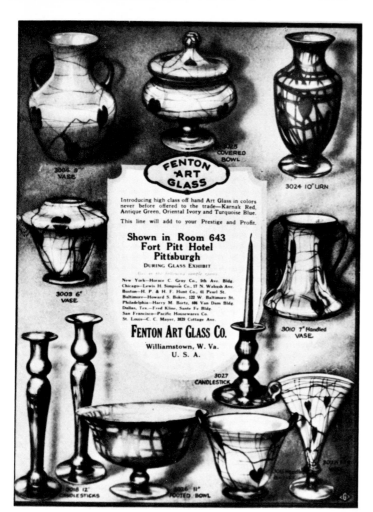

Fig. 468—Fenton Art Glass Co.'s advertisement in the *Crockery and Glass Journal,* Jan. 7, 1926, page 18. Note resemblance of shapes and decorations to other American Art Nouveau wares.

Fig. 469—Fenton "Mosaic" amphora-vase; mottled red, orange, and yellow on cobalt-blue body with Spider Webbing and lustre finish; height 9 inches. *Author's collection*

the general direction of the business, serving as president and general manager of the company from its inception until his death in 1948. He himself designed and developed many of the beautiful pieces made there. Charles and James were superintendents (Charles served as vice-president from 1931 to 1938), and Robert took over the sales. Later he became vice-president, serving as such until his death in 1948.

As of 1967, two of Frank L. Fenton's sons are actively engaged in the management of the business: Frank M., who succeeded his father as president and general manager, and Wilmer C., who succeeded his

uncle as vice-president and sales manager. The company has grown, from Frank L. Fenton's initial $248 investment, to become one of the largest and most successful of its kind in the industry.

During its first few years, the Fenton Art Glass Company made mostly crystal glass, but later almost eliminated crystal wares from its line. Fenton's first glassmaker was Jacob Rosenthal who had been associated with the Indiana Tumbler and Goblet Company of Greentown, Indiana, and its successor, the National Glass Company. He had originated his famous chocolate glass at Greentown, and he continued to make it at Fenton. For twenty-five years, Mr. Rosenthal made all of Fenton's glass; then, for eighteen more, his son Paul, to whom he had passed on his formulas, continued to make it.

During its early period, the Fenton Art Glass Company originated a popularly priced iridescent glassware in imitation of the Tiffany lustred glasses of the period. This proved one of the largest selling lines of glassware ever produced in America. Later, such Oriental colors as jade green, mandarin red, Chinese yellow, and turquoise blue were added to their color line.

In 1926, Fenton advertised their "Fenton Art Glass" line (Fig. 468). These wares could be had in "Karnak Red," "Antique Green," "Oriental Ivory," and "Turquoise." The decorations were either a leaf and vine motif, similar to Durand's

Fig. 470—Cobalt-blue vase with mottled orange, yellow, red, and green decorations and black Spider Web threading; original paper label reads: "Fenton Art Glass"; height 7⅝ inches. *Author's collection*

"Heart and Clinging Vine" design, or splotched all over with orange, yellow, red, and green in a haphazard fashion (Figs. 469-470). Occasionally some pieces were decorated with random trailings of glass threads. Almost always these wares were given a lustre finish.

Original paper labels found on Fenton's art-glass productions read either "Vasa Murrhina," or "Fenton Art Glass," but much of the early

glass can hardly be distinguished from similar products made by Northwood and other contemporary companies.

In recent years, Fenton has developed the many possibilities of opalescent glass and has borrowed the techniques of "old country" craftsmen to produce the overlays and cased glass pieces that fit so well with traditional settings in home decoration. At the present time, Fenton is producing real gold ruby glass, using coin gold, from which both the antique colors of peachblow, cranberry red, and ruby overlay are evolved.

THE H.C. FRY GLASS COMPANY

THE H. C. Fry Glass Company of Rochester, Pennsylvania, was organized in 1901 to succeed the ROCHESTER TUMBLER COMPANY which Mr. H. C. Fry had formed in 1872, and which had operated successfully under his direction since that time.

Mr. Fry had come to Rochester from Pittsburgh where he had been associated with various glass factories, including Fry & Scott which he and William A. Scott had organized and operated along about 1867 to 1868. The Rochester Tumbler Company had specialized in the manufacture of pressed- and cut-glass tumblers, and at the height of its production, had employed 1,100 people and produced 75,000 dozen tumblers a week. H. C. Fry had been its president always; and for many years J. Howard Fry (perhaps his brother) was secretary.

The H. C. Fry Glass Company continued to manufacture a fine grade of cut glassware, and expanded to produce oven glass, etched wares, pressed and blown crystal blanks for cutting, and numerous glass specialties. It was known throughout the trade for the excellent quality of its glass. In 1925, the company suffered financial reverses and went into receivership. It continued to operate under this condition until 1933 when it was reorganized. In 1934, it closed completely.

Henry Clay Fry was born September 17, 1840, near Lexington, Kentucky, and was educated there. In 1857, he went to Pittsburgh,

Fig. 471—Teaset in Fry's Foval glass; opalescent white with blue opaline handles; each piece in the set has been decorated with an etched "iced" effect; teapot 7 inches high. *Collection Mr. & Mrs. Ted Lagerberg*

Fig. 472—Fry ovenwares; large oval platter and smaller baking dishes; all pieces marked "Pat. 5-8-17" and "Pat. 5-27-19." *Collection Mr. & Mrs. Ted Lagerberg.*

Fig. 473—All pieces thought to be Fry's Foval glass. *Left to right:* Cup and saucer. Compote of opal glass with blue stem and drag loop pattern of blue threads on bowl. Opalescent white pitcher with green opaline handle. Vase of opalescent white glass, top edged with crystal. *Collection Mr. & Mrs. Ted Lagerberg*

Pennsylvania, to seek his fortune in the glass trade. He was hardly begun when the Civil War came along. Fry and his brother George enlisted together as privates in the Fifteenth Regiment, Pennsylvania Cavalry, and took part in all the engagements of the Army of the Cumberland until they were mustered out in 1864.

Fry returned to Pittsburgh and the glass industry. He traveled, for a while, as salesman for the William Phillips Glass Company of Pittsburgh; he served as manager at the O'Hara Glass Works, then under James B. Lyon's direction; he participated in the Fry & Scott venture. By 1872, when he formed the Rochester Tumbler Company, he was experienced enough in the

various phases of the glass business to ensure success for his new company. The H. C. Fry Company, which succeeded it, provided an opportunity for expansion and movement into wider fields of production.

In Rochester, Mr. Fry was always interested and active in civic affairs. He organized the First National Bank in 1883 and served as its president until 1926. He was president and director of the Duquesne Light Company for many years, and he served in similar capacities in other business and civic organizations in and around Rochester. He died at his home there, January 3, 1929.

From 1926 to 1927, the H. C. Fry Glass Company produced their

Fig. 474—*Left to right:* Water carafe and matching tumbler presumed to be Fry's Foval glass. Large opalescent white bowl with green opaline foot. Coffee pot at far right has been positively identified as a piece of Corning's "Pyrex" ware turned opalescent after much use; note how closely it resembles pieces attributed to the H. C. Fry Glass Co.

Fig. 475—Foval glass footed sherbet, opal with green foot, decorated with silver deposit decoration of strawberries and leaves; silver deposit decoration bears the mark of the Rockwell Silver Co., Meriden, Conn.; height 2⅜ inches. *Author's collection*

Pearl Art Glass line, more familiar to collectors as "Foval." (According to James R. Lafferty, Sr., the term was made up of the words *Fry OVenglass Art Line.*) This ware is often confused with Steuben's line of Jade glasses, and especially with Dorflinger's Opal glassware which it closely resembles.

Most of Fry's Foval glass is made of their milky white opalescent ovenglass, patented by Ralph F. Brenner on May 9, 1922, and immediately assigned to the H. C. Fry Glass Company (Figs. 471-475). Handles, feet, knobs, and other appendages were usually made of Delft (blue), Jade (green), or pink Opaline. Some pieces of Foval can be found with engraved decorations or with Silver Deposit designs put on the glass by the Rockwell Silver Company of Meriden, Connecticut. The latter will be marked with Rockwell's hallmark and the designation, "Sterling."

A few pieces of colored opalescent glass have been found with Fry's trademark, and these may have been part of their Foval line, too. However, some of the pieces illustrated in Mr. Lafferty's first book, *Fry's Pearl Ware* (1966), and in his second monograph, *Pearl Art Glass—Foval* (1967), are most assuredly Dorflinger's Opal glassware, and have been exactly illustrated in color in Dorflinger's catalogs.

We do not subscribe to the thought that Fry produced all of the colored opalescent wares that collectors have attributed to his firm. Often

pieces claimed as Foval are out of character as far as form is concerned and appear to be somewhat earlier than Foval glass. An illustrated catalog appended to Mr. Lafferty's second book has provided collectors with illustrations of most of the Foval glass articles produced by the H. C. Fry Glass Company.

The July 3, 1922 issue of *China, Glass and Lamps,* a trade magazine, contained a lengthy article on the Fry Art Glass and Oven Glass lines. Under the heading "New Art Shapes" references were made to shapes, colors, and decorations used on these wares. Ice tea sets and tea pots were mentioned in "crackled effects" and "iridescent crackled effects," indicating that some kind of lustrous finish can be found on some of these pieces. Still other decorations were described as "either etched or in color, and several are made in a combination of etching and enamel." Elsewhere in the article "vases in jade green, intended primarily for use as lamp bases," were said to produce "a warm and restful color." It was claimed that Fry's patented "stud" held the lids of their pots fast while tilted in a position for pouring. Some of their oven ware was "available with engraved designs."

An amusing article in the February 15, 1923 issue of *Crockery and Glass Journal,* another magazine for the trade, mentioned Fry's "Radio" glass line—which included floor lamps that sold for $500, and a large punch bowl set. It purported to be an account of a meeting at Fry's

Ft. Pitt Hotel showroom in Pittsburgh, Pennsylvania, between William Jennings Bryan, the great "Commoner," and Alexander Fraser, sales representative for the H. C. Fry Glass Company and the Beaver Valley Glass Company. Radio glass was transparent, and light yellow in color, and many of the pieces made in this line were molded with various "Optic" designs. In March 1923, another trade magazine reported that Fry's Radio glass was "being favored with an increased demand" because of the number of new pieces added to the line.

THE MT. WASHINGTON GLASS COMPANY

DESPITE the popular demand for Art Nouveau glassware, and the excitement the new forms and techniques were creating in the glass industry as a whole, there were some glass manufacturers for whom Art Nouveau did not exist. The Mt. Washington Glass Company was one of them.

The Mt. Washington Glass Company was established in New Bedford, Massachusetts, in 1869, an outgrowth of the original company of that name created in 1837 in South Boston by Deming Jarves for his son George. The New Bedford plant was finely equipped. There was a three-story decorating house with its own firing kiln, a cooper's shop, storage building, blacksmith shop, and boiler house in addition to the glass factory itself. At that time it was owned by W. L. Libbey & Company, though it operated under its original name. Its wares were diversified and its operation successful. Though it closed for a while during the general Depression of 1873, it reopened the following year with Frederick S. Shirley as manager, and continued to expand. Under Mr. Shirley, many new art-glass wares were brought out. "Burmese" originated there and the Mt. Washington versions of "Amberina," "Peachblow," and other art-glass wares rivaled the best of other glassworks. They were justly proud of their cut glass and boasted that theirs was the only glass factory in the country where complete crystal chandeliers were made.

FIG.1

FIG.2

FIG.3

Fig. 476—Albert Steffin's design for a glass shade; the idea was adapted to lamps with one or more shades and some shades were hand-painted; patent assigned to the Pairpoint Corp., July 9, 1907.

In 1880, the PAIRPOINT MANUFACTURING COMPANY came into the picture. This company, created for the purpose of making a complete line of staple and fancy articles in silverplate, including all the stands and holders that Mt. Washington needed for their fancy glass items, was located on land adjoining the Mt. Washington works.

In 1894, the Pairpoint Manufacturing Company took over the Mt. Washington glassworks. In 1900, it became THE PAIRPOINT CORPORATION, continuing to make both glassware and plated silver. The company employed, at that time, 350 glass cutters and 100 men in the blowing room. Pressed, cut, and art glasses were made, and the new lines they introduced—"Crown Milano," "Albertine," "Napoli," "Royal Flemish," and others—were all delicately late Victorian in design and feeling.

There seems no reason the company could not have joined the Art Nouveau caravan except that they did not care to do so. Nothing shows more clearly their total disinterest in this "far out" new style than the Pairpoint Manufacturing Company's catalog for 1898. Art Nouveau was then well advanced in acceptance, but the Pairpoint catalog showed not one design or form, either in glassware or in Pairpoint's silver-plated mountings, which remotely reflected the Art Nouveau influence (Fig. 476).

While they did introduce some Art Nouveau designs in their metalwares after 1900, the "new art" was still sadly lacking in their glassware. Their "Garland" pattern in cut glass which came out about 1900 hinted at it, but was not a true example of the style. Perhaps their only design, of the hundreds they produced, which could be classified as true Art Nouveau was their cut-glass "Tulip" pattern, designed by Albert Steffin and patented Oct. 27, 1908.

The Pairpoint Corporation suffered severe business losses in 1929 and closed down. The glassworks have since been opened sporadically under different managements, different names, and in different locations.

THE C.F. MONROE COMPANY

BEFORE Charles F. Monroe established his own business in 1880, he was a designer for the Meriden Flint Glass Company of Meriden, Connecticut. He was often sent abroad to observe and study the new designs and decorating techniques used by European glass manufacturers. Quite possibly he witnessed the beginning of the Art Nouveau style of decorating glassware—some of his wares reflect elements of such an influence—but for the most part Monroe's designs indicate that he clung to the old Victorian style of decoration.

When Monroe first opened his shop at 36 West Main Street in Meriden, Connecticut, in 1880, he offered imported glassware. In 1882, he started a glass-decorating studio; in 1883, his advertisement in the Meriden Directory stated that he maintained "Art Rooms and Glass Company's Show Rooms, Oil Paintings, Artist's Materials, Art Goods, Decorative Vases, &c., Art Glassware, and a Choice and Varied Line of Bric-a-Brac Articles." Monroe also advertised, "Orders taken and lessons given in glass and china decorating. Orders also received for Rich Gold Frames." In 1884, Mr. M. Rick was listed as the manager of the decorating department, and Monroe was president of the firm. By 1891, Monroe occupied a group of buildings on West Main Street and Capital Avenue, which he had converted into a glass-decorating works.

A corporation was formed in March, 1892, known as The C. F. Monroe Company. Monroe held 201 shares of stock; the remaining 199 shares were held by the following: William James Goulding, E. W. Smith, H. Wales Lines, Rufus M. Wilson, Mrs. George M. Ball, Albert Babb, A. Pritchard, E. J. Doolittle, David Smith, D. H. Schneider, George A. Church, I. L. Holt, George H. Wilcox, M. Seips, C. Berry Peets, George R. Curtis, C. V. Helmschmied (who later went into the glass-decorating business for himself), E. B. Everett, Edward Miller, Jr. (for Edward Miller & Company, lamp manufacturers in Meriden), and W. H. Lyon (for the Charles Parker Company of Meriden, manufacturers of lamps and other household articles). The C. F. Monroe Company supplied the Miller and Parker companies with decorated glass shades for their lamps.

Having this additional capital to work with, Monroe built a five-story factory to house his business. In 1903, a three-story addition was made to the new factory; this was used primarily for his latest venture, a glass-cutting shop. At first his cut-glass business was successful, but not long after it was established, Monroe began to lose money on this phase of his operation and it was common talk about town that the money he was making on the glass-decorating business was being lost in his cut-glass works. In April 1907, the firm's capital stock was increased from $40,000 to $100,000 (the issuance and sale of additional stock shares increasing the working capital).

The C. F. Monroe Company went out of business in 1916. Its factory and equipment was acquired by Edward Miller & Company and remained in their hands until about 1923. Monroe was employed as a foreman by Edward Miller & Company until 1920.

Among the top decorators working for The C. F. Monroe Company were Carl V. Helmschmied, Emil Melchior, Joseph Hickish, and Carl Puffee. Some of the girl decorators were Flora Feist, Alma E. Wenk (later Mrs. Clarence T. Wilks), Blanche Duval, Gussie Stremlan, Elizabeth Zeibart, and Elizabeth Casey. One of the foremen of the Monroe decorating shop was a man named ———— Idam.

Carl Helmschmied did most of the designing at Monroe's factory. When he went into business for himself, he kept on with this phase of the work, doing his own designing and most of his decorating, too. Helmschmied liked to paint landscapes, and he often used them to decorate his glasswares.

Alma Wenk spent ten years in the Monroe decorating department. As an outside hobby, in earlier years, she enjoyed china painting; later she turned to water colors and landscape painting. She developed a style of her own in this medium and was quite successful as an artist.

Joseph Knoblauch was Monroe's salesman, traveling all over the

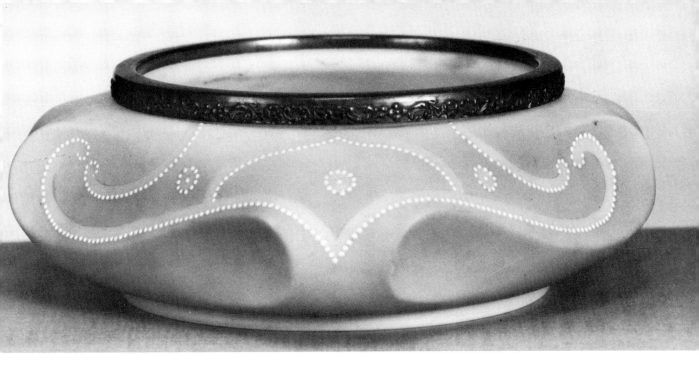

Fig. 477—Opal glass fern dish painted blue and with beige and pink Art Noveau decorations; signed "Nakara/C. F. M. Co."; made by the C. F. Monroe Co., Meriden, Conn., ca. 1900; diameter 9 inches, height 3 inches. *Author's collection*

country and selling to the best stores in the cities and towns he visited.

Almost all of Monroe's glass blanks were first put through an acid bath, giving them the mat finish that is characteristic of his productions. The Monroe line was enormous, encompassing just about everything imaginable for personal or household needs, usually beautifully decorated with enamels and gold. The metal fixtures were gilded, and objects such as jewelry boxes and other containers, with or without covers, were lined with delicately colored silk. A large work department was maintained where girls attached the metal parts (hinges, brackets, and so forth) to the painted glass parts with plaster-of-Paris, and installed the fancy silk linings.

Many of Monroe's designers and decorators went to work for other concerns in the Meriden locality. His influence on their designs was spread through the area and is quite apparent in those wares produced by Handel, Helmschmied, Hall, and many others.

Most collectors are familiar with Monroe's decorated opal wares— "Wave Crest Ware," trademark registered May 31, 1898; "Kelva," trademark registered August 2, 1904; and "Nakara," no trademark registered (Fig. 477). Relatively few know that, about 1885, Monroe advertised himself as a "Manufacturer of Architectural Glass for Doors, Stairs and Memorial Windows, Office and Bank Screens." He also claimed to be the "Patentee and Manufacturer of the Latest and Most Popular of Inventions, The Pyrene Lamp Shade."

HANDEL & COMPANY

THE HANDEL COMPANY, INCORPORATED, of Meriden, Connecticut, was initially founded, in 1885, as a partnership between Adolph Eyden and Philip Julius Handel, operating under the style of EYDEN & HANDEL, glass decorators. Their factory was located at 300 Main Street. In 1893, Mr. Handel purchased his partner's interest in the business, changed the name of it to HANDEL & COMPANY, and moved the works to 381 East Main Street. The company remained at that location until it closed, though the first wooden buildings were replaced by a fine brick structure about 1904.

Philip Handel was born in Meriden of sturdy German stock. His family were farmers, but when young Philip showed a talent for drawing, his parents encouraged him by supplying him with art books and instruction from local art teachers. As a boy, Handel started a small printing business of his own and operated it until he was about fourteen years old. At that age he left school and went to work at the Meriden Britannia Company. He stayed there only a month, then found employment more to his liking with the old Meriden Flint Glass Company. At the glassworks, Philip Handel was able to express his artistic nature, and he designed and decorated many pieces of their glass. His experience there stood him in good stead when, at the age of 19, with Adolph Eyden, he went into the glass-decorating business for himself.

His firm remained Handel & Company from 1893 until 1903.

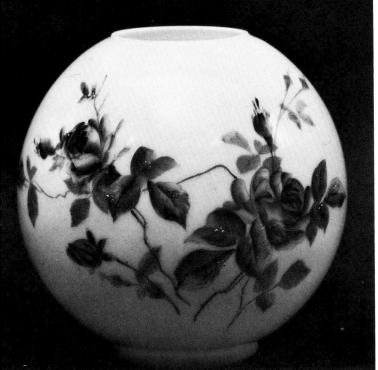

Philip Handel died on July 14, 1914, at the age of 48. His widow, Fannie Handel, assumed her husband's place as president and treasurer of the company, and took an active part in the business. Early in 1918, she married Millard Henry Turner. In 1919, Handel's cousin, William F. Handel, became manager of the firm and, eventually, in 1926,

Fig. 478—Opal glass ball-shade decorated with pink roses, green leaves, and brown stems; signed "Handel"; height 9 inches. *Collection Charles Newton*

Then a certificate of incorporation, filed on June 11, 1903, by Philip J. Handel, Albert M. Parlow, and Antone E. Teich, renamed the firm THE HANDEL COMPANY, INCORPORATED. Shortly afterward, on June 16, 1903, a certificate of organization was executed, listing all three men as directors of the company with Handel as president and treasurer; Antone E. Teich, vice-president; and Albert M. Parlow, secretary. Mr. Handel owned the major portion of the company's stock (294 shares), while Messrs. Teich and Parlow, between them, owned the rest (7 shares).

Fig. 479—Marked "Miller Co." Rochester oil lamp with signed "Handel" opal glass shade decorated with green, gray, and gold palm leaves; height 18½ inches. *Collection Mr. & Mrs. Howard Gianotti*

Figs. 480-481—*Left to right:* Handel table lamp with opal glass lamp vase painted maroon and green; gilded metal foot; glass shade decorated with red grapes and green leaves on a trellis against a background of light yellow; beaded fringe surrounds the rim of the metal shade-holder; height 18 inches. *Collection Mr. & Mrs. George Manley.* Night-light lamp with egg-shaped opal glass shade decorated with flowers and leaves in natural colors; painted metal base simulates a carved Teakwood base in the Chinese style; height 8 inches. *Privately owned.*

he was listed as vice-president of the corporation.

When Handel's widow finally retired from the business, William Handel continued to operate the factory in association with William F. Hirschfeld, John McGrath, and Frederick W. Hill, who had been a salesman for the company for many years. During the Depression years, every effort was made to keep the business alive. On October 18, 1933, and again on March 14, 1934, certificates of increase in the firm's capital stock were filed by these three men. Unfortunately none of their

Fig. 482—Desk-lamp with bronze base and "chipped" glass shade; underside of shade decorated with scenic design in colored enamels and signed "Handel 6318"; height 14¼ inches. *Collection Mrs. Leroy C. Simon*

Figs. 483-484—*Left to right:* Signed "Handel" table-lamp with bronzed Spelter base and "chipped" glass shade decorated on underside with brilliantly plumaged birds of paradise on a black ground; shade signed by the artist-decorator "Bedigie," and marked "Handel # 7026"; height 25 inches. *Privately owned.* Handel lamp with original cloth label. Antiqued bronze base; "chipped" shade decorated with dark green lily-pads and blue-green fern design; underside of shade painted iridescent yellow and marked "Handel # 5351/U.S. Patent No. 979,664"; height 21 inches. *Collection Mr. & Mrs. Howard Gianotti*

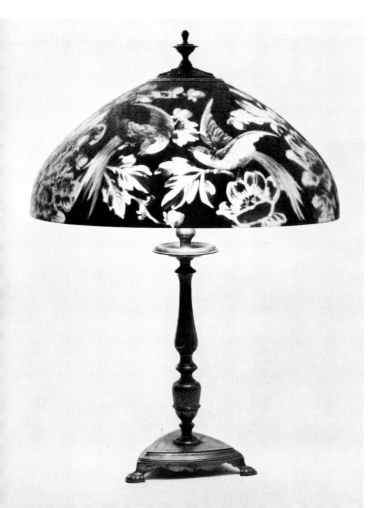

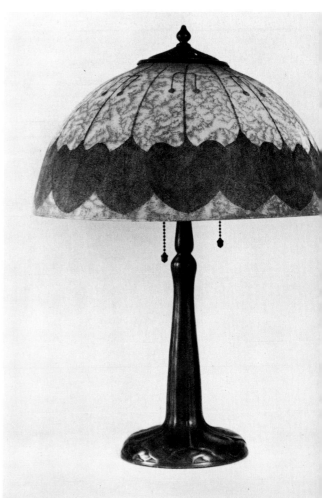

efforts proved successful; the factory was closed in the early part of 1936. The company was officially dissolved August 15, 1941.

Handel Products

At first Handel's company manufactured decorated opal wares— lamp globes, cologne bottles, vases, and the like. They purchased their undecorated opal glass blanks from several sources. The only one we could verify was the old Roederfer Brothers Glass Works in Bellaire, Ohio. As his business grew, Handel enlarged his factory to enable him to manufacture his own metalwares. In time, a showroom was opened in New York City at 200 Fifth Avenue, and subsidiary lines of metalwares, decorated china, and some wooden wares were added to their line.

Decorative lamps were the firm's most important commodity (Figs. 478-497). Handel advertised extensively in quality magazines, and many of his lamps were pictured on the advertising pages of such contemporary magazines as *Century, Country Life, Good Housekeeping, Harper's Bazaar, Harper's Magazine, House Beautiful, House & Garden, Scribner's Magazine,* and *Vogue*. Handel's lamps are usually signed or marked with the firm's name or trademark in one way or another. Sometimes the decorators signed their work, too, adding to the value of such objects today.

During our interview with Ernest C. Lewis, who was head designer for the Handel Company for many years,

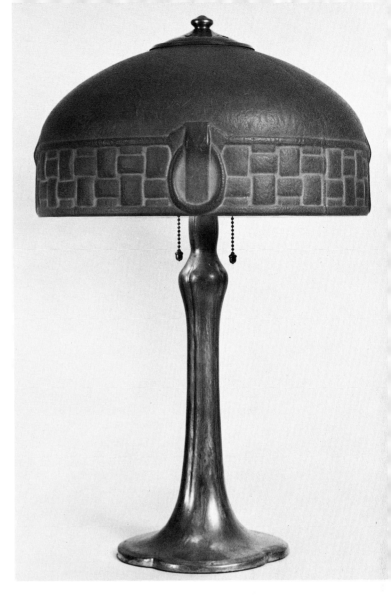

Fig. 485—Library lamp with copper-finished base bearing original "Handel" cloth label; pattern-molded opal glass shade painted dark brown on "chipped" ground marked "Handel/Brown/5635½-U.S. Patents No. 979,664, No. 775,818"; height 23 inches. *Collection Mr. & Mrs. Howard Gianotti*

we learned that 16 girls were employed in his department to hand color illustrations of articles he sketched for their color brochures and magazine advertisements. All Handel's promotional material, including the advertisements in the magazines mentioned, were directed

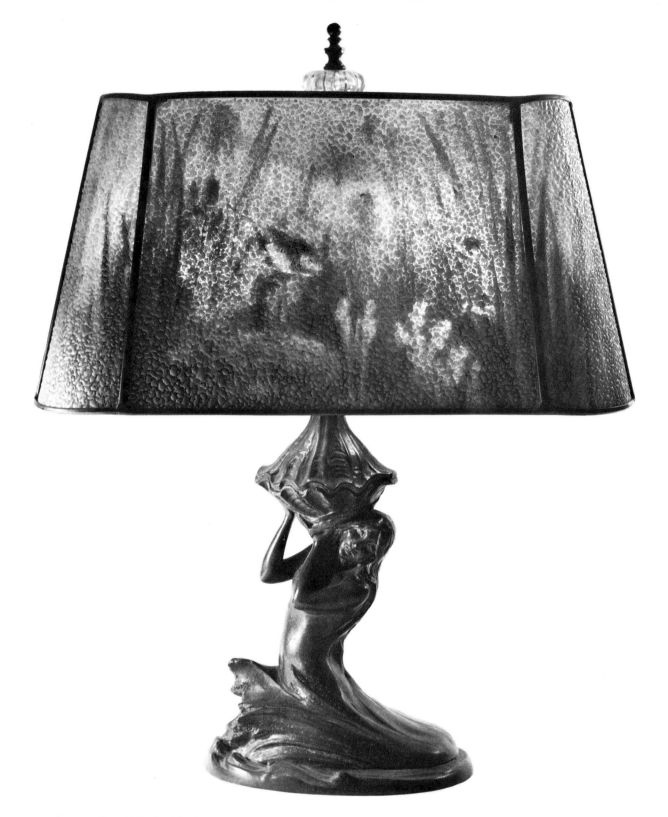

Fig. 486—Table lamp with Verde finished Spelter base in the form of a mermaid holding a shell. Panelled glass shade internally decorated with "Aquarium" design of goldfish swimming among aquatic plants; the exterior of the shade splotched with white enamel all over; shade signed by the artist-decorator "Bedigie" and marked "Handel Design # 7538"; height 24 inches. *Privately owned*

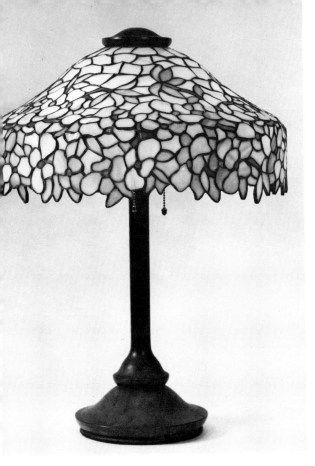

Fig. 487—Handel lamp with bronze base and leaded shade in Dogwood pattern; pink and white flowers and variegated yellow and green leaves; height 24½ inches. *Collection Mr. & Mrs. Howard Gianotti*

Fig. 488—Philip J. Handel's patent design No. 36,133 for a lamp bracket or standard; patented Nov. 4, 1902.

Fig. 489—Pond-lily lamp with antiqued bronze base marked "Handel"; shade and bud with striated green and white Bent-glass inserts; this is design shown in Fig. 488; height 13¼ inches. *Collection Mr. & Mrs. Howard Gianotti*

toward a quality-minded market, and were widely read by men and women of good taste.

Most of the actual decorating was done by a group of men, all artists, who turned out a great many hand-painted objects for home use. Handel's wares ran the gamut from simple ashtrays to extravagantly decorated lamps, painted with exotic designs.

Since lamps were Handel's biggest stock in trade, they were made in many sizes, from small egg-shaped night lights to table lamps, large floor lamps, and ceiling fixtures. The majority of Handel lamps found

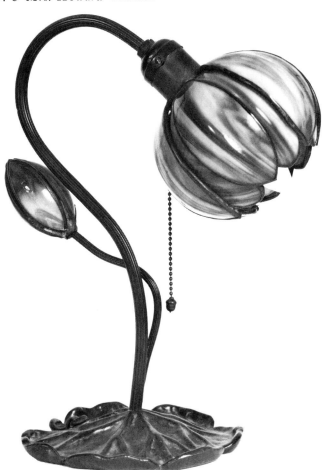

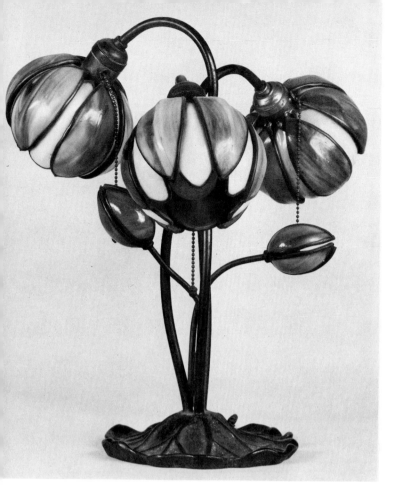

Fig. 490—Five-branch Pond-lily lamp, green and white Bent-glass shades; bronze base; signed "Handel" in base; height 16¾ inches. *Metropolitan Museum of Art*

Fig. 491—George Lockrow's patent design No. 36,134 for a lamp bracket or standard; patented Nov. 4, 1902.

Fig. 492—Signed "Handel" lamp with Chinoiserie lamp-vase decorated in white, gold, and pink on a green ground; leaded shade etched to resemble parchment with amber panels and deep amber "Bull's-eyes"; marked "Handel 7568"; height 27 inches. *Collection Mr. & Mrs. Howard Gianotti*

266

Fig. 493—Signed "Handel" lamp with bronze base and reticulated bronze shade representing palm trees; glass inserts on underside of the shade painted green, orange, and blue, giving the appearance of a tropical sunset; height 25 inches. *Privately owned*

Fig. 494—Philip J. Handel's patent design No. 40,721 for a lamp shade; patented June 7, 1910.

Fig. 495—Philip J Handel and Antone E. Teich's patent design No. 979,664 for a lamp-shade holder; patented Dec. 27, 1910.

Fig. 496—William F. Handel's patent design No. 55,464 for a shade for lighting fixtures; patented June 15, 1920.

Fig. 497—William F. Handel's patent design No. 56,922 for a shade for lighting fixtures; patented Jan. 18, 1921.

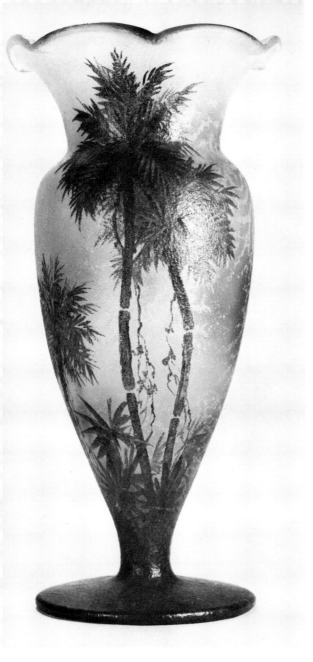

Fig. 498—Signed "Handel / 4214" vase; decoration of palm trees in tan, brown, green, and gray on a "chipped" crystal ground; height 10¾ inches. *Collection Mr. & Mrs. Frank Smith*

today have half-dome shades, 18 inches in diameter, the company's most popular size.

The lamp shades were textured, usually on the outer surface, by Handel's patented means for "chipping" glass (U.S. Patent No. 775,818, dated November 22, 1904; also patented in England, May 25, 1905). To produce this "chipped" effect the glass was sand-blasted and coated with fish glue. When the glue had hardened the shade was placed in a kiln and heated to 800° Fahrenheit. The heat caused the glue to contract and drop away from the surface of the object, carrying with it portions of the glass (Figs. 498-506). The textured surface produced by this process resembled frost on a windowpane. (The same decorating technique was patented earlier, in Germany, in September, 1883, by Carl Pieper of Herzogenrath, near Aachen.)

In the case of lamp shades, the designs were usually painted on the inner surface of the glass, and showed to advantage only when the lamp was in use. Occasionally pattern-molded blanks were ordered from Handel's suppliers, but the decorators did not always follow the molded designs.

Sometimes tiny glass beads were sprinkled on the outer or inner surface of the glass; refiring affixed them permanently to the glass.

Leaded-glass shades, and imitations of them, were also a part of Handel's line of fine lamps. The "imitations," less expensive than the leaded-glass shades, were simply metal frames with fancy cut-out designs backed by pieces of colored or painted glass.

Handel & Company used many decorating techniques to produce new and interesting effects. Besides the more familiar "chipped" effect, collectors will find some shades

Figs. 499-500—*Left to right:* Crystal vase with "chipped" ground and etched cameo decoration of amber-colored flowers in the Art Nouveau style; Handel & Co., ca. 1920; height 11 inches. *Author's collection.* Signed "Parlow" vase with colorful scenic decoration in enamels on a "chipped" crystal ground; height 11 inches. Shaded yellow and brown decorated opal glass jar with ceramic top in the Egyptian style; signed "Handel"; height 5 inches. *Collection Mr. & Mrs. Ted Lagerberg*

lustred with metallic stains. An unusual pebbled effect can also be found on Handel wares. This was produced by spotting the surface of the glass with white or colored enamel which melted slightly in the heat of the decorating kilns. This kind of decoration, when used on lamp shades, was visible only while the lamp was in repose. When the lamp was in use, the pebbled effect seemed to melt away and become a part of the textured surface. We examined a lamp so decorated by Henry Bedigie; the interior of the shade carried a design of fish, swimming in an aquarium. When the lamp was in use, the combination of the interior and exterior decorations was exceptionally beautiful.

Egg-shaped night lights are particularly sought by collectors

because of their small size and dainty decoration. Obviously Handel used stalactite globes, originally meant for ceiling fixtures, for these night lights. Not many of them have survived; they were of a shape easily knocked over and broken.

Around 1924, a contest was held among the Handel employees to select a name for a new kind of parchment shade the company was

Fig. 501—Crystal vase with "chipped" surface decorated with woodland scene in natural colors; signed in base "Teroma / Handel"; height 10¾ inches. *Author's collection*

Fig. 502—Tazza of pressed opal glass decorated with orange flowers and green leaves on a cream ground; signed "Handel"; height 7½ inches. *Collection Mr. & Mrs. Victor Buck*

producing. The new shades were first painted with colored designs and then sprinkled with tiny glass beads—not really a novel decoration, since it merely repeats a glass-decorating process used in the late nineteenth century, known then as "Coraline." The contest was won by Mr. Horace W. Kingsley, superintendent of the Handel plant at that time. He submitted the name "Fabrikon."

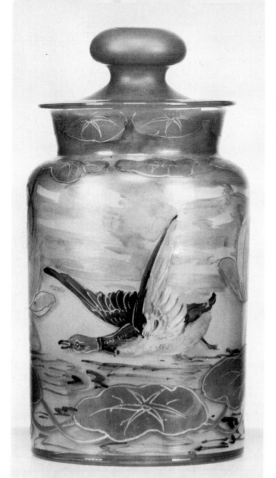

Fig. 503—Tobacco jar of crystal painted green, with ducks and water lilies in natural colors; signed "Handel Ware / 4091/2"; height 7½ inches. *Author's collection*

Fig. 504—Cameo-etched objects, light yellow on lustred, frosted crystal ground; all marked "Handel." *Left to right:* Vase with stylized thistle flowers and leaves; height 8¼ inches. Tobacco jar with Wild Geese design; height 7½ inches. Small bowl with Art Nouveau decoration; signed by the artist "Palme" and marked "Handel #4252"; diameter 6 inches. *Privately owned*

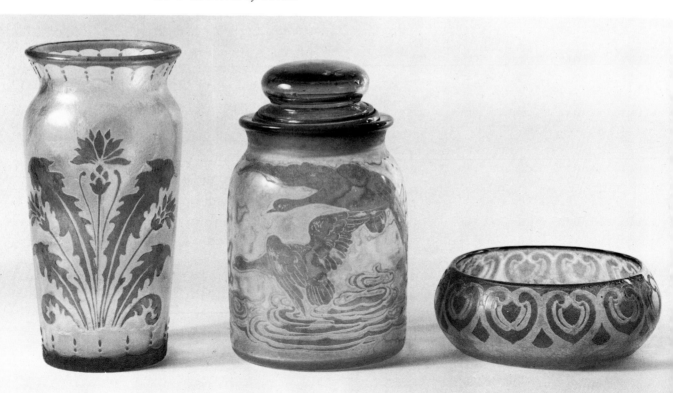

For a short period before it closed, the Handel factory put out a line of handsomely decorated china and earthenware products. Using undecorated blanks purchased from manufacturers in Limoges, France, and Bavaria, Handel put out complete services of hand-painted china for table use. Handel's most popular designs were the "Poppy," "Wild Rose," and "Iris" patterns. Several other floral patterns were also produced, all collectible in complete sets of tableware, and with incidental pieces such as vases, bowls, covered jars, ashtrays, nut and candy dishes, jardinieres, and the like, in various designs.

A few pieces of glazed pottery, decorated with Handel's "Verde" finish on a "chipped" ground were produced. The "Verde" pitcher with "Maize" decoration shown in our illustration is a rare and interesting example of this type ware (Figs. 507-508).

Handel's Decorators

Not all of Handel's decorators could be identified, but we did discover the names of some of the important artists employed over the years by this firm.

Henry (nicknamed Binge and Bingo) Bedigie was one of Handel's finest decorators. According to Mrs. William F. Hirschfeld, whose husband was with Handel when it closed, Bedigie was a rather large man, and his French ancestry may have influenced his penchant for the brilliant colors and designs he used

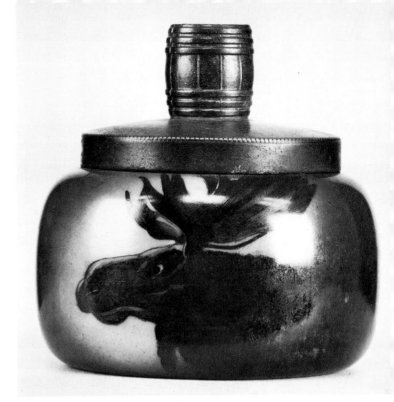

Fig. 505—Tobacco jar of opal glass painted green, brown, and russet; signed "Handel Ware"; height 5 inches to top of metal cover and matchsafe knob. *Author's collection*

Fig. 506—Decorated porcelain demitasse cup and saucer marked "Handel, Meriden, Ct." and the mark of the manufacturer "W. G. & Co. France" in the base; height 4 inches. *Collection Mrs. Leroy C. Simon*

on lamp shades and on glass and porcelain table and ornamental wares. Bedigie signed most of his articles, and they are eagerly sought by collectors.

F. Gubisch was originally from Holland. He, too, signed the lamp shades and other articles that he decorated by hand.

George Palme painted beautiful designs on glass and porcelain. He also etched shallow cameo-relief designs on cased glass blanks in the style of the French Art Nouveau cameo glass. Palme's etched cameo pieces were usually done on crystal blanks, lightly flashed with a canary-yellow glass or mineral stain. Most of these works were signed by Palme and usually have one of the Handel trademarks on the base. A hand-painted glass tobacco jar in the author's collection bears a striking similarity in its design to a cameo-etched tobacco jar which Palme made for Mr. Hirschfeld.

A man named Rochette also decorated and etched designs on cased colored blanks in the Art Nouveau style of cameo glass. Only a few pieces signed by this artist have been found to date, and it is quite likely he did not work for the Handel Company for any great length of time.

Albert M. Parlow was mentioned in *A Century of Meriden* (1906) as being in charge of the Handel factory. His designs for decorated wares and porcelain appear to be more original than those of most of the other artists employed by this firm, and obviously superior in style and execution. For this reason, Parlow's works should command a premium price in years to come. Parlow was a prolific decorator and his works are still to be found in homes and antique shops in the Meriden area. As the demand for Parlow's decorated art wares increases, the supply will most certainly diminish.

William Runge was considered one of the better artists working for Handel. In the opinion of Ernest C. Lewis, one of Handel's best designers, Runge was by far their finest decorator. Glass and parchment shades as well as decorated porcelain and glass objects can be found with Runge's signature on them. Those we have examined seem to bear out Mr. Lewis' appraisal of Runge's ability to translate his own and others' designs into objects of great beauty. Runge's sense of color ranges from the most flamboyant combinations to the subtlest tones and gradations.

Walter Wilson (born in Manchester, England, August 1, 1870) produced many handsomely decorated pieces of china and glass for Handel. His long and active interest in the glass- and china-decorating trade makes it relatively simple for collectors to acquire pieces bearing his signature. After leaving Handel's, he was the chief decorator for the A. J. Hall Company; then, from 1905 to 1917, he was associated with Joseph Hickish in a china-decorating studio of their own, located in Meriden at the corner of State and Cook Avenue.

Figs. 507-508—*Left to right:* Limoge pitcher with "chipped" ground and Verde finish, etched design of yellow corn with green husk; signed in base "Limoges, France / Handel Ware"; height 8 inches. Japanese porcelain covered chocolate pot with Verde and hand-painted decoration of pink and rose chrysanthemums; signed in base "Handel Ware"; height 10 inches. *Author's collection*

In 1917, when the partnership with Hickish was dissolved, Wilson moved his studio to his home in nearby Southington, Connecticut, close to the Meriden-Waterbury Turnpike.

Some of Mr. Wilson's most popular patterns for chinawares were originally Handel patterns which he continued to produce over a period of several years: "Poppy," "Wild Rose," "Iris," "Double Violet," "Daisy," "Nasturtium," "Orchid," "Pansy," "Dogwood," "Vineyard" (grapes and leaves), and two "Lily" designs. Wilson's "Dresden" pattern, which consisted of a delicate wreath of small flowers painted around each piece in a set of tableware, was one of his most popular designs, and was in production for several years. During World War I (1914–1918), when he was unable to purchase porcelain blanks from France and Germany, Wilson resorted to undecorated wares made in Japan. Most of his customers were displeased with the quality of the Japanese china, but they purchased it anyway because of Wilson's beautiful decoration.

Walter Wilson's son, Frank Wilson, continued the

china-decorating business his father had established for a few years after the elder Wilson's death. His pieces were signed "F. Wilson."

Peter Broggi decorated china and glass for the Handel company before going into business for himself. He is believed to have been a graduate of the Yale Art School.

Katherine Welch (nee Casey) was another fine decorator for Handel. She used both "K. Welch" and "K. Casey" as signatures. She was also an artist in water color. A certain painting by R. W. Rummell (a U.S. engineer, not connected with the company) appealed to her, and she copied it for reproduction in *Under the Shade,* a small magazine the Handel decorators published for their own amusement. The name of it, of course, alluded to the Handel lamp shade operations on which they all worked. Many of the other decorators listed here also presented spare-time drawings and paintings in this publication.

Emil Melchior, who formerly worked for Monroe, was considered one of Handel's best decorators. He also did some excellent sketches— hunting scenes and landscapes mostly.

George Lockrow was second in command to Albert M. Parlow in the decorating shop, and was a very fine decorator himself.

Hans Hueber, the editor of *Under the Shade,* a Mr. Anderson, who was a deaf mute, John Bailey, Margaret Sinon, Gustave Loehner, Harriet Bauer, Arthur Hall (see A. J. Hall Company), Arthur

Cunette (who later went into business for himself, decorating parchment shades), a minor decorator and sprayer of shades named William Clark, Edith Clark Owens, Carl Puffee, and Robert Godwin were other decorators remembered by those we interviewed in connection with our research on Handel & Company.

Handel's Designers

The artists who created the various designs for the decorators to work on were all under the direction of Ernest C. Lewis. Some of them were: Ray Freemantle, now a successful artist in water color, living in Austin, Texas (1966); Elsie Jordan, who married Ray Freemantle; Harry E. Homan, who later worked for the *Brooklyn Eagle* and was a popular syndicated cartoonist for many years; Elliott Gardner—he turned to boat design, and worked on the L.S.T.'s of World War II; and Rowena Cheney, who became an accomplished artist, writer, and poet.

The designers, too, published their own magazine to which all the designers named above contributed drawings and cartoons. They called their publication *Artgum-ption.* The coined name from Artgum erasers, standard artist equipment, and "gumption," variously defined as "shrewd common sense," "courageous or ambitious enterprise," and "the art of preparing painter's colors" seemed to exactly fit this little magazine with its potpourri of rakish cartoons and beautiful sketches.

Handel's Patents

Several patents for decorating techniques, fixtures, and designs were issued to Philip J. Handel or other members of his firm. On December 27, 1910, a joint patent for a shade-holder was issued to Handel and Antone E. Teich (Fig. 495) ; the holder was simply clipped to the small aperture in the top of the shade, permitting its engagement with the standard in an easy fashion.

A design for a "Pond Lily" lamp was registered by Handel on November 4, 1902; one exactly like it, from the Gianotti collection, is shown in our illustrations (Fig. 489). The flower-form shades are made of "bent glass" set into a metal framework. Bent glass was used a great deal at this period; it was effected by cutting pieces of colored glass from flat sheets and heating them to a temperature which would allow their being bent into the shapes desired.

In 1902, Henry O. Schmidt, of New Britain, Connecticut, also registered a design for a "Pond Lily" lamp, almost identical to Handel's. Schmidt was listed in the New Britain directories from 1912 to 1915 as a "designer." The only connection we could find between Schmidt and a lamp manufacturer was a patent issued to Schmidt on February 18, 1913, which was assigned to Tiffany Studios of New York City. In view of this latter fact it is quite possible that the lamp designed by Schmidt was made at the Tiffany Studios and not by some lamp manufacturer in Connecticut.

George Lockrow, who preceded Albert Parlow as head designer for Handel & Company, registered a design for a "Poppy Blossom" lamp on November 4, 1902, which is very much like P. J. Handel's design for a "Pond Lily" lamp. From the form of the shade, as it was shown in Lockrow's patent illustration, we presume it was made of blown glass, whereas Handel's "Pond Lily" lamp shade was leaded glass. Lockrow did some decorating of glass and china, too, but the pieces he made were mostly for members of his immediate family.

A ball shade representing a world globe, and depicting the continents surrounded by rippled and roughened waters, was patented by Philip Handel on June 7, 1910 (Fig. 494). The position of the aperture of the shade, as shown in the patent drawings, indicates it was meant for use as a ceiling fixture. It may have been decorated with colors to delineate and separate the representations of the various land masses from the seas and oceans.

Two designs for lamp shades were patented by William F. Handel— June 15, 1920 and January 18, 1921. The patent drawings are shown in our illustrations (Figs. 496-497).

Around 1906, Handel & Company decided to manufacture their own metalwares, and Antone Teich was put in charge of this department. He also made the plaster-of-Paris molds for their lamp shades and metal bases. He designed many of these himself, until Ernest C. Lewis was hired as a full-time designer. The

Fig. 509—Bronze book ends with antiqued finish; Handel's cloth label on felted base; height 7½ inches. *Author's collection*

The Verde finish was the result of treating the bronze and copper-plated wares with acid for several hours. After the acid had eaten into the metal, it was washed off, leaving a greenish coloring on the surface of the metal. The surface was then coated with wax and polished by hand with a soft cloth to preserve the finish.

Some of Handel's "Early American" lamp bases were made of spun pewter.

Library lamps with Verde or dark brown shades were particularly outstanding when mounted on Handel's Verde or copper-plated bases. The blanks for these shades were of opal (milk) glass, often pattern-molded with designs that are distinctly masculine in appearance. Most common was a Greek Key motif. Though these library lamps are quite handsome, and seem fewer in number than the more elaborately decorated lamps that Handel produced, they are not as popular with collectors.

It has been persistently rumored that Philip J. Handel once worked for Louis C. Tiffany; this is not true. Handel did supply decorated lamp shades and globes to Miller Brothers, lamp manufacturers in Meriden, Connecticut, and there is a possibility that he supplied decorated shades to other lamp manufacturers in the Meriden–New York City area, and perhaps as far west as Chicago, Illinois.

The name "Handel" is almost always found on this firm's wares;

plaster-of-Paris models for shades and other objects were sent to various glass factories in this country and abroad who manufactured the blanks which were subsequently decorated at the Handel factory. About 1920, the American glassworker's union demanded that their own men make these plaster molds for the blanks. From then on, only the molds and castings for Handel's metalware— bases, fixtures, and so forth—were produced at the Meriden factory.

A special composition of white metal called "Spelter" was produced at the Handel factory. Its high lead content enabled them to repair cracks or breaks in the metalware with ease. Spelter castings were heavily plated with bronze, copper, or brass, and very often finished with Handel's antique green finish, which they named "Verde" (Fig. 509).

Fig. 510—Handel & Co.'s trademark.

sometimes as shown in Fig. 510. Metalwares have the name impressed or embossed on the object; cloth labels were glued to the felt found on the bases of most of their lamps; their trademark was either painted or stamped on the glass and china pieces.

A.J. HALL COMPANY

ARTHUR J. HALL was once employed by Handel & Company as a decorator. In 1899, he rented space in a two-story building on the corner of North George and Mechanic Streets in Meriden, Connecticut, next to the New York, New Haven & Hartford Railroad, and went into the decorating business for himself. Hall's enterprise prospered from the start, and in the early 1900s, he took over the entire building for his decorating works.

In the front of the building, on the first floor, was a large office. In back of this was a storage area for undecorated glass and china blanks, and a shipping room. In a small ell-shaped area in the rear was the kiln room where all the decorated glass and china wares were fired. Cordwood, cut in four-foot lengths, was used as fuel for the kiln.

The second floor, front, was Hall's showroom. Large tables covered with his wares—lamps, lamp shades and globes, vases, cracker jars, jewelry and powder boxes, tablewares, and a host of other items—were always on exhibit to the trade and local people. In the center of the second floor, surrounding the hand-operated elevator which connected the first-floor storage area with the second floor, were various racks containing blanks for the decorators and decorated wares ready to be taken below to the kiln for firing.

The decorating department occupied the rest of the second floor. Work tables were lined up on the north side near the windows, set at

right angles to the windows so that the light came in on the left side of the artist as he faced toward the rear of the building. Walter Wilson, formerly with Handel & Company, was foreman of the decorating department.

As a boy of sixteen, Wilson had worked in a decorating shop in Honesdale, Pennsylvania, decorating opaque glass salt shakers. He became exceptionally adept at this work and was soon making $7 a day for ten hours of work, while ordinary workers were earning only $1.50. He liked to tell about this period of his career, and would recount his method of painting. Placing an undecorated salt shaker on his thumb and each finger of his left hand, he would paint "assembly line" with his right hand. If the designs were forget-me-nots, for instance, he would first paint all the blue petals, then he would put in all the yellow centers, and lastly, he would add the leaves and stems which he shaded with various greens.

Wilson loved to paint roses, and he did these designs with a fast and sure hand. He painted his roses directly on the object without sketching them first, starting with the center petals and working outward to the larger outside petals, then adding the buds, stems, and leaves. When the job was finished, his roses seemed alive and breathing, each flower, leaf, and stem in proper position. Wilson was a self-taught artist, and while he may not have been the finest decorator in the Meriden area, he was certainly the fastest. He was known to have

painted three large roses on a lamp shade in fifteen minutes. His art work was good and very saleable, and the speed with which he produced won him an enviable reputation in his field.

Gustave Reiman was the only other decorator in the Hall factory who had previously had long years of experience in the trade. He had worked once under the direction of Carl V. Helmschmied at the Handel factory. Reiman's work is characterized by the intricate and dainty details he gave each flower and leaf; his style was more like Monroe's than that of any of his contemporaries. Besides being a superb decorator, Reiman excelled at painting water-color landscapes; at one time he gave lessons in this medium. One of his paintings, a grove of beech trees seen through the rising ground mist of an early morning, was vividly recalled by Mr. Clarence T. Wilks, a former Hall employee. In Mr. Wilks' opinion, Reiman was by far the most accomplished artist in the area.

Two young men, Theodore Burghoff and Herbert Yanch, had about three years' experience as decorators when they first came to work at the Hall shop. There were girls working as decorators, too: Kate Walsh, Maude Drexler, Jimmy Ryerson, and Elizabeth Bauer. These girls worked entirely on what was called "printed work"; that is, they filled in printed designs of flowers and leaves with colored pigments. This type of work was also called "filling

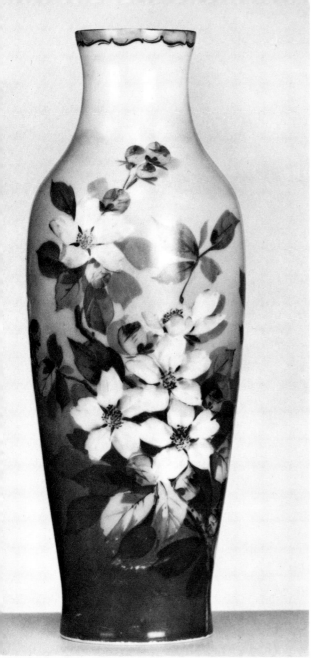

designs were repeated a number of times until the entire plate was covered with decorations. The plate was then laid on a hand-operated roll used for this type of work. A heavy mixture of brown paint was applied over the surface of the etched plate and the excess scraped off with a broad pallet knife, leaving the etched designs filled with pigment. A sheet of white tissue paper was then laid on the face of the plate and the plate was pushed through the rolls with a hand lever.

The tissue paper, with the design printed on it, was cut in sections, each piece bearing the same design. These printed tissues were then used as transfers to be placed on various objects. Julius Runge, another former Handel employee, and Mabel Alexander handled all the transfer printing for the Hall decorating shop. About 60 per cent of the work produced by Hall was done with printed transfer designs. The better grade wares were all hand decorated —oil lamps, shades, and globes.

Before the wares to be hand-decorated reached the decorators, they were "ground laid." This work was done on a potter's wheel. As the object was turned on the wheel, it was coated with a light oil, applied with a wide brush. While still wet, the object was batted all over with a cheese-cloth covered bat to even up the coating of oil and remove any brush marks and runs. The article would then go to the ground layer who dusted it all over with the desired mineral color. Any

in." In some instances, the girls traced parts of the design in bright gold.

The printing department was located near the back of the building on the second floor. The various designs were etched on oblong steel plates about 12 by 20 inches. The

excess color was wiped off with a piece of cotton batting. The piece was then placed on a rack to dry for at least one full day before it was given to the decorator. Walter Bainton was the man who did all the ground laying work at the Hall factory.

Frank Holman was the shipping clerk for Hall's establishment, and a man named John ———, remembered by some as "a foreigner, probably Polish," tended the kiln. Tending kiln was an important job, for unless the kilnsman was skilled at his trade, hundreds of pieces on which many hours of work had been spent could be ruined.

Arthur J. Hall was himself an artist-decorator, and his designs were quite different from those of his contemporaries in the Meriden area. His decorated china vases were usually painted with vivid colors around the top, shading to lighter tones near the base, and embellished with a brilliant blossom—a poppy, dahlia, or some other large flower (Fig. 511). On many of the plates he decorated, he painted water scenes or landscapes mostly in blue, which were extremely effective on white china. He used the same decorating techniques on his opaque glass lamp shades.

About 1908, some of Hall's family joined him in the decorating business. At this period they were making decorated parchment shades, and the family opened a lamp shop in Hartford, Connecticut, which they operated until about 1928. Peter Broggi, who had worked as a decorator at the Handel factory for years, was part owner of the Hall lamp shop in Hartford.

CARL V. HELMSCHMIED

THE founder of the HELMSCHMIED MANUFACTURING COMPANY of Meriden, Connecticut, Carl V. Helmschmied, was born on October 30, 1863, in Steinschoenau, Bohemia; he received his education in glass decorating there at the Imperial Technical School, and exhibited a real talent for decorating and designing. Eventually he emigrated to America where he sought and found employment in several cities before coming to Meriden.

At first, Helmschmied was employed by Smith Brothers of New Bedford, Massachusetts, manufacturers of decorated opal glass wares. He worked for that company for two years, then left to go to Trenton, New Jersey, where he decorated china for Jesse Dean. (Later, in 1886, it was called the Jesse Dean Decorating Co.) When he returned to New Bedford, he worked two years for the Mt. Washington Glass Company as a designer and decorator. In 1886, he entered the employ of The C. F. Monroe Company in Meriden, Connecticut. When this firm was incorporated, a few years later, he was listed as one of the stockholders; at that time he was superintendent of the Monroe plant, as well as their leading designer. Helmschmied patented at least two designs for Monroe, one for cut glass, and another for the shape of an article of glass—a series of helical twists—which was subsequently decorated, and sold in C. F. Monroe's line of Wave Crest Ware.

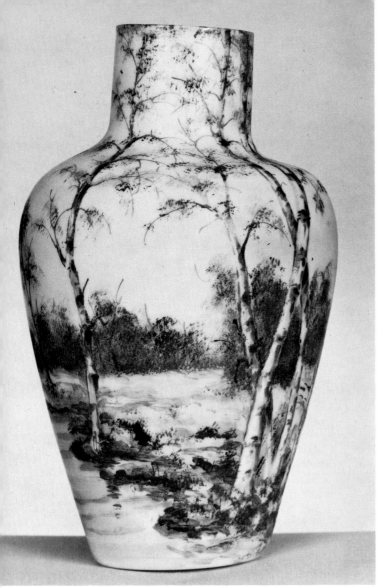

Fig. 512—Decorated opal glass vase signed "Carl V. Helmschmied"; height 16 inches. *Collection Mr. & Mrs. Howard Gianotti*

In 1903, Helmschmied withdrew from The C. F. Monroe Company and opened his own decorating works under the style, "CARL V. HELMSCHMIED." A corporation was formed on October 13, 1904, known as the Helmschmied Manufacturing Company with a capital stock of $10,000. The firm's certificate of organization listed the following stockholders. Carl V. Helmschmied (59 shares), E. W. Smith (1 share), Christian F. Fox (5 shares), Frank

D. Smith (2 shares), William G. Kooreman (1 share), Paul T. Saleski (6 shares), August Schmelzer (3 shares), Emil H. Kroeber (2 shares), Frank Eichorn (1 share), Charles C. Glock (3 shares), Eugene A. Hall (5 shares), Michael Keegan (1 share), John H. Parker (2 shares), Frank M. Kibbs (2 shares), Holt & Stevens (2 shares), Charles W. Glock (2 shares), Frederick Haaga (1 share), and Charles E. Benoit (2 shares). Carl V. Helmschmied was president and treasurer of the

Fig. 513—Decorated opal glass vase, pink and green, with pink flowers and aquamarine-colored butterfly; height 11¾ inches. *Author's collection; ex-coll. Carl V. Helmschmied*

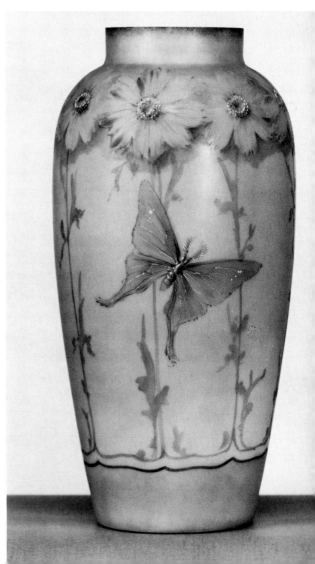

Fig. 514—Decorated opal glass vase, blue and beige, with blue birds and flowers; height 11¼ inches. *Author's collection; ex-coll. Carl V. Helmschmied*

company, and Paul T. Saleski, secretary. An increase in the company's capital stock from $10,000 to $17,000 was declared on December 28, 1906.

Helmschmied's decorating works was located on Reservoir Avenue in Meriden, and for a while he maintained a showroom in New York City at 253 Broadway, which Charles Schuller managed. Later, Helmschmied advertised that his line was carried by George Borgfeldt & Company at the same address. He also opened a showroom in Chicago, Illinois, located at 35-37 East Randolph Street.

In 1908, Helmschmied's stationery indicated that he was once again in business for himself as sole owner. His letterhead listed his services as a "Designer in silver, brass, glass and chinaware—Leaded work (stained-glass windows and ornamental objects)—Water Colors, and fresco painting," and "Photos colored for salesmen."

After his factory was closed and he was working alone, Helmschmied occasionally took space in the old C. F. Monroe building. Mrs. Florence Knoblauch (her husband Joseph Knoblauch had been one of C. F. Monroe's salesmen) worked with him there, as an assistant. Most of the time though, he worked by himself in a small studio in back of his residence at 47 Reservoir Avenue, Meriden. He continued to decorate glass and china wares until his death, January 1, 1934.

During his lifetime Carl V. Helmschmied painted several water color and oil pictures—mostly flowers and landscapes. Some of these he used as models for the designs he painted on his glass and china wares (Figs. 512-515). His nephew, Carl van Goerschen, reported that many of his uncle's paintings were exhibited in the art galleries and museums in Steinschoenau before he emigrated to America.

When the Helmschmied Manufacturing Company was

operating at full capacity, it employed at least ten girls to decorate glass and china wares of all kinds. Many of the pieces Mr. Helmschmied decorated bear his signature, and some of the blanks made for his use by glass manufacturers have his initials "C.V.H." molded in the base of the object.

In 1903, the year before he incorporated the business, Helmschmied issued an illustrated brochure announcing a new line of decorated glass and china wares designated as "The Belle Ware" (Figs. 516-520). The brochure stated that "the workmanship is of the highest character and all strictly HAND PAINTED," and that these wares were made "with the whole line, either in Pink, Blue, Lavender or Frosted Effects—The Figure Decorations, second to none" (See Appendix D).

Some Belle Ware has a slightly pebbled finish which gives the

Fig. 516—Belle Ware box with frosted finish; beige-colored ground with enamelled decoration of white lilies and green leaves; lined with cream-colored satin; diameter 6¾ inches. *Author's collection*

enameled decoration beneath it the "Frosted Effect" mentioned in Helmschmied's brochures; it was also made without the frosted finish and looks very much like the decorated opal glass wares produced at the C. F. Monroe factory. The name "Belle Ware" was a tribute to Helmschmied's sister-in-law, Mrs. Isabella van Goerschen, whom Helmschmied and his wife, Lillian, affectionately called "Bella."

The Belle Ware line included decorated opal glass covered boxes for jewelry, handkerchiefs, and trinkets—all lined with silk; open jewel trays, vases, bowls, cracker jars with silver-plated tops, salt and pepper shakers with metal tops, and decorated china trays for comb and brush sets and pins. There was even a paper knife in Belle Ware with a fancy metal handle finished in "bronze, antique copper, or aluminum." According to Helmschmied's brochure, George

Fig. 515—Hanging plaque of marbleized green and opal glass with painted floral decoration and quotation from the writings of Elbert Hubbard; 6 by 8 inches. *Author's collection; ex-coll. Carl V. Helmschmied*

WHAT OTHERS SAY OF ME MATTERS LITTLE, WHAT I MYSELF SAY AND DO MATTERS MUCH.

ELBERT HUBBARD.

288

Carl V. Helmschmied

Fig. 517—Belle Ware vase, brown with cartouche decorated in natural colors; height 12¾ inches. *Author's collection; ex-coll. Carl V. Helmschmied*

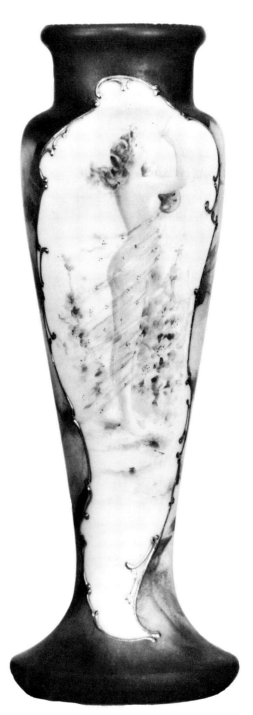

Fig. 518—Signed "Belle Ware" vase with initials "C.V.H." molded in the base; height 9¼ inches. *Collection Mr. & Mrs. Ted Lagerberg*

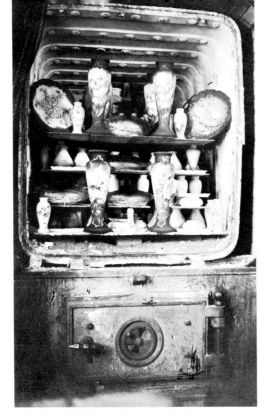

Fig. 519—A loaded kiln filled with Helmschmied's decorated glassware. *From an old photograph in the author's collection*

Fig. 520—Part of Helmschmied's showroom; tables are covered with decorated glass and china wares; beneath the tables are decorated opal glass lamp globes. *From an old photograph in the author's collection*

Borgfeldt & Company was selling the full line of decorated wares, including Belle Ware, in their New York City showrooms. Belle Ware pieces, for the most part, are marked on the base of the article.

Another brochure, advertising "Hand Painted China Shirtwaist Sets in Pins, Brooches, Hat Pins, Studs and Buckles" was issued by the Helmschmied Manufacturing Company in 1905. The sets were mounted in "high quality gold-plated settings" and came in floral designs with "burnished gold borders—Rose decoration, Violet decoration, Chrysanthemum decoration," and other designs, too (Fig. 521). One, using miniature portraits of children, is perhaps the most charming of all Mr. Helmschmied's designs for his decorated china shirtwaist sets. These hand-painted studs and buttons ranged in price from 40¢ each to $2.40 a set.

In *A Century of Meriden* (1906), it was reported that the Helmschmied Manufacturing Company produced "Colonial glass novelties and metalwares, consisting of shades, vases, and other decorative objects for the home." The elegant glass objects with metal mounts shown in the old illustration of this firm's wares (Fig. 522) may well be the Colonial line referred to. Carl Helmschmied's nephew confirmed that for several years his uncle also designed and manufactured beautiful bent-glass shades. The objects shown in the old photograph indicate that the line included vases, bowls, boxes,

290

No. 20. PIN SET. (Rose Decoration.)
(Actual Size.)

No. 57. STUD SET. (Rose Decoration.) No. 54. PIN. (Chrysanthemum Decoration.)
(Actual Size.) (Actual Size.)

Fig. 521—Decorated brooches, buckles and pins or studs for "shirtwaists." *Top row:* brooch and pin set in "Rose" pattern. *Second and third rows:* Pin and stud sets in "Chrysanthemum" pattern. *Bottom row:* Belt set, the larger pieces being "for front and back of the belt, one being fitten with a buckle and clasp and the other having a slide for adjustment on the back." *From an original brochure published by The Helmschmied Manufacturing Co.*

291

Figs. 523-524—*Left to right:* Helmschmied's patented Fern Jar illuminated from above. Helmschmied's patented Flower Pot illuminated from inside and above.

and letter racks. They appear to be made of the agate glass, mottled and streaked with colors, which was being used in the early 1900s for stained-glass windows and bent-glass shades. There are also some pottery pieces shown in the photograph which were painted to simulate agate wares.

On April 14, 1908, Helmschmied was granted a patent for the manufacture of "Illuminated Flower Pots." These pots consisted of a receptacle for flowers or plants with a pipe for conducting gas, oil, or electricity to a light fixture located in the center of the bowl and standing above the flower pot. (See patent drawings and illustrations of two of Helmschmied's designs, Figs. 523-525.)

According to Carl Helmschmied's nephew, Carl van Goerschen, these illuminated flower pots were originally made at the factory, but his uncle carried on their

Fig. 522—"Colonial" glass novelties with metal mountings in the Art Nouveau style. Note that the two beer mugs appear to be made of pottery. *From an old photograph marked "Helmschmied Manufacturing Co."*

Fig. 525—Patent drawings for Helmschmied's "Illuminated Flower Pots"; patent No. 884,924, dated Apr. 14, 1908.

manufacture for some time after the Helmschmied Manufacturing Company ceased to be a corporation.

On March 19, 1913, Helmschmied wrote to a patent attorney concerning an alleged infringement of his 1908 patent for this flower pot. "There is an illuminated Fern Jar on the market connected through the center of the bottom with a tubing to support an electric light and shade. This is exactly like my patent shown above (referring to illustrations of illuminated flower pots depicted on his letterhead), with the exception of the supporting plate." He asked the lawyer if he handled cases as to make arrangements for payment of royalty or sale of the patent and what his charges were for same. Unfortunately, any reply to this letter was not preserved.

H.E. RAINAUD COMPANY

THE H. E. RAINAUD COMPANY appeared in Meriden, Connecticut, *City Directories* from 1916 to 1932. The earliest address was given as 637 Center Street, and a later address was the Delaney Co. Building on Charles Street. Mr. Rainaud was also listed as the proprietor of the HERCO MANUFACTURING COMPANY, which appeared in a separate listing in the same directories. The Herco name was evolved from Mr. Rainaud's initials "H.E.R." and "Co."

On June 1, 1928, a certificate of incorporation was filed for the RAINAUD METAL PROCESS CORPORATION OF AMERICA by Henry E. Rainaud, Joseph C. Faeth, and Lillian N. Luby, all residents of Meriden. This certificate became void at the end of two years since no certificate of organization had been filed in that time. From this, it would appear that the corporation ceased to operate—at least under that name—before June of 1930.

The incorporation papers issued in 1928 state that the firm manufactured and sold metalwares —there was no mention of glass. These metalwares were primarily lamps composed of metal bases and metal and glass shades. Three design patents for such wares were issued to Mr. Rainaud on March 7, 1922— one was for a pierced metal and glass lamp shade (Fig. 526), the other two were for "Portable Lamps" (Fig. 527). On June 26, 1923, Rainaud was assigned another design patent for a glass and metal

Fig. 526—H. E. Rainaud's design for a pierced-metal lamp shade; U.S. Patent No. 60,569; Mar. 7, 1922.

lamp shade very similar to the one he patented the year before (Fig. 528).

While Rainaud's lamp designs are not Art Nouveau in the strictest interpretation of this design concept, they do retain some elements of Art Nouveau techniques. The lamp shades—pierced metal frames backed with colored glass—developed from the leaded-glass and bent-glass shades of the Art Nouveau era.

Actually, Rainaud and his
contemporaries were producing
lamps in a style that could be called
"neo-classical." These are now
becoming popular and collectors
are gravitating toward these later
productions more and more. Perhaps
the high prices now asked for lamps
with leaded-glass shades—Tiffany

Fig. 527—Two designs for portable lamps
patented by H. E. Rainaud; U.S. Patents
Nos. 60,570 and 60,571; both Mar. 7, 1922.

or otherwise—have precipitated this
renewed interest in the lamps
produced by Rainaud and others
in the late 1920s and early 1930s.

Fig. 528—H. E. Rainaud's design for a pierced-metal lamp shade; U.S. Patent No. 62,590; June 26, 1923.

OTHER MANUFACTURERS OF ART-GLASS AND BENT-GLASS LAMPS AND WINDOWS

THE popularity of art-glass windows and lighting fixtures was widespread in America between 1890 and 1920. Fortunately we were able to find several illustrated catalogs distributed by various manufacturers in different parts of the country that afford us a documentary of the tastes in such objects of this period.

In 1892, The L. Grosse Art Glass Company, corner of Penn Avenue and Tenth Street, Pittsburgh, Pennsylvania, issued a catalog showing their stained-glass windows and ornamental panels. Most of their designs were obviously Victorian, but a few of the art-glass figure windows approach the fine Art Nouveau works produced by Tiffany Studios; this is best illustrated in their "Spring" and "Fate and Hope" windows (Fig. 529).

The U. S. Art Bent Glass Company, Incorporated, of 62 Market Street, Hartford, Connecticut, offered one hundred art- and bent-glass lighting fixtures in one of their 1910 catalogs. Fourteen color plates of colorful leaded (art-glass) domes measuring as much as 26 inches in diameter, sixty-four black and white illustrations of hanging shades and domes in art and bent glass, twenty-one small art- and bent-glass shades for various kinds of lamps, and one complete table lamp made entirely of bent glass shows how large and varied was their line (Fig. 530).

In the Midwest the need for artistic lighting fixtures was supplied

Fig. 529—Art-glass windows from The L. Grosse Art Glass Co.'s 1892 catalog; *left:* "Fate and Hope"; *right:* "Spring."

by at least three firms in Chicago, Illinois, and two in Ohio. R. Williamson & Company, Washington and Jefferson Streets, Chicago, Illinois, claimed to be the largest manufacturer of such wares in the country in their 1917 catalog (Fig. 531). The firm had been in business since 1885 and no doubt many homes in the surrounding states were furnished with decorative lighting from "The Williamson Line."

The Moran & Hastings Manufacturing Company also produced a comprehensive line of decorative lighting fixtures in art glass and bent glass. Their factory was located at the corner of West Lake and Jefferson Streets in Chicago, and they maintained a large office and showroom at 16-18 Washington Street, "just one-half block west of

Fig. 530 (pp. 301-303)—Design and shapes for lamp shades and a complete vase-lamp from a catalog of The U.S. Art Bent Glass Co., Hartford, Conn.

960

965

360

26 Inch 1015

24 Inch 1075

500

501

502

665

615

505

825

24 Inch 1030

26 Inch 1040

24 Inch 995

20 Inch 1058

24 Inch 1080

22 Inch 955½

24 Inch 1065

24 Inch 1020

Fig. 531—Art-glass and Bent-glass hanging domes and a lamp; from an original catalog published by R. Williamson & Co., Chicago, Ill.

Marshall Field & Company's retail store." Moran & Hastings' catalogs offered their lamps in a variety of finishes—"Rich Gilt," "Polished Brass," "Brush Brass," "Old Brass," "Lemon Brass," "Brush Brass and Black," "Black Iron," "English Gilt and Matt," "Rich Gilt and Satin," "Oxidized Copper," "Polished Nickel," "Verde Antique," "Polished Blue Steel," and "Statuary Bronze." Their 1912 catalog (Fig. 532) illustrated decorated opal glass shades of every description, cut-glass shades, and lustred-glass shades—the

latter probably supplied by the Fostoria Glass Specialty Company, Quezal, Lustre Art Glass Company, Steuben, or one of the other manufacturers of lustred-glass shades in America.

The H. J. Peters Company's 1914 catalog (Figs. 533-534), contained a full page in color of decorated lustred-glass lamp shades all of which could have been manufactured by any of the firms mentioned in the preceding paragraph. Color illustrations of the agate-like Mosaic glasses used by most manufacturers of bent-glass lamp shades and art-

Fig. 532 (pp. 305-312)—Table lamps and hanging domes and light fixtures from the Moran & Hastings Manufacturing Co.'s 1912 catalog.

No. 10309—BRUSH BRASS
Length, 42 in.

Includes 22 in. art glass dome, body color No. 11, panel edges No. 98, corners and diamonds No. 41, unless otherwise specified.

Includes square socket covers, as shown, in all prices.

	Not Wired	Wired	Complete No Lamps
6 Lt. Elec. (2 Lts. Under)	$61.00	$63.00	$65.52
8 Lt. Elec. (4 Lts. Under)	61.50	64.00	67.36

305

No. 10310—BRUSH BRASS
Length, 36 in.

Includes 18 in. art glass dome, body color No. 13, leaves No. 98, and purple grapes, unless otherwise specified.

	Not Wired	Wired	Complete No Lamps
1 Lt. Elec.	$33.00	$34.00	$34.40
2 Lt. Elec.	33.25	34.50	35.30
3 Lt. Elec.	33.50	35.00	36.20

Extra Lengthening, per foot

Not Wired.........$2.00 Wired.........$2.20

No. 10311—BRUSH BRASS
Length, 36 in.

Includes 20 in. art glass dome, body color No. 98, panels No. 98, No. 41 and No. 11, unless otherwise specified.

	Not Wired	Wired	Comp'ete No Lamps
1 Lt. Elec.	$30.00	$31.00	$31.42
2 Lt. Elec.	30.25	31.50	32.34
3 Lt. Elec.	30.50	32.00	33.26

Extra Lengthening, per foot

Not Wired.........$1.50 Wired.........$1.70

No. 10312—BRUSH BRASS
Length, 36 in.

Includes 24 in. art glass dome, colors No. 11 and No. 41, unless otherwise specified.

	Not Wired	Wired	Complete No Lamps
1 Lt. Elec.	$72.00	$73.00	$73.40
2 Lt. Elec.	72.25	73.50	74.30
3 Lt. Elec.	72.50	74.00	75.20
4 Lt. Elec.	72.75	74.50	76.10

Extra Lengthening, per foot

Not Wired.........$1.50 Wired.........$1.70

No. 10316—BRUSH BRASS
Length, 36 in.

Includes 18 in. bent art glass dome, color No. 98, unless otherwise specified, and 4 in. glass beaded fringe.

	Not Wired	Wired	Complete No Lamps
1 Lt. Elec.	$26.00	$27.50	$27.90
2 Lt. Elec.	26.25	28.00	28.80

Extra Lengthening, per stem, per foot

Not Wired..$0.50 Wired..$0.60

No. 10314—BRUSH BRASS

Length, 36 in.

Includes 3¼ in. holder and 10 in. art glass dome, body color No. 98, diamonds No. 13 and No. 41, unless otherwise specified.

	Not Wired	Wired	Complete No Lamp
1 Lt. Elec.	$23.00	$23.75	$24.15

Extra Lengthening, per foot

Not Wired..$1.00 Wired..$1.10

No. 10313—BRUSH BRASS

Length, 36 in.

Includes 12 in. tulip art glass shade, colors No. 98 and No. 12, as shown, in all prices.

	Not Wired	Wired	Complete No Lamp
1 Lt. Elec.	$20.00	$20.75	$21.15

Extra Lengthening, per foot

Not Wired.........$0.60 Wired.........$0.70

No. 10315—BRUSH BRASS

Length, 36 in.

Includes 14 in. art glass dome, color No. 98, unless otherwise specified.

	Not Wired	Wired	Complete No Lamp
1 Lt. Elec.	$18.00	$18.75	$19.15

Extra Lengthening, per foot

Not Wired.........$0.60 Wired.........$0.70

No. 10318—BRUSH BRASS
Length, 36 in.

Includes 14 in. bent art glass dome, color No. 98, unless otherwise specified, and 4 in. glass beaded fringe.

	Not Wired	Wired	Complete No Lamps
1 Lt. Elec.	$17.50	$18.50	$18.90
2 Lt. Elec.	17.75	19.00	19.80

Extra Lengthening, per foot
Not Wired..$0.60 Wired..$0.70

No. 10317—BRUSH BRASS
Length, 36 in.

Includes 12 in. art glass dome, color No. 99, unless otherwise specified, and 4 in. glass beaded fringe.

	Not Wired	Wired	Complete No Lamp
1 Lt. Elec.	$12.00	$12.75	$13.15

Extra Lengthening, per foot
Not Wired.......$0.60 Wired........$0.70

No. 10319—BRUSH BRASS
Length, 36 in.

Includes 16 in. art glass dome, as shown, colors No. 98 in body, No. 41 in corners, unless otherwise specified, with 4 in. glass beaded fringe.

	Not Wired	Wired	Complete No Lamps
1 Lt. Elec.	$18.00	$19.00	$19.40
2 Lt. Elec.	18.25	19.50	20.30

Extra Lengthening, per foot
Not Wired.........$0.60 Wired.........$0.70

**No. 10513—VERDE AN-
TIQUE**

Height, 29 in. Base, 8½ in.

Complete with 6 ft. silk
lamp cord, pull chain sockets,
and attachment plug.

3 Lt. Elec.$90.00

Diameter of dome, 21 in.

Colors of glass, old rose,
amber and green.

**No. 10514—VERDE AN-
TIQUE**

Height, 25 in. Base, 9 in.

Complete with 6 ft. silk
lamp cord, pull chain sockets,
and attachment plug.

3 Lt. Elec.$48.00

Diameter of dome, 22 in.

Colors of art glass, amber,
green and pearl.

No. 10517—BRUSH BRASS

Height, 23 in. Base, 8½ in.

Complete with 6 ft. silk
lamp cord, pull chain sockets,
and attachment plug.

2 Lt. Elec.$16.50

Diameter of dome, 16 in.

Colors of art glass, amber,
old rose and green.

**No. 10518—VERDE AN-
TIQUE**

Height, 27½ in. Base, 9 in.

Complete with 6 ft. silk
lamp cord, pull chain sockets,
and attachment plug.

3 Lt. Elec.$68.00

Diameter of dome, 20 in.

Colors of art glass, rose,
pearl and green.

No. 10515—VERDE AN-TIQUE

Height, 24 in. Base, 7½ in.
Complete with 6 ft. silk
lamp cord, pull chain sockets,
and attachment plug.
3 Lt. Elec.$33.00
Diameter of dome, 18 in.
Colors of art glass, amber,
green and ruby.

No. 10516—BRUSH BRASS

Height, 20½ in. Base, 8½ in.
Complete with 6 ft. silk
lamp cord, pull chain sockets,
and attachment plug.
3 Lt. Elec.$26.00
Diameter of dome, 15 in.
Colors of art glass, green.

No. 10520—VERDE AN-TIQUE

Height, 25 in. Base, 9 in.
Complete with 6 ft. lamp
cord, pull chain sockets, and
attachment plug.
3 Lt. Elec.$54.00
Diameter of dome, 18½ in.
Colors of art glass, amber,
rose and green.

No. 10521—VERDE AN-TIQUE

Height, 25 in. Base, 9 in.
Complete with 6 ft. lamp
cord, pull chain sockets, and
attachment plug.
3 Lt. Elec.$46.00
Diameter of dome, 18 in.
Colors of art glass, green,
amber and ruby.

EXCLUSIVE
LIGHTING
EFFECTS

H.J. PETERS CO.
CHICAGO

CREATORS
CLASSIC
DESIGNS

No. A996

No. A996—STOCK FINISH—BRUSHED BRASS AND BLACK.

Height 25 in. Shade 17½ in.

Art Glass Shade with Heavy Cast Over-Metal Scenic Design.

Wired
Complete as
shown except
Lamps

3-Lt. Elec. .. **$39.50**

Stock color, upper panels sunset art glass, water scene blue art glass.
Price includes pull chain sockets, 6 ft. silk cord and swivel attachment
plug.

Fig. 533 (pp. 313-323)—Table lamps and hanging domes from the 1914 catalog of
H. J. Peters Co., Chicago, Ill.

No. A995—STOCK FINISH—SILVER PLATED.

Height 21 in. Shade 16 in.

Art Glass Shade with Heavy Cast Over-Metal Trim.

Wired
Complete as
shown except
Lamps

2-Lt. Elec. ... **$18.75**

Stock color, top panels amber green blended mixture. Lower fancy panels sunset art glass.

Price includes pull chain sockets, 6 ft. silk cord and swivel attachment plug.

No. A995

No. A997—STOCK FINISH—BRUSHED BRASS AND BLACK.

Height 23 in. Shade 16½ in.

Art Glass Shade with Heavy Cast Over-Metal Trim.

Wired
Complete as
shown except
Lamps

3-Lt. Elec. ... **$20.00**

Stock art glass, color amber green blended mixture.

Price includes pull chain sockets, 6 ft. silk cord and swivel attachment plug.

No. A997

No. A1083—STOCK FINISH—ANTIQUE BRUSHED BRASS.

Height 24 in. Shade 18 in.
Octagon Art Glass Shade with Heavy Cast Over-Metal Trim.

Wired Complete as shown except Lamps

2-Lt. Elec............ **$16.00**

Stock color amber art glass.

Price includes key sockets, 6 ft. silk cord and swivel attachment plug.

No. A1082

No. A1082—STOCK FINISH—ANTIQUE BRUSHED BRASS.

Height 20 in. Shade 16 in.
Hexagon Art Glass Shade.

Wired Complete as shown except Lamps

2-Lt. Elec............ **$13.60**

Stock color, art glass amber.

Price includes key sockets, 6 ft. silk cord and swivel attachment plug.

No. A1083

No. A998

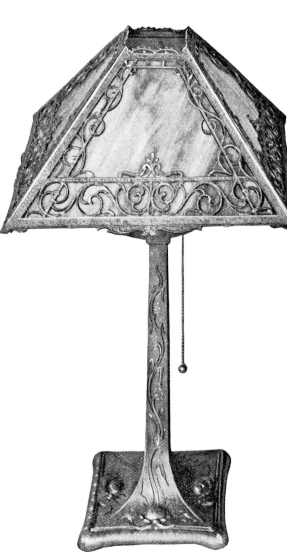

No. A999—STOCK FINISH—RICH GOLD.

Height 22 in. Shade 12½ in.
Square Over-Metal Art Glass
Shade.

Wired
Complete as
shown except
Lamps

1-Lt. Elec............ **$11.00**

Stock color sunset art glass.

Price includes pull chain socket, 6
ft. silk cord and swivel attach-
ment plug.

No. A998—STOCK FINISH—RICH GOLD.

Height 21 in. Shade 15 in.
Hexagon Over-Metal Art Glass
Scenic Design.

Wired
Complete as
shown except
Lamps

1-Lt. Elec............ **$14.00**

Stock color, art glass amber green
blended mixture.

Price includes pull chain socket, 6
ft. silk cord and swivel attach-
ment plug.

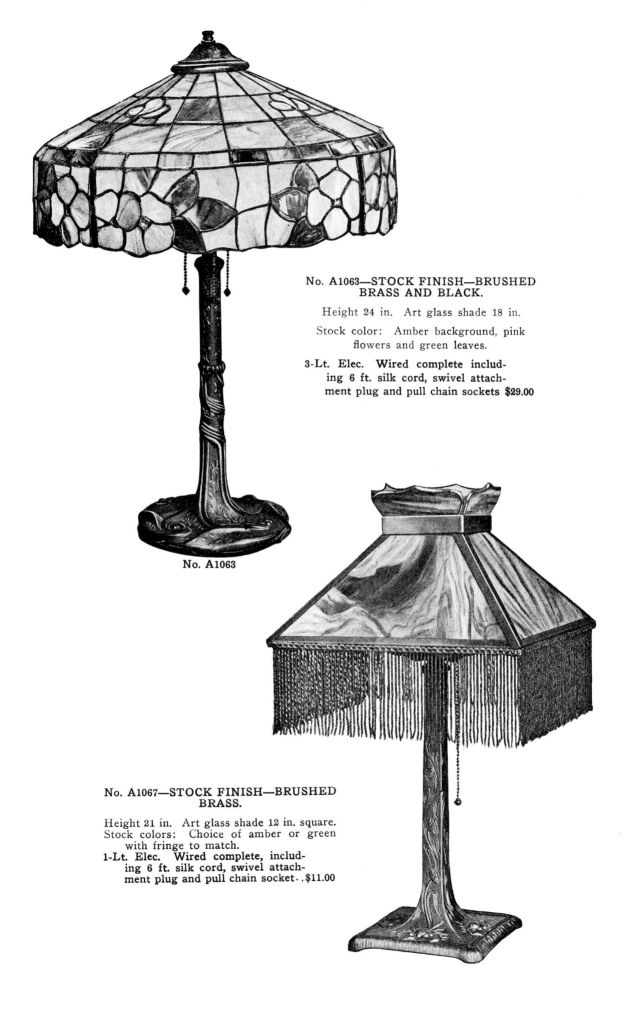

No. A1063—STOCK FINISH—BRUSHED BRASS AND BLACK.

Height 24 in. Art glass shade 18 in.

Stock color: Amber background, pink flowers and green leaves.

3-Lt. Elec. Wired complete including 6 ft. silk cord, swivel attachment plug and pull chain sockets $29.00

No. A1063

No. A1067—STOCK FINISH—BRUSHED BRASS.

Height 21 in. Art glass shade 12 in. square.
Stock colors: Choice of amber or green with fringe to match.
1-Lt. Elec. Wired complete, including 6 ft. silk cord, swivel attachment plug and pull chain socket . . $11.00

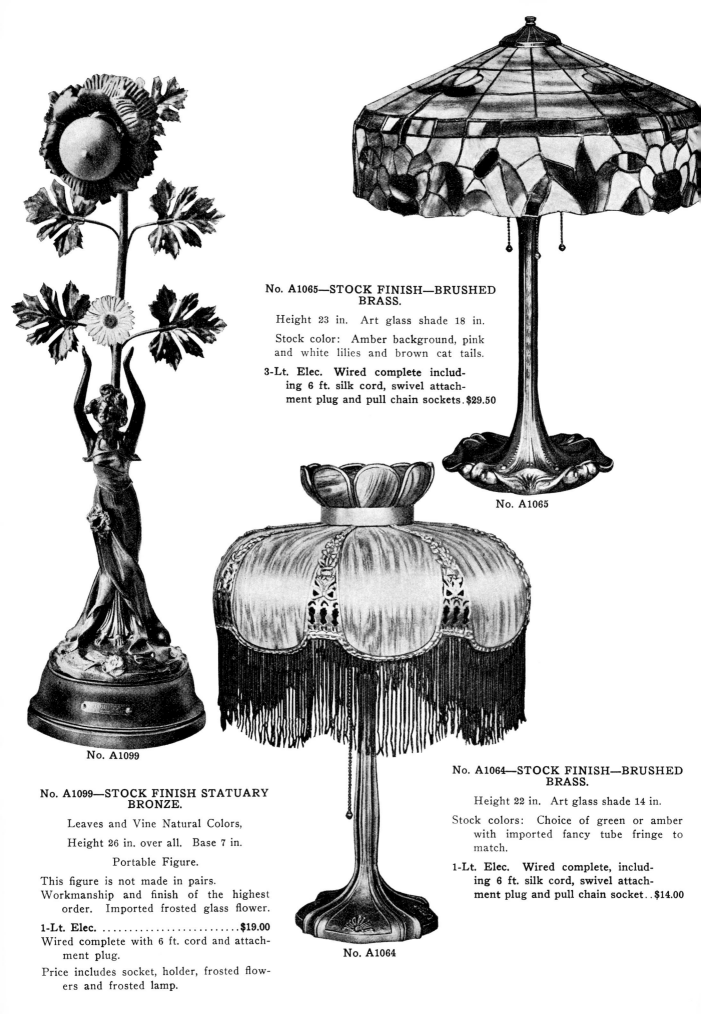

No. A1065—STOCK FINISH—BRUSHED BRASS.

Height 23 in. Art glass shade 18 in.

Stock color: Amber background, pink and white lilies and brown cat tails.

3-Lt. Elec. Wired complete including 6 ft. silk cord, swivel attachment plug and pull chain sockets. $29.50

No. A1065

No. A1099

No. A1099—STOCK FINISH STATUARY BRONZE.

Leaves and Vine Natural Colors,

Height 26 in. over all. Base 7 in.

Portable Figure.

This figure is not made in pairs. Workmanship and finish of the highest order. Imported frosted glass flower.

1-Lt. Elec.$19.00
Wired complete with 6 ft. cord and attachment plug.

Price includes socket, holder, frosted flowers and frosted lamp.

No. A1064

No. A1064—STOCK FINISH—BRUSHED BRASS.

Height 22 in. Art glass shade 14 in.

Stock colors: Choice of green or amber with imported fancy tube fringe to match.

1-Lt. Elec. Wired complete, including 6 ft. silk cord, swivel attachment plug and pull chain socket. .$14.00

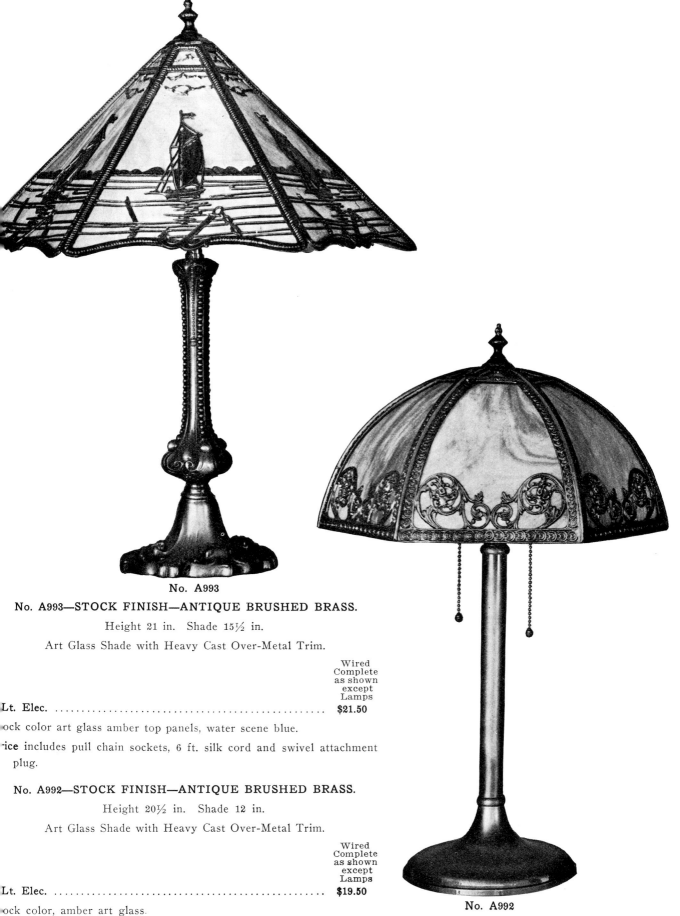

No. A993

No. A993—STOCK FINISH—ANTIQUE BRUSHED BRASS.

Height 21 in. Shade 15½ in.

Art Glass Shade with Heavy Cast Over-Metal Trim.

Wired
Complete
as shown
except
Lamps

Lt. Elec. ... **$21.50**

ock color art glass amber top panels, water scene blue.

ice includes pull chain sockets, 6 ft. silk cord and swivel attachment
plug.

No. A992—STOCK FINISH—ANTIQUE BRUSHED BRASS.

Height 20½ in. Shade 12 in.

Art Glass Shade with Heavy Cast Over-Metal Trim.

Wired
Complete
as shown
except
Lamps

Lt. Elec. ... **$19.50**

ock color, amber art glass.

ice includes pull chain sockets, 6 ft. silk cord and swivel attachment
plug.

No. A992

No. A3703

No. A3703—STOCK FINISH—BRUSHED BRASS.

Length 42 in. Dome 24 in.
Bent Panel Dome in Solid Brass Frame with Heavy Cast Over-Metal Trim.

	Not Wired	Wired	Complete as shown except Lamps
1-Lt. Elec.	$32.20	$33.20	$33.88
2-Lt. Elec.	32.45	33.70	35.06
3-Lt. Elec.	32.70	34.20	36.24
4-Lt. Elec.	32.95	34.70	37.42

Includes 24 in. art glass dome with fancy imported Wedding Bell fringe in all prices. Stock color, amber art glass.
Complete price includes pull chain sockets.
Extra lengthening No. 712 solid brass chain stem, per foot,
Not Wired.................$1.25 Wired........................$1.35

No. A3704—STOCK FINISH—BRUSHED BRASS.

Length 42 in. Dome 22 in.
Bent Panel Dome in Solid Brass Frame with Heavy Cast Over-Metal
Trim.

	Not Wired	Wired	Complete as shown except Lamps
1-Lt. Elec.	$26.20	$27.20	$27.88
2-Lt. Elec.	26.45	27.70	29.06
3-Lt. Elec.	26.70	28.20	30.24
4-Lt. Elec.	26.95	28.70	31.42

Includes 22 in. art glass dome with fancy imported Wedding Bell fringe
in all prices. Stock color, amber green blended mixture.
Complete price includes pull chain sockets.
Extra lengthening No. 712 solid brass chain stem, per foot,
Not Wired..................$1.25 Wired......................$1.35

No. A3353

No. A3353—STOCK FINISH—BRUSHED BRASS.

Length 42 in. Dome 22 in.

Bent Panel Dome in Solid Brass Frame with Heavy Cast Over-Metal Trim.

	Not Wired	Wired	Complete as shown except Lamps
1-Lt. Elec.	$25.20	$26.20	$26.88
2-Lt. Elec.	25.45	26.70	28.06
3-Lt. Elec.	25.70	27.20	29.24
4-Lt. Elec.	25.95	27.70	30.42

Includes 22 in. art glass dome in all prices. Stock color—body amber, water scene blue.

Complete price includes pull chain sockets.

Extra lengthening No. 712 solid brass chain stem, per foot,

Not Wired................$1.25 **Wired**......................$1.35

No. A3706—STOCK FINISH—BRUSHED BRASS.

Length 42 in. Dome 24 in.

Bent Panel Dome in Solid Brass Frame with Heavy Cast Over-Metal Trim.

	Not Wired	Wired	Complete as shown except Lamps
1-Lt. Elec.	$32.20	$33.20	$33.88
2-Lt. Elec.	32.45	33.70	35.06
3-Lt. Elec.	32.70	34.20	36.24
4-Lt. Elec.	32.95	34.70	37.42

Stock color—top panels amber green blended mixture, apron sunset art glass.

Complete price includes pull chain sockets.

Extra lengthening No. 712 solid brass chain stem, per foot,

Not Wired.................$1.25 Wired......................$1.35

Fig. 534—Hanging light fixtures from the 1914 catalog of the H. J. Peters Co., Chicago, Ill.

No. A3705

No. A3705—STOCK FINISH—BRUSHED BRASS.

Length 42 in. Dome 24 in.
Bent Panel Dome in Solid Brass Frame with Heavy Cast Over-Metal Trim.

	Not Wired	Wired	Complete as shown except Lamps
1-Lt. Elec.	$31.80	$32.80	$33.48
2-Lt. Elec.	32.05	33.30	34.66
3-Lt. Elec.	32.30	33.80	35.84
4-Lt. Elec.	32.55	34.30	37.02

Includes 24 in. art glass dome with fancy imported Wedding Bell fringe in all prices. Stock color, amber art glass.

Complete price includes pull chain sockets.

Extra lengthening No. 712 solid brass chain stem, per foot,

Not Wired..................$1.25 Wired.......................$1.35

No. A3707

No. A3707—STOCK FINISH—BRUSHED BRASS.

Length 42 in. Dome 22 in.

Bent Panel Dome in Solid Brass Frame with Heavy Cast Over-Metal Trim.

	Not Wired	Wired	Complete as shown except Lamps
1-Lt. Elec.	$24.20	$25.20	$25.88
2-Lt. Elec.	24.45	25.70	27.06
3-Lt. Elec.	24.70	26.20	28.24
4-Lt. Elec.	24.95	26.70	29.42

Includes 22 in. art glass dome in all prices. Stock color—body greenish amber blended mixture, lower fancy panels Truscan brown.

Complete price includes pull chain sockets.

Extra lengthening No. 712 solid brass chain stem, per foot,

Not Wired.................$1.25 **Wired**......................$1.35

No. G236
Iridescent Pearl
Shell, with Gold
and Green Lines.
Each
2¼x4½ in....$4.00
Diameter of Shade
5 in.

No. G247
Rich Amber, Iri-
descent Lustre.
Each
2¼x4 in.....$3.00
Diameter of Shade
4¾ in.

No. G257
Rich Amber Iri-
descent Lustre.
Each
3¼x5½ in.... 4.50
Diameter of Shade
3¾ in.

No. G269
Rich Amber Iri-
descent Lustre.
Each
2¼x5¼ in....$2.50
Diameter of Shade
5 in.

No. G270
Rich Amber Iri-
descent Lustre.
Each
2¼x5 in.....$3.00
Diameter of Shade
4¾ in.

No. G274
Iridescent Pearl
Shell with Gold
and Green Lines.
Each
2¼x5 in.....$4.00
Diameter of Shade
3½ in.

No. G351
Iridescent Ivory
Pearl Shell with
Gold Spider Web
and Gold Leaves.
Each
2¼x4½ in.....$5.00
Diameter of Shade
5 in.

No. G352
Iridescent Pearl
Shell with Gold and
Green Lines.
Each
2¼x4½ in.....$4.50
Diameter of Shade
5 in.

No. G353
Iridescent Ivory
Pearl Shell with
Gold Spider Web
and Gold Leaves.
Each
2¼x4¼ in.....$5.00
Diameter of Shade
4½ in.

No. G266
Rich Amber Iri-
descent Lustre.
Each
2¼x6 in.....$3.50
2¼x7 in.....$4.00
Diameter of Shade
4¼ in.

No. G267
Rich Amber Iri-
descent Lustre.
Each
2¼x5½ in....$4.00
Diameter of Shade
4½ in.

No. G281
Rich Amber Iri-
descent Lustre.
Each
2¼x5 in......$3.00
Diameter of Shade
4¼ in.

No. G350
Iridescent Pearl
Shell with Gold
and Green Lines.
Each
2¼x5½ in....$3.00
Diam. of Shade 6 in.

No. G354
Iridescent Pearl
Shell with Rich
Golden Decoration.
Each
3¼x6½ in.....$9.00
Diameter of Shade
5 in.

No. G355
Iridescent Pearl
Shell with Gold
and Green Lines.
Each
2¼x6½ in.....$8.00
Diameter of Shade
4½ in.

glass windows of this era indicate a range of hues far wider than might be expected from a firm that did not manufacture its own glass. Peters' 208-page catalog contained illustrations of lamps and hanging domes and shades of decorated pierced metal backed with various kinds of glass—colored and painted —and a very large selection of opal glass, and frosted- and cut-glass lighting fixtures. The H. J. Peters. Company was located between Jackson Boulevard and Van Buren Street at 320-322 South Wabash Avenue, Chicago, Illinois. A

Fig. 535 (pp. 328-334)—Table lamps and boudoir lamps from the Frankel Light Co., Cleveland, Ohio, catalog.

5905
Bronze Finish
Natural Vines and Leaves
Height, 28 in. over all
Base, 6¼ in. diameter
Wired complete with 6 ft. silk cord,
plug socket and
Yellow Frosted Grapes and Lamp

5901
Bronze Finish
Natural Vines and Leaves
Height, 27 in. over all
Base, 6¼ in. diameter
Wired with 6 ft. silk cord, plug
sockets, 2¼ in. electric holders,
Frosted Tulip Shades and Lamps

5902
Bronze Finish
Natural Vines and Leaves
Height, 27 in. over all
Base, 6¼ in. diameter
Wired with 6 ft. silk cord, plug
sockets, 2¼ in. electric holders
Frosted Tulip Shades and Lamps
2 lights

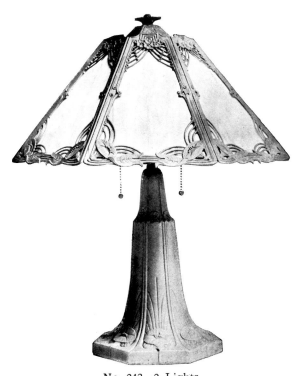

No. 242—2 Lights

Height 19 in. Width 17 in.
List $24.00

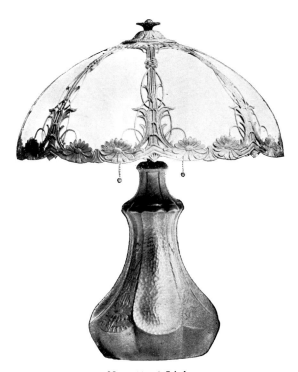

No. 243—2 Lights

Height 23 in.
Width of Shade 18½ in.
List $44.00
Cast Metal Openwork Shade, with Art Glass

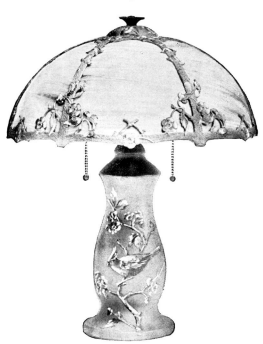

No. 244—2 Lights

Extreme Height 19 in
Width of Shade 16 in.
List $34.00
Cast Metal Openwork Shade, with Art **Glass**

No. 252—2 Lights

Height 23 in. Width 18 in.
List $35.50

No. 245—2 Lights

Height 24 in. Width 20 in.
List $44.00

No. 238—2 Lights

Height 24 in. Width 20 in.
All Lamps in Assorted Finishes
List $44.00

No. 239—2 Lights

Height 23 in. Width 20 in.
List $34.00

No. 246—2 Lights

Height 23 in. Width 18 in.
List $35.50

No. 214

Height 25 in. Diam. of shade 18 in.
Electric wired with 2 pull chain sockets.
Gas—1 light complete.
Amber, amber-green, green, sunset glass.
Finishes: Stat. bronze, old gold, Dublin green.
List—Each $32.00

No. 216

Height 23 in. Diam. of shade 16 in.
Electric wired with 2 pull chain sockets.
Amber, amber-green, green, sunset glass.
Finishes—Stat. bronze, old gold, Dublin green or Flemish.
List—Each $21.00

No. 220

Height 24½ in. Diam. of shade 17 in.
Electric wired with 2 pull chain sockets.
Gas—1 light complete.
Finishes—Stat. bronze, old gold, Dublin green or Flemish.
List—Each $20.50

No. 212

Height 25 in. Diam. of shade 18 in.
Electric wired with 2 pull chain sockets.
Gas—1 light complete.
Amber, amber-green, green, sunset glass.
Finishes: Stat. bronze, old gold, Dublin green.
List—Each $32.00

No. 253—Rec. D—2 Lights
Height 22½ in. Width 16 in.
List $28.00

No. 253—Dec. C—2 Lights
Height 22½ in. Width 16 in.
List $28.00

No. 215
Height 14 in. Shade 7 in.
1 Light Electric Complete with Chain
Pull Socket
Silver, Ivory or Stat. Bronze…$11.00

No. 218—One Height
Height 15 in. Width 8 in.
List $11.00

No. 219—One Height
Height 15 in. Width 8 in.
List $3.50
All Lamps in Assorted Finish

No. 217—One Height
Height 15 in. Width 8 in.
List $10.00

No. 247—2 Lights in Shade, 1 Light in Base
Height 23 in. Width 20 in.
List $44.00

All Lamps in Assorted Finishes. Socket in Base by individual switch.

No. 241—2 Lights in Shade, 1 Light in Base
Height 24 in. Width 20 in.
List $44.00

No. 248—2 Lights in Shade, 1 Light in Base
Height 22 in. Width 19 in.
List $44.00

No. 249—2 Lights in Shade, 1 Light in Base
Height 23 in. Width 2 in.
List $44.00

No. 226
Cast Base, Copper Body
Wired with 2 pull chain sockets
18 in shades Height 24 in.
Finishes—Jap. Bronze and French Bronze
Price $33.00

No. 222
Height 25 in. Diameter of shade 18 in.
Electric wired with 2 pull chain sockets
Gas—1 light complete
Amber, Amber-green, Green or Sunset Glass
Finishes—Stat. Bronze. Old Gold, Dublin Green or
Flemish
List Each—$24.00

No. 208
Height 25 in. Diameter of shade 18 in.
Electric wired with 2 pull chain sockets
Gas—1 light complete
List—$20.00
Amber, amber-green, Dublin green glass
Finishes—Stationary bronze, old gold, Dublin green
or Flemish
List—$20.00

No. 206

CAST LAMP FOR
ELECTRIC
Wired with 2 pull chain
sockets
Made in Amber, Green
and Nile glass
Diameter 18 in.
Height 25 in.

Price—$27.70

Finishes—Ivory, gold or B. B.
and B.

guarantee of 24-hour delivery on every order received was signed by H. J. Peters, president, and F. D. Fox, secretary-treasurer.

Catalog "B" (Fig. 535) published by the Frankel Light Company, 5016 Woodland Avenue, Cleveland, Ohio, contained many illustrations of table lamps which look very much like those produced by the Handel Company of Meriden, Connecticut, and some lamp designs patented by Frederick Roettges for William R. Noe & Sons of New York City. These were described by them as

No. 7004. Diameter of dome 24 inches, $20.00. No charge for packing. $1.50 extra for stem or chain. We ship dome without stem or chain, except when specially ordered.

Fig. 536 (pp. 335-338)—Table lamps and hanging domes from a catalog published by the Cincinnati Artistic Wrought Iron Works, Cincinnati, Ohio.

No. 1042 No. 1027-S No. 1010-A.

No. 1042. Height, 25 inches. Diameter of shade, 15 inches. Verde green finish. $14.50. **No. 1010-A.** Height, 26½ inches. Shade, 23 inches. $50.00. **No. 1027-S.** Height, 15½ inches. Shade, 8 inches. Swedish iron finish. $10.00.

No. 1010-C. Electric Lamp. Height to top 32 inches. Diameter of shade 22 inches. Verde green or brushed brass, $34.00. Fast seller, try a sample.

No. 627. Height, 27 inches. Dome, 15 inches. Art glass and fringe. Gas, $21.00. Same for electric complete, wired, $23.00. 25 per cent. extra for old copper.

No. 7005. Diameter of dome 24 inches. Brushed brass finish. No charge for packing, $26.00. Stem or chain $1.50. We ship dome without stem or chain except when ordered.

No. 7005-A. Same dome, only 20 inches. $20.00. These domes are fast sellers, try a sample.

337

No. 1010. Brushed brass. Height, 28 inches. Dome, 18 inches. 4 electric. $46.00.

Fig. 537—Oil lamp with pierced-metal shade and base painted antique green; shade and base backed with mottled green and white glass; original paper label on base reads "Murano / Aug. 1, 1905," identifying it as having been purchased from Carbone, Inc., Boston, Mass., ca. 1905; height to top of lamp chimney 15 inches. *Collection Mr. & Mrs. Howard Gianotti*

"Cast Metal Openwork Shades with Art Glass." The metal fixtures were given various kinds of special finishes —"Roman Bronze," "Oxidized Copper," "Polished Nickel," "Butler Silver," "Silver and Black," "White Enamel," and "Statuary Bronze."

In Cincinnati, Ohio, the Artistic Wrought Iron Works, 2941-2943 Eastern Avenue, were suppliers of ornamental wrought iron and metal art goods of every kind, including fireplace equipment, mirrors, grillwork, candlesticks and matchstands, jardiniere and umbrella stands, sconces, and most important of all, art-glass and bent-glass lamps (Fig. 536). Most of the lamps offered by this firm are modified versions of ancient designs combining rustic iron frames with colored glass inserts, but there were also art-glass and bent-glass lighting fixtures—some with tree trunk bases not unlike those used by Tiffany Studios. In an open letter to his clients the proprietor

of the firm, B. Schaefer, announced the introduction of a new sandblasting technique which would give his plated and iron wares a new finish. Samples of their new finishes were included in a large selection of objects being shown by their agent, Herman Halle, at 810 Broadway, New York City.

Finally, three large catalogs issued by The Albert Sechrist Manufacturing Company, 1717 Logan Avenue and 1033 Sixteenth Street, Denver, Colorado, offered a host of art-glass and bent-glass domes, table lamps, sconces, and newel post lights that employed every known decorating technique of the Art Nouveau period. Their line was so vast that they worked out a code system for their wholesale trade enabling them to wire orders to the factory by using just a few letters or short words. Selecting illustrations from their 1910, 1912, and 1914 catalogs was not an easy task, but

Fig. 538 (pp. 340-351)—Dome lamps and hanging light fixtures; two desk lamps; from a catalog of The Albert Sechrist Manufacturing Co., Denver, Colo.

2495

275

1184

1183

PLATE 190

2109

2110

2466

2458

2478

2409

2488

2435

2436

2468

2457

2416

PLATE 248

2411

PLATE 242

2491

349

2449

1272

PLATE 165

PLATE 167

Fig. 539—Table lamps and a ceiling fixture with bunches of grapes for shades; from a catalog of The Albert Sechrist Manufacturing Co., Denver, Colo.

Fig. 540 (pp. 353-357)—Hanging lamp fixtures from a catalog of The Albert Sechrist Manufacturing Co., Denver, Colo.

2421

2425

2422

2424

2423

1569

1302

2426

2427

2430

Fig. 541 (pp. 358-361)—Table lamps from a catalog of The Albert Sechrist Manufacturing Co., Denver, Colo.

29

2200

TE 225

1194

2220

224

1193

359

2229

1199

245

2204

234

2202

2235

360

we included as many as possible to give our readers an idea of the similarities and differences between the Sechrist line and those of their contemporaries all over the country (Figs. 538-541). In particular we wish to draw your attention to the Pond Lily table lamps, sconces, and hanging fixtures offered by this company as compared to P. J. Handel's patented design for a Pond Lily lamp with shades made of green and white bent glass.

POST– ART NOUVEAU LAMP DESIGNS

Y the turn of the century, as electric lighting came more and more into use, several companies began to manufacture decorative lighting fixtures. The Patent Office records for the 1910 to 1930 period reveal that many more designs for table lamps were issued than for any other type of lamp. Most of the design patents show pierced ornamental shades, finished with either bent-glass sections or flat sheets of colored and/or decorated glass. Sometimes these glass panels were textured, and had fine ribbed, rippled, or pebbled surfaces. Many had decorations of some sort painted on the interior of the shade, which cast a soft and colorful glow when the lamps were lighted.

Lamps of this period, 1910 to 1930, like those made by Rainaud, Handel, and Helmschmied, are now sought by collectors.

Edward Miller & Company of Meriden, Connecticut, were essentially producers of fancy metalwares for all sorts of home use. Almost from their beginning, metal bases for kerosene lamps had been among their products. Some of their designs for oil lamps were registered at the Patent Office in Washington, D.C. (Five design patents for "Bases for Lamps" were assigned to them by Louis Hornberger of Bridgeport, Connecticut, on February 11, 1896.) When electricity came into more general use, they manufactured electric lighting fixtures—table lamps, ceiling

No. 53,284, May 13, 1919,
"Pedestal" (lamp base).
Albert Boehringer, designer.

No. 55,925, July 20, 1920,
"Support" (for a desk lamp).
Herman H. Wolter, designer.

No. 59,168, Sept. 20, 1921,
"Support for Lamp or Similar
Article" (for a desk lamp).
Herman H. Wolter, designer.

No. 59,169, Sept. 20, 1921, "Lamp"
(with bent-glass shade).
Herman H. Wolter, designer
(Fig. 543).

No. 59,170, Sept. 20, 1921, "Lamp"
(small table lamp). Herman
H. Wolter, designer
(Fig. 544).

Fig. 543—Lamp with pierced-metal and
Bent-glass shade designed by Herman
H. Wolter for Edward Miller & Co.,
Meriden, Conn., patented Sept. 20, 1921.

Fig. 542—Designs for pierced-metal and
Bent-glass lamp shade and matching metal
base registered by Albert Boehringer for
Edward Miller & Co., Meriden, Conn.,
May 13, 1919.

fixtures, small desk lamps, and
wall lights.

The following patents for electric
lighting fixtures were issued to
Edward Miller & Company:

No. 44,671, Sept. 16, 1913, "Panel
for Lamp Shades, Domes, and
the Like." Frederick P.
Schoenhardt, designer.

No. 53,283, May 13, 1919, "Lamp
Shade (of Metal and Bent
Glass)." Albert Boehringer,
designer (Fig. 542).

Post-Art Nouveau Lamp Designs

Fig. 544—Design for table lamp with pierced-metal and Bent-glass shade and metal base patented by Herman H. Wolter for Edward Miller & Co., Meriden, Conn., Sept. 20, 1921.

No. 67,174, Apr. 28, 1925, "Lighting Fixture" (hanging light). Herman H. Wolter, designer.

No. 67,175, Apr. 28, 1925, "Lighting Fixture" (hanging light). Herman H. Wolter, designer.

Fig. 545—Three designs for metal and Bent-glass shaded lamps registered by Albert J. D. Ohm for the Lion Electric Co., Brooklyn, N.Y., June 8 and Aug. 3, 1920.

Fig. 546—Two designs for metal and glass lamp shades patented by Frank Yokel for Wm. B. Young Co., Philadelphia, Pa., Feb. 13 and Mar. 20, 1923.

The Lion Electric Appliance Company of Brooklyn, New York, produced decorative electric fixtures. Some of the designs they used were patented for them by Albert J. D. Ohm, designer, of Astoria, Long Island, New York (Fig. 545).

> No. 55,430, June 8, 1920, "Electric Lamp" (small table lamp with pierced metal and glass shade).
>
> No. 55,431, June 8, 1920, "Electric Lamp" (pierced metal shade with glass panels).
>
> No. 55,954, Aug. 3, 1920, "Electric Lamp" (pierced metal shade with bent-glass panels).

Designer Frank Yokel of Philadelphia and Avalon, Pennsylvania, assigned two design patents to the William B. Young Company of Philadelphia, in 1923 (Fig. 546).

> No. 61,933, Feb. 13, 1923, "Lamp Shade" (pierced metal with textured glass panels).
>
> No. 62,113, Mar. 20, 1923, "Lamp Shade" (pierced metal with bent-glass panels).

On September 9, 1923, Abel Magui of New York City, assigned a design patent for a pierced-metal shade frame (to be used with bent-glass panels) to the Royal Art Glass Company, a corporation of New York (Fig. 547).

The Moe-Bridges Company of Milwaukee, Wisconsin, and San Francisco, California, were assigned a design patent for a "Lamp Base"

Fig. 547—Design for a metal and Bent-glass lamp shade patented by Abel Magui for the Royal Art Glass Co., New York, N.Y., Sept. 9, 1924.

Fig. 548—Design for a lamp base patented by George L. Ludwig for Moe-Bridges Co., Milwaukee, Wis., Mar. 6, 1923.

Fig. 549—Design for a lamp shade patented by Louis W. Rice of New York, N.Y., June 23, 1908.

by designer George L. Ludwig of Milwaukee, Wisconsin, on March 6, 1923 (Fig. 548). We have seen several lamps produced by this company; all had painted shades similar to those made by the Handel Company of Meriden, Connecticut. In most cases, both base and shade were marked with the firm name on the metal and/or glass fixtures.

Fig. 550—Edward M. Cummings' design for a metal lamp with a metal and glass shade; registered July 9, 1907.

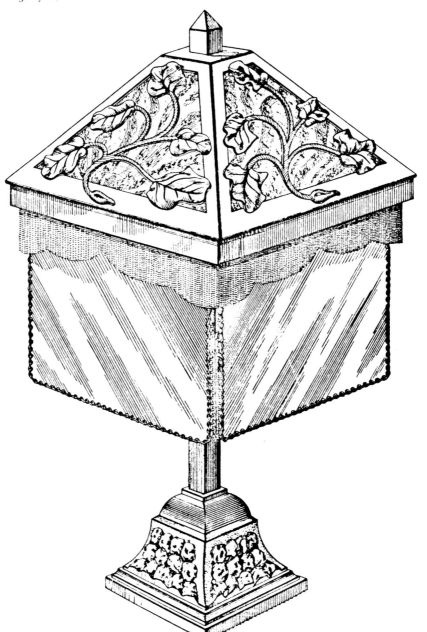

Fig. 551—Frank S. Verbeck's design for a metal and glass lamp shade; patented Apr. 28, 1908.

Louis W. Rice patented a design for a lamp shade that appears to resemble the overlapping petals of a flower (Fig. 549). Lamp shades of this design are to be found in leaded glass and in an imitation of leaded glass made of a plastic material.

Two early patents for pierced-metal shades are shown in our illustrations. One (Fig. 550), registered by Edward M. Cummings,

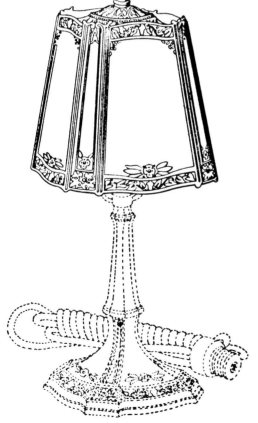

Fig. 552—Frederick Roettges's design for a lamp shade patented and assigned to S. Robert Schwartz of New York, N.Y., June 20, 1922.

Fig. 553—Two designs for lamp shades by Frederick Roettges; patented and assigned to William R. Noe & Sons, New York, N.Y., Nov. 22, 1921.

Fig. 554—Two designs for lamp shades by Frederick Roettges; patented and assigned to William R. Noe & Sons, New York, N.Y., July 18, 1922.

Figs. 555-556—*Left to right:* Frederick Roettges's design for a lamp shade patented and assigned to William R. Noe & Sons, New York, N.Y., Nov. 7, 1922. Frederick Roettges's design for a lamp shade patented and assigned to William R. Noe & Sons, New York, N.Y., Nov. 13, 1923.

Fig. 557—Frederick Roettges's design for a lamp patented and assigned to William R. Noe & Sons, New York, N.Y., Sept 2, 1923.

Fig. 558—Designs for pedestals for lighting
fixtures by Frederick Roettges; patented
and assigned to William R. Noe & Sons, New
York, N.Y., July 18, 1922; Sept. 19, 1922;
Dec. 5, 1922; and three on June 12, 1923.

of Catonsville, a suburb of
Baltimore, Maryland, shows a design
for both shade and lamp; the other
(Fig. 551), registered April 28,
1908, by Frank S. Verbeck of
Chicago, Illinois, for a lamp shade
only. At the time of issuance, no
assignment had been made on either
of these patent designs. Several
companies made lamps in these
general styles during the first decade
of the twentieth century. We have
found lamp shades similar to
Verbeck's design backed with various
colored agate glass panels. Usually
a lamp of this kind had a very plain
base to match the awkward design
of the shade.

Perhaps the most prolific
registerer of design patents for lamps,
shades, and bases was Frederick
Roettges of Stamford, Connecticut.
All of his design patents listed below
were assigned, on issuance, to
William R. Noe & Sons of New York
City. All of the shade designs were
of pierced metal and glass (Figs.
552-557).

Nos. 59,779 to 59,781, Nov. 22,
 1921, Lamp Shade
No. 61,104, June 20, 1922, Lamp
 Shade
Nos. 61,254 to 61,257, July 18,
 1922, Lamp Shade
No. 61,264, July 18, 1922, Lamp
 Shade
No. 61,650, Nov. 7, 1922, Lamp
 Shade
No. 61,706, Dec. 5, 1922, Lamp
 Shade
No. 61,863, Jan. 30, 1923, Lamp
 Shade

Fig. 560—Adolph Magnus's design for a pierced-metal and Bent-glass hanging lamp shade; patented Aug. 20, 1912.

No. 62,501, June 12, 1923, Lamp
 Shade
No. 63,270, Nov. 13, 1923, Lamp
 Shade
Nos. 63,805 to 63,807, Jan. 15,
 1924, Lamp Shade
No. 65,540, Sept. 2, 1924, Table
 Lamp

Roettges also patented several designs for "Lamp Pedestals" in neo-classic styles, all of which were assigned to William R. Noe & Sons (Fig. 558).
Nos. 59,776 to 59,778, Nov. 22, 1921
Nos. 61,258 to 61,263, July 18, 1922
Nos. 61,510 and 61,511, Sept. 19,
 1922
Nos. 61,705 to 61,709, Dec. 5, 1922
Nos. 62,497 to 62,503, June 12, 1923

Fig. 559—Kathryn Goetz's design for a boudoir lamp; patented July 8, 1913.

374

Fig. 561—Clarence G. Wing's design for a glass and metal chandelier patented and assigned to John C. Virden Co., Cleveland, Ohio, June 7, 1932.

Frivolous little boudoir lamps (Fig. 559), on the order of one designed and patented by Kathryn Goetz of Brooklyn, New York, on July 8, 1913, were much in vogue in the first quarter of the twentieth century. (Hers was designed with a ribbon- and fringe-trimmed shade.)

Typical of the many ceiling fixtures produced in the post-Art Nouveau era were those patented by Adolph Magnus (Fig. 560) of New York City, August 20, 1912 (bent glass set into a metal frame), and by Clarence G. Wing (Fig. 561) of Cleveland, Ohio, on June 7, 1932, assigned to John G. Virden Co. of the same place (ornate pressed-glass inserts held by an elaborately decorated metal fixture).

APPENDIX A

Complete 1932 catalog with more than 500 items, published by the Steuben Division of The Corning Glass Works. Items "are clearly sketched with number, shape, size, pattern, colors, types of glass and price."

No.	Class	Size	Pattern	Color		Finish	Price Retail
913	Vase	5½"	Plain " " " " "	Pomona Green . . . Ivory Crystal . . . Wisteria . . . Dark Jade Blue . . . Jade Green . . . Alabaster . . . Fr. Blue Gold Aurene . . . Blue Aurene Cerise Ruby		Mouss.H'v'y " " " " " " " " " " " "	$ 1.50ea 1.50 " 1.50 " 1.50 " 1.50 " 2.00 " 2.00 "
938	Vase	5"	Plain " " " " "	Pomona Green . . . Ivory . . . Crystal . . . Wisteria . . . Dark Jade Blue . . . Jade Green . . . Alabaster Gold Aurene . . . Blue Aurene Cerise Ruby		Mouss.H'v'y " " " " " " " " " "	1.50ea 1.50 " 1.50 " 1.50 " 2.00 " 2.00 "
938	Vase (Footed)	9" 9" 9"	Marlene* Bird* Matzu*	Jade over Alabaster Jade over Alabaster Rosaline over Alabaster		Etched " "	13.00ea 13.00 " 13.00 "
938	Vase (Fish Bowl)	11" 11"	Plain Design 10018*	Crystal Crystal		Plain Eng. Grey	8.00 " 12.00 "
1044	Cocktail Glass			Crystal, Black reeded . . . Crystal, Green reeded Crystal, Rose Cherries, Engraved Stem		Optic " "	21.00dz 21.00 " 27.00 "
1455	Cologne		Plain " " " " " "	Jade Green, Alabaster Stpr. . . . Ivory, Black Stpr. . . . Verre de Soie, Pom. Green Stpr. . . . V. D. S., French Blue Stpr. . . . V.D.S., Rose Stopper . . . Wisteria		Plain " " " " " "	3.00ea 3.00 " 3.00 " 3.00 " 3.00 " 3.00 " 3.00 "
1455	Puff		Plain " " " " " "	Jade Green, Alabaster Knob . . . Ivory, Black Knob . . . V.D.S., Po- mona Green Knob . . . V. D.S., French Blue Knob . . . V.D.S., Rose Knob Wisteria		Plain " " " " " "	3.00ea 3.00 " 3.00 " 3.00 " 3.00 " 3.00 " 3.00 "
2028	Salad Plate	8½"	Plain " " " "	Crystal . . . French Blue . . . Bristol Yellow . . . Po- mona Green . . . Verre de Soie Cerise Ruby		Plain " " " Optic	36.00dz 36.00 " 36.00 " 36.00 " 42.00 "
2230	Vase	7"	Plain " " " " " "	Crystal . . . Pomona Green . . . Ivory . . . Ala- baster . . . Dark Jade Blue . . . Jade Green, Wisteria Gold Aurene . . . Blue Aurene		Mouss. Lt. " " " " " " " " " " " "	1.75ea 1.75 " 1.75 " 1.75 " 1.75 " 2.25 " 2.25 "
2533	Vase	5"	Plain " " " " "	Pomona Green . . . Ivory . . . Alabaster . . . Wisteria . . . Dark Jade Blue . . . Jade Green Gold Aurene . . . Blue Aurene . . . Cerise Ruby		Mouss. Lt. " " " " " " " " " "	1.50ea 1.50 " 1.50 " 1.50 " 2.00 " 2.00 "

*See Appendix for decorated pieces

No.	Class	Size	Pattern	Color		Finish	Price Retail
2683	Vase	6½″	Plain	Ivory . . . Jade Green		Plain	$ 2.50 ea
			"	Alab. & Bl. .		"	3.00 "
			"	White Cluthra...Green		"	3.50 "
			"	Cluthra...Rose Cluthra		"	3.50 "
			"	Amethyst Cluthra . . .		"	3.50 "
			"	Blue Cluthra		"	3.50 "
			"	Gold Aurene . . . Blue		"	4.00 "
			"	Aurene		"	4.00 "
2683	Vase	8½″	Plain	Ivory . . . Jade Green		Plain	3.50 ea
			"	White Cluthra...Green		"	4.50 "
			"	Cluthra . . . Rose Clu-		"	4.50 "
			"	thra . . . Amethyst Clu-		"	4.50 "
			"	thra ... Blue Cluthra ...		"	4.50 "
			"	Alab. & Bl.		"	4.00 "
			"	Gold Aurene . . . Blue		"	5.00 "
			"	Aurene		"	5.00 "
2683	Vase	10½″	Plain	Ivory . . . Jade Green		Plain	6.00 ea
			"	Alab. & Bl.		"	7.00 "
			"	White Cluthra... Green		"	8.00 "
			"	Cluthra . . . Rose Clu-		"	8.00 "
			"	thra . . . Amethyst		"	8.00 "
			"	Cluthra . . . Blue Cluthra		"	8.00 "
			"	Gold Aurene . . . Blue		"	12.00 "
			"	Aurene		"	12.00 "
2683	Vase	12″	Plain	White Cluthra, Green		Plain	11.00 ea
			"	Cluthra, Rose Cluthra,		"	11.00 "
			"	Blue Cluthra, Amethyst		"	11.00 "
			"	Cluthra		"	11.00 "
2683	Vase	6½″	Teazle*	Black over Jade Green		Etched	12.50 ea
		6½″	Pussy Willow*	Black over Alabaster		"	8.50 "
		10½″	Stamford*	Ivory		Sculptured	17.50 "
		12″	Shelton*	Gold over Alabaster		Etched	44.00 "
		12″	Hunting*	Black over Alabaster		"	50.00 "
2687	Bowl	6″	Plain	Jade Green		Plain	2.50 ea
			"	Blue Aurene . . . Gold		"	4.00 "
				Aurene		"	4.00 "
		8″	"	Jade Green		"	4.00 "
			"	Blue Aurene . . . Gold		"	6.00 "
				Aurene		"	6.00 "
		8″	Compton*	Blue Aurene over Alab.		Etched	17.00 "
		8″	Canton*	Plum		Cameo Etched	20.00 "
		10″	Plain	Jade Green		Plain	7.00 "
			"	Blue Aurene . . . Gold		"	12.00 "
				Aurene		"	12.00 "
2744	Rustic 3 prong Flower Vase		Plain	Jade Green, Alabaster		Rustic	2.50 ea
			"	Foot . . . Crystal . . .		"	2.50 "
			"	Ivory . . . Pomona		"	2.50 "
			"	Green		"	2.50 "
			"	Gold Aurene . . . Blue		"	4.00 "
			"	Aurene		"	4.00 "
2851	Bowl	10″	Plain	Crystal . . . Jade Green		Ripple	4.00 ea
2852	Bowl	10″	Plain	Crystal		Ripple	6.00 ea
		9″	"	Gold Aurene . . . Blue		Plain	8.00 "
		9″	"	Aurene		"	8.00 "

*See Appendix for decorated pieces

No.	Class	Size	Pattern	Color		Finish	Price Retail
2909	Vase	6″	Plain	Ivory . . . Jade Green, Alab. Foot		Plain	$ 2.00 ea
			"			Plain	2.00 "
			"	Pomona Green...French		Mouss.	2.00 "
			"	Blue . . Crystal, Wisteria		"	2.00 "
			"	Cerise Ruby			3.50 "
			"	Gold Aurene . . . Blue		Plain	4.00 "
			"	Aurene		"	4.00 "
2909	Vase	8″	Plain	Ivory . . . Jade Green, Alab. Foot		Plain	2.50 ea
			"				2.50 "
			"	Pomona Green...French		Mouss.	2.50 "
			"	Blue . . Crystal, Wisteria		"	2.50 "
			"	Cerise Ruby			4.00 "
			"	Gold Aurene . . . Blue		Plain	5.00 "
			"	Aurene		"	5.00 "
2909	Vase	10″	Plain	Ivory, Black Foot . . .		Plain	3.00 ea
			"	Jade Green, Alab. Ft.			3.00 "
			"	Pomona Green...French		Mouss.	3.00 "
			"	Blue		Mouss.	3.00 "
			"	Crystal		Ripple	3.00 "
			"	Gold Aurene . . . Blue		Plain	6.00 "
			"	Aurene		"	6.00 "
2909	Vase	10″	T-9*	Crystal		Eng. Grey	5.00 ea
2909	Vase	12″	Plain	Gold Aurene . . . Blue		Plain	10.00 ea
			"	Aurene		"	10.00 "
2989	Cigarette Box		Plain	Crystal . . . Pomona		Plain	4.50 ea
			"	Green...French Blue...		"	4.50 "
			"	Bristol Yellow . . . Jade		"	4.50 "
			"	Green...Alabaster with		"	4.50 "
			"	Black Cover		"	4.50 "
			Duck *	Any of the above colors		Engraved	8.00 ea
			Hunting Dog*	may be engraved.		"	7.00 "
			Pheasant*			"	8.00 "
			Polo*			"	6.00 "
			Tennis*			"	6.00 "
			Guns*			"	7.00 "
2997	Ash Tray		Plain	Ivory and Black...Jade		Plain	2.50 ea
			"	Green and Alabaster		"	2.50 "
3269	Flower Blk.		Plain	Crystal		Plain	3.00 "
5000	Covered Jar	6″	Matzu*	Rosaline over Alab . . .		Etched	12.00 ea
			Matzu*	Jade Green over Alab.		"	12.00 "
			Chinese*	Jade Green over Alab....		"	15.00 "
			Chinese*	Rosaline over Alab.		"	15.00 "
6030	Vase	7″	Plain	Crystal		Ripple	2.50 ea
			"	Pomona Green . . . Light		Twist	2.50 "
			"	Amethyst...Bristol Yel-		"	2.50 "
			"	low . . . Wisteria . . .		"	2.50 "
			"	French Blue . . . Jade		"	2.50 "
			"	Green		"	2.50 "
			"	Ivory		Plain	2.50 "
			"	Cerise Ruby		Twist	3.50 "
			"	Blue Aurene . . . Gold		Plain	5.00 "
			"	Aurene		"	5.00 "
			T-11*	Crystal		Eng. Grey	6.00 "
6030	Vase	10″	Plain	Pomona Green...Light		Twist	4.00 ea
			"	Amethyst . . . Bristol		"	4.00 "
			"	Yellow . . . Wisteria . . .		"	4.00 "
			"	French Blue . . . Jade		"	4.00 "
			"	Green		"	4.00 "
			"	Crystal		Ripple	4.00 "
			"	Cerise Ruby		Twist	5.00 "

*See Appendix for decorated pieces

No.	Class	Size	Pattern	Color		Finish	Price Retail
6031	Vase	7″	Plain	Pomona Green...Light		Twist	$ 2.50 ea
			"	Amethyst . . . Bristol		"	2.50 "
			"	Yellow . . . Wisteria . . .		"	2.50 "
			"	French Blue . . . Jade		"	2.50 "
			"	Green		Plain	2.50 "
			"	Ivory		Twist	2.50 "
			"	Cerise Ruby			3.50 "
6034	Vase (see 7372)	12″	Plain	Pomona Green . . . Jade		Plain	3.50 ea
			"	Green, Alabaster Foot,		"	3.50 "
			"	Wisteria, Crystal		"	3.50 "
			"	Cerise Ruby		Mouss.	5.00 "
			"	Gold Aurene . . . Blue		Plain	7.00 "
			"	Aurene			7.00 "
			Grape*	Cerise Ruby		Eng. Grey	7.00 "
			Matzu*	Jade over Alabaster . . .		Etched	15.00 "
			Matzu*	Rosaline over Alabaster		"	15.00 "
			Marlene*	Jade over Alabaster . . .		"	17.00 "
			Marlene*	Rosaline over Alabaster		"	17.00 "
6053	Vase	7″	Plain	Crystal . . . Pomona		Bubbly	2.50 ea
			"	Green . . . Bristol Yel-		"	2.50 "
			"	low . . . French Blue . . .		"	2.50 "
			"	Wisteria		"	2.50 "
6078	Vase	8″	Floral*			Etched	14.50 ea
			Fircone*			"	14.50 "
			Sea Holly*	Jade Green over Alabaster		"	14.00 "
			Nedra*	or		"	14.50 "
			Marlene*	Rosaline over Alabaster		"	12.00 "
			Matzu*			"	13.00 "
			Sea Holly*	Black over Alabaster		"	14.00 "
			Nedra*	Black over Alabaster		"	14.50 "
6106	Bowl	11½″	Plain	Crystal . . . Pomona		Twist	4.00 ea
			"	Green . . . Jade Green . . .		"	4.00 "
			"	French Blue . . . Wis-		"	4.00 "
			"	teria . . . Bristol Yellow		"	4.00 "
6112	Vase	8″	Chang*	Plum		Cameo Etched	45.00 ea
6123	Vase (see 7374)	10″	Plain	Crystal...Pomona Green		Ripple	4.00 ea
			"	French Blue . . . Bristol		"	4.00 "
			"	Yellow . . . Ivory		"	4.00 "
			T-10*	Crystal		Eng. Grey	11.00 "
			Plain	Cerise Ruby		Ripple	5.00 "

*See Appendix for decorated pieces

No.	Class	Size	Pattern	Color		Finish	Price Retail
6126	Goblet		Noyon*	Crystal		Rk. Cry. Eng.	$144.00 dz
	Champagne					" " "	128.00 "
	Claret					" " "	128.00 "
	Wine					" " "	108.00 "
	Cocktail					" " "	108.00 "
	Finger Bowl					" " "	128.00 "
	Sherbet					" " "	130.00 "
	8½" Plate					" " "	120.00 "
	14oz. Tumbler					" " "	122.00 "
	Cordial					" " "	96.00 "
	F. B. Plate					" " "	108.00 "
6178	Vase	5"	Plain	Alabaster and Black		Plain	2.50 ea
			"	Gold Aurene . . . Blue		Plain	4.50 "
			"	Aurene		"	4.50 "
6183	Goblet		Thistle*	Crystal		Cut	144.00 dz
	Champagne					"	132.00 "
	Wine					"	120.00 "
	Highball					"	144.00 "
	Cocktail					"	114.00 "
	Cordial					"	102.00 "
	Finger Bowl					"	120.00 "
	F. B. Plate					"	114.00 "
6199	Vase	9½"	Plain	Crystal...Pomona Green		Mouss. Rgh.	3.50 ea
			"	French Blue . . . Jade		" "	3.50 "
			"	Green		" "	3.50 "
			Sculptured*	Jade Green		Sculptured*	10.00 "
6237	Cologne		Plain	Light Amethyst . . .		Mouss.	6.00 ea
			"	French Blue		"	6.00 "
			"	Jade Green, Alab. Stpr.		Plain	6.00 "
			"	Ivory, Black Stopper		"	6.00 "
6237	Puff		Plain	Light Amethyst . . .		Mouss.	6.00 ea
			"	French Blue		"	6.00 "
			"	Jade Green, Alab. Knob		Plain	6.00 "
			"	Ivory with Black Knob		"	6.00 "
6268 (See 7448)	Goblet		Warwick*	Crystal		Heavy Cut	72.00 dz
	Champagne					" "	66.00 "
	Wine					" "	60.00 "
	Highball					" "	72.00 "
	8½" Plate					" "	72.00 "
	Finger Bowl					" "	60.00 "
	F. B. Plate					" "	60.00 "
	Cocktail					" "	60.00 "
	Cordial					" "	54.00 "
6268	Goblet		Queen Anne*	Crystal		Heavy Cut	120.00 dz
	Champagne					" "	108.00 "
	Cocktail					" "	102.00 "
	Highball					" "	126.00 "
	Finger Bowl					" "	108.00 "
	F. B. Plate					" "	108.00 "
	Wine					" "	102.00 "
	Cordial					" "	84.00 "
	Claret					" "	90.00 "
	8½" Plate					" "	150.00 "
	Sherbet					" "	108.00 "
6272	Vase	10"	Indian*	Black over Green		Etched	20.00 ea

*See Appendix for decorated pieces

No.	Class	Size	Pattern	Color		Finish	Price Retail
6302	Ash Tray		Plain	Jade Green, Alabaster		Plain	$ 3.00 ea
			"	Handle . . . Ivory, Black	6302	"	3.00 "
			"	Handle . . . Green Cluthra . . . White Cluthra . . .		"	3.00 "
			"			"	3.00 "
			"	Rose Cluthra . . . Blue Cluthra . . . Amethyst Cluthra		"	3.00 "
			"			"	3.00 "
			"			"	3.00 "
6333	Cocktail Gl., (see 1044) (see 7056)		Footed, no handle	Crystal, Black reeded . . .	6333	Plain	24.00 dz
				Crystal, Green reeded . . .		"	24.00 "
				Crystal, Rose Cherries		Eng. Stem	30.00 "
	Cocktail Gl., (see 1044) (see 7056)		Footed, With handle	Crystal, Black reeded . . .	6333	Plain	30.00 "
				Crystal, Green reeded		"	30.00 "
				Crystal, Rose Cherries		Eng. Stem	36.00 "
6389	Vase	12"	Marlene*	Jade over Alabaster . . .	6389	Etched	16.00 ea
			" *	Rosaline over Alabaster		"	16.00 "
6391	Vase	12"	Sculptured*	Jade Green	6391	Sculptured*	25.00 ea
6406	Vase	11"	Acanthus*	Rose Quartz	6406	Sculptured*	32.00 ea
6415	Bowl	8"	Plain	French Blue . . . Jade Green		Twist	3.50 ea
			"			"	3.50 "
			"	Ivory . . . Alabaster		Plain	3.50 "
			"	Crystal		Twist	3.50 "
			Thistle*	Ivory	6415	Sculptured*	8.00 "
			Acanthus*	Light Amethyst . . .		"	9.00 "
			" *	Crystal		"	9.00 "
		11½"	Plain	French Blue . . . Jade Green		Twist	7.00 "
			"			"	7.00 "
			"	Ivory . . . Alabaster . . .		Plain	7.00 "
			"	Crystal		"	7.00 "
			Thistle*	Ivory . . . Crystal	6448	Sculptured*	12.00 "
			Acanthus*	Crystal		"	13.00 "
6448	Flower Blk.		Plain	Crystal		Plain	4.00 "
6468	Vase	15"	Florida*	Black over Alabaster	6468	Etched*	65.00 ea

*See Appendix for decorated pieces

No.	Class	Size	Pattern	Color		Finish	Price Retail
6495	Flower Blk. and kneeling figure. (see 7450 Base)			Crystal block with matted figure			$ 8.00 ea
6500	Vase	5″	Plain " "	Ivory Gold Aurene . . . Blue Aurene		Plain " "	2.50 ea 4.00 " 4.00 "
6501	Vase	6″	Mansard*	Rose Quartz		Sculptured*	10.50 ea
6502	Eagle			Crystal		Cut	15.00 ea
6504	Pheasant			Crystal		Cut	35.00 ea
6505	Goblet Champagne Cocktail Claret Sherbet Finger Bowl Highball 8½″ Plate Cordial F. B. Plate		Shirley*	Crystal		Rk. Cry. Eng. "	42.00 dz 42.00 " 36.00 " 36.00 " 42.00 " 36.00 " 42.00 " 48.00 " 36.00 " 42.00 "
6505	Candlestick	12″	Shirley*	Crystal		Rk. Cry. Eng.	7.00 ea
	Compote	7x7″	Shirley*	Crystal		Rk. Cry. Eng.	8.00 ea
	Bowl	12″	Shirley*	Crystal		Rk. Cry. Eng.	14.00 ea

*See Appendix for decorated pieces

No.	Class	Size	Pattern	Color		Finish	Price Retail
6515	Canoe Bowl	15″ 20″	Plain Cut No. 1*	Bristol Yel. . . . Crystal Crystal		Plain Cut No. 1*	$ 13.00 ea 100.00 "
6547	Candlestick	3¼″	Plain " " " "	Crystal...French Blue... Pomona Green . . .Light Amethyst. . .Wisteria... Bristol Yellow . . . Jade Green		Plain " " " "	1.75 ea 1.75 " 1.75 " 1.75 " 1.75 "
6559	Covered Jar	13½″	Cut No. 1*	Crystal		Cut No. 1*	80.00 ea
6593	Candlestick (To match 6106 bowl)	4½″	Plain " " "	Jade Green . . . Pomona Green . . . Bristol Yel- low . . . Crystal . . . French Blue . . .Wisteria		Opt. or Twist " " " " " " " " "	2.00 ea 2.00 " 2.00 " 2.00 "
6596 (see 6768)	Goblet Champagne Claret Cocktail Wine Sherry Cordial Finger Bowl F. B. Plate Sherbet Sherbet Plate 8½″ Plate ½ Pt. Tumb. 11 oz. Tumb. 14 oz. Tumb.		Torino*	Crystal		Rk.'Cry. Eng. "	120.00 dz 108.00 108.00 108.00 108.00 102.00 96.00 90.00 90.00 108.00 90.00 108.00 84.00 96.00 108.00
6599 (see 6626)	Goblet Champagne Cocktail Finger Bowl 8½″ Plate Cordial Claret F. B. Plate		Burlington*	Cerise Ruby and Crystal		Eng. Grey " " " " " " " " " " " " " "	60.00 dz 60.00 60.00 42.00 48.00 42.00 60.00 45.00
6600	Cologne		Plain " " " " " " "	Jade Green, Alabaster Stopper . . . Ivory with Black Stopper . . . Verre de Soie with Pomona Green Stopper . . . V.D. S., French Blue Stopper V.D.S., with Rose Stop- per . . . Wisteria		Plain " " " " " " "	3.00 ea 3.00 " 3.00 " 3.00 " 3.00 " 3.00 " 3.00 " 3.00 "
6600	Puff		Plain " " " " " " "	Jade Green, Alabaster Knob . . . Ivory with Black Knob . . . V.D.S. with Pomona Green Knob... V.D.S., French Blue Knob . . . V.D.S., with Rose Knob . . . Wisteria		Plain " " " " " " "	3.00 ea 3.00 " 3.00 " 3.00 " 3.00 " 3.00 " 3.00 " 3.00 "

*See Appendix for decorated pieces

No.	Class	Size	Pattern	Color		Finish	Price Retail
6619	Cologne		Plain " " " " " " " "	Jade Green, Alabaster Stopper...Ivory with Bl. Stopper . . . V.D.S., Pomona Green Stopper V. D. S., French Blue Stopper ...V.D.S., with Rose Stopper . . . Wisteria		Plain " " " " " " " "	$ 3.00ea 3.00 " 3.00 " 3.00 " 3.00 " 3.00 " 3.00 "
6619	Puff		Plain " " " " " " " "	Jade Green, Alabaster Knob . . . Ivory with Black Knob . . . V.D.S., Pomona Green Knob... V. D. S., French Blue Knob . . . V.D.S., with Rose Knob . . . Wisteria		Plain " " " " " " " "	3.00ea 3.00 " 3.00 " 3.00 " 3.00 " 3.00 " 3.00 "
6626	Candlestick (see 6599)	7″	Burlington*	Cerise Ruby and Crystal		Eng. Grey	8.00ea
	Compote	8″x7″	Burlington*	Cerise Ruby and Crystal		Eng. Grey	9.00ea
	Bowl	12″	Burlington*	Cerise Ruby and Crystal		Eng. Grey	15.00ea
6627	Vase	6½″	Plain "	Gold Aurene . . . Blue Aurene		Plain "	7.00ea 7.00 "
6630	Vase	12″	Plain "	Blue Aurene . . . Gold Aurene		Plain "	11.00ea 11.00 "
6636	Covered Jar	16″	H'v'y Cut*	Light Amethyst		H'v'y Cut*	70.00ea
6662	Flower Blk.		Oval or Round Plain	Crystal Crystal		Plain "	3.50ea 3.50 "

*See Appendix for decorated pieces

No.	Class	Size	Pattern	Color		Finish	Price Retail
6680	Vase	12″	Lion*	Jade Green		Sculptured	$ 45.00 ea
6687	Cologne		H'v'y Cut*	Moss Agate and Crystal		H'v'y Cut*	30.00 ea
6688	Puff		H'v'y Cut*	Moss Agate and Crystal		H'v'y Cut*	40.00 ea
6727	Goblet		Virginia*	Crystal		Rk. Cry. Eng.	192.00 dz
	Champagne					" " "	168.00 "
	Claret					" " "	156.00 "
	Cocktail					" " "	156.00 "
	Cordial					" " "	132.00 "
	Finger Bowl					" " "	156.00 "
	F. B. Plate					" " "	156.00 "
6763	Vase	10″	Cut No. 1*	Crystal		Cut No. 1*	23.00 ea
6768	Candlestick (see 6596)	14″	Torino*	Crystal		Rk. Cry. Eng.	25.00 ea
	Compote	7x7″	Torino*	Crystal		Rk. Cry. Eng.	30.00 ea
	Bowl	14″	Torino*	Crystal		Rk. Cry. Eng.	60.00 ea

*See Appendix for decorated pieces

No.	Class	Size	Pattern	Color		Finish	Price Retail
6774	Bowl	8"	Plain	Crystal		Ripple	$ 3.00 ea
		10"	"	Crystal		Ripple	4.00 "
		10"	"	French Blue . . . Pomona		Mouss.	4.00 "
			"	Green . . . Wisteria . . .		"	4.00 "
			"	Jade Green . . . Bristol		"	4.00 "
				Yellow		"	4.00 "
6813	Vase (see 7379)	8"	Plain	Jade Green . . . Ivory		Plain	2.50 ea
			"	Gold Aurene . . . Blue		"	5.00 "
			"	Aurene		"	5.00 "
6814	Vase	8"	Plain	Crystal		Plain	2.50 ea
6821	Luminor Ball		(5 large bubbles in bottom)	Crystal with Black Base		Bubbly	15.00 ea
				Ball Only			8.00 "
6824	Pigeon			Crystal with Black Base		Cut	35.00 ea
				Pigeon Only		"	25.00 "
6828	Candlestick	14"	Cut*	Crystal		Cut*	25.00 ea
	Bowl	14"	Cut*	Crystal		Cut*	45.00 ea
6844	Goblet		Poussin*	Cased Black over Crystal		Rk. Cry. Eng.	228.00 dz
	Champagne					" " "	222.00 "
	Wine					" " "	208.00 "
	Cocktail					" " "	210.00 "
	Sherry					" " "	210.00 "
	Cordial					" " "	198.00 "
	Finger Bowl					" " "	210.00 "
	8½" Plate					" " "	252.00 "
	F. B. Plate					" " "	210.00 "
6856	Vase	7"	Sculptured*	Rose Quartz . . .		Sculptured*	25.00 ea
				Amethyst Quartz		"	25.00 "

*See Appendix for decorated pieces

No.	Class	Size	Pattern	Color		Finish	Price Retail
6858	Bowl	12″	Plain	Ivory, Pomona Green Bristol Yellow, Crystal, Cerise Ruby		Plain " "	$ 6.00 ea 6.00 " 7.50 "
6861	Goblet Champagne Wine Cocktail Finger Bowl F. B. Plate 8½″ Plate B.&S.Tumb. Sherbet Claret Cordial		Wellington*	Crystal		Rk. Cry. Eng. "	192.00 dz 192.00 " 174.00 " 180.00 " 132.00 " 132.00 " 156.00 " 138.00 " 192.00 " 180.00 " 138.00 "
6869	Goblet Finger Bowl F. B. Plate 8½″ Plate Sherbet Claret Champagne Wine Cocktail Cordial		Marine*	Crystal		Eng. Grey " " " " " " " " " " " " " " " " " "	102.00 dz 90.00 " 96.00 " 102.00 " 96.00 " 96.00 " 102.00 " 84.00 " 96.00 " 90.00 "
6869	Vase (Brandy and Soda)	6½″	T-3* T-12* T-14*	Crystal Crystal Crystal		Eng. Grey " " " "	2.25 ea 2.50 " 2.25 "
6875	Vase	8″	Plain " " " " " "	Crystal...Pomona Green French Blue . . . Ivory... Jade Green, Alab Foot... Wisteria . . . Black		Plain " " " " " "	2.00 ea 2.00 " 2.00 " 2.00 "
6876	Vase	6″	Plain " "	Crystal . . . Pomona Green . . . Wisteria		Plain " "	3.50 ea 3.50 "
6880	Ash Tray		Plain Sand Blasted*	Crystal		Plain Sand Blasted*	7.50 ea 7.50 "
6890	Bowl	12″	Plain " " " "	French Blue . . . Bristol Yellow ... Jade Green ... Ivory...Alabaster, Pomona Green, . . . Crystal		Plain " " " "	6.00 ea 6.00 " 6.00 " 6.00 "

*See Appendix for decorated pieces

No.	Class	Size	Pattern	Color		Finish	Price Retail
6893	Vase	18″	Plain Grape*	Crystal "		Plain Etched	$ 20.00 ea 30.00 "
6928	Goblet Champagne Cocktail Wine Finger Bowl F. B. Plate 8½″ Plate Footed Ice Tea B.&S. Tumb. Sherbet Claret Cordial		Bayard*	Crystal		Rk. Cry. Eng. "	204.00 dz 192.00 " 168.00 " 180.00 " 144.00 " 132.00 " 156.00 " 144.00 " 162.00 " 180.00 " 168.00 " 156.00 "
6936	Goblet Champagne Claret Cocktail Wine Sherry Finger Bowl F. B. Plate B.&S. Tumb. Cordial		Leaves*	Crystal		H'v'y Cut " " " " " " " " " " " " " " " " " "	66.00 dz 60.00 " 54.00 " 54.00 " 54.00 " 54.00 " 54.00 " 60.00 " 72.00 " 48.00 "
6936 (see 7448)	Goblet Champagne Cocktail Wine Cordial Sherbet Highball Finger Bowl 8½″ Plate F. B. Plate		Warwick*	Crystal		H'v'y Cut " " " " " " " " " " " " " " " " " "	66.00 dz 54.00 " 54.00 " 54.00 " 54.00 " 60.00 " 72.00 " 54.00 " 60.00 " 48.00 "
6968	Vase 5 Prong	10″	Plain " " "	Crystal . . .Pomona Green. . .French Blue. . . Ivory . . . Jade Green, Alab. Foot . . . Wisteria		Plain " " "	7.00 ea 7.00 " 7.00 " 7.00 "
6971	Pineapple Luminor Pineapple Only			Crystal with Black Base Crystal			14.00 ea 7.00 ea
6980	Vase	8″	Plain	Alabaster and Black		Plain	3.00 ea

*See Appendix for decorated pieces

No.	Class	Size	Pattern	Color		Finish	Price Retail
7007	Vase	14"	Boothbay*	Green over Brown into Rose Cluthra		Etched*	$40.00 ea
7010	Luminor Horse			Crystal with Black Base		Cut	32.00 ea
	Horse Only			Crystal		Cut	23.00 ea
7035	Vase	12"	H'v'y Cut*	Crystal		H'v'y Cut*	35.00 ea
7036	Vase	12"	Hollywood*	Ivory		Sculptured	16.50 ea
7039	Flower Block and Girl Figure (see 7450 Base)			Crystal Block, Matted Figure			9.00 ea
7046	Goblet		Regal*	Crystal		Rk. Cry. Eng.	33.00 dz
	Champagne					" " "	30.00 "
	Highball					" " "	33.00 "
	Finger Bowl					" " "	32.00 "
	8½" Plate					" " "	42.00 "
	Claret					" " "	30.00 "
	Cocktail					" " "	30.00 "
	Cordial					" " "	30.00 "
	F. B. Plate					" " "	36.00 "
7050	Vase	6½"	Intarsia*	Crystal and Black		Inlaid	20.00 ea

*See Appendix for decorated pieces

No.	Class	Size	Pattern	Color		Finish	Price Retail
7051	Bowl	6″	Intarsia*	Crystal and Blue		Inlaid	$16.00 ea
7053	Vase	7¾″	Intarsia*	Crystal and Purple		Inlaid	20.00 ea
7056 (see 1044 glasses) (see 6333 glasses)	Cocktail Shaker	Large Size		Crystal, Black reeded... Crystal, Green reeded Crystal with Rose Cherries		Plain " Eng. Grey	10.00 ea 10.00 " 11.00 "
7064 (see 7450 Base)	Flower Block & Fish			Crystal Block, fish matted			7.00 ea
7078	Covered Jar	13¼″	La France*	Crystal		Eng. Grey	80.00 ea
7090	Vase	9″	Plain " " " " "	Crystal and Green . . . Crystal and Rose . . . Crystal and Amethyst... Crystal and Blue . . . Ivory . . . Wisteria . . . Crystal		Plain " " " " "	3.50 ea 3.50 " 3.50 " 3.50 " 3.50 " 3.50 "
		11″	Plain " " " " "	Crystal and Green . . . Crystal and Rose . . . Crystal and Amethyst... Crystal and Blue . . . Ivory . . . Wisteria . . . Crystal		" " " " " "	5.00 ea 5.00 " 5.00 " 5.00 " 5.00 " 5.00 "
7091	Bowl	6″	Plain " " " " "	Crystal and Green . . . Crystal and Rose . . . Crystal and Amethyst... Crystal and Blue . . . Ivory . . . Wisteria . . . Crystal		Plain " " " " "	3.50 ea 3.50 " 3.50 " 3.50 " 3.50 " 3.50 "
		8″	Plain " " " " "	Crystal and Green . . . Crystal and Rose . . . Crystal and Amethyst... Crystal and Blue . . . Ivory . . . Wisteria . . . Crystal		Plain " " " " "	4.00 ea 4.00 " 4.00 " 4.00 " 4.00 " 4.00 "
		9½″	Plain " " " " "	Crystal and Green . . . Crystal and Rose . . . Crystal and Amethyst... Crystal and Blue . . . Ivory . . . Wisteria . . . Crystal		Plain " " " " "	5.00 ea 5.00 " 5.00 " 5.00 " 5.00 " 5.00 "

7051

7053

7056

7064

7078

7090

7091

*See Appendix for decorated pieces

No	Class	Size	Pattern	Color		Finish	Price Retail
7128	3 prong Vase	10″	Plain " "	Crystal . . . Ivory . . . Jade Green, Alabaster Foot . . . Wisteria		Plain " "	$ 4.50 ea 4.50 " 4.50 "
7129	6 prong Vase	14″	Plain " "	Crystal . . . Ivory . . . Jade Green, Alabaster Foot . . . Black		Plain " "	9.00 ea 9.00 " 9.00 "
7134	Ash Tray		Plain	Crystal		Plain	3.50 ea
7208	Vase (3 handled)	10½″	Plain " "	Wisteria . . . Alabaster with Black Handle . . . Dark Jade Blue		Mouss. " "	6.00 ea 6.00 " 6.00 "
7218	Ice Tea Jug		Plain " " " "	Ivory & Black . . . Alabaster & Black . . . Jade Green & Black . . . Jade Green & Alabaster Crystal		Plain " " " Optic	5.00 ea 5.00 " 5.00 " 5.00 " 5.00 "
7218	Iced Tea Glasses		Plain " " " "	Ivory & Black . . . Alabaster & Black . . . Jade Green & Black . . . Jade Green & Alabaster . . . Crystal		Plain " " " Optic	18.00 dz 18.00 " 18.00 " 18.00 " 18.00 "
7223	Luminor		Round Figure	Crystal & Black Base			20.00 ea

No.	Class	Size	Pattern	Color		Finish	Price Retail
7224	Luminor			Crystal and Black Base			$ 20.00ea
7227	Vase	8″	Plain	Alabaster and Black		Plain	3.50ea
7230	Bowl	8″	Plain	Ivory . . . Jade Green . . .		Plain	4.50ea
			"	Alabaster . . . Dark Jade		"	4.50 "
			"	Blue . . . Black		"	4.50 "
7231	Flower Blk. & Elephant (see 7450 Base)			Crystal Block, Matted Figure			7.50ea
7231	Elephant Luminor with Black Base (comp.)			Crystal		Matted or Plain	12.50ea
	Elephant Only		(Paper Weight)	Crystal		Matted or Plain	4.50ea
7232	Bowl	6½″	Plain	Crystal...French Blue...		Plain	2.50ea
			"	Jade Green . . . Ivory . . .		"	2.50 "
			"	Alabaster . . . Black		"	2.50 "
7233	Bowl	6½″	Plain	Crystal...French Blue...		Plain	2.50ea
			"	Jade Green . . . Ivory . . .		"	2.50 "
			"	Alabaster . . . Black		"	2.50 "
		6½″	Eldred*	Cased Green over Crystal		H'v'y Cut	10.00ea
7234	Goblet		Mosella*	Cased Black over Crystal		Rk. Cry. Eng.	296.00dz
	Champagne					" " "	294.00 "
	Wine					" " "	282.00 "
	Cocktail					" " "	282.00 "
	Finger Bowl					" " "	252.00 "
	F. B. Plate					" " "	258.00 "
	8½″ Plate					" " "	294.00 "
	Highball					" " "	264.00 "
	B.&S. Tumb.					" " "	276.00 "
	Sherbet					" " "	288.00 "
	Claret					" " "	282.00 "
	Cordial					" " "	282.00 "
7236	Goblet		Chatham*	Crystal		Rk. Cry. Eng.	222.00dz
	Champagne					" " "	210.00 "
	Wine					" " "	198.00 "
	Cocktail					" " "	204.00 "
	Finger Bowl					" " "	192.00 "
	8½″ Plate					" " "	210.00 "
	Sherbet					" " "	210.00 "
	Highball					" " "	198.00 "
	Cordial					" " "	186.00 "
	F. B. Plate					" " "	180.00 "

*See Appendix for decorated pieces

No.	Class	Size	Pattern	Color		Finish	Price Retail
7237	Goblet Champagne Cocktail Wine Finger Bowl F. B. Plate 8½″ Plate F't'd Ice Tea Sherbet Claret Cordial		Danbury*	Crystal		Rk. Cry. Eng. "	$216.00dz 192.00 " 192.00 " 180.00 " 174.00 " 174.00 " 204.00 " 180.00 " 198.00 " 186.00 " 180.00 "
7238 (see 7389)	Goblet Champagne Wine Finger Bowl F. B. Plate Tumblers Cocktail Cordial		Strawberry* Mansion	Crystal		Eng. Grey " " " " " " " " " " " " " "	144.00dz 132.00 " 120.00 " 96.00 " 114.00 " 138.00 " 126.00 " 102.00 "
7242	Candelabra	14″	Cut	Crystal		H'v'y Cut	50.00ea
7243	Candelabra	17″	Cut	Crystal		H'v'y Cut	60.00ea
7244	Ash Tray		Plain " " "	French Blue . . . Jade Green, Alab. Handle... Ivory with Black Han- dle . . . Wisteria		Plain " " "	3.00ea 3.00 " 3.00 " 3.00 "
7245	Candlestick	9″	Sterling*	Crystal		Eng. Grey	14.50ea

*See Appendix for decorated pieces

No.	Class	Size	Pattern	Color		Finish	Price Retail
7245	Compote	8″x8½″	Sterling*	Crystal		Eng. Grey	$17.00ea
	Bowl	14″	Sterling*	Crystal		Eng. Grey	27.00ea
7250	Candlestick	12″	Elkay*	Crystal		Eng. Grey	11.00ea
	Compote	7″x7″	Elkay*	Crystal		Eng. Grey	12.00ea
	Bowl	12″	Elkay* Plain " "	Crystal Ivory, Pomona Green, Bristol Yellow, Crystal, Cerise Ruby		Eng. Grey Plain " "	24.00ea 14.00 " 14.00 " 18.00 "
7255	Candlestick	9½″	Cut	Crystal		H'v'y Cut	30.00ea
	Compote	7″x9″	Cut	Crystal		H'v'y Cut	40.00ea
	Bowl	12″	Cut	Crystal		H'v'y Cut	70.00ea

*See Appendix for decorated pieces

No.	Class	Size	Pattern	Color		Finish	Price Retail
7257	Door Stop		Plain "	Crystal Crystal with Black Spiral		Bubbly Spiral	$ 7.00 ea 7.00 "
7265	Vase	10"	Plain " " "	Ivory . . . Jade Green, Alabaster Foot Gold Aurene . . . Blue Aurene		Plain " " "	5.00 ea 5.00 " 6.00 " 6.00 "
7270	Goblet Champagne Finger Bowl F. B. Plate Wine 8½" Plate 14 oz. High- ball Cocktail Cordial		Georgian†	Crystal		H'v'y Cut " " " " " " " " " " " " " " " "	84.00 dz 78.00 " 78.00 " 78.00 " 72.00 " 102.00 " 102.00 " 78.00 " 66.00 "
7276	Bowl	5"	Plain "	Gold Aurene . . . Blue Aurene		Plain "	6.00 ea 6.00 "
7282	Vase	11"	Plain "	Gold Aurene . . . Blue Aurene		Plain	9.00 ea 9.00 "
7283	Goblet Champagne Cocktail Highball Finger Bowl 8½" Plate Wine Cordial Sherbet F. B. Plate		Engraved Grey with 3 Letters	Crystal, Blue Diamond or Crystal, Ruby Diamond			96.00 dz 96.00 " 96.00 " 84.00 " 84.00 " 90.00 " 84.00 " 84.00 " 90.00 " 84.00 "
7284	Cocktail Gl.		Red Cherry	Crystal		Eng. Grey	36.00 dz
7286	Cocktail Sh.	Large	Red Cherry	Crystal, Red Stopper		Eng. Grey	14.00 ea

†Design goes all around

No.	Class	Size	Pattern	Color		Finish	Price Retail
7289	Oval Bowl		Cut Punty*	Crystal		H'v'y Cut	$10.00 ea
			Thistle†	Crystal		Sculptured	9.00 "
			Plain	Jade Green . . . Alabaster . . . Wisteria		Plain	4.00 "
			"			"	4.00 "
7291	Globe		Plain	Crystal			2.00 ea
7292	Bowl	15"	Kenelwood	Crystal		H'v'y Cut	50.00 ea
7302	Candlestick	12"	Cut	Crystal		H'v'y Cut	24.00 ea
	Compote	7"x7"	Cut	Crystal		H"v'y Cut	30.00 ea
	Bowl	12½"	Cut	Crystal		H'v'y Cut	50.00 ea
7303	Goblet		Cut	Crystal		H'v'y Cut	138.00 dz
	Champagne					" "	126.00 "
	Cocktail					" "	114.00 "
	Finger Bowl					" "	102.00 "
	Sherbet					" "	120.00 "
	8½" Plate					" "	108.00 "
	Sherry					" "	108.00 "
	Claret					" "	114.00 "
	Cordial					" "	102.00 "
	F. B. Plate					" "	96.00 "
7305	Vase	7½"	Cut	Crystal		H'v'y Cut	25.00 ea
7307	Bowl	8"	Plain	Crystal . . . Ivory . . .		Plain	3.50 ea
			"	Ivory & Black . . . Jade		"	3.50 "
			"	Green, Alab. Foot . . .		"	3.50 "
			"	Black . . . Wisteria		"	3.50 "
			"	Gold Aurene . . . Blue		"	6.00 "
			"	Aurene		"	6.00 "
			Engraved*	Crystal		Eng. Grey	6.00 "
		12"	Plain	Crystal . . . Ivory . . .		Plain	6.00 ea
			"	Ivory & Black . . . Jade		"	6.00 "
			"	Green, Alab. Foot . . .		"	6.00 "
			"	Black . . . Wisteria		"	6.00 "
			"	Gold Aurene . . . Blue		"	10.00 "
			"	Aurene		"	10.00 "
			Engraved*	Crystal		Eng. Grey	10.00 "

*See Appendix for decorated pieces
†Illustration shown is Thistle

No.	Class	Size	Pattern	Color		Finish	Price Retail
7311	Vase	6"	Plain "	Ivory . . . Dark Jade Blue . . . Jade Green		Plain "	$ 4.50 ea 4.50 "
		9"	Plain "	Ivory . . . Dark Jade Blue . . . Jade Green		Plain "	5.50 ea 5.50 "
7313	Brandy Sniffer		Plain	Crystal		Plain	30.00 dz
7316	Vase (see 7388)	9"	Plain " " " "	Ivory . . . Crystal Pomona Green . . . Jade Green and Alabaster . . . Wisteria Alabaster and Black		Plain Twist " " Plain	2.50 ea 2.50 " 2.50 " 2.50 " 2.50 "
7317	Candlestick (Two prong)	11"	Plain " "	Ivory . . . Ivory and Black . . . Jade Green and Alabaster		Plain " "	7.00 ea 7.00 " 7.00 "
7317	Candlestick (Three prong)	11"	Plain " "	Ivory . . . Ivory and Black . . . Jade Green and Alabaster		Plain " "	9.00 ea 9.00 " 9.00 "
7331	Vase	9½"	Plain " " " " "	Crystal...French Blue... Ivory . . . Ivory and Black . . . Jade Green and Alab. . . . Pomona Green . . . Alabaster . . . Wisteria, Bristol Yellow		Plain " " " " "	3.50 ea 3.50 " 3.50 " 3.50 " 3.50 " 3.50 "
7348	Decanter		Engraved Crest No. 3	Crystal		H'v'y Cut	40.00 ea
7349	Decanter		Engraved* Crest No. 2	Crystal		H'v'y Cut	27.00 ea

*See Appendix for decorated pieces

No.	Class	Size	Pattern	Color		Finish	Price Retail
7372 (6034)	Vase	12"	Marguerite† Renwick*	Crystal Crystal		Rk. Cry. Eng. " " "	$ 6.50 ea 6.50 "
7373 (6030)	Vase	7"	Marguerite† Renwick*	Crystal Crystal		Rk. Cry. Eng. " " "	4.50 ea 4.50 "
7374 (6123)	Vase	10"	Marguerite† Renwick*	Crystal Crystal		Rk. Cry. Eng. " " "	7.00 ea 7.00 "
7375 (6500)	Vase	5"	Marguerite† Renwick*	Crystal Crystal		Rk. Cry. Eng. " " "	4.00 ea 4.00 "
7376	Compote	7x5¼"	Marguerite† Renwick*	Crystal Crystal		Rk. Cry. Eng. " " "	4.00 ea 4.00 "
7377 (2909)	Vase	10"	Marguerite† Renwick*	Crystal Crystal		Rk. Cry. Eng. " " "	4.50 ea 4.50 "
7378 (2839)	Bowl	14"	Marguerite† Renwick* Plain " "	Crystal Crystal Ivory, Pomona Green Bristol Yellow, Crystal Cerise Ruby		Rk. Cry. Eng. " " " Plain " "	11.00 ea 11.00 " 6.50 " 6.50 " 8.00 "
7379 (6813)	Vase	8"	Marguerite† Renwick*	Crystal Crystal		Rk. Cry. Eng. " " "	5.00 ea 5.00 "
7380	Candlestick	10" 12"	Marguerite† Renwick* Marguerite† Renwick*	Crystal Crystal Crystal Crystal		Rk. Cry. Eng. " " " " " " " " "	5.50 ea 5.50 " 6.00 " 6.00 "

†Illustration shown is Marguerite
*See Appendix for decorated pieces

No.	Class	Size	Pattern	Color		Finish	Price Retail
7381 (6616)	Bowl	11″	Marguerite† Renwick* Plain " "	Crystal Crystal Ivory, Pomona Green Bristol Yellow, Crystal Cerise Ruby		Rk. Cry. Eng. " " " Plain " "	$ 7.00 ea 7.00 " 3.50 " 3.50 " 4.50 "
7387 (6031)	Vase	7″	Marguerite† Renwick*	Crystal Crystal		Rk. Cry. Eng. " " "	4.50 ea 4.50 "
7388 (7316)	Vase	9″	Marguerite† Renwick*	Crystal Crystal		Rk. Cry. Eng. " " "	4.00 ea 4.00 "
7389	Vase (see 7238)	12½″	Strawberry* Mansion	Crystal		Eng. Grey	35.00 ea
7391	Vase	9″	Hartwick* Valeria* Peony*	Jade Green Jade Green Jade Green		Etched " "	12.00 ea 14.50 " 15.00 "
7398	Peacock		Cut	Crystal		Cut	55.00 ea
7399	Gazelle		Plain	Crystal		Plain	6.00 ea
7400	Duck		Cut	Crystal		Cut	25.00 ea

†Illustration shown is Marguerite
*See Appendix for decorated pieces

No.	Class	Size	Pattern	Color		Finish	Price Retail
7401	Goblet		Traymore*	Crystal		Rk. Cry. Eng.	$120.00dz
	Champagne					" " "	114.00 "
	Cocktail					" " "	108.00 "
	Wine					" " "	114.00 "
	Cordial					" " "	102.00 "
	Finger Bowl					" " "	102.00 "
	Sherbet					" " "	108.00 "
	Highball					" " "	108.00 "
	8½″ Plate					" " "	120.00 "
	F. B. Plate					" " "	102.00 "
7401	Candlestick	12″	Traymore*	Crystal		Eng. Grey or Rk. Cry. Eng.	17.50ea
	Compote	8x6″	Traymore*	Crystal		Eng. Grey or Rk. Cry. Eng.	19.00ea
	Bowl	12″	Traymore*	Crystal		Eng. Grey or Rk. Cry. Eng.	33.00ea
7402	Goblet		Marguerite* or Renwick*	Crystal		Rk. Cry. Eng.	24.00dz
	Champagne					" " "	23.00 "
	Cocktail					" " "	22.00 "
	Claret					" " "	22.00 "
	Sherbet					" " "	23.00 "
	Highball					" " "	25.50 "
	Finger Bowl					" " "	25.50 "
	8½″ Plate					" " "	42.00 "
	Cordial					" " "	21.00 "
	F. B. Plate					" " "	36.00 "
7403	Goblet		Marguerite* or Renwick*	Crystal		Rk. Cry. Eng.	24.00dz
	Champagne					" " "	23.00 "
	Cocktail					" " "	22.00 "
	Claret					" " "	22.00 "
	Sherbet					" " "	23.00 "
	Cordial					" " "	21.00 "
	Highball					" " "	25.50 "
	Finger Bowl					" " "	25.50 "
	8½″ Plate					" " "	42.00 "
	F. B. Plate					" " "	36.00 "
7403	Candlestick	12″	Marguerite* Renwick*	Crystal Crystal		Rk. Cry. Eng. " " "	6.00ea 6.00 "
	Compote	7x7″	Marguerite* Renwick*	Crystal Crystal		Rk. Cry. Eng. " " "	4.50ea 4.50 "
	Bowl	12″	Marguerite* Renwick*	Crystal Crystal		Rk. Cry. Eng. " " "	12.00ea 12.00 "

*See Appendix for decorated pieces

No.	Class	Size	Pattern	Color		Finish	Price Retail
7404	Vase	10″	Cut	Crystal		H'v'y Cut	$17.00 ea
7405	Vase	10″	Lambert	Crystal		H'v'y Cut	20.00 ea
7406	Vase	10″	Arvid	Crystal		H'v'y Cut	18.00 ea
7407	Vase	10″	Cut No. 1* Cut No. 2* Cut No. 2* Cut No. 2*	Crystal Blue Cased . . . Ruby Cased . . . Green Cased Crystal		H'v'y Cut " " " " " "	22.50 ea 25.00 " 25.00 " 20.00 "
7408	Vase	10″	Plain "	White Cluthra ... Green Cluthra ... Rose Cluthra		Plain "	8.00 ea 8.00 "
7409	Vase	11″	Plain "	White Cluthra ... Green Cluthra ... Rose Cluthra		Plain "	8.00 ea 8.00 "
7410	Vase	12″	Plain "	White Cluthra ... Green Cluthra ... Rose Cluthra		Plain "	15.00 ea 15.00 "

*See Appendix for decorated pieces

No.	Class	Size	Pattern	Color		Finish	Price Retail
7411	Vase	14"	Plain "	White Cluthra ... Green Cluthra ... Rose Cluthra		Plain "	$15.00 ea 15.00 "
7412	Vase	16"	Plain " "	White Cluthra ... Green Cluthra . . . Rose Cluthra . . . Blue Cluthra		Plain " "	20.00 ea 20.00 " 20.00 "
7413	Vase	10"	Plain	Jade Green, Alab. hdls.		Plain	6.00 ea
7414	Vase	10"	Plain	Ivory with Black hdls.		Plain	6.00 ea
7415	Vase	10"	Plain " " " "	Pomona Green . . . Dark Jade Blue . . . Jade Green . . . Ivory Gold Aurene . . . Blue Aurene		Mouss. " " Plain "	3.00 ea 3.00 " 3.00 " 5.00 " 5.00 "
7416	Vase	8"	Plain "	Gold Aurene . . . Blue Aurene		Plain "	5.00 ea 5.00 "

No.	Class	Size	Pattern	Color		Finish	Price Retail
7417	Vase	9½''	Plain "	Gold Aurene . . . Blue Aurene	7417	Plain "	$ 7.50 ea 7.50 "
7418	Vase	10''	Plain "	Gold Aurene . . . Blue Aurene	7418	Plain "	7.00 ea 7.00 "
7419	Vase	10''	Plain "	Gold Aurene . . . Blue Aurene	7419	Plain "	14.00 ea 14.00 "
7420	Vase	9'' 11'' 13''	Plain " Plain " Plain " "	Gold Aurene . . . Blue Aurene Gold Aurene . . . Blue Aurene Cerise Ruby Gold Aurene . . . Blue Aurene	7420	Plain " Plain " Mouss. Plain "	7.00 ea 7.00 " 8.50 " 8.50 " 9.00 " 10.50 " 10.50 "
7421	Vase	10''	Plain "	Gold Aurene . . . Blue Aurene	7421	Plain "	7.00 ea 7.00 "
7422	Bowl	11½''	Plain "	Gold Aurene . . . Blue Aurene	7422	Plain "	6.00 ea 6.00 "
7423	Bowl	12''	Plain " " " "	Gold Aurene . . . Blue Aurene Ivory, Pomona Green Bristol Yellow, Crystal Cerise Ruby	7423	Plain " " " "	6.00 ea 6.00 " 4.00 " 4.00 " 4.50 "
7424	Vase	8''	Winton*	Gold over Alabaster	7424	Etched	13.00 ea

*See Appendix for decorated pieces

No.	Class	Size	Pattern	Color		Finish	Price Retail
7425	Vase	8″	Sculptured*	Jade Green		Sculptured	$12.00 ea
7426	Vase	6″	Marigold* Marigold*	Jade Green over Alab.... Rosaline over Alabaster		Etched "	10.00 ea 10.00 "
7429	Vase	4½″	Plain "	Dark Jade Blue...Crystal Cerise Ruby		Mouss. "	2.00 ea 2.50 "
7430	Vase	6″	Plain "	Dark Jade Blue ... Crystal ... Bristol Yellow		Mouss. "	2.50 ea 2.50 "
7431	Vase	7″	Plain " " " "	Dark Jade Blue ... Crystal ... Bristol Yellow Wisteria, Ivory Pomona Green Cerise Ruby		Mouss. H'v'y " " " " " " " "	3.00 ea 3.00 " 3.00 " 3.00 " 3.50 "
7432	Vase	6″	Plain " "	Dark Jade Blue ... Wisteria Cerise Ruby		Mouss. " "	2.00 ea 2.00 " 2.50 "
7433	Vase	6″	Plain "	Dark Jade Blue ... Wisteria		Mouss. "	2.00 ea 2.00 "
7434	Vase	6″	Plain " "	Dark Jade Blue ... Wisteria...Pomona Green... Crystal		Mouss. " "	2.00 ea 2.00 " 2.00 "
7435	Vase	8″	Plain " "	Dark Jade Blue ... Crystal ... Wisteria Cerise Ruby		Mouss. " "	3.00 ea 3.00 " 3.50 "
7436	Vase	8″	Plain " " " "	Dark Jade Blue ... Crystal, Ivory Pomona Green, Bristol Yellow Cerise Ruby		Mouss. H'v'y " " " " " " " "	3.00 ea 3.00 " 3.00 " 3.00 " 3.50 "

*See Appendix for decorated pieces

No.	Class	Size	Pattern	Color		Finish	Price Retail
7437	Vase	10″	Plain "" ""	Pomona Green . . . Jade Green . . . Ivory . . . Dark Jade Blue . . . Crystal		Mouss. "" ""	$ 3.00 ea 3.00 "" 3.00 ""
7439	Vase	8″ 8″	Sculpt. Leaves* Cut† Cut†	Rose Quartz Blue Cased . . . Green Cased . . . Ruby Cased		Sculptured H'v'y Cut "" ""	15.00 ea 15.00 "" 15.00 ""
7440	Vase	8″ 8″	Evelyn* "" *	Rosaline over Alabaster Jade Green over Alab.		Etched ""	15.00 ea 15.00 ""
7441	Vase	8″	Gordon* Gordon*	Rosaline over Alabaster Jade Green over Alab.		Etched ""	15.00 ea 15.00 ""
7442	Vase	12″	Maplewood* Mayfair* Delwood*	Rosaline or Jade Green over Alab. Rosaline or Jade Green over Alab. Ruby over Crystal		Etched "" ""	17.00 ea 17.00 "" 16.00 ""
7443	Vase	6″	Alicia*	Rosaline . . . Jade Green		Etched	10.00 ea
7444	Vase	6″	Greta*	Rosaline . . . Jade Green		Etched	10.00 ea
7445	Vase	7″	Rosario*	Gold over Alabaster		Etched	30.00 ea
7446	Vase	6″	Plain ""	Dark Jade Blue . . . Jade Green		Mouss. ""	4.00 ea 4.00 ""

†Illustrated
*See Appendix for decorated pieces

No.	Class	Size	Pattern	Color		Finish	Price Retail
7447	Vase	6″	Plain	Pomona Green . . . Dark		Mouss.	$1.75 ea
			"	Jade Blue...Jade Green...		"	1.75 "
			"	Ivory . . . Alabaster . . .		"	1.75 "
			"	Wisteria		"	1.75 "
				Cerise Ruby			2.00 "
			Plain	Gold Aurene . . . Blue		Plain	2.25 "
			"	Aurene			2.25 "
7448 (See 6268 and 6936)	Center Ball	6″	Warwick†	Crystal		H'v'y Cut	17.00 ea
	"	8″	Warwick†	Crystal		" "	25.00 "
	Candlestick	3″	Warwick†	Crystal		" "	10.00 "
7449	Oval Bowl	11½″	Plain	Ivory . . . Dark Jade		Plain	4.00 ea
			"	Blue . . . Crystal . . .		"	4.00 "
			"	Crystal and Blue . . .		"	4.00 "
			"	Crystal and Green . . .		"	4.00 "
			"	Crystal and Rose . . .		"	4.00 "
			"	Crystal and Amethyst		"	4.00 "
7450	Globe & Base (see 6495 & 7064)		Plain	Crystal Hollow Globe, Solid Black Base			3.00 ea
7451	Vase	8″	Plain	Dark Jade Blue		Mouss.	3.00 ea
7452	Washington Head with metal base.			Crystal		Intaglio	10.00 ea
7453	Candlestick	12″	Plain	Alabaster and Black		Plain	6.00 ea
	Compote	8x7″	"	Alabaster and Black		Plain	7.00 ea
	Bowl	12″	"	Alabaster and Black		Plain	8.00 ea
			"	Cerise Ruby		"	8.50 "
			"	Ivory, Pomona Green		"	7.50 "
			"	Bristol Yellow, Crystal		"	7.50 "

†Illustrated. Design goes all around

No.	Class	Size	Pattern	Color		Finish	Price Retail
7454	Candlestick	12″	Plain	Alabaster and Black		Plain	$ 8.00 ea
	Compote	8x7″	Plain	Alabaster and Black		Plain	10.00 ea
	Bowl	12″	Plain	Alabaster and Black		Plain	12.00 ea
7455	Bowl	8″ 12″	Plain ″	Alabaster and Black Alabaster and Black		Plain ″	6.00 ea 7.00 ″
7456	Vase	8″	Plain	Alabaster and Black		Plain	5.00 ea
7457	Vase	8″	Plain	Alabaster and Black		Plain	6.00 ea
7458	Vase	9″ 11″	Plain ″	Alabaster and Black Alabaster and Black		Plain ″	5.00 ea 6.00 ″
7459	Vase	6″ 8″	Plain ″	Alabaster and Black Alabaster and Black		Plain ″	4.50 ea 5.50 ″

No.	Class	Size	Pattern	Color		Finish	Price Retail
7460	Bowl	12″	Plain	Alabaster and Black		Plain	$ 8.00 ea
7461	Bowl	12″	Plain	Alabaster and Black		Plain	8.00 ea
7462	Goblet Champagne Claret Cocktail Cordial Finger Bowl F. B. Plate		Plain	Alabaster and Black Dots		Plain	30.00 dz 30.00 " 30.00 " 30.00 " 27.00 " 30.00 " 24.00 "
7463	Cocktail Shaker		Plain "	Crystal with Red Cherries Alab. & Black		Eng. Grey Plain	12.00 ea 12.00 "
7463	Cocktail Gl. (Handled)		Plain "	Crystal with Red Cherries . . . Alab. and Black			30.00 dz 30.00 "
7464	Vase	8″	Plain	Alabaster and Black			7.00 ea
7465	Vase	8″	Plain	Alabaster and Black			7.00 ea
7466	Candelabra	8″	Plain	Alabaster and Black			13.50 ea
7467	Vase (Urn shaped)	6″	Plain	Alabaster and Black			6.00 ea
7468	Vase (Urn shaped)	12″	Plain	Alabaster and Black			16.00 ea
7469	Ash Tray		Plain " " "	Alabaster and Black Handle Alabaster (plain) Alabaster with Black Leaf Alabaster and Black Line			2.50 ea 1.75 " 2.00 " 2.00 "

No.	Class	Size	Pattern	Color		Finish	Price Retail
7470	Bowl	10"	Plain	Dark Jade Blue			$ 4.00 ea
7471	Vase	11"	Plain	Crystal (Grey foot)		Plain	5.50 ea
			"	Wisteria . . . Pomona Green		"	5.50 "
			"	Black with Gold Band		"	7.00 "
			T-6*	Crystal		Eng. Grey	6.50 "
			T-7*	Crystal		"	6.50 "
			T-34*	Crystal		" "	36.00 "
			T-100*	Crystal		" "	7.50 "
			T-114*	Crystal (See 7492, 7503)		Cut Grey	7.50 "
7472	Goblet		Plain	Crystal with Red and Blue Band			48.00 dz
	Champagne		"	Crystal with Red and Blue Band			45.50 "
	Cocktail		"	Crystal with Red and Blue Band			43.00 "
	Wine		"	Crystal with Red and Blue Band			43.00 "
	Finger Bowl		"	Crystal with Red and Blue Band			48.00 "
	8½" Salad Plate		"	Crystal with Red and Blue Band			44.00 "
	F. B. Plate		"	Crystal with Red and Blue Band			36.00 "
	Cordial		"	Crystal with Red and Blue Band			36.00 "
7472	Bowl	12"	Plain	Crystal with Red and Blue Band			16.00 ea
	Compote	7x8"	"	Crystal with Red and Blue Band			8.50 "
	Candlestick	6"	"	Crystal with Red and Blue Band			9.00 "
7472	Candlestick	6"	Plain	Crystal		Plain	5.00 ea
	"	6"	Renwick*	Crystal } Engraved 1 side		Rk. Cry. Eng.	{ 7.00 "
	"	6"	Marguerite*	Crystal }			{ 7.00 "
	"	6"	Renwick*	Crystal } Eng. 2 sides		" " "	{ 9.00 "
	"	6"	Marguerite*	Crystal }			{ 9.00 "
7473	Cocktail Gl.	3"	T-37*	Crystal		Cut Grey	27.00 dz
	Cocktail Gl.	3"	T-101*	Crystal		Sandb.Ct.G.	27.00 "
	O. F. Glass	3½"	T-23*	Crystal (See 7485)		Eng. Grey	30.00 "
7474	Fruit	Apple Pear	Small	Alabaster			18.00 dz
				Ivory			18.00 "
				Black			18.00 "
		Apple Pear	Medium	Alabaster			21.00 "
				Ivory			21.00 "
				Black			21.00 "
		Apple Pear	Large	Alabaster			24.00 "
				Ivory			24.00 "
				Black			24.00 "
		Banana	(large size only)	Alabaster			24.00 "
				Ivory			24.00 "
				Black			24.00 "
7475	Vase	8"	Plain	Crystal . . .Black . . . French Blue		Plain	2.75 ea
						"	2.75 "
			T-109*	Crystal		Eng. Grey	5.50 "
		9"	Plain	Crystal . . . Black . . . French Blue		Plain	3.25 "
						"	3.25 "
			T-102*	Crystal		Eng. Grey	6.50 "
			T-103*	Crystal			6.00 "
		10"	Plain	Crystal . . . Black . . . French Blue		Plain	3.75 "
						"	3.75 "
			T-103*	Crystal		Eng. Grey	7.00 "
			T-102*	Crystal		" "	7.50 "

*See Appendix for decorated pieces

No.	Class	Size	Pattern	Color		Finish	Price Retail
7476	Bowl	10″	Plain T-102* T-103*	French Blue . . . Crystal Crystal Crystal		Plain Eng. Grey " "	$ 4.25 ea 8.00 " 8.00 "
7477	Pitcher " Glass "	11″ 9¾″ 6¾″ 6″	Plain " " "	Crystal Crystal Crystal Crystal		Plain " " "	10.00 ea 9.00 " 48.00 dz 42.00 "
7478	**TABLEWARE** Gold Fork Gold Spoon Gold Butter Knife			Crystal Handle . . . Bristol Yellow Handle . . . French Blue Handle . . . Pomona Green Handle Black Handle		Plain " " " "	60.00 dz 60.00 " 60.00 " 60.00 " 60.00 "
	Silver Fork Silver Spoon Silver Butter Knife			Crystal Handle . . . Bristol Yellow Handle . . . French Blue Handle . . . Pomona Green Handle Black Handle		" " " " "	54.00 " 54.00 " 54.00 " 54.00 " 54.00 "
7479	Vase	12″	Millefiori	Crystal		Sculptured	35.00 ea
7480	Bowl	10″	Millefiori	Crystal		Sculptured	30.00 ea
7481	Goblet Highball Wine Hollow Stem Champagne Sherbet Finger Bowl 8½″ Plate F. B. Plate Cocktail Cordial 10″ Bowl Candle Stick Compote		Riviera*† T-24	Crystal		Eng. Grey "	48.00 dz 48.00 " 42.00 " 48.00 " 42.00 " 42.00 " 66.00 " 48.00 " 42.00 " 42.00 " 15.00 ea 8.50 " 10.00 "
7482	Vase	12″	T-35* T-36* T-25*	Crystal Crystal Crystal		Eng. Grey " "	4.25 ea 4.00 " 30.00 "

*See Appendix for decorated pieces
†See Appendix for Compote and Candle Stick

No.	Class	Size	Pattern	Color		Finish	Price Retail
7483	Vase	10½"	T-27* T-29*	Crystal Crystal	7483	Eng. Grey Cut	$ 17.00 ea 11.50 "
7484	Vase	7½"	T-30*	Crystal	7484	Cut Grey	4.00 ea
7485	Goblet Highball Wine Sherbet Fingerbowl Champagne 8½" Plate F. B. Plate Cordial Cocktail Bowl Candle Stick Compote	10"	St. Tropez*† T-31	Crystal	7485 7485	Eng. Grey "	48.00 dz 48.00 " 42.00 " 48.00 " 48.00 " 48.00 " 54.00 " 48.00 " 42.00 " 42.00 " 16.00 ea 9.00 " 8.00 "
7486	Goblet Champagne Sherbert Wine Cocktail Cordial 8½" Plate F. B. Plate Finger Bowl Bowl Compote		Spiral* T-32	Crystal	7486 7486	Eng. Grey " " " " " " " " " " " " " " " " " "	48.00 dz 48.00 " 48.00 " 48.00 " 48.00 " 42.00 " 54.00 " 48.00 " 42.00 " 7.50 ea 6.00 "
7486	Candle Stick		Spiral*	Crystal	7486	Eng. Grey	7.00 ea
7486	Bowl	10"	T-104*	Crystal	7486	Eng. Grey	6.00 ea
7487	8½" Plate		T-33*	Crystal	7487	Eng. Grey	11.50 ea
7488	Cocktail Gl.		Cut Punties*	Crystal	7488	Cut Grey	27.00 dz

*See Appendix for decorated pieces
†See Appendix for Compote and Candle Stick

No.	Class	Size	Pattern	Color		Finish	Price Retail
7489	Vase	12″	Plain	Crystal		Plain	$ 3.50 ea
			T-105*	Crystal		Eng. Grey	15.00 ''
			Plain	Ivory, Pomona Green		Plain	3.50 ''
			''	Bristol Yellow		''	3.50 ''
			''	Cerise Ruby		''	4.50 ''
7490	Vase	12″	Plain	Crystal . . . Crystal and		Plain	5.00 ea
			''	Blue . . . Crystal and		''	5.00 ''
			''	Green . . . Crystal and		''	5.00 ''
			''	Rose . . . Crystal and		''	5.00 ''
			''	Amethyst, Ivory		''	5.00 ''
7491	Lincoln Head with Metal Base			Crystal		Intaglio	10.00 ea
7492	Candlestick	6½″	Plain	Crystal . . . Ivory and		Plain	1.50 ea
			''	Black ... French Blue ...		''	1.50 ''
			''	Jade Green & Alabaster		''	1.50 ''
			''	Ivory ... Pomona Green		''	1.50 ''
			''	Alabaster and Black		''	1.50 ''
			T-102*	Crystal		Eng. Grey	2.50 ''
			T-103*	Crystal		'' ''	3.50 ''
			T-104*	Crystal		'' ''	2.50 ''
			T-112*	Crystal Riviera		'' ''	3.75 ''
			T-113*	Crystal St. Tropez		'' ''	2.50 ''
			T-114*	Crystal (See 7471, 7503)		Cut Grey	2.00 ''
7493	Flower Pot	5″	Plain	Jade Green . . . Jade		Plain	2.00 ea
			''	Blue . . . Black		''	2.00 ''
7493	Flower Pot Saucer	6″	''	Jade Green . . . Jade		Plain	1.50 ea
			''	Blue . . Black		''	1.50 ''
7494	Vase	8″	Millefiori*	Crystal		Sculptured	19.00 ea
7495	Vase	8″	Sculptured*	Crystal		Sculptured	17.00 ea

*See Appendix for decorated pieces

No.	Class	Size	Pattern	Color		Finish	Price Retail
7497	Vase	10½″	T-106*	Crystal		Eng. Grey	$ 9.50 ea
7498	Vase	6½″	T-107*	Crystal		Eng. Grey	6.50 ea
7499	Vase	10″	T-108*	Crystal		Eng. Grey	7.00 ea
7500	Vase	10″	T-110* T-111*	Crystal Crystal		Eng. Grey ″ ″	7.00 ea 7.50 ″
7501	Goblet Wine Champagne 8½″ Plate Fingerbowl Highball Cocktail Hollow Stem Champagne Sherbert Cordial Brandy & Soda		Empire* T-115*	Crystal Cased Blue			108.00 dz 90.00 ″ 102.00 ″ 84.00 ″ 102.00 ″ 108.00 ″ 90.00 ″ 102.00 ″ 102.00 ″ 84.00 ″ 114.00 ″
	Candle Stick						13.00 ea
	Compote						15.00 ea
	Bowl	10″					35.00 ea

*See Appendix for decorated pieces

No.	Class	Size	Pattern	Color		Finish	Price Retail
7502	Covered Jar	9½″	Plain " " "	Pomona Green Wisteria French Blue Ivory and Black		Twist " " Plain	$ 7.00 ea 7.00 " 7.00 " 7.00 "
7503	Bowl (See 7471 T-114) (See 7492 T-114)	10″	T-114*	Crystal		Cut Grey	5.00 ea
7504	Candlestick	4″	Plain	Crystal, Bristol Yellow Pomona Green Cerise Ruby		Plain " "	1.75 ea 1.75 " 2.00 "
7505	Candlestick	3¾″	Plain	Crystal, Bristol Yellow Pomona Green Cerise Ruby		Plain " "	1.75 ea 1.75 " 2.00 "
7506	Candlestick	4″	Plain	Crystal, Bristol Yellow Pomona Green Cerise Ruby			2.25 ea 2.25 " 2.75 "

*See Appendix for decorated pieces

No.	Class	Size	Pattern	Color		Finish	Price Retail
8413	Vase	12½″	Bristol*	White over Blue		Cameo Etched	$62.00 ea
8508	Vase	10″	Plain	Jade Green, Alab. Hdls.		Plain	6.00 ea
			"	Ivory, Black Handles		"	6.00 "
			"	White Cluthra ... Green		"	8.00 "
			"	Cluthra . . . Rose Clu-		"	8.00 "
			"	thra...Amethyst Cluthra		"	8.00 "
	Cullet			Slag Cullet Chunks for Rock Gardens		Unfinished	.08 lb.

*See Appendix for decorated pieces

APPENDIX

In the following pages are sketched all of the designs referred to in the catalog proper.

The numbers or names of the designs are shown, together with the numbers of the pieces to which they are applied. Any design, however, may be applied to pieces other than those shown, for which we would be glad to quote, upon your special request.

Due to the limited space, objects are not drawn to scale; nor designs drawn to a fine accuracy. Consult the catalogue proper for size. To be appreciated, Steuben Glassware must be seen for its charm of color, grace of line, and beauty of design, all of which may not be apparent in sketches.

CATALOG No. 938
Decoration—MARLENE

CATALOG No. 938
Decoration—BIRD

CATALOG No. 938
Decoration—MATZU

CATALOG No. 938
Decoration—10018

CATALOG No. 2683
Decoration—TEAZLE

CATALOG No. 2683
Decoration—PUSSYWILLOW

CATALOG No. 2683
Decoration—STAMFORD

CATALOG No. 2683
Decoration—SHELTON

CATALOG No. 2683
Decoration—HUNTING

CATALOG No. 2687
Decoration—COMPTON

CATALOG No. 2687
Decoration—CANTON

CATALOG No. 2909
Decoration—T-9

CATALOG No. 2989
Decoration—DUCK

CATALOG No. 2989
Decoration—HUNTING DOG

CATALOG No. 2989
Decoration—PHEASANT

CATALOG No. 2989
Decoration—POLO

CATALOG No. 2989
Decoration—TENNIS

CATALOG No. 2989
Decoration—GUNS

CATALOG No. 5000
Decoration—MATZU

CATALOG No. 5000
Decoration—CHINESE

CATALOG No. 6030
Decoration—T-11

CATALOG No. 6034
Decoration—GRAPE

CATALOG No. 6034
Decoration—MATZU

CATALOG No. 6034
Decoration—MARLENE

CATALOG No. 6078
Decoration—FLORAL

CATALOG No. 6078
Decoration—FIRCONE

CATALOG No. 6078
Decoration—SEA HOLLY

CATALOG No. 6078
Decoration—NEDRA

CATALOG No. 6078
Decoration—MARLENE

CATALOG No. 6078
Decoration—MATZU

CATALOG No. 6112
Decoration—CHANG

CATALOG No. 6123
Decoration—T-10

CATALOG No. 6126
Decoration—NOYON

CATALOG No. 6183
Decoration—THISTLE

CATALOG No. 6199
Decoration—SCULPTURED

CATALOG No. 6268
Decoration—WARWICK

CATALOG No. 6268
Decoration—QUEEN ANNE

CATALOG No. 6272
Decoration—INDIAN

CATALOG No. 6389
Decoration—MARLENE

CATALOG No. 6391
Decoration—
SCULPTURED

CATALOG No. 6406
Decoration—ACANTHUS

CATALOG No. 6415
Decoration—THISTLE

CATALOG No. 6415
Decoration—ACANTHUS

CATALOG No. 6468
Decoration—FLORIDA

CATALOG No. 6501
Decoration—MANSARD

CATALOG No. 6505
Decoration—SHIRLEY

CATALOG No. 6505
Decoration—SHIRLEY

CATALOG No. 6505
Decoration—SHIRLEY

CATALOG No. 6505
Decoration—SHIRLEY

CATALOG No. 6515
Decoration—CUT No. 1

CATALOG No. 6559
Decoration—CUT No. 1

CATALOG No. 6596
Decoration—TORINO

CATALOG No. 6599
Decoration—
BURLINGTON

CATALOG No. 6626
Decoration—BURLINGTON

CATALOG No. 6626
Decoration—BURLINGTON

CATALOG No. 6626
Decoration—BURLINGTON

CATALOG No. 6636
Decoration—
HEAVY CUT

CATALOG No. 6680
Decoration—
LION

CATALOG No. 6687
Decoration—
HEAVY CUT

CATALOG No. 6688
Decoration—
HEAVY CUT

CATALOG No. 6727
Decoration—
VIRGINIA

CATALOG No. 6763
Decoration—
CUT No. 1

CATALOG No. 6768
Decoration—
TORINO

CATALOG No. 6768
Decoration—TORINO

CATALOG No. 6768
Decoration—TORINO

CATALOG No. 6828
Decoration—CUT

CATALOG No. 6828
Decoration—CUT

CATALOG No. 6844
Decoration—POUSSIN

CATALOG No. 6856
Decoration—SCULPTURED

CATALOG No. 6861
Decoration—WELLINGTON

CATALOG No. 6869
Decoration—MARINE

CATALOG No. 6869
Decoration—T-3

CATALOG No. 6869
Decoration—T-12

CATALOG No. 6869
Decoration—T-14

CATALOG No. 6880
Decoration—SAND BLASTED

CATALOG No. 6893
Decoration—GRAPE

CATALOG No. 6928
Decoration—BAYARD

CATALOG No. 6936
Decoration—LEAVES

CATALOG No. 6936
Decoration—WARWICK

CATALOG No. 7007
Decoration—BOOTHBAY

CATALOG No. 7035
Decoration—HEAVY CUT

CATALOG No. 7036
Decoration—HOLLYWOOD

CATALOG No. 7046
Decoration—REGAL

CATALOG No. 7050
Decoration—INTARSIA

CATALOG No. 7051
Decoration—INTARSIA

CATALOG No. 7053
Decoration—
INTARSIA

CATALOG No. 7078
Decoration—
LA FRANCE

CATALOG No. 7233
Decoration—ELDRED

CATALOG No. 7234
Decoration—
MOSELLA

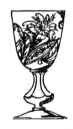

CATALOG No. 7236
Decoration—
CHATHAM

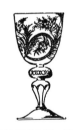

CATALOG No. 7237
Decoration—
DANBURY

CATALOG No. 7238
Decoration—
STRAWBERRY
MANSION

CATALOG No. 7245
Decoration—STERLING

CATALOG No. 7245
Decoration—STERLING

CATALOG No. 7245
Decoration—STERLING

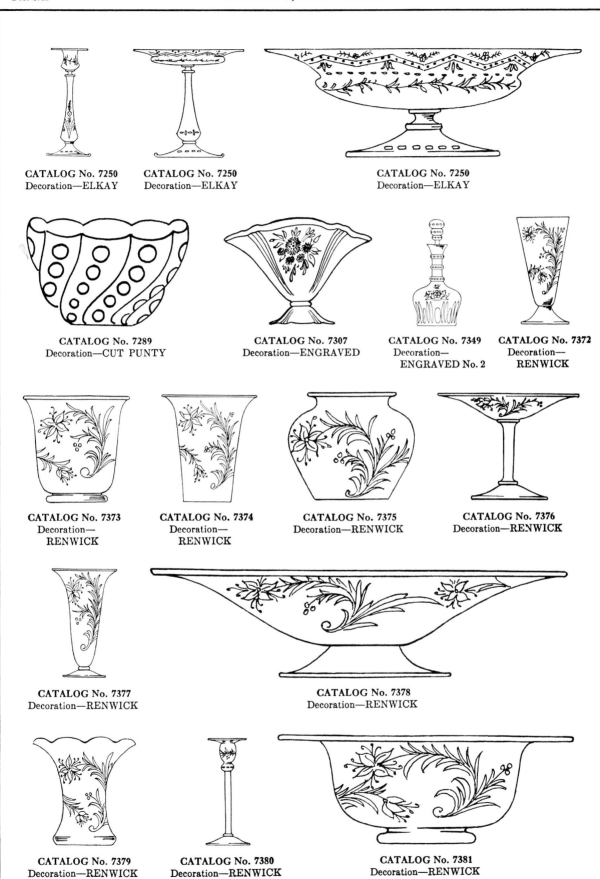

CATALOG No. 7250
Decoration—ELKAY

CATALOG No. 7250
Decoration—ELKAY

CATALOG No. 7250
Decoration—ELKAY

CATALOG No. 7289
Decoration—CUT PUNTY

CATALOG No. 7307
Decoration—ENGRAVED

CATALOG No. 7349
Decoration—
ENGRAVED No. 2

CATALOG No. 7372
Decoration—
RENWICK

CATALOG No. 7373
Decoration—
RENWICK

CATALOG No. 7374
Decoration—
RENWICK

CATALOG No. 7375
Decoration—RENWICK

CATALOG No. 7376
Decoration—RENWICK

CATALOG No. 7377
Decoration—RENWICK

CATALOG No. 7378
Decoration—RENWICK

CATALOG No. 7379
Decoration—RENWICK

CATALOG No. 7380
Decoration—RENWICK

CATALOG No. 7381
Decoration—RENWICK

CATALOG No. 7387
Decoration—
RENWICK

CATALOG No. 7388
Decoration—
RENWICK

CATALOG No. 7389
Decoration—
STRAWBERRY
MANSION

CATALOG No. 7391
Decoration—
HARTWICK

CATALOG No. 7391
Decoration—
VALERIA

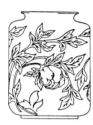

CATALOG No. 7391
Decoration—PEONY

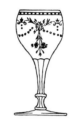

CATALOG No. 7401
Decoration—TRAYMORE

CATALOG No. 7401
Decoration—TRAYMORE

CATALOG No. 7401
Decoration—TRAYMORE

CATALOG No. 7401
Decoration—TRAYMORE

CATALOG No. 7402
Decoration—MARGUERITE

CATALOG No. 7402
Decoration—RENWICK

**CATALOG
No. 7403**
Decoration—
MARGUERITE

**CATALOG
No. 7403**
Decoration—
MARGUERITE

CATALOG No. 7403
Decoration—
MARGUERITE

CATALOG No. 7403
Decoration—MARGUERITE

**CATALOG
No. 7403**
Decoration—
RENWICK

**CATALOG
No. 7403**
Decoration—
RENWICK

CATALOG No. 7403
Decoration—
RENWICK

CATALOG No. 7403
Decoration—RENWICK

CATALOG No. 7407
Decoration—CUT No. 1

CATALOG No. 7407
Decoration—CUT No. 2

CATALOG No. 7424
Decoration—WINTON

CATALOG No. 7425
Decoration—SCULPTURED

CATALOG No. 7426
Decoration—MARIGOLD

CATALOG No. 7439
Decoration—
SCULPTURED LEAVES

CATALOG No. 7440
Decoration—EVELYN

CATALOG No. 7441
Decoration—GORDON

CATALOG No. 7442
Decoration—MAPLEWOOD

CATALOG No. 7442
Decoration—MAYFAIR

CATALOG No. 7442
Decoration—DELWOOD

CATALOG No. 7443
Decoration—ALICIA

CATALOG No. 7444
Decoration—GRETA

CATALOG No. 7445
Decoration—ROSARIO

CATALOG No. 7471
Decoration—T-6

CATALOG No. 7471
Decoration—T-7

CATALOG No. 7471
Decoration—T-34

CATALOG No. 7471
Decoration—T-100

CATALOG No. 7471
Decoration—T-114

CATALOG No. 7472
Decoration—RENWICK

CATALOG No. 7472
Decoration—MARGUERITE

CATALOG No. 7473
Decoration—T-37

CATALOGG No. 7473
Decoration—T-101

CATALOG No. 7473
Decoration—T-23

CATALOG No. 7475
Decoration—T-109

CATALOG No. 7475
Decoration—T-102

CATALOG No. 7475
Decoration—T-103

CATALOG No. 7476
Decoration—T-102

CATALOG No. 7476
Decoration—T-103

CATALOG No. 7481
Decoration—RIVIERA

CATALOG No. 7481
Decoration—RIVIERA

CATALOG No. 7481
Decoration—RIVIERA

CATALOG No. 7481
Decoration—RIVIERA

CATALOG No. 7482
Decoration—T-35

CATALOG No. 7482
Decoration—T-36

CATALOG No. 7482
Decoration—T-25

CATALOG No. 7483
Decoration—T-27

CATALOG No. 7483
Decoration—T-29

CATALOG No. 7484
Decoration—T-30

CATALOG No. 7485
Decoration—T-31 ST. TROPEZ

CATALOG No. 7485
Decoration—T-31 ST. TROPEZ

CATALOG No. 7485
Decoration—T-31 ST. TROPEZ

CATALOG No. 7485
Decoration—T-31 ST. TROPEZ

CATALOG No. 7486
Decoration—T-32 SPIRAL

CATALOG No. 7486
Decoration—T-32 SPIRAL

CATALOG No. 7486
Decoration—T-32 SPIRAL

CATALOG No. 7486
Decoration—T-32 SPIRAL

CATALOG No. 7486
Decoration—T-104

CATALOG No. 7487
Decoration—T-33

CATALOG No. 7488
Decoration—CUT PUNTIES

CATALOG No. 7489
Decoration—T-105

CATALOG No. 7492
Decoration—T-102

CATALOG No. 7492
Decoration—T-103

CATALOG No. 7492
Decoration—T-104

CATALOG No. 7492
Decoration—T-112
RIVIERA

CATALOG No. 7492
Decoration—T-113
ST. TROPEZ

CATALOG No. 7492
Decoration—T-114

CATALOG No. 7494
Decoration—MILLEFIORI

CATALOG No. 7495
Decoration—SCULPTURED

CATALOG No. 7497
Decoration—T-106

CATALOG No. 7498
Decoration—T-107

CATALOG No. 7499
Decoration—T-108

CATALOG No. 7500
Decoration—T-110

CATALOG No. 7500
Decoration—T-111

CATALOG No. 7501
Decoration—T-115 EMPIRE

CATALOG No. 7501
Decoration—T-115 EMPIRE

CATALOG No. 7501
Decoration—T-115 EMPIRE

CATALOG No. 7501
Decoration—T-115 EMPIRE

CATALOG No. 7503
Decoration—T-114

CATALOG No. 8413
Decoration—BRISTOL

APPENDIX B

Pages from a Vineland Flint Glass Works (Durand) catalog, ca. 1928; numbers beneath objects refer to the shape.

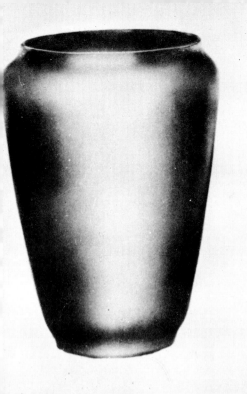
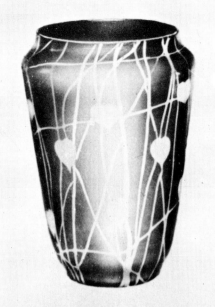
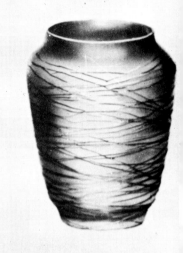

1970

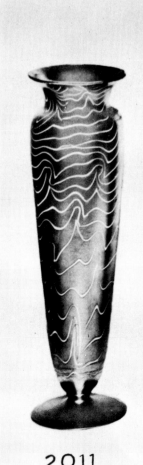
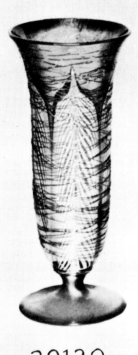
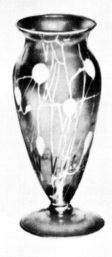

2011 20120 2028½

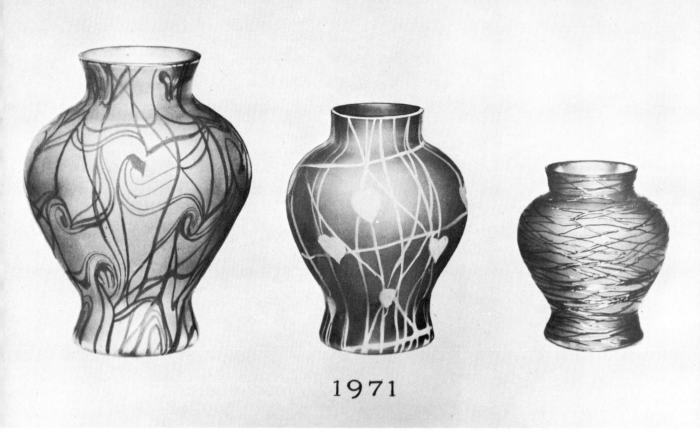

1971

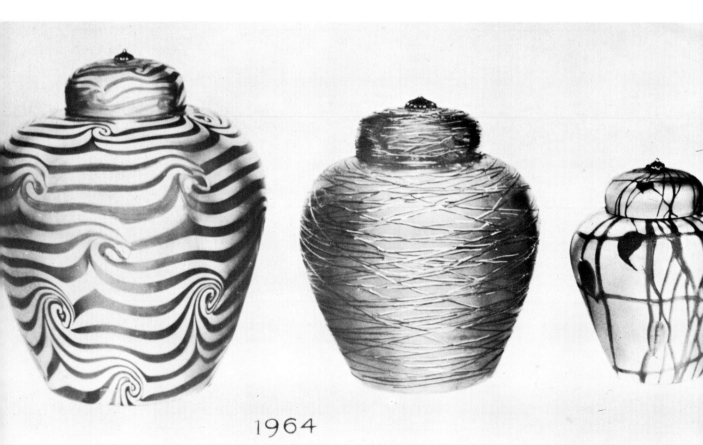

1964

434

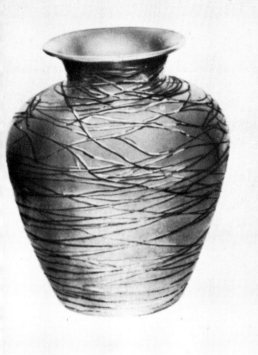
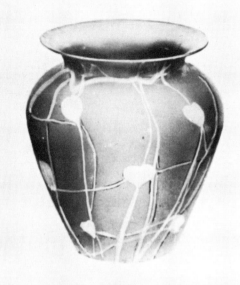
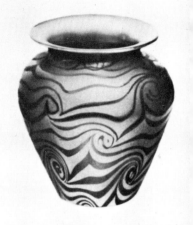

1710

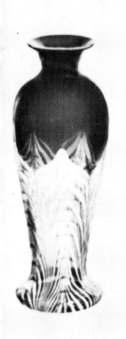
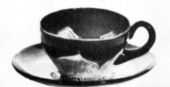
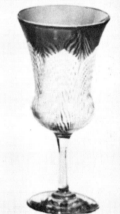

1707

PEACOCK
5030

5030

PITCHER

LEMONADE

GLASS

ICE BUCKET

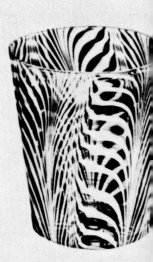

60

5000 5000 5005

1716 ALMOND DISH 1722

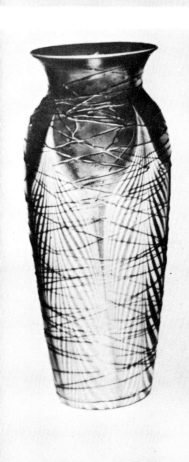
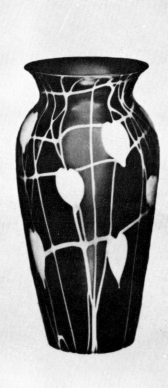

1812

1716 2028 2029

10" BALL BOTTLE R 1 CYLINDE

V 10

V 16

V 18

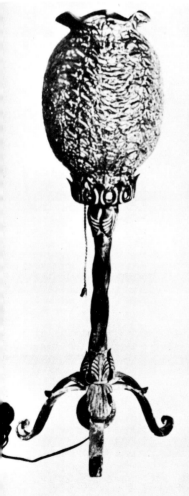

804

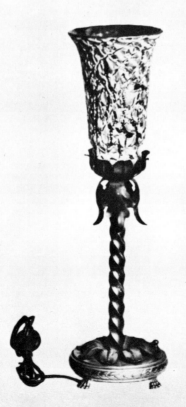

V 12

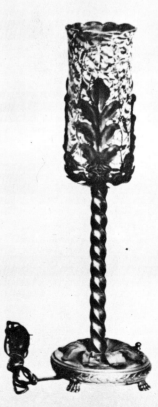

V 13

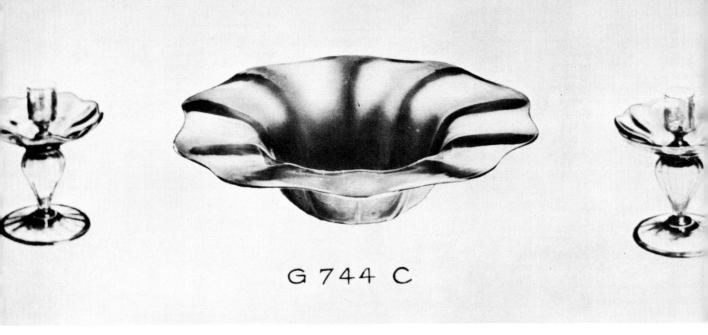

G 744 C

1974

440

2506/2044

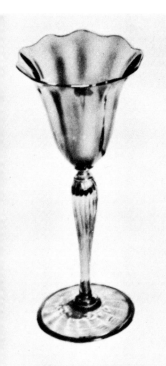

G 744 C

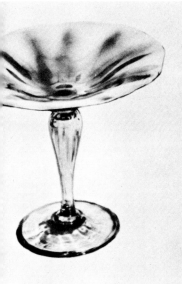
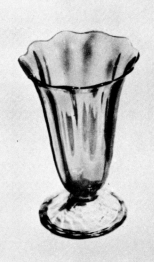

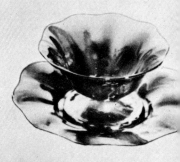

G 744 C

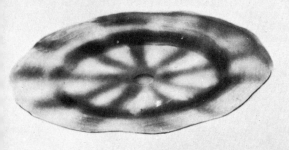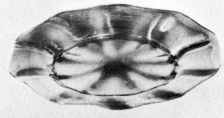

G 744 C

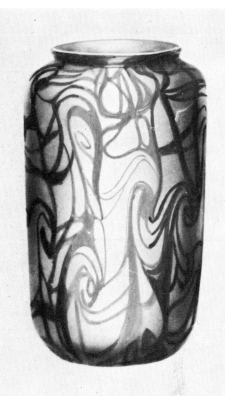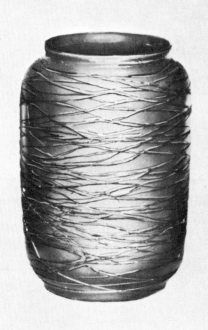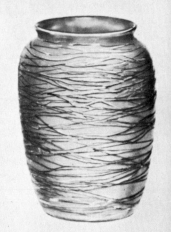

1968

442

APPENDIX C

Pages from a catalog published by C. Dorflinger & Sons (The Honesdale Decorating Company), ca. 1914.

443

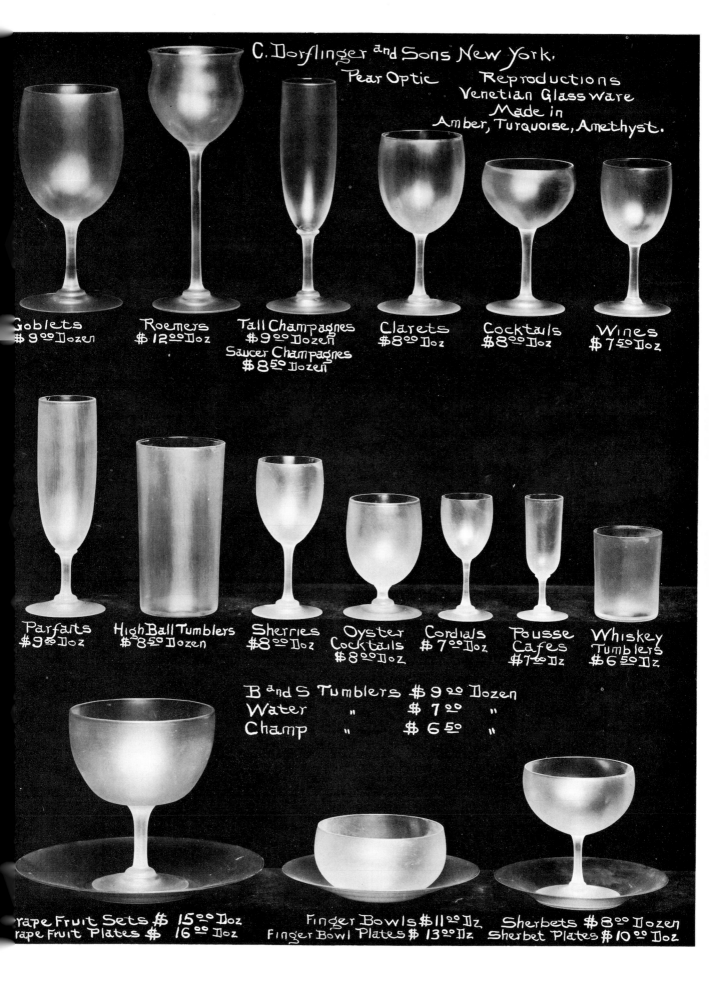

C. Dorflinger and Sons New York.

Pear Optic Reproductions
Venetian Glassware
Made in
Amber, Turquoise, Amethyst.

Goblets
$9.00 Dozen

Roemers
$12.00 Doz

Tall Champagnes
$9.00 Dozen
Saucer Champagnes
$8.50 Dozen

Clarets
$8.00 Doz

Cocktails
$8.00 Doz

Wines
$7.50 Doz

Parfaits
$9.00 Doz

High Ball Tumblers
$8.50 Dozen

Sherries
$8.00 Doz

Oyster
Cocktails
$8.00 Doz

Cordials
$7.00 Doz

Pousse
Cafes
$7.00 Dz

Whiskey
Tumblers
$6.50 Dz

B and S Tumblers $9.00 Dozen
Water " $7.00 "
Champ " $6.50 "

rape Fruit Sets $ 15.00 Doz
rape Fruit Plates $ 16.00 Doz

Finger Bowls $11.00 Dz
Finger Bowl Plates $ 13.00 Dz

Sherbets $8.00 Dozen
Sherbet Plates $10.00 Doz

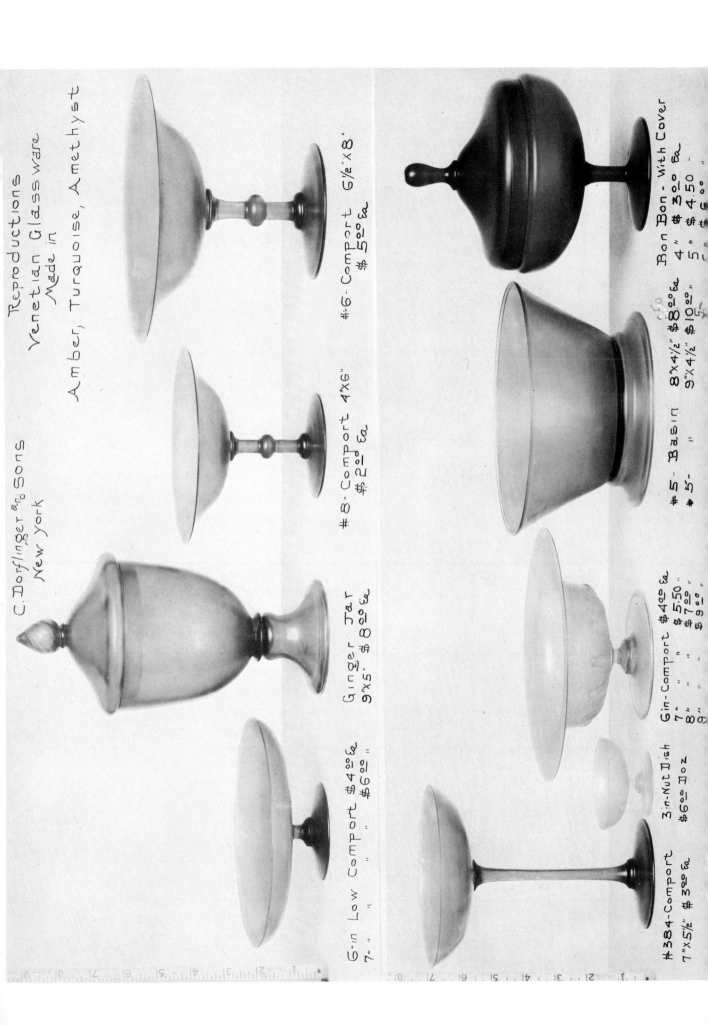

Reproductions
Venetian Glassware
Made in

Amber, Turquoise, Amethyst

C. Dorflinger and Sons
New York

#6- Comport 6½"x8"
$5⁰⁰ ea

#8- Comport 4"x6"
$2⁰⁰ ea

Ginger Jar
9"x5" $8⁰⁰ ea

6-in Low Comport $4⁰⁰ ea
7- " " $6⁰⁰ "

Bon Bon- with Cover
4" $3⁰⁰ ea
5" $4.50 "
6" $6⁰⁰ "

#5- Basin 8"x4½" $8⁰⁰ ea
#5- " 9"x4½" $10⁰⁰ ea

Gin-Comport $4⁰⁰ ea
7" " $5.50 "
8" " $7⁰⁰ "
9" " $9⁰⁰ "

3-in-Nut Dish
$6⁰⁰ Doz

#384-Comport
7"x5½" $3⁰⁰ ea

Venetian Glassware
Made in
Amber, Turquoise, Amethyst

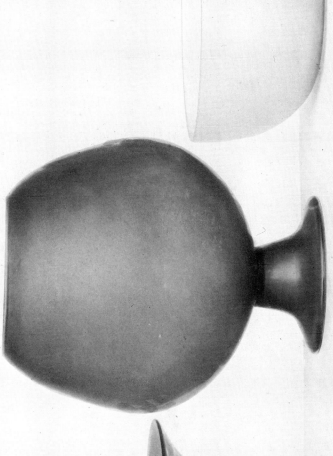

#125 - Aquarium

14"X 7" Cap 5 Gal $10 00 Ea
16"X 8" " 7 " $10 00 "
18"x 9" " 8 " $20 00 "
20"X 9" " 9 " $20 00 "
22x 9" " 10 " $20 00 "

5 Gal Aquarium $20 00 Ea
(18"x 15")

554 - Aquarium $30 00 Ea

(18"X 9") (Capacity 4½ Gal)

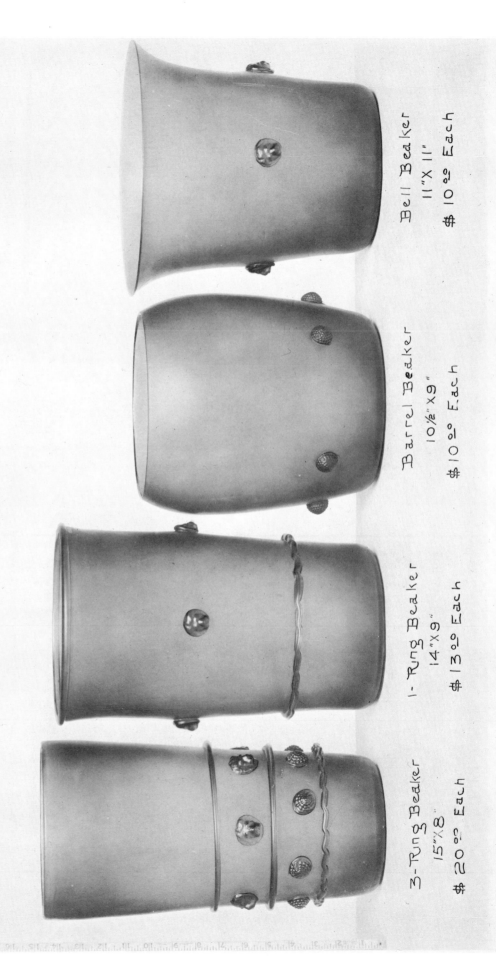

C. Dorflinger and Sons New York

Reproductions
Venetian Glassware
Made in
Amber, Turquoise, Amethyst

3-Ring Beaker
15"X8"
$20.00 Each

1-Ring Beaker
14"X9"
$13.00 Each

Barrel Beaker
10½"X9"
$10.00 Each

Bell Beaker
11"X 11"
$10.00 Each

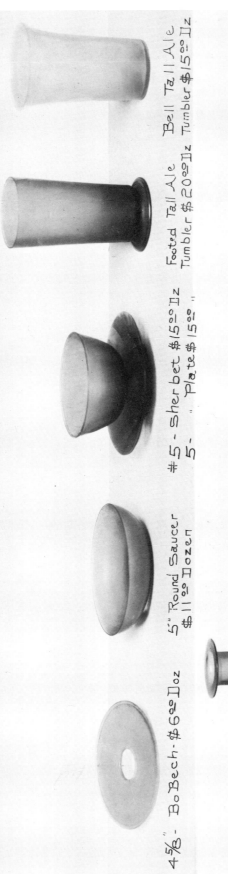

4 5/8" - Bo Bech - $6.00 Doz

5" Round Saucer $11.00 Dozen

#5 - Sherbet $15.00 Dz
5 - " Plate $15.00 "

Footed Tall Ale Tumbler $20.00 Dz

Bell Tall Ale Tumbler $15.00 Dz

#2-7½" Candle Stick $10.00 Pair

#2- 12" Candle Stick $12.00 Pair

#1-10½" Candle Stick $16.00 Pair

#3-8½" Candle Stick $8.00 Pair

#915 Cocktail $18.00 Dozen

#790 Cocktail Twist Stem $12.00 Dozen

C. Dorflinger and Sons. New York.

Reproductions
Venetian Glass ware
Made in
Amber, Turquoise, Amerthyst.

2-Gal Aquarium
(15"x10") $10.00 Ea
1/2 Gal Aquarium
(11"x 7") $8.00 Ea

Goblet Aquarium
(14"x 9") $12.00 Ea
Capacity 1/2 Gal
Also made in Flint with
Colored Trimmings

#2- Beaker (10"x 9") $18.00 Ea
Capacity 2 Gal
Different Colored Trimmings

C. Dorflinger and Sons New York.

Reproductions
Venetian Glass Ware
Made in
Amber, Turquoise, Amethyst

8" Puff Box and Cover
$6.00 Each

#30 – 12" Fruit Bowl
$10.00 Each

13½" – #7 Flower Pan
$4.00 Each

8" Salad Plate
$15.00 Dozen

11" Service Plate
$48.00 Dozen

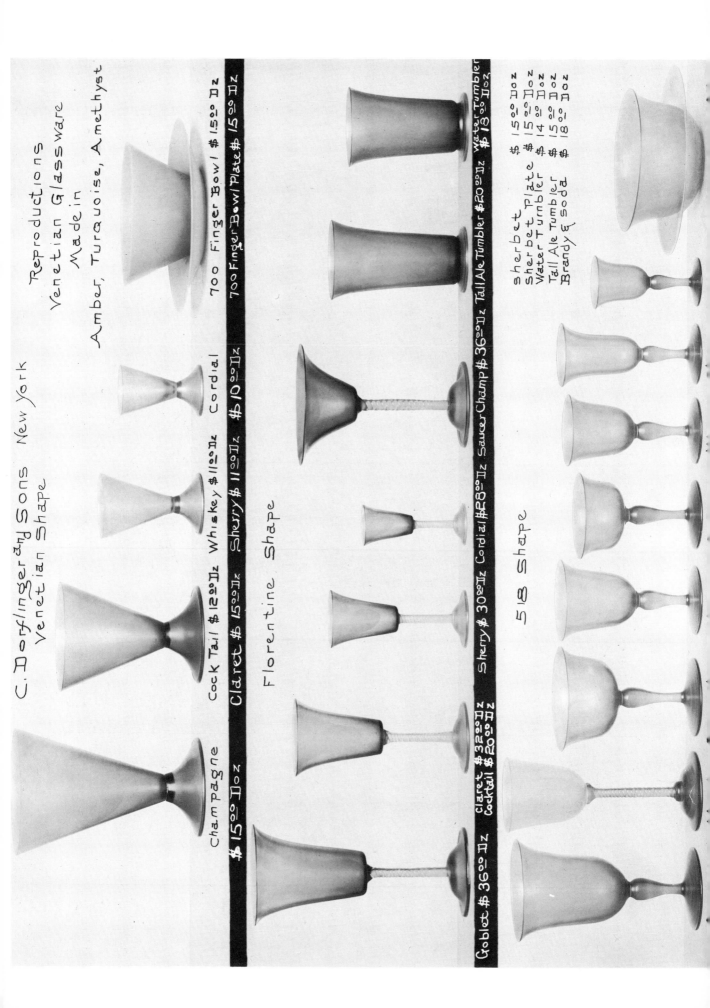

C. Dorflinger & Sons New York

Reproductions
Venetian Glassware
Made in
Amber, Turquoise, Amethyst

Venetian Shape

700 Finger Bowl $15.00 Dz
700 Finger Bowl/Plate $15.00 Dz

Champagne Cock Tail $12.00 Dz Whiskey $11.00 Dz Cordial
$15.00 Dz Claret #15.00 Dz Sherry #11.00 Dz #10.00 Dz

Florentine Shape

Water Tumbler
Tall Ale Tumbler $20.00 Dz #13.00 Dz
Saucer Champ #36.00 Dz

Goblet #36.00 Dz Sherry $30.00 Dz Cordial #28.00 Dz
Claret #32.00 Dz
Cocktail $20.00 Dz

518 Shape

sherbet $15.00 Doz
Sherbet Plate $15.00 Doz
Water Tumbler $14.00 Doz
Tall Ale Tumbler $15.00 Doz
Brandy & soda $18.00 Doz

Venetian Glassware
Made in
Amber, Turquoise, Amethyst

#40- Comport (13"x7") $20.00 Ea.

#11- Flower Comport (16"x4") $16.00 Ea.

#42- Comport (14"x6") $12.00 Ea.

#2- Comport (11"x9") $24.00 Ea.
With Rings

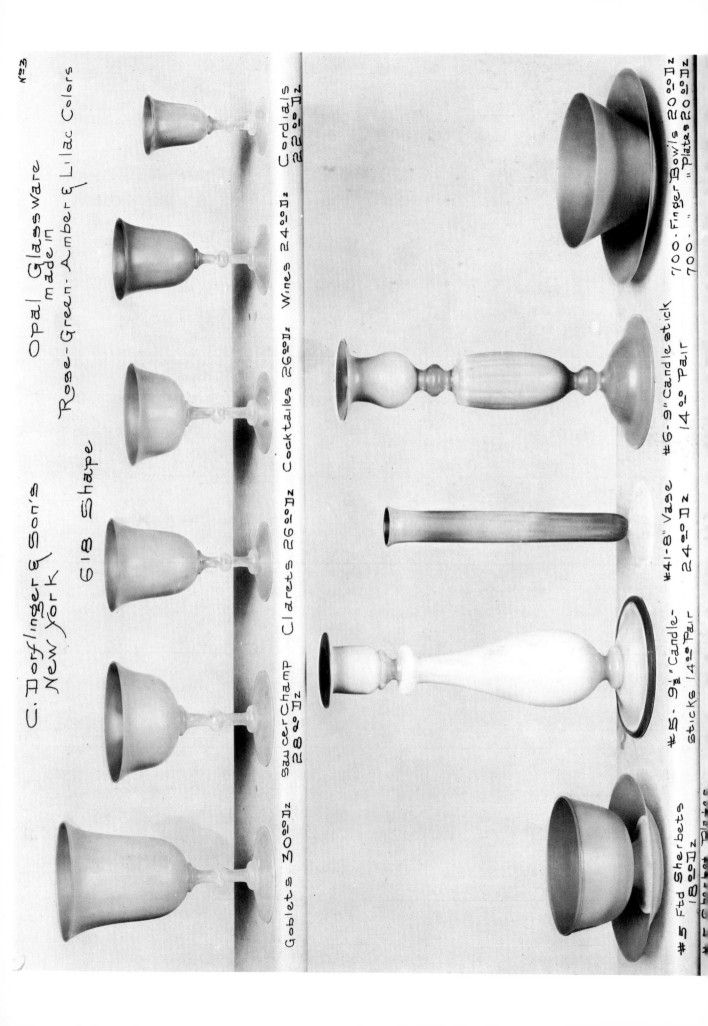

C. Dorflinger & Son's
New York

Opal Glassware
made in
Rose-Green-Amber & Lilac Colors

618 Shape

Goblets 30⁰⁰ Dz SaucerChamp Clarets 26⁰⁰ Dz Cocktails 26⁰⁰ Dz Wines 24⁰⁰ Dz Cordials
 28⁰⁰ Dz 22⁰⁰ Dz

#5 Ftd Sherbets #5.- 9½" Candle- #41-8" Vase #6-9" Candlestick 700.-Finger Bowls 20⁰⁰ Dz
18⁰⁰ Dz sticks 14⁰⁰ Pair 24⁰⁰ Dz 14⁰⁰ Pair 700. - "Plates 20⁰⁰ Dz

The Honesdale Decorating Co Gold Decorated Glassware

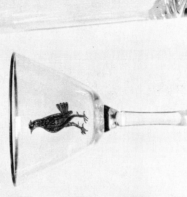

#10-Cocktail-Enameled
Black & White $18ºº Dz

#10-Cocktail
Enameled Rooster
$16º Dz

#790-Cocktail
Two Enameled Cocks
$24ºº Dz

#790-Cocktail
Enameled Rooster
$27ºº Dz

#3307-Cocktail
Enameled Rooster
$18ºº Dz

#555-Cocktail
C S & S F
Enameled Rooster
Gilded Rooster
$19ºº Dz

#790-Cocktail
Gilded R&RS
Two Gilded Fight Cocks
$17ºº Dz

#790-Cocktail Bell Cocktail
Gilded R&RS Two Gilded Cocks Gilded R&RS
$24ºº Dz $9ºº Dz

#795-Cocktail
Engraved Cock
$12ºº Dz

#795-Cocktail
Gilded Rooster
$14ºº Dz

Mixing Tumbler
Gilded R&RS
$16º EA

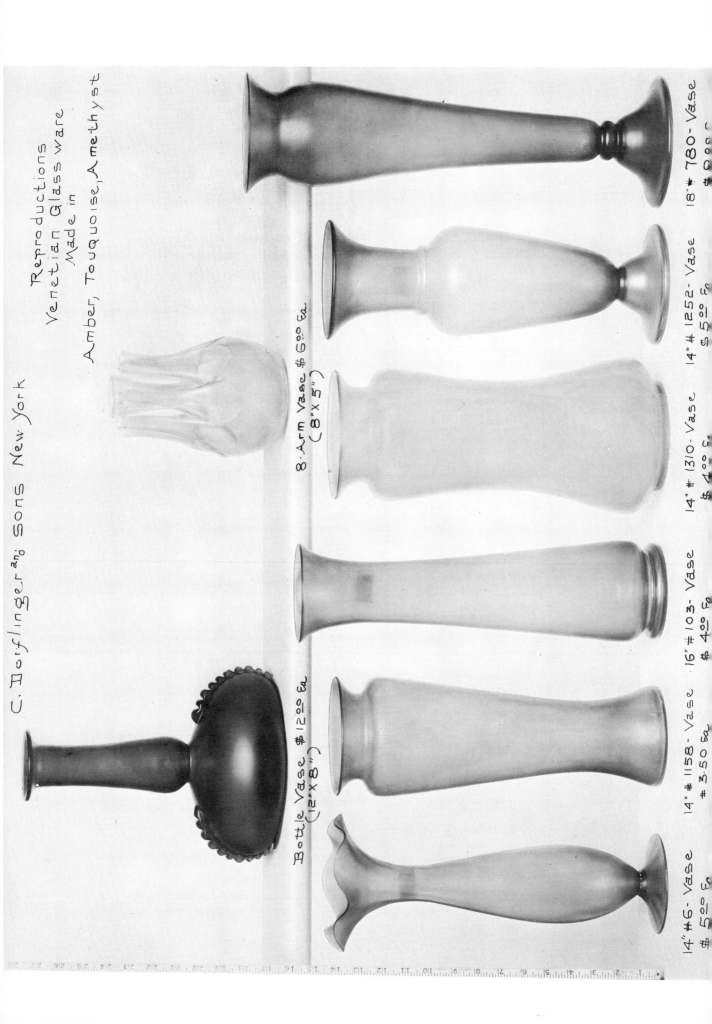

C. Dorflinger and Sons New York

Reproductions
Venetian Glass ware
Made in
Amber, Touquoise, Amethyst

8-Arm Vase $6.00 ea
(8" x 5")

Bottle Vase $12.00 ea
(12" x 8")

14" #6- Vase 14" #1158- Vase 16" #103- Vase 14" #1310- Vase 14" #1252- Vase 18" #780- Vase
$5.00 ea $3.50 ea $4.00 ea $4.00 ea $5.00 ea $6.00 ea

APPENDIX D

"The Belle Ware" catalog
published by Carl V. Helmschmied
(later stamped "The Helmschmied
Mfg. Co.").

HANDKERCHIEF, No. 200.

ORDER No. 1.	BLUE FLOWERS, Blue Tint,		List each,	$4.70
2.	VIOLETS,	Lavender Tint,	'' ''	4.70
3.	ROSES,	Pink Tint,	'' ''	4.70
100.	CHRYSANTHEMUM, Frosted, Fancy Grd.,		'' ''	6.80
200.	GIRL IN PINK, Dark Green Tint and Gold,		'' ''	9.50
201.	GIRL IN WAVES, Light Green Frosted, Gold,		'' ''	9.50

HANDKERCHIEF, No. 202.

4.	BLUE FLOWERS, Blue Tint,	- -	List each,	$4.?
5.	VIOLETS,	Lavender Tint,	- - '' ''	4.?
6.	ROSES,	PINK Tint,	- - '' ''	4.?
101.	POND LILLIES, Frosted, Fancy Ground,	-	'' ''	5.8
202.	BOY on Deep Old Rose and Gold,	-	'' ''	9.0
203.	LADY AND CUPID, Yellow, Frosted and Gold,		'' ''	8.?
204.	CUPID IN CLOUDS, Dark Green and Gold,		'' ''	8.0

JEWEL CASE, No. 206.

ORDER No. 7.	BLUE FLOWERS, Blue Tint,	- -	List each,	$3.70
8.	VIOLETS,	Lavender Tint,	'' ''	3.70
9.	ROSES,	Pink Tint,	'' ''	3.70
102.	CHRYSANTHEMUM, Frosted, FancyGround,		'' ''	5.20
205.	GIRL SWIMMING, Light Blue, Frosted, Gold,		'' ''	7.50
206.	DANCING GIRL, Pink, Frosted and Gold,		'' ''	7.70
207.	ROCOCO FIGURE, Dark Green Tint, Gold,		'' ''	7.90

JEWEL CASE, No. 208.

10.	BLUE FLOWERS, Blue Tint,	- -	List each,	$2.9
11.	VIOLETS,	Lavender Tint,	'' ''	2.9
12.	ROSES,	Pink Tint,	'' ''	2.9
103.	POND LILLIES, Frosted,	- -	'' ''	4.5
208.	SWEET SIXTEEN, Light Green, Frosted and Gold,		'' ''	6.5

China Brush and Comb Trays to match,

ated Trimmings and lined with the best Satin.

BOUT ONE-HALF SIZE.)

BRUSH AND COMB TRAY, 8 x 12 IN.

64.	BLUE FLOWERS,	Blue Tint,	.	.	.	List each,	$4 00
65.	VIOLETS,	Lavender Tint,	.	.	.	" "	4.00
66.	ROSES,	Pink Tint,	.	.	.	" "	4.00
108.	POND LILLIES,	Fancy Tint, Frosted,	.	.		" "	6.00

JEWEL TRAY.

13.	BLUE, List per doz.,	$20.40
14.	VIOLET, " "	20.40
15.	ROSES, " "	20.40
104.	Frosted, List each,	2.70

PUFF OR BON BON,
NOT LINED.

16.	BLUE, List per doz.,	$18.00
17.	VIOLET, " "	18.00
18.	ROSES, " "	18.00

JEWEL CASE.

19.	BLUE,	List per dozen,	$19.20
20.	VIOLET,	" " "	19.20
21.	ROSES,	" " "	19.20
105.	Frosted, List each,		2.50

PUFF OR BON BON, NOT LINED.

22.	BLUE,	List per dozen,	$16 80
23.	VIOLET,	" " "	16.80
24.	ROSES,	" " "	16.80

OPEN JEWEL TRAY.

atin Lined.

ASH TRAY.

Not Lined.

25.	BLUE, List per doz.,	$18.00		28.	BLUE, List per doz.,	$14.40
26.	VIOLET, " "	18.00		29.	VIOLET, " "	14.40
27.	ROSE, " "	18.00		30.	ROSE, " "	14.40

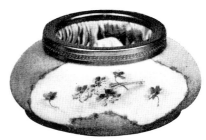

JEWEL TRAY.

31.	BLUE,	- -	List per dozen,	$10 80
32.	VIOLET,	-	" " "	10.80
33.	ROSES,	- -	" " "	10.80
105½.	Frosted, List each,			1.40

OPEN BON BON.

34.	BLUE,	- -	List per dozen,	$9.60
35.	VIOLET,	-	" " "	9.60
36.	ROSES,	- -	" " "	9.60

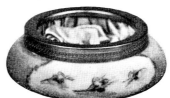

JEWEL TRAY.

38.	BLUE,	- -	List per dozen,	$9.60
39.	VIOLET,	-	" " "	9.60
40.	ROSES,	- -	" " "	9.60

BON BON.

41.	BLUE,	- -	List per dozen,	$8.40
42.	VIOLET,	-	" " "	8.40
43.	ROSES,	- -	" " "	8.40

BRUSH AND COMB TRAY, 8 x 12 IN.

67.	BLUE FLOWERS,	Blue Tint,	-	-	List each,	$4.00
68.	VIOLET,	Lavender,			" "	4.00
69.	ROSES,	Pink Tint,			" "	4.00
109.	CHRYSANTHEMUM,	Frosted, Fancy Ground,			" "	6.00

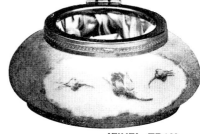

"BELLE WARE."
China Trays, Cracker Jars, Pepper and Salts, and Paper Cutter.
(Cuts About One-Half Size.)

58.	Blue, List per doz.,	$3.00
59.	Violet, " " "	3.00
60.	Rose, " " "	3.00

CHINA PEN TRAY, 3 x 9¼ In.

76.	Blue,				List per dozen,	$13 20
77.	Violet,				" "	13.20
78.	Rose,				" "	13.20
112.	Chrysanthemum, Frosted,				" each,	1.80

61.	Blue, List per doz.,	$3.00
62.	Violet, " " "	3.00
63.	Rose, " " "	3.00

CHINA BRUSH AND COMB TRAY, 6 x 10 In.

70.	Blue,			List each,	$3.00
71.	Violet,			" "	3.00
72.	Rose,			" "	3.00
110.	Pond Lillies, Frosted,			" "	4 00

CHINA PIN TRAY, 3¼ x 6½ In.

73.	Blue,				List per dozen,	$9.60
74.	Violet,				" "	9.60
75.	Rose,				" "	9.60
111.	Rose, Frosted,				each,	1.50

CRACKER JAR with Silver Plated Top.

44.	Blue,			List each,	$3.00
45.	Violet,			" "	3.00
46.	Rose,			" "	3 00
106.	Pond Lillies, Frosted,			" "	3.50

PAPER CUTTER.

Bronze,	List per doz ,	$9.60
Antique Copper,	" "	9.60
Aluminum,	" "	9.60

CRACKER JAR with Silver Plated Top.

47.	Blue,			List each,	$3.40
48.	Violet,			" "	3.40
49.	Rose,			" "	3.40
107.	Chrysanthemum, Frosted,			" "	4.50

BIBLIOGRAPHY

Books

Beer, Thomas, *The Mauve Decade.* Alfred A. Knopf, New York, 1926.

Ericson, Eric E., *A Guide to Colored Steuben Glass, 1903-1933.* The Lithographic Press, Denver, Col., 1963.

Freeman, Larry, *Iridescent Glass.* Century House, Watkins Glen, N.Y.

Koch, Robert, *Louis C. Tiffany—Rebel in Glass.* Crown Publishers, Inc., New York, 1964.

Lafferty, James R., *Fry's Pearl Ware.* Privately published, 1966.

Lee, Ruth Webb, *Nineteenth Century Art Glass.* M. Barrows & Co., New York, 1949.

McConnell, Jane and Burt, *The White House.* Studio Publications, New York, 1954.

McKearin, Helen and George S., *American Glass.* Crown Publishers, Inc., New York, 1941.

————, *Two Hundred Years of American Glass.* Crown Publishers, Inc., New York, 1950.

Madsden, Stephan Tschudi, *Sources of Art Nouveau.* Wittenborn & Co., New York, 1955.

Philpot, Cecily and Gerry, *Creations by Carder of Steuben.* The Fieldstone Porch, n.d.

Revi, Albert Christian, *Nineteenth Century Glass.* Thomas Nelson & Sons, Camden, N.J., 1959.

Speenburgh, Gertrude, *The Arts of the Tiffanys.* Lightner Publishing Corp., Chicago, Ill., 1956.

Tiffany, Nelson Otis, "The Tiffanys of America." Privately printed, Buffalo, N.Y., 1903.

Signed articles

Feld, Stuart P., "Nature in Her Most Seductive Aspects." *Bulletin of the Metropolitan Museum of Art,* November, 1962, pp. 100-112.

Haden, H. J., "Frederick Carder—designer, technologist, and centenarian." *Glass Technology,* Vol. 5, No. 3, June 1964.

463

Messanelle, Ray, "Art Glass Signed Nash." *Spinning Wheel,* February, 1962, pp. 12-13.

O'Neal, William B., "Three Art Nouveau Glass Makers." *Journal of Glass Studies,* Vol. 2, 1960, pp. 125-137.

Perrot, Paul, "Frederick Carder's Legacy to Glass." *Craft Horizons,* May/June, 1961.

Polak, Ada, "Tiffany 'Favrile' Glass." *Antique Dealer and Collector Guide,* January, 1962, pp. 39-41.